Coaching Volleyball FOR DUMMIES®

by National Alliance for Youth Sports
with Greg Bach

WILEY

Wiley Publishing, Inc.

Coaching Volleyball For Dummies®

Published by
Wiley Publishing, Inc.
111 River St.
Hoboken, NJ 07030-5774
www.wiley.com

For general information on our other products and services, please contact our Customer Care Department within the U.S. at 877-762-2974, outside the U.S. at 317-572-3993, or fax 317-572-4002.

For technical support, please visit www.wiley.com/techsupport.

Wiley also publishes its books in a variety of electronic formats. Some content that appears in print may not be available in electronic books.

Library of Congress Control Number: 2009927338

ISBN: 978-0-470-46469-4

Manufactured in the United States of America

13

WILEY

About the Authors

The **National Alliance for Youth Sports** (NAYS) has been America's leading advocate for positive and safe sports for children since 1981. NAYS serves volunteer coaches, parents with children involved in organized sports, game officials, youth sports administrators, league directors, and the youngsters who participate in organized sports. More than 3,000 communities nationwide, including parks and recreation departments, Boys & Girls Clubs, Police Athletic Leagues, YMCAs and YWCAs, and various independent youth service groups, along with military installations worldwide, use NAYS's programs. For more information on the alliance's programs, which are listed below, visit www.nays.org.

National Youth Sports Coaches Association (NYSCA) — More than 2.5 million volunteer coaches have been trained through NYSCA, which provides training, support, and continuing education.

Parents Association for Youth Sports — Parents gain a clear understanding of their roles and responsibilities in youth sports through this sportsmanship training program, which is used in more than 500 communities nationwide.

Academy for Youth Sports Administrators — More than 2,000 administrators worldwide have gone through the Academy, which is a 20-hour certification program that raises the professionalism of people delivering youth sport services. A professional faculty presents the information, and participants earn Continuing Education Units (CEUs).

National Youth Sports Administrators Association — This program provides training, information, and resources for volunteer administrators responsible for the planning and implementation of out-of-school sports programs.

National Youth Sports Officials Association — Officials who go through this certification program gain valuable knowledge on skills, fundamentals, and the characteristics that every good official must possess.

Start Smart Sports Development Program — This proven instructional program prepares children for the world of organized sports without the threat of competition or the fear of getting hurt. The program uses an innovative approach that promotes parent-child bonding.

Hook A Kid On Golf — Thousands of children of all ages and skill levels tee up every year in the nation's most comprehensive junior golf development program, which features an array of instructional clinics and tournaments.

Game On! Youth Sports — This worldwide effort introduces sports to children who otherwise would not have opportunities to participate.

Greg Bach is the vice president of communications for the National Alliance for Youth Sports (NAYS), where he has worked since 1993. Before joining NAYS, he worked as the sports editor of the *Huron Daily Tribune* in Bad Axe, Michigan, where he captured numerous writing awards from the Associated Press, Michigan Press Association, and Hearst Corporation. In 1989, he earned a journalism degree from Michigan State University. He's an avid sports fan and has coached a variety of youth sports. He is also the author of *Coaching Soccer For Dummies, Coaching Football For Dummies, Coaching Baseball For Dummies, Coaching Basketball For Dummies,* and *Coaching Lacrosse For Dummies.*

Dedication

National Alliance for Youth Sports: This book is dedicated to all the volunteer volleyball coaches who give up countless hours of their free time to work with children and to ensure that they have positive, safe, and rewarding experiences in the sport. We applaud their efforts and commend them for making a difference in the lives of youngsters everywhere.

Greg Bach: For Boomer, Rocky, and Benny and all the good times we had.

Authors' Acknowledgments

A lot goes into making a youth volleyball program a truly successful one that meets every child's needs. It takes a real commitment from dedicated volunteer coaches who understand the game and love teaching it to kids; it requires parents to clearly understand their roles and responsibilities; and it calls for league directors and administrators who know what it takes to ensure that every child who steps on the volleyball court in their community has a safe, fun, and rewarding experience. The exciting, action-packed sport of volleyball plays an important role in the lives of millions of children — it provides them with the opportunity to learn the skills of the game and gives them the chance to develop both emotionally and physically as individuals. The National Alliance for Youth Sports extends a heartfelt thank you to every person who makes a positive difference in the life of a child through volleyball.

This book is the result of countless hours of hard work from a tremendous group of people, and we can't thank all the wonderful people at Wiley enough for making it all happen. For starters, there's Stacy Kennedy, the acquisitions editor, whose efforts have led to this being the sixth book in a series for youth coaches; Chad Sievers, the project editor, whose passion for the sport, as both a fan and a longtime official, significantly upgraded the quality of every chapter; Amanda Gillum, the copy editor, whose ideas and great eye for detail made a tremendous difference in the quality of the material presented; the fabulous talents of the illustrators — Rashell Smith, Mark Pinto, Brooke Graczyk — whose work will be great references as you teach your team all the various skills and strategies of the game; and Michelle York, the former all-SEC setter from the University of Mississippi, whose wealth of volleyball knowledge and experience with the sport was a huge asset every step of the way.

Publisher's Acknowledgments

We're proud of this book; please send us your comments through our Dummies online registration form located at http://dummies.custhelp.com. For other comments, please contact our Customer Care Department within the U.S. at 877-762-2974, outside the U.S. at 317-572-3993, or fax 317-572-4002.

Some of the people who helped bring this book to market include the following:

Acquisitions, Editorial, and Media Development

Project Editor: Chad R. Sievers

Acquisitions Editor: Stacy Kennedy

Copy Editor: Amanda M. Gillum

Assistant Editor: Erin Calligan Mooney

Editorial Program Coordinator: Joe Niesen

Technical Editor: Michelle York

Editorial Manager: Michelle Hacker

Editorial Assistant: Jennette ElNaggar

Art Coordinator: Alicia B. South

Cover Photos: © Thomas Northcut

Cartoons: Rich Tennant (www.the5thwave.com)

Composition Services

Project Coordinator: Patrick Redmond

Layout and Graphics: Reuben W. Davis, Brooke Graczyk, Melissa K. Jester, Mark Pinto, Rashell Smith, Christine Williams

Proofreaders: Jessica Kramer, Toni Settle

Indexer: Broccoli Information Management

Publishing and Editorial for Consumer Dummies

Diane Graves Steele, Vice President and Publisher, Consumer Dummies

Kristin Ferguson-Wagstaffe, Product Development Director, Consumer Dummies

Ensley Eikenburg, Associate Publisher, Travel

Kelly Regan, Editorial Director, Travel

Publishing for Technology Dummies

Andy Cummings, Vice President and Publisher, Dummies Technology/General User

Composition Services

Debbie Stailey, Director of Composition Services

Contents at a Glance

Table of Contents

Introduction

· ·

*W*elcome to *Coaching Volleyball For Dummies,* a book dedicated to all the wonderful volunteer coaches who commit their time and energy to helping children learn about this amazing sport and giving them a fun-filled and stress-free atmosphere to play in. We hope you find the material informative, entertaining, and — most importantly — useful in helping guide all your players to a fun and safe experience, an experience that's so rewarding they can't wait to return to the court next season!

About This Book

We wrote this book to lend a hand to first-time volleyball coaches searching for guidance before they step on the court with their new team. After all, having some preseason jitters is perfectly understandable if you're new to the sport or simply new to coaching it to a group of kids. Not to worry, the book you hold in your hands can put your mind at ease by revealing everything you need to know to help you have a positive impact on the kids and provide them with wonderful memories all season long.

We also wrote this book for those coaches who have been involved with the sport for a few seasons and who are looking for additional insight into different aspects of the game, such as how to upgrade their offensive attack, strengthen their defense, or incorporate more challenging drills into their practice sessions to help keep pace with their players' ever-changing needs. Whether you're searching for how to use quick sets or run a 5-1 formation on offense or how to use multiple blocking schemes or defend a left-side attack with a player up alignment on defense, you can find help here.

One of the neat features of this book is that you can dig in anywhere. If you're a rookie volleyball coach, you may have questions about how to talk to the parents before the season begins or what skills you need to focus on teaching first. If you're a veteran, you may just want to know how to bolster your defense or improve your offense. Just head to the table of contents or index for the topic you're most interested in, and then read on to get the scoop on the best approaches. Each chapter is divided into sections, and each section contains information on a specific topic concerning coaching youth volleyball.

Conventions Used in This Book

To help guide you through this book, we use the following conventions:

- ✔ *Italic* text emphasizes certain words and highlights new words or phrases that we define in the text.
- ✔ **Boldface** text indicates key words in bulleted lists and the action parts of numbered steps.
- ✔ Monofont sets apart Web addresses.
- ✔ Mixed genders — *he* and *she* — are interchanged throughout this book because all the material we present here works for coaches of both girls' and boys' volleyball teams. Also, the *we* you find throughout the book refers to the National Alliance for Youth Sports, which is America's leading advocate for positive and safe sports for kids.

What You're Not to Read

If you ask us, every single page of this book is overflowing with valuable information, and you don't want to skip over any of it. But we're realistic and understand that you're a busy person, so you really don't have to read every single word. For example, the sidebars — the shaded gray boxes that you see in some of the chapters — feature interesting information that you can skip over when you're pressed for time or are in a rush because you have a volleyball practice to get to.

Foolish Assumptions

The following are some assumptions we make about you, our reader. All or just some of these may apply to you. No matter what, we had you in mind as we wrote this book:

- ✔ You know that the game is played on a court with a net; that teams send the ball back and forth across the net; and that the ball hitting the court is only good when it occurs on the opposing team's side.
- ✔ You have a son or daughter who wants to play volleyball this season, but you're not sure how to teach him or her — as well as his or her teammates — the game.

✔ You're a first-time volleyball coach, or someone who's relatively new to coaching young volleyball players, and you're looking for information on how to oversee a youth team.

✔ You've been coaching volleyball for a few years for a club program and want to take your practices to the next level so your team can be more competitive.

✔ You don't have your sights set on coaching a high school or college volleyball team anytime soon.

If any of these descriptions are on target, you've come to the right place.

How This Book Is Organized

This book is divided into parts, and each part pertains to a specific aspect of coaching a youth volleyball team. The following sections give you a quick rundown.

Part 1: Getting Started Coaching Volleyball

Coaching a youth volleyball team — regardless of whether it's a group of 8-year-olds who have no clue how to put on their knee pads or a 14-and-under team that has a lot of tournament experience — is a real challenge. Often, the difference between a season that surpasses the kids' expectations and one that has you reaching for the antacid tablets is the work you do before you ever step onto the court with your team. This part addresses all those areas that often get overlooked but that are crucial for starting the season off on a positive note: creating a coaching philosophy that meets the players' needs, running an effective preseason parents meeting to get everyone focused on what's truly best for the kids, and getting a handle on all the rules and terminology of the sport so you can teach them to your players.

Part 11: Building Your Team

You volunteered this season to teach your players all sorts of offensive and defensive skills. This section addresses all those questions that are stockpiling in the back of your mind early in the season, such as how to evaluate the

strengths and weaknesses of your players, how to find roles for all the kids to succeed in, and how to coach all different types of kids, ranging from the shy and inattentive to the athletically gifted. This part also answers all your practice and game day questions, including the following:

- ✔ How do I plan practices that the kids can't wait to be a part of?
- ✔ How do I make sure that I'm maximizing my time with the kids during practice?
- ✔ What do I say to my team before a match to help put them in the proper mindset to play their best at the same time that they enjoy the sport?
- ✔ What is the best approach for motivating kids during matches, especially when they're really struggling?
- ✔ What aspects of the match should I be monitoring closely to ensure that every player has a rewarding experience?

Part III: Basic Training: Teaching Volleyball Fundamentals

Teaching kids the basic elements of volleyball — serving, passing, setting, attacking, and blocking, among others — is crucial for their short-term enjoyment and long-term participation. The better your players can perform these skills, the more satisfying their experience is. In this part, we cover all the basic offensive and defensive skills your players need to be successful when game day rolls around. Plus, we provide an assortment of drills designed to help both beginning level players and those who are ready to build on the basics.

Part IV: Net Gains: Zeroing In on Advanced Volleyball Skills

After your players have a handle on the basics of the game, and are proficient at performing them, you have to keep pace with their development so that their progress doesn't stall. This part helps you do the job. Here we describe the advanced offensive and defensive techniques you can use to raise the level of the kids' play and keep their interest in volleyball going strong.

Part V: The Extra Points

We hope that your season will be an injury-free one for your players and a problem-free one for you, but injuries and behaviors are often out of your control. So, the better prepared you are to deal with unexpected injuries or behavior problems, the greater the chance is that your season will continue to run smoothly even if they do arise. In this part, we cover how to help protect your players from injuries; how to treat the minor ones if they do occur; and how to respond to the major ones. We also provide an array of information on resolving conflicts with players, parents, opposing coaches, and even your assistant coaches who may veer away from your coaching philosophy. Also, if you harbor any aspirations to coach at a more advanced volleyball level, such as a club team, we provide everything you need to know to help make your transition to this more elite level a smooth one.

Part VI: The Part of Tens

A feature of all *For Dummies* books, the Part of Tens has some great information that can help propel your team to a fun-filled season on the volleyball court. We present information on making the season memorable for every player and helping each youngster take her skills to the next level.

Icons Used in This Book

Every *For Dummies* book includes cute little pictures in the margins to help you navigate important information. Here are the icons we use in this book:

This icon signals valuable tips that can save you time, erase frustration, and upgrade your coaching skills. If you only have time to scan a chapter, you should take a moment to read these tips when you come across them. You — and your players — will be glad you did.

Coaching a youth volleyball team requires a large time commitment on your part, and having the most important facts and reminders in easy-to-find places is helpful. This icon alerts you to key information that's worth revisiting after you close this book and take the court with your team.

Pay close attention anytime you come across this icon, which highlights dangerous situations that you have to be aware of to help protect your players.

Where to Go from Here

If this season marks your first experience as a youth volleyball coach on the sidelines, you may be most comfortable diving into Chapter 1 and moving through the book from there. Please note, though, that we structured this book so that you can jump around with ease from chapter to chapter at your convenience. So, if you're searching for answers to specific questions — perhaps how to teach blocking to your players or which type of serve-receive formation to use — you can scan the table of contents or index for those topics and head right to those chapters. Otherwise, start from the beginning and use the information you gather along the way to help ensure that your youth volleyball team has a fun, safe, and memorable season for all the right reasons.

Part I

Getting Started Coaching Volleyball

"Sure, you see a bunch of kids scraping and painting my house for free. I see the first steps in building a strong sense of team unity."

In this part . . .

Before stepping onto the court with your team, you need to do a little preparation to get your season off to a great start. Crafting your coaching philosophy, understanding the basic rules of volleyball, knowing whether your league has modified any of those rules, and planning and conducting a preseason parents meeting are all important items on your preseason agenda. Each task plays a big role in what type of experience both you and your players have during the season. You can find valuable information on how to execute these tasks and much more in this part.

Chapter 1

Teaching Volleyball to Children

* *

In This Chapter

▶ Preparing for the volleyball season

▶ Stepping on the court with your players

▶ Coaching your own child

▶ Dealing with problems on and off the court

* *

Congratulations on making the decision to coach a youth volleyball team this season. Regardless of whether you stepped forward because of your love for the game and kids, or because the friendly woman at the registration desk persuaded you when you went to sign your child up for the program, you're about to begin something truly special. Few experiences are more rewarding than coaching a group of children in the exciting and action-packed sport of volleyball. You'll see what I mean as you help them not only learn and develop skills but also grow as individuals.

Before you take the court with your team, please be aware of the important role you've assumed. How you approach your position and how you interact with your players during practices and matches will have life-shaping implications for all your players. How you choose to address the lengthy list of responsibilities that come with your job as coach can help your players become passionate about the sport and also ignite their interest in playing it for years to come, or it can push them away from ever participating again.

We know you're capable of doing an outstanding job — all you need is some quality information to help you get started. In this chapter, we give you a quick overview of what you need to do to navigate your team to a safe, fun, and memorable season that your players will remember for the right reasons. Use this chapter as a jumping-off point to the world of coaching youth volleyball.

Recognizing Your Behind-the-Scenes Responsibilities

Before you drape that whistle around your neck and your players slide on their knee pads to take the court, you need to tend to several behind-the-scenes tasks to get the season headed in the right direction. Whether you volunteered to coach because your son or daughter is playing on the team or you simply love the game and want to share that passion with others doesn't matter. What does matter is that you're fully aware of the huge responsibility you've accepted — a responsibility you can't afford to take lightly. This section delves into two important aspects of coaching youth volleyball that you need to grasp before stepping on the court.

Working with children and parents

Whenever you volunteer to coach a youth volleyball team, or any organized children's sport for that matter, not only do you have to work closely with all different types of children, but you have to communicate effectively with their parents, too. Most of the parents you come in contact with are wonderful, supportive, caring people who naturally want the best for their kids; they may even turn out to be great assets to you as assistant coaches. (Check out Chapter 4 for details on how to choose assistant coaches.) However, some of the parents you meet may not be as pleasant to work with. For example, they may demand that their children deserve more playing time, or they may disrupt matches with their inappropriate behaviors.

Anytime you bring a group of parents together in an organized sports setting, some may become sources of aggravation for you and the kids when they misbehave during matches or cause other distractions throughout the season. If you're not prepared to handle these situations quickly and efficiently, they can take away from the kids' enjoyment. Plus, if you don't address the problems at the outset, they can snowball into something much more serious and maybe even ruin the season for everyone. For tips on dealing with problem parents, head to Chapter 18.

You can avoid a lot of problems — and save yourself a lot of grief — by meeting with all the parents before you take the floor with their kids. This initial parents meeting is crucial for laying the ground rules on what you expect in terms of behavior during matches, as well as outlining what the parents' responsibilities are to their children and their children's teammates. Check out Chapter 4 for all the details on how to conduct a preseason parents meeting.

Parents play important roles in youth volleyball programs, and they can be real assets to providing a fun-filled season when everyone — the parents, the players, and you — works together. Keep the following tips in mind to help make the season go smoothly for both you and the parents:

- **Explain expectations.** Prior to your first practice session, let parents know what you expect — of both them and their kids. Go over your coaching methods and your plans for handling those all-important issues of distributing playing time and positioning players. Chapter 2 helps you craft your coaching philosophy and develop an understanding of your league's policies and rules so that you can clearly communicate this information to parents. Providing a clear picture of what's in store for everyone leaves little room for those dreaded misunderstandings that can derail a season and squash the fun.

- **Involve parents.** Parents invest a lot of time in your season by getting their kids to practice on time (hopefully), spending money on league registration fees, and often even springing for postmatch treats and drinks for all the players. They will find the season much more satisfying if you find ways to include them in the team's season-long journey. Get parents involved at practices, for example, and recruit the right ones to assist with your matches. See Chapter 6 for some fun ways to get your parents involved.

- **Communicate constantly.** Although conducting a preseason parents meeting is the first step toward establishing a strong foundation with your players' parents, you have to make sure you keep those communication lines open all season long. Find time at different junctures during the season to talk to the parents about their children's progress. Parents enjoy hearing about the areas of the game in which their children are really excelling and appreciate your efforts to keep them fully informed.

You should make a habit of checking in with parents from time to time by having a quick casual chat before or after practice just to make sure that everything is going well and that their children are having fun playing for you. Including parents in all facets of the season is one of the smartest coaching moves you can make, and doing so can also be one of the most effective tools for ensuring that children have a positive experience playing for you. If the parent has an important issue to discuss with you, make arrangements to speak in private — perhaps over the phone later that day or in private prior to your next practice.

Understanding rules and terms

The more you know and understand about the sport of volleyball, including all the rules, terms, and — at the advanced levels — strategies, and the better you can explain these concepts to your team, the more enjoyable the

experience will be for everyone involved. Although getting a firm grasp on everything isn't too difficult, it does require some time and effort on your part. So be ready to put some energy into learning all the rules of the game and then teaching them to your players. In Chapter 3, we dive into the rule book and describe everything from common volleyball terms to what officials whistle as violations during matches.

Many programs adjust the rules based on the age and experience levels of the kids, so make sure you check out your league's rule book and alert your players to any differences between your league's rules and general volleyball rules. Everything from the size of the court to which rules the officials enforce changes from league to league. Knowing these rules — and sharing them with your team — makes a tremendous difference in whether you and your players enjoy the season.

Taking the Court

Being on the court with the kids during practices and watching them have fun and excel during matches make all the time and energy you put into coaching worthwhile. To make everyone's experience an enjoyable one, spend some time before practices and matches preparing for them. Be aware that everything you say to your players — and how you say it — significantly impacts their experience. How much thought you put into your practice planning and how prepared you are for juggling all your responsibilities during matches set the tone for your season. This section gives you some pointers on how to start off on the right foot.

Planning and executing practices

One of the qualities that all good volleyball coaches possess is the ability to help kids grasp and develop skills in a way that lets them have fun at the same time. Of course, kids naturally look forward to participating in matches more than participating in weekly practices. But you want to strive to generate similar game day excitement toward attending your practices. To do so, you want to put together a practice plan that pays big dividends in your players' development while also being enjoyable. (Check out Chapter 6 for how to set a practice plan.)

To maximize your time with the kids during each of your practice sessions, keep the following tips in mind when establishing and carrying out your practice plan:

✔ **Count on creativity.** Put some real thought into interesting ways you can enhance the fun during your practices. You want the kids to be smiling as they learn. Put yourself in their shoes, and ask yourself what can make a particular drill more interesting. If you can conduct practices that the kids can't wait to get to, their skill development will skyrocket. Practices that you throw together minutes before the team takes the court aren't likely to be very effective. Plus, they're unfair to your players, who came to develop their skills and have fun.

When designing your practices, go with the drills that keep the kids on the move and that match their skill levels. Drills that force kids to stand in line or spend more time watching their teammates than actually participating kill energy levels and bring learning, development, and that all-important fun factor to a grinding halt. We provide an array of high-energy drills that cover all areas of the game for beginning level players in Chapter 10 and advanced level players in Chapter 12.

✔ **Focus on fun.** The most effective practices are the ones that you conduct in an enjoyable atmosphere in which you emphasize fun and deemphasize mistakes. Before the season gets underway, kids need to know that making mistakes is all part of learning to play volleyball. So, be sure to point out that players at all levels miss serves, get whistled for violations, and misplay balls. As long as kids are listening to your instructions, hustling on the court, and giving their best effort, you can't ask anything else of them. After players know that they can make mistakes on the court without hearing you yell at them or seeing you take them out of the game, they can relax and have a much more enjoyable time.

✔ **Be a positive influence.** Although your main role is to teach your players volleyball skills, you're also in a great position to impact the kids' lives in many other areas, and you should take full advantage of this opportunity. During practices, devote some time to discussing the importance of staying away from tobacco, alcohol, and drugs and the ways these substances can harm the body. Stress the importance of working hard in school and how their hard work can lead to success in adulthood. You can also talk about the importance of getting exercise and eating healthy food to help prevent future health issues or physical injuries. (Chapter 17 discusses proper nutrition and stretching techniques.) Be sure to include the importance of playing hard and showing good sportsmanship no matter the outcome of the match.

While the kids are stretching at the beginning of practice is a great time to interact with them on a more personal level. Show them that you're interested in their lives outside of volleyball by discussing how they're enjoying school.

Handling game day duties

Being a good volleyball coach during matches has nothing to do with what the scoreboard reads after the final point has been played. Rather, being a good volleyball coach depends on how you handle your different game day duties, such as encouraging and motivating the kids and — at the more advanced levels of play — adjusting your strategy to account for how the opposition is attacking and defending. Just as your players have to make quick decisions during the course of the action, you also have to make important decisions at crunch time. You have pregame and postgame talks to deliver; playing time to monitor; substitutions to make; and strategies to employ. Yes, when your matches roll around, a lengthy list of responsibilities accompanies them, but don't worry because you're fully capable of handling all of them. In Chapter 7, you find all the information you need to help your matches go smoothly so that you don't have to reach for the aspirin bottle.

Your team's matches give your players the chance to put everything they've learned from you to use. Hopefully, what they've learned includes more than simply how to hit a particular type of serve or how to dig an attack. You also want teamwork, good sportsmanship, and adherence to the rules to be on full display.

Juggling the Dual Parent-Coach Role

Running a marathon, climbing a mountain, and winning a Nobel Prize are all goals that are difficult to achieve, and managing the role of both parent and coach of your child's team can rank right up there with them — if you aren't prepared. Handling this dual role can present some pretty unique challenges, some of which may not have even crossed your mind. When you and your child step onto the court together, all sorts of new issues have the potential to pop up. The key to handling these issues effectively is to prepare yourself beforehand, because if you're ready to handle them, you and your child are on your way to an enormously rewarding and memorable season.

If you and your child agree that becoming the team's coach is a good idea, keep the following tips in mind to help you maximize the fun and minimize the problems:

> ✔ **Remember that your number one job is parenting.** Regardless of how great a volleyball coach you are, you're a parent first and foremost. After the practice or game is over, you must transition out of coaching mode and into parenting mode, which means that you need to leave your negative thoughts on the court if your child didn't play as well as you had

hoped or if the team didn't perform like you expected. Don't use the ride home to dissect every detail of the match. Instead, concentrate on being a supportive, caring parent.

✔ **Open the lines of communication.** Making sure that your child understands that he can come to you with a problem at anytime is extremely important. You want all your other players to understand that you're there to help, and your child is no different. Just because you've taken on the coaching role doesn't mean that you can't help your own child deal with problems or concerns, whether they involve volleyball or not.

✔ **Refrain from extra repetitions.** Sometimes during the season, your child may encounter some difficulty getting a handle on a particular skill. Your natural tendency is to push extra practice time on him at home. However, giving any kid extra practice plans is dangerous territory to navigate, so always proceed cautiously. Casually asking whether your child would like to spend a little extra time working on a particular skill at home is the best approach. If he wants to, great; if not, let it go. You run the risk of making him feel inferior to some of his teammates if you push him too hard.

✔ **Silence sibling comparisons.** One of the worst moves you can make — as parent or coach — is comparing a child's skills to those of a brother or sister who plays volleyball or making the child feel unwanted pressure to perform to his sibling's level. When you bring unfair comparisons into the picture, you just suffocate the fun the child can have, and you may even chase the youngster away from participating in the future. Allow all your players, including your child, to develop at their own rates without placing performance demands on their young shoulders. Anytime you start comparing kids, you create problems, such as crushed confidence, low self-esteem, and lack of interest in future participation, all of which can be mighty difficult to repair.

✔ **Master the balancing act.** Arguably your biggest challenge is making sure that your behavior falls somewhere in between providing preferential treatment to your child and overcompensating to avert the perception that you're giving your child special treatment. Of course, all eyes are on you to see whether you give your child extra playing time during matches, so you want to be sure that you're treating everyone equally in terms of playing time and positions. But, at the same time, you want to make sure you don't go to unfair lengths to *reduce* your child's playing time or give him *less* attention or instruction during practices because you don't want other parents to think you're favoring him.

For a lot of kids, having to share their moms or dads with a group of other kids can be quite an adjustment, so be sure to let your child know how proud you are of him for understanding that coaching requires that you distribute your attention to everyone during practices and games. When children understand that you're aware of the situation and that you're doing your best to meet everyone's needs, fewer misunderstandings are likely to occur.

Like all parents, of course you want to see your child play well and enjoy a lot of success during matches. But, don't allow yourself to use your coaching position to control your child's destiny. For starters, erase any thoughts of using coaching as a way to help him secure a college scholarship. Entering the season with those types of thoughts can lead you to put unwanted pressure on the child and push him harder than you do the other kids. If you allow yourself to lose sight of what youth volleyball is all about — having fun and developing skills — chances are good that you'll create an avalanche of problems that you'll have a hard time fixing.

Preparing for All Kinds of Obstacles

As a volleyball coach, you may face many types of obstacles during the season, ranging from frustrated players to injuries. Yet, you don't need to worry about these potential issues. Preparation is the key to disarming problems before they sweep over the entire team. Two of the greatest coaching challenges you need to be aware of before the start of the season are

- ✔ **Making a positive impact on every child:** As a youth volleyball coach, you most likely have a diverse cast of kids to oversee. You likely have kids who have a lot of athletic talent and those who are just plain clumsy; you probably have kids who are nonstop talkers and those who are super shy. Your job as coach is to connect with each child, regardless of whether he's the team's best attacker or weakest defender. Sure, this job is a big undertaking, but it's one you're equipped to handle. Check out Chapter 5 for details on the different types of kids who are likely to show up on the court and Chapter 11 for info on how to make adjustments to your coaching strategy midway through the season after you get to know the kids better.

- ✔ **Keeping everyone safe:** Regardless of which skill you're teaching or which drill you're running, you never want to lose sight of the importance of maintaining a safe playing environment at all times. Although you can't throw a suit of armor on the kids to eliminate the chances that injuries will occur, you can take some steps to significantly reduce the risk. For example, you need to teach only proper and safe techniques, make sure your players stretch adequately before each practice and match, and know how to handle any emergencies that may take place. Chapter 17 provides tips and advice for keeping kids safe. *Note:* Anytime you take the court for a practice or game, make sure you have a properly stocked first-aid kit on hand (check out Chapter 17 for what you need to have in your first-aid kit).

Chapter 2

Building a Strong Foundation for a Successful Season

*I*f you want to be a volleyball coach whom kids look up to and love playing for — and we know you do — you have to complete several behind-the-scenes tasks before you roll the balls out for your first practice of the season. Of course, planning practices and teaching basic skills are certainly top priorities on your radar, but you can't afford to overlook other responsibilities that often get bumped to the side amid the excitement of an approaching season.

This chapter covers what you can do before and during the season to help you prepare yourself and your team for a fun-filled experience. Here you can find out how to motivate your players and help them reach their goals, create a positive, team-oriented atmosphere, and make displays of good sportsmanship a team staple. Plus, we talk about knowing the rules of your league and getting the equipment your team needs to take the court.

Developing Your Volleyball Coaching Philosophy

Your coaching checklist heading into the season is pretty extensive, listing everything from devising an opening practice plan to coordinating a pre-season parents meeting. But despite that lengthy list of responsibilities, make

sure you find time to craft your own coaching philosophy. After all, your coaching philosophy plays a significant role in how you approach the season and interact with the kids during it.

In this section, we introduce the importance of having a philosophy and point out the various components to consider in developing a philosophy that stresses respect, sportsmanship, skill development, and, of course, fun. After you have incorporated these elements into your philosophy, you and your players can set your sights on a memorable season.

Eyeing the importance of a philosophy

A *coaching philosophy* is an important tool because it reflects the standards you set for yourself and your team. It represents the foundation you build for your values and beliefs as a coach, a foundation you can rely on to start off on the right foot and then to move smoothly through the rest of the season. Spending some time creating your own coaching philosophy can help make your season a great one for both you and your team — win or lose.

You may be wondering what philosophy has to do with setting up a potent attack on offense or creating an intimidating front line on defense. Don't worry, putting together a coaching philosophy that meets the kids' needs — and has their best interests at heart — isn't as difficult or time consuming as you may think. Heading into the season with a good coaching philosophy in place is as important to achieving a winning season as showing your players how to hit strong and accurate serves.

Your coaching philosophy speaks volumes about you — not just as a volleyball coach, but also as a person — so take the time to really think about it. You'll be glad you did. Your players will benefit if you clearly define your approach from the start and enter the season with the full intention of sticking to it. Lead your players in the direction you know is right, the direction you would want your own kids to go. If you accomplish this goal, you and your team will be winners in the truest sense — regardless of how many games you win.

Putting together your coaching philosophy and determining what is important to you and your players are the easy parts. The tricky part comes with sticking to it on game day. Your philosophy (and how strongly you really feel about it) will be put to the test in the middle of the season when Susie's mom asks why your team hasn't won more matches or when Kayla's dad complains that his daughter should receive more time on the court. (Explaining your coaching philosophy to parents before the season gets under way helps you steer clear of many of these potential headaches. See Chapter 4 for details.)

Crafting your philosophy to match your age group

The kids you meet while coaching volleyball will be different in many ways — physically, emotionally, and athletically, just to name a few. During that first practice of the season, some kids will stand out for their ability to pass or set the ball, yet others will draw your attention because they lack coordination or familiarity with the game. Regardless of the specific strengths and weaknesses they have, kids possess general characteristics that are influenced by age. Children are continually growing and evolving, and part of your coaching responsibility is to know and understand what to expect from them — both physically and emotionally — depending on their ages.

Being fully aware of the general age-related differences we cover in the following sections can enhance both your coaching skills and your effectiveness in relating to your team. Understanding these differences can also ensure that you don't favor the players who are more mature and better at attacking and defending than their counterparts who may be less developed at digging, blocking, and serving at this point in their volleyball careers.

No matter how old your players are or how skilled they are at helping your team score points (or prevent the opponent from scoring them), always be supportive and enthusiastic of their efforts. Pile on the praise, and never stop encouraging them. You must keep your interactions with the team positive, whether you're talking to them during a midweek practice or in the middle of a timeout in a tied game. Staying positive is important in both your words and your body language, because doing so helps build the kids' confidence and self-esteem. Constantly encouraging kids, regardless of their age, to work hard and keep practicing will positively affect their volleyball development, as well as how they approach different tasks in everyday life.

Ages 9 and younger

Some kids you encounter in this age range have probably participated in volleyball for at least one season. Typically, they enjoyed their first experience with the sport and chose to continue playing so that they can improve their skill level. Others, though, may be playing for the first time, so you want to keep these different experience levels in mind.

Kids ages 8 and 9 start paying closer attention to their teammates' abilities and comparing how their own skills stack up. These kids crave feedback from coaches and parents on how they're performing certain skills and how they're progressing with new ones, so be prepared to meet those needs when you're instructing them on different areas of the game. Kids at this level lack a lot of coordination, so their frustration levels may mount when they're unable to make plays on the ball.

If you have any players on your team age 7 or younger, chances are pretty good they have never played any type of organized volleyball, or any other sport for that matter. Because kids in this age range lack coordination and strength, your job — an important one because how you interact with these children may determine whether they choose to keep playing the sport or drop it forever — is to introduce to them the most basic elements of volleyball and then to make the game so much fun during practice and on game day that they can't wait to come back again next season. (Chapters 8 and 9 cover some of the fundamentals of offense and defense you can focus on with this age group.)

Many kids at this level are more concerned about the postgame treat than how the team fared, so many leagues don't even keep the score during games. Even though the scoreboard may not have the kids' attention, the same can't be said for all the parents, some of whom get a little too emotionally invested in the final score. (For more on dealing with problem parents, check out Chapter 18.)

Because volleyball is just a small slice of the kids' lives at this stage, don't focus only on the sport during your conversations with them. Instead, periodically ask them about their favorite television shows, for example. Asking about other areas of their lives allows you to get to know them a little bit better and will also help them become more comfortable around you. Establishing that type of relationship will help enable them to be more relaxed, perform better, and have more fun.

Ages 10–12

Quite often, sports take on added importance at this juncture in kids' lives. As soon as children enter this age bracket, their performance on game day and their progression in everything from serving to digging become more important than they were before. They want to do well, and for many kids, the competitive juices really start flowing in this age range. Or, unfortunately, they may be facing pressure from Mom or Dad to play well, because adults often perceive having an athletic child as a status symbol that they are great parents. If the kids are really into volleyball, many of their conversations will revolve around the sport and their team's abilities. Kids' bodies at this age are developing at vastly different rates, so be prepared to have some players who display excellent coordination on everything from serving to digging and others who endure many struggles when attempting to perform some of the sport's most basic techniques.

You can probably safely assume that most kids in this age range have been playing volleyball for at least a couple of seasons. However, if you do have first-timers on your team, make sure they don't get lost in the shuffle just because their skills don't stack up to those kids who have been around the

sport for a season or two. If some of your players are struggling with certain skills, make sure that you devote just as much attention to helping them get a handle on the basics of the game as you do to working with your more experienced players on elevating their skills. Every child, regardless of skill or level of experience, deserves your full attention and support. (For more information on catering to kids with different skill levels, see Chapter 5.) You also want to spend time getting to know all your players on a personal level. Talking to them about subjects that don't involve volleyball demonstrates that you care about them not just for how well they attack and defend, but for who they are as individuals, too.

For the most part, kids in this age range are on the court with you because they love the constant action of the game or because they've found out during the past few seasons that they're pretty good at playing it. One of your tasks is keeping that positive momentum going by adding to their skill library so they can become more well-rounded players. Making sure that practices meet — and sometimes even challenge — your players' skill levels, as well as feature lots of fun, is important in this age group. (For more details on crafting quality practices, check out Chapter 6.)

Ages 13–14

Be prepared! With this age group, you're stepping into treacherous territory — the teenage years! Don't worry, you don't have to reach for the aspirin bottle just yet. Sure, these kids pose some unique challenges for you — ones we're confident you can handle — but they can also be some of the most enjoyable players to coach. At this point in their development, many of them have a really good handle on the basic skills and are now ready to bump their skills up a level or two. Plus, these kids are gaining strength and have pretty well-developed coordination, so they're ready to take on new challenges that push their development along. At this age range, your practices have to feature drills that are more advanced in nature. If you aren't challenging these kids every time they step on the court, their skills will stagnate, and any hopes they had of improving their serve or upgrading their passing will be squashed. (Chapter 12 has some great drills, if we do say so ourselves, for challenging your more experienced players.)

Be aware that many of the parents will also be following your moves even more closely in this age range. This is about the time when visions of starring on the high school team, or obtaining a college scholarship, appear on the horizon. Many parents will count on you to help their child latch onto these types of success.

You may look back on your early teenage years and want to forget most of that time for good reason. Adjusting to ever-changing bodies while also trying to fit in at school and forge friendships makes for a very difficult time. So keep

that in mind as you work with this age group. Kids are looking to identify with something — anything that helps them find out who they are — and with your help, volleyball may be that something. One of the best ways to make a difference with them is to get to know them on a personal level, where your conversations involve more than the proper arm position for executing a pass or set. Ask them whether they enjoy watching volleyball during the Olympics, or whether the two-player beach tournaments that are popular on television grab their interest. Of course, building that personal connection with kids is a great coaching tool at any age level. See the "Keeping communication lines open" section later in this chapter, for more information.

Ages 15 and older

Anytime you're coaching players in the 15-and-older age bracket, they have likely been setting, passing, and attacking for many seasons and have developed a real passion for the sport. Many of them may attend volleyball camps, run laps around their schools' tracks or neighborhoods, and lift weights to stay in top condition. In some cases, they may even enlist the help of personal coaches to push them to higher levels of performance. Some of these kids may even know more about some aspects of the sport than you do — or at least think they do! The same goes for some of the parents who have watched their children advance in the sport for many seasons. Some may question how you are positioning the players, or debate with you what the best defensive strategy is for the team to employ.

Sure, this age group is challenging because of its level of experience, but coaching and being around these older kids, who have a deep-rooted passion for playing volleyball, can be a tremendous amount of fun if you know how to communicate with them. Right from the start, before you toss the first volleyball into the air, let them know that you value their opinions, suggestions, and input regarding the team. Doing so helps establish those vital coach-player bonds, and you'll find that their enthusiasm, and even their insight on various strategies, can often help make your job easier.

Emphasizing teamwork

Volleyball is the ultimate team sport, which is one of the many reasons why it's so much fun to coach and play. Even if you have a highly skilled player who's great at attacking, she'll never get the chance to shine if the team can't control the opponent's serve and make accurate passes and sets. Playing successful volleyball requires the entire team to work as one cohesive unit. If players don't buy into your team-first philosophy, the team chemistry can be spoiled, and everyone's enjoyment of the season may wane.

Getting your kids to play as a team, instead of as a group of individuals, is vital for helping them enjoy a rewarding season, as well as for helping them fully understand what playing volleyball is all about. If you allow players to

run all over the court, all with their own goals in mind, not only will you have a unit that's continually out of position and easy to attack and defend, but you'll also have total chaos. So, talking to your players about the enormous benefits that come with working together as a team is well worth your time and effort. Use the following pointers to help you mold a team that opponents will hate facing because of its team-oriented style of play:

- **Praise positive team play.** During practices, try to recognize team effort more often than you single out individual play to help hammer home just how important teamwork is to you. When you spread praise among all the kids who played a part in the team's scoring a point, they begin to understand that each of them fills an important role. For example, even though the attacker executes an effective attack during a drill, often you can trace the success of the play back to the person who made a nice pass to the setter, who then put the ball in great position for the attacker to take a strong swing at it.

- **Promote peer praise.** Yes, kids love hearing you praise them for their efforts diving to dig a ball or making a difficult set from the backcourt, but what you may not know is that players love hearing praise from their teammates just as much, maybe even more. Don't take offense. Encourage kids to compliment one another. Getting kids into the habit of giving high-fives or saying "Great pass" or "Nice hustle" forges bonds and strengthens team unity — it also makes kids want to play harder for one another.

- **Stress sideline support.** On game days, encourage players who aren't on the court to stay involved in the action by cheering and supporting their teammates. Hearing teammates' cheers provides extra encouragement for the players involved in the action and can do wonders for a player's tired legs or sagging confidence.

- **Spread the captain's role around.** Don't rely on two or three players to serve as team captains throughout the season, because the captain label elevates them above the other players and can divide the team, creating instant trouble. Instead, give every player the opportunity to lead warm-ups in practice or on game day. Doing so infuses the team with the sense that all players are equal parts of the group.

Most youth volleyball programs don't require captains until around age 14 or on club teams, when the competition becomes more intense and the players are more experienced. (See Chapter 19 for more information on club teams.) At these higher levels, your captain usually is your setter. If your league for younger children requires you to designate a captain, use this rule to your advantage as another way to build kids' self-esteem. Give every child the chance to be a captain at some point during the season. Most kids will look forward to being captain; you can use the rotating captain role as another tool to generate excitement among your players.

✔ **Recognize hustle plays after the game.** The kids who delivered most of the attacks that resulted in the team's points typically don't need as much additional praise after the game. Their play generates cheers and applause from the spectators, as well as high-fives from their teammates, during the game. So after the game, direct your praise to the kids whose strong defense or accurate setting can be easily overlooked; or praise the youngster who, despite not getting his hands on many balls, sacrificed his body and continually dove for them all over the court. Recognizing these plays and the kids who make them reinforces the idea that one player doesn't win games and that the entire team has an important role in the outcome.

Motivating players

You want every player on your team to reach her full potential and enjoy the thrill that accompanies developing key skills of the game. You can help your players do this through *motivation,* one of a coach's biggest assets when used the right way. The challenge is not only uncovering how to motivate kids but also determining which motivational approach works for them.

Every kid you meet is remarkably different from the others, and you have to discover for yourself what works for each child to get the best out of her as both a volleyball player and a kid. Choose your words carefully. What motivates one player may completely backfire with another. You may find that some of your players are strongly motivated — the kids who push themselves to succeed and constantly want to improve their games. Usually, these strongly motivated kids have been around volleyball for a couple of seasons. You'll probably also have kids who rely on your words of encouragement to nudge them along. Some of your players may respond in a positive manner to your challenges during practice, but others may find too much pressure in trying to fulfill your demands. For these kids, your challenges in practice may actually turn them off from participating. Thus, you have to remember that all kids are different, and you need to approach them with this idea in mind.

Here are a few general tips you can employ to help ignite passion in your players and motivate them to strive to become the best they can be:

✔ **Be enthusiastic.** If you have a true passion for the sport and teaching it to children, don't be afraid to let it show through. If you exhibit genuine excitement and enthusiasm for teaching and making skill learning fun, your team will gobble up that enthusiasm and respond accordingly.

✔ **Set reachable goals.** Setting goals that your players have zero chance of attaining does nothing but frustrate them, and it may even chase them away from the sport altogether. Keep in mind that your players are

children, some of whom may never have played volleyball before. Keep your expectations reasonable for the kids you're coaching, and set goals that are within their reach. Kids will likely perform better and try harder when the goals you set for them are within their reach.

If players sense that your expectations are impossibly far-fetched, they may wonder what the point of trying is, and their play on the court suffers. This problem negatively affects the entire team. Furthermore, you should stay away from setting goals that involve the team's final record, because not only are they unfair, but they don't prove helpful in improving personal or skill development. You want to teach winning, but be sure to define winners as players who always give their best effort, regardless of the score in the game.

✔ **Emphasize the positives.** Some coaches tend to raise their voices or make a big scene when the team makes a mistake setting up an attack attempt or fails to defend an opponent's attack. You should take the reverse approach and make a big deal out of the positives that occur instead of harping on the negatives. Try stopping practice for a moment to point out when the team does something really well. Guess what happens? The kids get big boosts of confidence and respond with even more focus and energy during the remainder of your drill because they want to hear that praise again. Also, if a player has been struggling with a specific skill, such as setting, use this technique to boost her confidence and self-esteem when she finally catches on and executes a good set during a drill or team scrimmage. Being positive is one of the best motivational tools around, and your players will really latch onto it.

The youth volleyball court is no place to issue threats camouflaged as motivation, such as making players run laps whenever they fail to execute a skill during practice. That type of approach merely handcuffs kids' abilities to perform, because they're afraid of making any mistakes that may translate into punishment. Using motivation-through-fear tactics just isn't conducive to learning or having fun. Children have to feel free to make mistakes to improve. Also, relying on these tactics will likely chase kids away from participating in the future. Children are practicing to develop and learn from their mistakes, not to be humiliated or punished for them.

Creating a positive atmosphere

The more relaxed and comfortable kids are playing for you, the more satisfying the experience is for them and the more stress-free for you. Plus, the better the chance is that they'll be effective on the court. Here are a couple of ways you can help create an atmosphere that promotes team spirit, encourages participation, and rewards the ideal of doing your best at all times.

✓ **Create a team cheer.** Work with the kids to come up with a clever team cheer to use before games. For example, something like "One . . . two . . . three . . . together!" works well. You just need something quick and basic that reminds them that they're taking the court as a team and must work together to play at their highest and most effective levels.

✓ **Applaud effort.** Nobody enjoys making mistakes, especially in sports. Many children, particularly those just starting out, probably won't have a good understanding that mistakes are a part of playing volleyball and that they're inevitable, regardless of age, experience, or skill level. So be sure to remind them. **Praising players for doing their best, rather than criticizing them for their mistakes, allows them to continue putting forth maximum effort until they improve the skills that give them particular difficulty.** Taking this approach opens the door to all sorts of learning; players aren't going to fear making mistakes when they know negative comments won't be following them.

Keeping communication lines open

Sure, you want your players to learn how to hit a float serve or perform a good pass, but as a volleyball coach, you're in a unique position to impact many other areas of your players' lives after they step off the court. But you can only be a part of their lives away from volleyball if your players feel comfortable enough talking to you about subjects unrelated to blocking and attacking. You want to establish from the outset that they can come to you with questions, problems, or concerns about anything at any time.

Besides being their coach, you can be their friend. For example, while they're stretching, ask them how they're doing in school, what their favorite subjects are, or which teachers they like. Find out whether they have any brothers or sisters, pets, or hobbies other than playing volleyball. Getting to know kids on a more personal level lets them know you care about them as individuals and makes opening up to you much easier for them to do if they ever need to — which is more important than any offensive or defensive technique you can teach them.

Making every child count

Every child who puts on knee pads and steps on the court to learn from you must feel like a valued and appreciated member of the team, and that responsibility falls squarely on your shoulders. Pay close attention to all your players, regardless of how talented they are — doing so sounds easy enough, but, in reality, it's not an easy task. After all, sometimes you may allow some of the lesser-skilled kids to get lost in the shuffle while the more athletically

gifted ones monopolize all your praise and attention. If you truly want to make every kid feel like a part of the team, you have to refrain from focusing on only the best players.

Doling out the praise in equal doses to all the kids takes a concentrated effort on your part, but making sure that each child — no matter how big or small her actual contributions are during games and practices — feels like an important part of the team is one of the cornerstones of good volleyball coaching. Sincere appreciation helps keep kids interested in volleyball, particularly the marginal players who may choose to call it quits if they don't receive the positive feedback they deserve.

Providing immediate feedback and continually recognizing all players for their contributions are the most effective ways to boost your players' self-confidence and fuel their interest in giving their best efforts all season long. Consider these three ways to make every player feel important:

- ✔ **Acknowledge all the pieces.** Although the player who pounds the attacks tends to receive a lot of praise because her actions result in points for the team, don't overlook the contributions of the other players. After all, if the server didn't get the ball in and put the opponent off balance so your team could be in position to attack, that player never would've had the chance to attack the ball. Getting into the habit of acknowledging every player's actions — no matter how big or small — goes a long way toward making each child feel truly appreciated and a part of the team.

- ✔ **Don't overlook anything.** Some players aren't the best servers or attackers, or they struggle with passing, setting, or blocking. Yet, that doesn't mean you should overlook them when you start handing out praise. You need to recognize even the less-skilled kids for their contributions, however big or small they may be. These are the kids who are on the fence when it comes to their participation. By recognizing them, you can help them want to stay involved. If you neglect them, they may run from the court for good because they don't feel like an important part of the team. Recognizing kids is easier than you may think. For example, simply applaud a player's hustle or effort diving for a ball; the encouraging words you overhear her share with a teammate; or the good sportsmanship she displays following a game. A little recognition goes a long way.

- ✔ **Give out awards.** Many coaches enjoy handing out awards to their players at the end of the season. Doing so is a great way to recognize all the kids; especially at the beginning levels of play, kids cherish a small trophy, medal, or plaque. Just make sure that you come up with something for every player, and don't be afraid to get creative. Awards for Most Likely to Dive for a Ball, Most Positive Teammate, Best Display of Sportsmanship, and Most Improved Setter are just some of the ways you can highlight the contributions of all your players and make them feel good about themselves. Plus, that small token of appreciation may be enough to spur them to come back to the sport next season.

Putting fun and skill development first

The worst measuring stick you can use to judge your team's progress — and your coaching abilities — is your win-loss record. Instead, focus on whether kids show up at practice with smiles on their faces because they can't wait to take the court with you and whether they learn and improve skills at every practice. After all, these experiences make up the true barometer of coaching prowess. At the more advanced levels of play, winning takes on a more prominent role, and that's okay because, like with all competitive sports, winning is a part of playing volleyball. But fun and fair play should never take a back seat, even as you do your best to achieve victories.

Children are highly impressionable. If they get a sense that winning is all that really matters to you, having fun and developing skills become secondary in their minds, too, and getting back on track is difficult. The younger and less experienced your players are, the less you should focus on wins and losses, and the more you should concentrate on teaching skills and ensuring that everyone has fun playing and learning.

Children's short attention spans can make coaching difficult at times, but they can also work to your advantage. Many kids just beginning in the sport usually forget the score of the last game quickly and direct their attention to something else — like whether Grandma saw them dive for that ball early in the match! So even if your team happens to lose every game it plays by a substantial margin, the kids still deserve recognition from you for giving their best efforts.

Never let scoreboards or opposing teams define how much fun you or your players have on the volleyball court, or affect your team's progress in learning the game. Sure, winning games is fun, but just because your players outscored their opponents doesn't necessarily mean they performed to the best of their abilities. A squad can put forth a lackluster effort and still come out ahead because the opposing team played poorly or simply didn't have as many talented players. Conversely, your team can play extremely well and still lose the contest. Whatever the case may be, push the score to the side and take a close look at how your players performed, and make the necessary adjustments in areas of the game you need to work on at your next practice.

Making good sportsmanship really matter

Teaching kids the proper technique for delivering a float serve or the correct body position for passing a ball is important for their development into well-rounded offensive and defensive volleyball players. Working with them to be good sports — the kind who display good behavior, win or lose — is

important for their personal growth. Good sportsmanship, one of those aspects of the game that you can easily overlook if you're not careful, is one of the healthiest and most important ideals you can instill in your players.

Here are a few ways you can help make your team one of the most liked and respected teams in the league:

- ✔ **Talk about sportsmanship any chance you get.** The more time you devote to talking about being good sports, the better chance your message has to sink in. Reinforcing the importance of good sportsmanship whenever you can goes a long way toward building model players.

- ✔ **Set a positive tone on game day.** Greeting the opposing coach and officials with friendly handshakes before the game helps set the tone for a fun day of volleyball. Remember, being a good sport isn't a sign of weakness or an indication that you don't care about winning the game. It shows that you're a caring coach who respects the game and wants your players to approach it the right way.

When meeting with the opposing coach before games, encourage her to provide positive feedback to your players when they make good plays, and tell her that you'll do the same for her team. Being open with the other coach helps lay the foundation for a great day of volleyball.

- ✔ **Always demonstrate good behavior toward officials.** If you aren't a model of good sportsmanship, you can't expect your players to be good sports themselves. Players are going to take their cue from you, so if you rant and rave to an official about a call, expecting your team to show respect toward the official or anyone else on the court is unreasonable. Good coaching behavior means not yelling at officials or questioning their judgment calls even when you're sure they should've gone your team's way. Respect officials and keep your emotions in check, and your players will follow your lead.

- ✔ **Recognize good sportsmanship.** Continually recognizing displays of good sportsmanship reinforces to players that how they behave during and after games really is important to you and that you admire and appreciate their efforts at good sportsmanship.

- ✔ **Always shake hands with opponents after the game.** Regardless of the game's outcome, you always want your players lining up to shake hands with the opposing team's players and coaches. If your team won, your players should acknowledge that their opponents played a good game, and if your team lost, they should congratulate the opponents on their victory. Your players can make an especially classy move by shaking the referee's hand after the contest — a true statement that you care about molding caring and respectful players.

During the season, you may encounter a win-at-all-costs coach who prowls the sidelines, yelling and berating her team. Or you may see an out-of-control parent who spends the entire game shouting instructions at her child or arguing every call that doesn't go the team's way. Chapter 18 presents tips for handling this type of inappropriate behavior, which has no place in youth volleyball at any level.

Understanding the League You're Coaching In

When you step into the youth volleyball coaching arena, you never quite know what you'll find. Your community may have leagues that stick to the official rules of the game, as well as leagues that tweak everything from the height of the net to the number of players allowed on the court at one time to fit the kids' needs (see Chapter 3 for a rundown on basic rules). In the following sections, we address the importance of knowing your league's rules and the differences between recreational and competitive programs.

Knowing the rules

A volleyball rule book probably isn't going to make your bedtime reading list, unless you're in search of a faster way to fall asleep. But to be a successful volleyball coach, you have to know the rules of the game and the best way to teach them to your players, so make sure you review the basics well before your first practice. Knowing any particular rules that your league may have modified to fit the needs and experience level of the kids you're coaching is equally important. If you don't have a good handle on all the rules, you won't be able to teach them to your players, and that sets up a frustrating experience for everyone involved.

Rather than plunging in and attempting to memorize all the rules in a single sitting, which is an impossible task to attempt anyway, try to review a few pages every night before the season's start until you're comfortable with them. (For a quick primer on the rules of volleyball and some modifications that youth leagues often make, check out Chapter 3.)

If you're coaching an older group of players, don't assume that they have a firm grasp on all the rules. Longevity in the sport doesn't always equate to knowledge, because if no one took the time to explain to them certain rules (rules that some players find confusing or pointless), chances are they may never have learned them. Plus, as players advance into new age brackets,

different rules are usually in place. Sometimes programs tweak certain rules from season to season, too, so kids who remain in the same age bracket are still affected. By going over these unfamiliar rules with your players, you can make a big difference in broadening your players' understanding of the game. Leagues tend to enforce more rules at the higher levels of play.

Even if you were a pretty good high school or college volleyball player, do yourself and your team a big favor and dig into your league's rule book. You may be surprised with what you find, because some rules have probably changed and your league may apply some of the rules a tad differently than you're used to.

Playing for fun or first place

Two distinct program classifications exist in youth volleyball: recreational and competitive. Each type requires a different approach to coaching. Before agreeing to volunteer, you should check with the recreation director to learn more about the league and make sure that you're in the right place.

Recreational leagues

If you decided to step forward to coach for the first time this season, or you were talked into taking over a team, you're probably coaching in a *recreational volleyball league.* These leagues focus on teaching kids the basic skills of the game. Generally, a recreational league has rules in place regarding equal playing time, which makes your job easier because all the kids get a fair chance to play — as long as they're showing up and participating in your practices. (For information on dealing with kids who don't show up for practices, see Chapter 18.)

Quite often, at the beginning levels — think ages 10 and younger here — the league scales teams down and has them play games on smaller courts with lighter-weight volleyballs. Smaller courts create more opportunities for kids to pass and set the ball, while also increasing the number of rallies with the opposing team. The lighter ball doesn't hurt the kids' on impact and allows for more control so they can generate rallies. Recreational leagues often also alter standard rules to meet the players' ages and experience levels.

Competitive leagues

Children whose thirst for competition can't be quenched in their local recreational leagues can find opportunities to participate in more competitive programs often referred to as *club* or *travel teams,* which Chapter 19 discusses in greater detail.

The more competitive programs are for youngsters who have demonstrated higher skill levels than many other kids their age. These elite programs give kids the chance to compete against others with similar abilities in their state or region. Usually, kids involved in these programs have their eyes on long-term advancement in the sport. (Or, in many cases, their parents have their eyes on college scholarships and have pushed their children into this highly competitive environment.)

If you're assigned a volleyball team in a competitive league that you don't believe you're qualified to coach in, notify the league director right away. Tell her that in the best interests of the kids, you prefer to coach a less experienced team in a less competitive league. Do what you're suited for at this time in your volunteer coaching career. Down the road, if you choose to oversee a more competitive team, or even have interest in coaching a travel team, you'll be well prepared to do so after a couple of seasons of recreational coaching.

Getting on Schedule

When you sign up to coach a team (or are talked into taking over one), you typically receive a schedule for the season. In some leagues, arranging practices and reserving court time is up to you, while in others, the league directors take care of scheduling practices for you, assuring that each team is only allowed to practice a certain number of days each week for a specific amount of time.

Depending on where you live, Mother Nature can interfere with games. When bad weather strikes, making it unsafe for parents to drive their kids to games, the games will either be canceled or rescheduled on a later day. You need to be aware of your league's policies for handling make-up games so that you can inform your players and their parents. This section covers how to create a practice schedule and what to do about make-up games.

Scheduling team practices

Your players' age group generally dictates how much time you'll get to spend practicing with them during the season. Most beginner leagues, for example, generally have just one hour-long practice during the week and one game on the weekend. Many leagues restrict the number of practices a coach can hold during the season, so be aware of this restriction before you put together your practice plans. Also, many programs give you your practice schedule for the season in advance, because many teams have to share the courts. Receiving a schedule from your league eliminates scheduling problems on your part and ensures equal court time for all the teams in the league.

Every minute you spend with your team during practice is critical to the success of your team, especially if you can hold only one practice a week. Although you want practices to be fun, practice time isn't a social hour. It's also not a matter of breaking the kids up into two teams and watching them scrimmage for an hour. You have to plan your practices carefully and be actively involved in them at all times. Chapter 6 features some in-depth tips on running great practices.

Dealing with makeup matches

Leagues handle games that have been canceled in different ways. For example, some leagues set aside a week at the end of the season during which time teams can play canceled games; others let the two coaches work together to determine a date and time that works for them. Being aware of the league policy regarding cancellations alleviates a lot of confusion among parents and team members when you have to stray from the schedule.

To make sure that everyone's notified about cancellations, ask parents to organize a telephone tree at your preseason parents meeting. See Chapter 4 for details about organizing parent contact information.

Dressed for Success: Volleyball Equipment

One aspect of volleyball that makes your life a little easier is that you don't need a whole lot of equipment to play the game. Parents will also appreciate this fact, especially on game day when they're hustling to get to the court on time. The following sections examine the different types of equipment.

What the league provides

Youth volleyball leagues across the country differ in the rules they enforce and in what they provide for the kids. Most leagues furnish volleyballs for you and the kids to use. Some leagues provide each player with her own jersey with her name on it; other leagues loan out plain jerseys for the season, making parents responsible for keeping the shirts in good condition and turning them in at the end of the season.

If parents have to purchase jerseys, they usually buy them through the league to ensure that each player on the team has the same type and color. The registration fee typically includes the uniform cost.

What players must bring

Make sure that parents understand what they're responsible for purchasing before your first practice. After all, you don't want kids showing up to their first practice without knee pads and, as a result, suffering bruises — not a good way to start off the season. Parents typically have to provide the following items:

- ✔ **Water bottle:** Every player should bring a water bottle with her name clearly marked on it — so that germs aren't spread by players drinking from the same bottle — to every practice and game.

- ✔ **Shoes:** Players need to wear basic tennis shoes to provide traction on the court.

- ✔ **Knee pads:** Knee pads protect players' knees when they hit the floor diving for balls. They come in different styles and sizes, so recommend that parents have their children try them on so they have pairs that fit comfortably and don't compromise their mobility on the court.

Because every volleyball program is different, always check with your league director to find out what equipment the league provides the kids and what equipment the parents need to purchase. Get this information in advance so that you can inform the parents during your preseason parents meeting. (See Chapter 4 for more information on what to cover in this meeting.)

Chapter 3

The Rundown on Basic Volleyball Rules

*V*olleyball is an extremely fast-paced, action-packed sport, so if you're not up to speed on every aspect of the game before you take the floor, your season may spiral out of control before you even finish your first game. Not to worry — this chapter runs through everything you need to know about the sport to ensure that you and your players can savor every exciting serve, set, and attack along the way.

First, we guide you on a quick tour of the markings on the court, and then we go over all the rules of the game — both the general ones and those that leagues often modify to fit the age and skill level of the kids in their programs. To help you better understand how the officials call the match, we show you the different hand signals you may encounter and what they mean. We also go over some of the most commonly used volleyball terms so that you have a handle on the lingo as the season begins. Finally, we take a look at the positions on the floor and the skills and responsibilities associated with playing them.

Stepping on the Court

If you're somewhat new to the sport of volleyball, or haven't played it for many years, all the lines on the floor may seem a little confusing. But you don't need to lose any sleep over them even though knowing what the different markings and lines mean is important to understanding the rules of the

game. In this section, we give you a quick rundown of exactly what you find when you step on the court with your players — everything from baselines and sidelines to attack lines and centerlines. Oh yes, and we acquaint you with that troublesome net that stretches across the court — the one that you have to teach your players to hit the ball over!

Examining the markings on the court

Every line on the volleyball court serves a distinct purpose and affects both how players play the game and how officials officiate it. To play the sport properly and to enjoy it completely, every youngster on your team must be able to identify these court markings and their context within the game. Before you can teach your players what the court elements mean, however, you have to take the court yourself. The volleyball court features the following elements (see Figure 3-1):

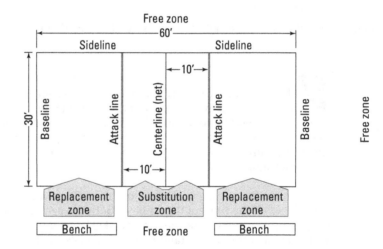

Figure 3-1:
The court
of play.

✔ **Antenna:** The flexible rods that are 6 feet long and $3/8$ inch in diameter. They're considered part of the net during play, and they make an imaginary out-of-bounds extension all the way up to the ceiling and down to the floor.

✔ **Attack line:** The line that is 10 feet (3 meters) from the net and runs parallel to it on each side of the court. Backcourt players must jump from behind this line for an attack to be legal.

✔ **Backcourt:** The area of the court behind the attack line that is in front of the baseline and between the sidelines.

✔ **Baseline:** The back line of the court that is 30 feet long. It is also known as the *end line*.

- ✔ **Free zone:** The area outside the boundary lines of the court where players sometimes make plays from. This term applies strictly to club volleyball. (For more information on club teams, head to Chapter 19.)

- ✔ **Centerline:** The line underneath the net that runs the width of the court and divides the court in half.

- ✔ **Net:** The piece of equipment in the middle of the court that divides the playing area in half. It is 39 inches wide and 31 feet long.

- ✔ **Replacement zone:** The place on the court where the libero, the team's defensive specialist, enters the game for a back row player.

- ✔ **Sidelines:** The boundary lines on the sides of the court that connect to the baselines. They are 60 feet long.

- ✔ **Substitution zone:** The area between the attack line and the centerline along the sideline where substitutes report.

Eyeing the court and the net

The volleyball court is 60 feet long and 30 feet wide, with a net dividing the court in half. For a regulation male match, the net is 7 feet, $11^5/_8$ inches high; for a female match, the net is 7 feet, $4^1/_4$ inches high. The younger and more inexperienced the players are, the lower the net usually is so that the kids have a better chance of hitting the ball back and forth over the net several times during each point.

Court sizes vary greatly from league to league. Often the amount of space available, the number of kids in the league, and their age and experience levels dictate the court size. Be sure to check with your league director to find out what size court your team has to play on, as well as the height of the net.

Knowing the Rules of the Game

To coach your team and instruct them in the fundamentals and skills of playing volleyball, you first need to have a firm grasp of the rules. Some rules are really easy to understand while others may initially have you scratching your head. If you're new to the sport and unfamiliar with its rules, you can easily become overwhelmed — and frustrated — by them. In the following sections, we take a look at some of the more basic rules and some special rules that your league may choose to adapt.

Although you may be anxious to get a handle on everything you need to know regarding the rules of the sport, refrain from trying to memorize all of them in one evening. Instead, dive into several rules each night, and over the course of a few days, give yourself time to understand the rules themselves and how

officials apply them during matches. You don't expect your players to learn all the rules during the first week of the season, so you don't have to put that kind of pressure on yourself, either.

Identifying the basic rules

In simple terms, a volleyball match consists of six players on each side of the net. Play begins when a server stands anywhere behind the baseline and hits the ball over the net to the opposing team. The opposing team can use three contacts to return the ball across the net. During those three contacts, a player can't touch the ball twice in succession. Teams may choose to use fewer than three contacts to return the ball, but at the advanced levels of play, teams generally use all three, which include a pass toward the net area on the serve-return, a set to an attacker, and an attack across the net. For a rundown on the most common volleyball terminology, head to the "Mastering Volleyball Lingo" section later in this chapter.

If two or more players touch the ball at the same time, either player involved in the simultaneous touch can make the next hit because their joint contact is considered only one contact. Be sure to consult your league's rule book because many programs don't allow players to play the ball with any body part below waist level unless it's incidental contact.

At the advanced levels of volleyball, players have specialized positions, and they switch to those positions after their team's first contact with the serve. Coaches have players move around to take advantage of specific skills they have that give the team a better chance to score points. One exception to moving players is that players in the back row can't move to the net to block or attack a ball in front of the attack line.

Every play ends when one team wins a point. A team doesn't have to serve the ball to record a point. Officials consider a ball that lands on any part of the boundary line in, and they rule the ball out if it touches the antennas, any of the cables outside the antennas, the referee stand, the ceiling, the ground, or, of course, anywhere beyond the boundary lines. A play also ends when the official blows his whistle to make a call regarding a violation.

If the team that didn't serve wins the point, each player on that team rotates clockwise around the court after they win the point (see Figure 3-2), and the player in the right back position gets to serve the next point. However, if the serving team wins the point, the players on that team remain in their positions for the next point, and the player who delivered the serve does so again to start the next point. Teams submit *lineups* before each game. The order of this lineup is the rotational order that the players must maintain throughout the game.

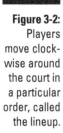

Figure 3-2:
Players move clockwise around the court in a particular order, called the lineup.

The following are some basic volleyball rule violations that result in a point for the opponent:

✔ When a team serves out of order, or when a player steps on or across the baseline (called a *foot fault*) while making contact with the serve.

✔ When a player makes *prolonged contact* with the ball, such as lifting, throwing, or carrying it, which are all illegal plays on the ball. Some volleyball programs do allow you to slightly lift or push the ball when you're making a defensive play, such as digging a hard hit ball.

✔ When a player touches the net with any part of his body during a point. However, in club volleyball, an official doesn't call a foul if a player comes in contact with the net because the opposing player hit the ball hard enough to move the net into him. In this situation, the point continues on. Play also continues when a youngster's hair contacts the net.

✔ When a player crosses the centerline with any part of his body. However, the player's *entire* hand or foot must cross the centerline for an official to call a violation.

✔ When a player reaches over the net and contacts the ball before the opponent has used its three contacts and if the opponent has someone in position to make a play on the ball.

✔ When a back row player attacks a ball on or in front of the attack line if the ball is completely above the net at the moment of contact.

✔ When a back row player has part of his body above the top of the net at the moment he makes contact with the ball during a block, or when he's part of a two- or three-player block, even though he may not actually touch the ball.

✔ When a player blocks or attacks a serve.

✔ When a player hits the ball twice in a row. A block isn't considered a hit, so a player who blocks an opponent's attack can make contact with the ball right after that play. Players are allowed to make a double hit on the first ball as long as they make only one attempt to play the ball.

✔ When a player isn't in the correct position on the court when the serve is delivered, the official calls a *rotation overlap* or *player out of alignment fault*. When this situation occurs, the opposition receives a point, and the team that committed the fault loses its serve (if it was serving). Check out the "Pointing out player positions and their responsibilities" section later in this chapter for more on proper alignment.

✔ When a player illegally substitutes for another player. A *substitution* is when a player enters the game for another player; a substitution must be authorized by the referee. The substituting player occupies the position of the player he's replacing. A player can't enter the game for one player in one rotation and then another player in another rotation unless he is the libero. The designated libero must wait at least one possession before entering for another player. Teams are allowed a specific number of substitutions per game, depending on the rules set by the league.

Knowing slight rule differences among different ruling organizations

Volleyball has all sorts of rules — and all sorts of ways to apply them. The Fédération Internationale de Volleyball (FIVB) provides the official rules of the game for international play. During all designated international competitions, FIVB's rules are in effect. For more information about FIVB, visit www.fivb.org.

USA Volleyball (www.usavolleyball.org) is the national governing body for volleyball in the United States and is recognized by FIVB, as well as by the U.S. Olympic Committee. Besides looking to USA Volleyball for rules and policies, countless U.S. club programs use the majority of the FIVB's rules while modifying others to meet the needs of the kids involved in their programs (for more on coaching club teams, head to Chapter 19).

The National Federation of State High School Associations (NFHS) (www.nfhs.org) is an education-based organization that publishes rules for 16 sports for boys' and girls' competition, including volleyball at the high school level.

(Most middle schools and junior high programs also follow the National Federation's rules.)

A rule that many youth volleyball programs modify, particularly at the recreation level, is the number of substitutions allowed during the course of a match. When programs have a large number of players, and the goal is to give as many youngsters as possible the chance to experience action during a match, they increase the number of substitutions allowed.

The majority of youth recreational volleyball programs around the country have their own combination of rules in place, and you should be familiar with them before stepping on the floor with your team. Even if you're well versed in the different rules, no two youth volleyball programs are alike and run the same way. You need to be aware of any alterations to the rules that have been made — regardless of whether they're major or minor changes — so that you can relay this information to your players to help enhance their experience.

Games are usually played to 25 points, although some programs play to 21 points or 15 points. Some programs require that the team wins by two points, especially in the deciding game of the match, while others allow a team to win a game by only one point with the score of 25-24, for example. Typically, the first team to win two out of three games, or three out of five games, wins the match. Because so many different scoring systems are in place around the country, be sure to know your league rules before you take the floor with your team.

Considering special rules

One of the neat aspects of volleyball is that you can easily tweak the game in any number of ways — the court size or number of players, for example — to fit the age and skill level of the kids participating in a given league. At the beginning levels of play, your emphasis is on teaching your players the basics of the game, not on explaining every trivial rule that advanced volleyball programs use in their games. The most common adjustments to the rules and court that youth leagues make to help create a more enjoyable experience for the kids include the following:

- ✔ **Fewer players:** Regulation volleyball matches feature six kids on each side of the court; however, matches in younger leagues sometimes feature four-on-four matches instead. The focus at the younger age levels is on introducing kids to the game by giving them many chances to contact the ball — the fewer players on the court, the more chances each player has to perform the different skills of the game.

- ✔ **Smaller courts:** Typically, the younger the kids, the smaller the court they play on. Leagues often put young kids on a smaller court because, when they have less area to cover, they have more opportunities to get their hands — and arms — on the ball.

- ✔ **Lower nets:** Leagues lower nets to create more opportunities for *rallies,* which are points during which the ball crosses the net several times. Kids enjoy their experience more when they get to play points in which the ball remains alive instead of ending with just one or two contacts. Plus, a lower net gives kids a chance to gain confidence in their skills. After all, if they constantly hit the ball into the net, they'll most likely become frustrated with their performance and, in turn, disenchanted with the sport.

- ✔ **Coaches on the court:** Youngsters new to the game are often overwhelmed by all the rules and the different positions on the court, so some leagues allow coaches to be on the court with the kids. Doing so allows the coaches the opportunity to provide guidance and to easily direct the kids where to go — they just have to be quick enough to get out of the ball's way!

✔ **Minimal rules in place:** At the beginning levels, the main goal is to help the kids get better at sending the ball back and forth over the net, not to get nitpicky on the rules. Many beginning level leagues don't enforce every rule during the match, but they do often ask the officials to explain certain violations to the kids when they see them so that the kids can try to correct their mistakes next time. For example, if a youngster steps on the baseline before he makes contact with a serve, the official lets the teams play out the point. Then, after one team wins the point, the official mentions to the youngster what he did so that he can learn the proper way to serve. This approach keeps the match moving and also instills some of the basics of the game into the kids.

✔ **Timed games:** Youth volleyball programs often feature a large number of teams, so to allow equal play for all the teams, many leagues establish a set amount of playing time for each match instead of letting the kids play to a certain number of points. A beginning level league, for example, may run 45-minute matches. After that amount of time elapses, the team who leads wins, and the next two teams on the schedule take the floor.

✔ **Service scoring:** *Service scoring* is a type of scoring that allows only the serving team to score points. So, if the receiving team wins the rally, they earn the right to serve and the chance to record a point during the next rally, but they don't receive a point. This change of possession without a point is called a *side-out.* One benefit of this type of scoring is that it prolongs matches, so chances are good that youngsters will be involved in more points and gain more experience playing the game. For coaches who have a large roster of players, service scoring helps them rotate all their players into the match and gives them all a lot of playing time.

✔ **Ceiling shots:** Some programs count the ceiling as being in play, as long as the ball stays on your team's side of the court and you haven't used up all three of your contacts yet.

Because of the many challenging aspects of volleyball, including the coordination and timing kids need to hit the ball back and forth to each other during a game, youth leagues often make several different modifications to the rules to help the kids gain the most out of their experience. So make sure you check out your league's rule book before the season starts. For more information on getting to know your league, see Chapter 2.

Mastering Volleyball Lingo

Although understanding volleyball isn't quite as difficult as mastering a foreign language, volleyball does feature a unique language of its own. To understand the different aspects of the game, you need to have a good grasp of these terms. The following list presents some of the most common volleyball terms and phrases:

- **Ace:** A serve the opponent can't return that results in an immediate point for the serving team.

- **Assist:** A set or pass to a hitter whose attack results in an immediate point.

- **Attack:** Also called a *hit*, a ball that a player strikes in an overhand motion in an attempt to win the point by knocking the ball to the floor on the opponent's side of the net.

- **Attacker:** The player who hits the ball during an attack.

- **Back set:** A type of set a player uses to set the ball in the opposite direction he's facing.

- **Base:** The beginning formation a team uses at the start of a point.

- **Block:** A defensive technique a player uses to get his arms and hands in front of the opponent's attacker to stop, or slow down, the attack.

- **Crosscourt:** The direction the ball goes when an attacker hits the ball from one corner of the net to the opposite side of the opponent's court.

- **Dig:** A defensive technique a player uses to keep the ball alive after an attacker hits it (see Chapter 9 for details on how to execute it).

- **Dive:** A defensive technique in which a player sprawls on the floor and extends his body to save the ball (see Chapter 9).

- **Down ball:** A type of ball the opponent hits when he doesn't leave the floor.

- **Dump:** A type of attack a player, usually a front row setter, uses to surprise the opponent, in which the player delivers the ball to an open area of the court.

- **Error:** A mistake a player makes that results in a point for the opponent.

- **Float serve:** A service technique in which the ball moves like a knuckleball because the server hits it with no spin (see Chapter 8).

- **Forearm pass:** A basic passing technique in which a player passes the ball to a teammate by contacting the ball with his forearms (see Chapter 9).

- **Free ball:** A ball that crosses the net slowly and that teams want to use to set up an attack.

- **Game:** The individual contest (also called a *set*) that makes up a volleyball match. Depending on the league you're coaching in (see Chapter 2), you may play only one game. Most matches, however, consist of the best of three games, and at the more advanced levels, the best of five games. Games are typically played to 25 points in federation and club matches, while the scoring systems used at the youth recreation level vary dramatically.

- **Game plan:** The offensive and defensive strategies a coach uses against an opponent.

✔ **Hit:** Also called an *attack*, an offensive technique in which the player attacks the ball in an overhand motion in an attempt to put the ball on the floor on the opponent's side of the net.

✔ **Joust:** A situation in which two opposing players make contact with the ball above the net at the same time.

✔ **Jump float serve:** A service technique in which the player takes a small jump into the air before contacting the ball (for more details on executing it, head to Chapter 13).

✔ **Jump serve:** A service technique in which the player jumps in the air behind the baseline and hits the ball like he does during an attack (see Chapter 13).

✔ **Kill:** A situation in which a player hits a successful overhand shot that results in a point.

✔ **Libero** (*lee*-ba-ro or li-*bare*-o): The player who is a defensive specialist and who can't set the ball in front of the attack line or jump and attack the ball above the top of the net. The libero wears a different colored jersey than the rest of the team, and his entrances into the game (called *replacements*) don't count against the team's number of substitutions. He must enter for a back row player through the replacement zone. In federation and collegiate volleyball, the libero can serve in one position, but the libero can't serve in club. Many leagues have different rules regarding this position, so be aware of your league's rules (see Chapter 2 for more on getting to know your league).

✔ **Lineup:** The serving order for the team and the positioning of the players on the court at the beginning of the match.

✔ **Match:** A series of games that determines which team wins and which one loses. Matches usually end when one team wins two of three or three of five games.

✔ **Multiple block:** Also called a *collective block*, a defensive technique in which two or more players block the opposition's attack at the same time (see Chapter 14). Only one of the two defensive players must touch the ball for it to be a collective block. It's illegal for a back row player to participate in a collective block, regardless of whether he makes contact with the ball or not.

✔ **Off-speed attack:** An offensive technique in which a player purposely hits the ball softly in an attempt to catch the opponent off guard (see Chapter 13).

✔ **Overhand pass:** A pass that a player makes with both hands above his head.

✔ **Overlap:** A foul in which one player is out of position with another player when the ball is served.

✔ **Overpass:** A pass that a player makes when he passes the ball across the net on the first contact.

✔ **Overset:** A set that goes over the net.

✔ **Pancake dig:** A defensive technique in which the player dives on the floor with his palm facing down to save the ball by contacting it with the back of his hand (see Chapter 14).

✔ **Penetration:** A defensive technique in which a player reaches across the plane of the net to block the ball.

✔ **Perimeter defense:** A type of defense that takes place near the boundaries of the court (see Chapter 14).

✔ **Quick set:** An offensive technique in which the setter sets the ball low and fast and his teammate hits it fast in an attempt to catch the opponent off balance (see Chapter 13).

✔ **Rally:** A situation during play in which the ball goes back and forth between the two teams.

✔ **Read:** A defensive skill in which a player watches the body and arm positions of the opposing attackers and attempts to determine in advance where the attacker will hit the ball.

✔ **Ready position:** The correct position a player assumes before performing a skill (see Chapter 9).

✔ **Replacement:** The situation that occurs when the libero enters the game for a back row player through the replacement zone.

✔ **Roll shot:** An offensive technique in which the player hits the ball softly over the net with some topspin (see Chapter 13).

✔ **Rotation:** The clockwise movement in the lineup a team makes after winning a point.

✔ **Serve:** The technique a player uses to begin every point by hitting the ball over the net from behind the baseline.

✔ **Set:** The offensive technique in which a player delivers an overhead two-handed pass to an attacker (see Chapter 8).

✔ **Setter:** The designated player on the team who delivers sets to the attackers.

✔ **Shuffle step:** The technique a player uses to move left and right on the court by shuffling — not crossing — his feet.

✔ **Side-out:** The situation that occurs when the team receiving the serve wins the rally and gains the advantage of serving. On a side-out, the service-receiving team doesn't earn an actual point.

✔ **Slide attack:** An offensive technique in which the attacker jumps into the air off one leg (see Chapter 13).

✔ **Soft block:** A defensive technique in which the blocker angles his hands upward to deflect the ball (see Chapter 9).

✓ **Substitution:** The situation in which one player replaces another on the court. A team is usually allowed a specific number of substitutions during a set (the numbers usually vary from 12 to 18).

✓ **Tip:** An offensive technique in which the hitter softly taps the ball with one hand into the opponent's court (see Chapter 8).

✓ **Tool:** An offensive technique in which an attacking player attempts to move the ball off the blocker's hands.

✓ **Topspin:** A type of spin that players put on the ball while serving and attacking to cause it to rotate forward and drop.

✓ **Touch:** Any situation in which a player contacts the ball.

✓ **Underhand serve:** A basic service technique in which the player contacts the ball with an underhand motion.

✓ **W:** A five-player serve-receive formation that is in — you guessed it! — the shape of a W.

Understanding the Official's Signals

To fulfill your coaching responsibilities and help your players progress in the sport, you have to know what an official's signals mean and understand why he makes his calls. Take a look at Figure 3-3 for some of the most common hand signals officials use during matches. You're sure to see some of the following signals this season, so you want to be familiar with what they mean:

✓ **Double hit:** A foul that occurs when players hit the ball twice in succession; the official awards a point to the opposition when your team commits this foul.

✓ **Four hits:** A foul that occurs when one team uses more than three hits to send the ball over the net; the official awards a point to the opposition when your team commits this foul.

✓ **Illegal attack of serve:** A foul that occurs when players in the front row make contact with the serve. The official awards a point to the opposition when your team commits this foul.

✓ **Illegal hit:** A foul that occurs when a player makes prolonged contact with the ball by holding it or by changing its direction. When your team commits this foul, the opposition receives a point.

✓ **Line violation:** A foul that occurs when a server steps on or over the baseline before making contact with the ball. When your team commits this foul, the opposition receives a point.

✓ **Illegal substitution:** A foul in which a team substitutes a player who hasn't been approved by the referee.

⮣ **Illegal alignment:** A foul that occurs when one player is out of position with another when the ball is served.

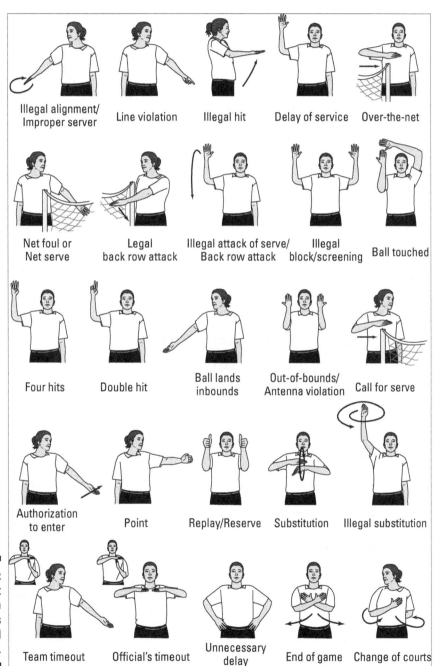

Figure 3-3:
The most common hand signals a volleyball official uses.

Getting Your Kids Ready to Step on the Court

Before your team takes the court for their first match, you want to make sure your players are prepared and know their positions. In a regulation volleyball match with six players on each side of the court, each position has its own unique set of responsibilities — and array of skills — that your players need to have to play it effectively. The older and more advanced your players, the bigger role that specialization plays when you're assigning kids to positions. At the beginning levels, you want to focus on introducing *all* the skills to the kids. You want to give them a well-rounded experience by allowing them to play all the different positions so they can get a taste of the different responsibilities associated with moving to various spots on the floor. In the following sections, we take a closer look at what each position requires in terms of responsibilities and skills.

Regardless of which position any youngster on your team plays, your responsibility is to make sure that his contributions — whatever they may be — are clearly valued and appreciated (by both you and the rest of the team) at all times. Children want to feel like a real part of the team, and your job is to make sure they do.

Pointing out player positions and their responsibilities

A volleyball court is broken down into six zones (see Figure 3-4). Zone 1 begins in the back right corner, and the zones move counterclockwise, with Zone 2 in the right front, Zone 3 in the middle front, and so on. Players start in their respective zones and move to the area of the court they're responsible for only after their teammate serves the ball, or if their team is receiving the serve, they move into their specific areas only after their team has sent the ball back over the net. When the team rotates following a point, the player who rotates into the right back position in Zone 1 becomes the server. In the following sections, we take a look at the different positions on the floor.

Setter

Just like a basketball team relies on a point guard or a football team depends on the quarterback to direct the team on offense, a volleyball team relies on the *setter* to lead the team on offense. The offense revolves around the setter's skills; his job is to take the second ball and deliver an accurate set to a teammate who can attack it. The stronger your setter is, the more efficient your offense can be, and the more opportunities the kids can have to score points. The attributes you should look for in a setter include the following:

Zone 5	Zone 4	Zone 2	Zone 1
Zone 6	Zone 3	Zone 3	Zone 6
Zone 1	Zone 2	Zone 4	Zone 5

Figure 3-4:
A volleyball court is broken into six zones for player alignment.

- ✔ **Passion for the position:** The player you assign to handle the bulk of the setting duties must want to take on the role. Being the team's setter is a tremendous responsibility because how this player performs directly impacts the ability of the hitters to deliver strong attacks. Thus, how well a setter does his job plays a significant role in how effective the offense is overall.

- ✔ **Quick feet:** The quicker the setter is at getting into position to receive a pass, the more likely he is to make an accurate set. If he's constantly out of position, he compromises his ability to make quality sets, and as a result, the team's attacking power wilts.

- ✔ **Great hands:** Possessing good setting technique is paramount for playing — and excelling at — this position. Players must be able to use their hands to make accurate sets from anywhere on the court, and at anytime during the match. A setter who uses the exact same hand position on every set keeps the opponent off balance because a defender can't get a good read on where the setter intends to place the ball when every set starts out the same way.

- ✔ **Good decision-making skills:** Effective setting requires recognizing how the opponent is defending the play and then putting the ball in the best spots for teammates to score points. To be a good setter, your player also has to be able to recognize when sending the ball over the net on the second contact may be more effective than giving it to a hitter for the third contact.

- ✔ **Dependability:** Mishandling balls and being called for illegal hits deflate a team's ability to generate offense. Plus, by making these faults, your team gives free points to the opposition. Sure, mistakes are part of the game, and they're going to happen, but for the benefit of your team, you want a reliable player in the position of setter, someone who won't be whistled for illegal plays very often.

✔ **Mental strength:** Because the setter is directly involved in a majority of the points, sometimes during the course of a match he may set the ball off target or perhaps allow the opposition to easily block the hit he set up. You want players in this position to be able to push out of their minds what went wrong on the last play and focus their entire attention on the next point. You want them to stay in the present and not waste time worrying about past miscues or previous points that didn't turn out quite like they'd planned.

Strong-side hitter

The *strong-side hitter,* also called the *outside hitter,* typically plays the left front position. The obvious goal whenever your team has control of the ball is to set the ball up to a hitter who is in position to hit it over to the opponent's side of the court — enter the strong-side hitter. He is your number one weapon in terms of producing points, and your team relies on him to hit shots — with both speed and accuracy — to all the different areas of the court. When this player is in the back row, he assumes a more defense-oriented role. Plus, at the more advanced levels of play, when the strong-side hitter rotates to the back row, coaches often replace him with a defensive specialist to handle all the digging that is usually required of back row players. You need to look for the following skills in your strong-side hitters:

✔ **Confidence:** Even the best hitters have some of their shots blocked. To be an offensive threat all match long, your strong-side hitters must continue to go aggressively after balls — even after they see the opponent block a few of their shots — with the mindset that the opponent won't be able to block any more of them.

✔ **Ability to make adjustments:** Your strongest hitters have to be able to recognize how defenders are attempting to block them and then change how they're attacking the ball or where they're aiming to put the ball to catch the defense off balance.

✔ **Ability to hit a variety of shots:** Even the hardest hitting attackers know the value of a really soft touch every now and then to throw the defense off balance. When hitters constantly see a double block during a match, the ability to deliver a tip or roll shot (see Chapter 8) is essential for making the opposition a little less aggressive.

✔ **Good physical condition:** Strong-side hitters do a lot of jumping, so kids in these positions have to be in good shape to be productive throughout the match. Teams can't afford to have their strong-side hitters tire as the match progresses because if they do, their ability to generate quality scoring opportunities plummets.

Middle hitter

The *middle hitter,* also referred to as the *middle blocker,* attacks balls set in the middle of the court and is often used as a decoy during points. For example, when opponents see this player stepping forward and going airborne for an attack, they can't be as aggressive in blocking the strong-side hitter because the setter may put the ball in the middle hitter's hands instead. Players who excel at this position have the following skills:

- ✔ **Good lateral movement:** Because the middle hitter is responsible for blocking along the front row, he must have good lateral movement, particularly if he's assisting a teammate on the outside with a double block.
- ✔ **Availability:** The middle hitter must have good transition skills and be ready to attack every time, whether he receives the set or not.
- ✔ **Good timing:** Because the middle hitter executes many of his attacks off of quick sets, he must have good timing and coordination to increase his chances of being successful.

Opposite hitter

The *opposite hitter,* also referred to as the *weak-side hitter,* plays across the court from the strong-side hitter. He's responsible for attacking from this position, as well as blocking the opposition's strong-side hitter when the ball is on the other side of the net. Important skills to have as an opposite hitter include the following:

- ✔ **Concentration and preparedness:** Many teams don't use the opposite hitter as often as they use the strong-side hitter — primarily because setting to the opposite hitter's spot on the floor is more challenging. As a result, opposite hitters usually have a hard time getting in a rhythm because they typically don't receive a steady flow of sets. Thus, this position requires good concentration to execute an attack when the player hasn't had to deliver one for several points.
- ✔ **Ability to set in emergencies:** In the situations in which the setter has to make the first contact on an opponent's shot, the opposite hitter must step up and set the ball to ensure that the team still manages to create a good chance to score a point.

Libero

The *libero* is the team's main defensive specialist, a player who excels at passing and digging. The libero can replace any player in the back row, and the replacement doesn't count as a substitution. He can't attack the ball from above the height of the net or set the ball from in front of the attack line. To replace a player along the back row, he enters the court through the replacement zone.

Because a libero may enter and exit the game as many times as a coach sees fit (after leaving the game, he must sit out one point before reentering for another back row player), coaches who have these defensive specialists on their squad can use them to their advantage throughout a match. Liberos come in handy particularly when the team is receiving the serve and needs a good pass to get its attack going.

An effective libero possesses the following skills:

- **Willingness and ability to dive:** To excel as the libero, a player must be willing to dive on the floor — and maybe receive a few floor burns — to keep balls alive in the back row.

- **Fast feet:** Coaches insert liberos into the match to make plays, so when opponents hit balls in between the libero and a teammate, the libero must aggressively go after them to make a play.

- **Solid understanding of his role:** Hitters grab a lot of the attention during a match for the exciting attacks they pound, but the libero's role is equally important. Kids who handle this position need to understand that although the skills they perform during a match may not be as glamorous as those that directly result in points, how well they perform has a significant impact on how the team fares.

- **Good communication skills:** The libero must be able to communicate effectively with his teammates because he's the team's defensive leader — that means speaking up and assuming control during points, as well as always being ready to play the first ball.

Defensive specialist

The *defensive specialist* is similar to the libero because of its emphasis on strong defensive play, but one significant difference between them is that the defensive specialist's substitutions do count. A defensive specialist can also enter the game in the same floor position every time as long as the coach still has substitutions left. Coaches often turn to the defensive specialist when their best hitters are in the back row and their defensive skills don't quite stack up to their offensive ones. In situations like this, these players can be a real asset to the team and help capture points. The most effective defensive specialists possess the following skills:

- **Constant readiness:** The defensive specialist never knows when the coach will call on him to step on the floor, so he must be focused on the match at all times and ready to step into the heat of the action whenever his team needs him.

- **Immunity to pressure:** Coaches usually call upon the defensive specialist when their team needs to stop the opposition's momentum, or when the team is behind and needs a good pass to the setter to turn its attack around. So not succumbing to the pressure of stepping up in the heat of the action is key.

Filling out a lineup card

Among your list of game day responsibilities is filling out and submitting a lineup card for your team. (At the beginning levels of play, this action often isn't required because the idea is to get as many kids as possible rotating in to experience the game.) A lineup card lists the names of the players, their jersey numbers, and the order in which they'll be serving. The lineup card helps the referee or official scorer (depending on the type of program you're coaching in) maintain order during the match. Lineup cards vary greatly from program to program, but all versions generally require the same basic information.

Coaches typically have to submit their lineup cards to the scorer two minutes before the match begins. (Be sure to know your league rules regarding this policy because times vary depending on the program.) Also, be aware that you need to fill out a lineup card before each game of the match, so if you're coaching in an advanced program playing a three-out-of-five match, you may have to submit five lineup cards on game day. Depending on how your team is performing that day, or what type of strategy the opposition is employing, you may go with identical lineup cards each time, or each of your lineup cards may be quite different.

To complete a lineup card (see Figure 3-5), follow these simple steps:

		Libero# 14
GAME	Serving Order	Player #
1	I	3
	II	7
	III	2
	IV	11
	V	8
	VI	4

Figure 3-5:
A standard
lineup card.

1. **Fill in the service order.**

 Enter the jersey numbers of your players in the six spots on the card. Pencil in the player you choose to serve first for your team in the I slot, the player you want serving second (who begins in the right front position on the court) in the II spot, and so on.

2. **Label the libero.**

 Fill in the jersey number of your libero in the special spot, usually at the top of the lineup card. You can change who handles the libero position for each game.

3. **Designate your floor captain.**

 Place a C by the name and number of this player on the lineup card.

Highlighting the basic skills your kids need to play the game

Volleyball is an action-packed, fast-paced game that requires players to perform a wide variety of skills with little reaction time. The better your players are at executing the basic skills of the game, the more they can enjoy their participation, and the higher their confidence can soar.

In the following sections, we examine all the basic skills your players have to be able to execute during matches to squeeze the most enjoyment out of their experience. For additional details on teaching these skills to your players, head to Chapter 8 for the offensive elements, and go to Chapter 9 for the basic defensive elements.

Passing

The stronger your team's passing skills are, the more effective your attacks can be. *Passing* is the skill a player uses to send the ball to a teammate during the course of a point. A team that can consistently pass the ball to its setter enables the setter to get the ball to the front row attackers, which increases the likelihood of the team's scoring points. Conversely, teams that have some difficulty with this aspect of the game have a less-than-effective attack because, when the setter doesn't receive the ball in position off the pass, he can't get the ball to the attackers in the right location, either, which translates into fewer scoring opportunities for the team.

Serving

The *serve* — the act of beginning the point by standing behind the baseline and hitting the ball over the net — is arguably the one skill that every player on the team must be able to execute effectively on a consistent basis. As the game progresses and the youngsters rotate around the court, they continually have to serve.

Your players have a wide variety of serves to choose from, including everything from the basic underhand serve that first-time players start out with to the aggressive jump serve that players at the advanced levels of play often use. As your players rotate around the court, each one has several opportunities

to get his hands on the ball. Anytime your team possesses the serve, you want to be able to take full advantage of the opportunity to score points. You want a team that not only sends the ball over the net to the opposition, but that also looks to win the point directly off the serve — or at least makes the task of getting an accurate pass to the attacker a difficult one for the opposition to complete. You don't want players surrendering points to the opposition by knocking serves into the net or out of bounds.

Here are a few additional points to keep in mind regarding the importance of having a team full of effective servers:

- ✔ **Target the weak passers.** A strong serving team can put their skills to even greater use against an opponent that has some players on the floor who aren't proficient passers. By targeting the areas of the court that weaker passers are protecting, your team can win some easy points — if they have the ability to hit those well-placed serves.

- ✔ **Change the momentum.** One of the most effective ways to turn the momentum of a match in your team's favor is to deliver a serve that the opposition can't return. Doing so pumps up your kids, increases the server's confidence, and puts your team in position to ride that wave of positive emotion and play well in the points that follow.

- ✔ **Use every player.** One of the neat aspects of serving is that any player — regardless of his size — can become a strong performer in this area of the game. Because the opponents are half a court away, they can't do much to affect how the server hits the ball (aside from being in good position to make an efficient return).

 Although other skills — such as hitting, setting, and passing — require a partner to practice them, serving is a skill that kids can work on by themselves. Through lots of practice and repetition, kids can gain a good feel for how to toss the ball in the air and consistently deliver it exactly where they intend to. Plus, as players learn to serve the ball with more pace, or some spin, their serves become more and more problematic for the opposition to defend.

Setting

Setting is one of the main specialty skills of volleyball, which is why, at the advanced levels of play, so many coaches opt to go with one main setter. The skill of *setting* is when a player delivers the ball in a position where a hitter can attack it and drive it toward the floor on the opponent's side of the net. A player can use a variety of different sets — the quick set or back set, for example — to get the ball to his teammates. All players need to have a good understanding of setting, because even when the team relies on one player to handle the setting responsibilities, other players have to step up and deliver sets during the match when the setter either has to make the first hit or isn't in position to make the second hit.

Hitting

A team wins matches by scoring points, and the most effective way to score points is to have accurate hitters handle the third ball. The skill of *hitting* is when a player jumps up in the air and strikes the ball so that it lands on the opponent's side of the court. Hits are among the most exciting plays in volleyball, especially at the advanced levels, when players unleash powerful shots that drive into the floor. Because players rotate around the floor during games, and because back row players can't cross the attack line, the more players you have who are capable of hitting aggressive shots when they're in the front row, the more difficulty the opposition has in defending your attack.

Blocking

Although most players, particularly at the younger levels, enjoy playing defense about as much as they enjoy tackling big homework assignments, blocking is an important defensive skill for youngsters to learn. The skill of *blocking* is when a defensive player stops, or at least disrupts, an opposing player's attack on the ball. A player blocks a shot by jumping up in the air with his arms above his head at the moment the opposing player strikes the ball. A good blocking team reaps the following benefits:

- ✔ **Frustrates the opposition:** Whenever your team blocks, or even just deflects several of an opponent's hits in a row, the opponent is likely to let frustration settle in and confidence dwindle. On the flip side, derailing an attack with an effective block builds confidence in your players and helps them appreciate the important role that good defense plays in scoring points.

- ✔ **Makes your defense's job easier:** Having to dig a hard hit ball is one of the toughest skills to perform, so the more blocks or deflections your front row players achieve, the more thankful your back row players are for not having to face such a barrage of shots coming at them. Plus, by channeling the blocked ball to where teammates are standing, your team can make a smoother transition to its attack.

- ✔ **Provides an offensive springboard:** Teams that can prevent the opposition from hitting the ball where they want to every time they set up an attack create more scoring opportunities for themselves.

Moving around the court

Because of the relatively confined playing area of the court, volleyball players don't have to do a lot of running during matches. But, players do have to move side to side, as well as forward and backward, in short, quick bursts throughout matches. Footwork is key. They have to be able to keep up with the fast pace of the game in which points end in the blink of an eye. Of course, on occasion, they may have to do more running than usual to chase after a deflected ball to keep the rally alive, but players primarily have to rely on fast, short steps when they're reacting to the ball.

Chapter 4

Getting in Sync with Your Players' Parents

Coaching a youth volleyball team certainly requires positively interacting with all your players every time they step on the court, but being a successful coach also demands maintaining good relationships with their parents off the court. To help ensure that you have a fun-filled and headache-free season, you have to establish rapport with the parents well before the season's first point is contested on the court. In this chapter, we take a look at the preseason parents meeting, your tool for welcoming parents to the season ahead, outlining your expectations, and highlighting the importance of working together for the kids' benefit.

We go over what you should cover during the meeting and give you tips for explaining your coaching philosophy, goals, and various team policies on touchy subjects like playing time. We also prepare you for the stack of papers, ranging from consent forms to medical evaluation forms, that may wind up in front of you. You can also find some highly valuable information on recruiting and then selecting parents to be assistant coaches, as well as filling other key positions away from the court that help the season run more smoothly.

Introducing Yourself

You're probably anxious about taking the court with your team so you can get the kids started passing, hitting, and attacking. However, before you conduct the first practice of the season, you need to gather your players' parents together for a preseason meeting. Before your players get a chance to break a sweat, hold a meeting with the moms and dads to open critical lines of communication and to send the all-important message that you'll be working with them to help ensure that their children have a rewarding season.

A preseason parents meeting can be helpful for both you and the parents — when you handle it the right way. The meeting gives the parents a chance to get to know you a little better, which helps the parents feel more comfortable with sending their children to spend a few hours a week with you. The meeting also serves as an opportunity for you to let parents know how you plan to handle the team so that no one encounters any surprises along the way.

The first impression you make with the parents is significant, so approach the meeting with a lot of enthusiasm. No one expects you to be a professional speaker during this meeting, so don't spend your nights tossing and turning, worrying about how you're going to pull this off. However, being able to clearly explain your thoughts on the topics you cover demonstrates how deeply you care about the upcoming season and reinforces your commitment to each child on the team. Parents will appreciate your initiative and feel much more at ease turning their children over to you for the season.

The more comfortable parents are with you, the stronger your relationship will be with both them and their children. To help start the season off right, take some time before the meeting to make sure the meeting is effective and informative for both the parents and you by doing the following:

- ✔ **Choose a well-known meeting spot.** Your best bet is to meet at the recreation department that runs the league because parents probably know where this is from signing their kids up in the league. If you contact the league director early, the director can make arrangements to reserve a room for you. If space is a problem, local libraries often have meeting rooms available.

- ✔ **Pick a convenient time.** Choose a time that matches, as closely as possible, the time your team will take the court for practices during the season. Because parents have to bring their children to practice, they should be able to attend a meeting held at the same time.

- ✔ **Let parents know about the meeting as soon as possible.** Most parents juggle hectic schedules, so getting everyone together at one time can be tricky. As soon as you get your hands on your team roster, contact each child's parents to introduce yourself as the coach and to tell them the date, time, and location of your meeting — and stress the importance of

being there. Giving parents as much notice as possible gives them time to rearrange their schedules, if necessary, and increases the likelihood of their attendance.

✔ **Cover the key areas.** You can determine which points you want to cover by asking yourself what you would want to know if you were handing your child over to a coach you didn't know for a season. You'd want to know what type of coaching experience the individual has, how often the team will practice, and how the coach will determine positions, among other details.

✔ **Prepare notes.** Outline your main points on a notepad and bring it to the meeting. Referring to your notes often throughout the meeting isn't a sign of being unprepared — it indicates that you want to make sure you're covering all the important points for the parents' benefit. Being properly prepared is the best antidote for conquering any speaking nerves you may have. Although tempting, don't write out everything you want to say and read it word for word at the meeting. Doing so may bore parents and make them wonder just how much fun their children will have with you this season. Be confident in your abilities, and you'll do fine.

✔ **Rehearse your material.** What do you tell kids to do to get better at serving or attacking? Practice, of course. The same applies to you concerning public speaking. In the days leading up to the meeting, stand in front of a mirror and practice what you're going to say. If you sense that you're really going to be uncomfortable, rehearse in front of your spouse, a family member, or a friend. Don't try to memorize your material; just become really familiar with it. The more comfortable you are with the information, the less nervous you'll likely be.

Keep the following additional points in mind during the actual meeting:

✔ **Keep it brief.** Plan on spending no more than an hour with the meeting. Don't forget to include time for a question-and-answer session at the end of the meeting.

✔ **Include time for parent introductions.** Parents will see quite a bit of one another during the season, so at some point during the meeting, have the parents introduce themselves and who their children are. Although some parents probably already know each other, introductions can be a good icebreaker for the entire group.

✔ **Pass out the paperwork.** Distribute the paperwork at the end of your meeting to avoid creating distractions; otherwise, some parents may tune out what you say because they're too busy flipping through the material you gave them to review. (See the section "Shuffling Papers: Managing Parental Forms" later in this chapter for more information on what paperwork you may have to deal with at the meeting.)

✔ **Have a back-up plan.** Ideally, you want all the parents to show up at your designated meeting, but if some can't attend, you need to have a back-up plan in place. For example, you can cover everything on the phone some evening you both have free or meet at a time and place that works for both of you. You can also prepare handouts of the material you presented during your meeting and give them to the parents who weren't there. Whatever your plan is, make sure you meet with all the parents *before* the team begins practicing.

Explaining Your Coaching Philosophy

During your preseason parents meeting, you want to put your *coaching philosophy* in plain words. By detailing your coaching philosophy — how you'll handle everything from tracking playing time and assigning positions to stressing good sportsmanship and promoting a team-oriented atmosphere — you can answer many of the parents' questions before they have a chance to ask them. Plus, you can minimize the number of misunderstandings that often lead to unwanted aggravation and grief throughout the season. (Check out Chapter 2 for more details on crafting a coaching philosophy.)

This section explains the best approaches for explaining how you plan to work with the kids and outlining what your goals are for the season. If some of the parents don't like your philosophy, your plan for overseeing the team, or the recreational aspect of the league — and chances are some parents won't — telling them early gives them time to find a more appropriate league or level of competitiveness for their children.

Verbalizing your stance on wins and losses

Politics, religion, and the role that winning and losing plays in youth sports are topics that ignite heated opinions among adults. Luckily, you don't have to address the first two, but because of the nature and sensitivity of the subject, you must clearly state your stance on winning and losing. You'll have the parents' full attention the moment you bring up the topic, and because it's one of the most important topics you discuss during the preseason meeting, consider the following details to help you get through this conversation with ease:

✔ **Fun comes first for the younger age levels.** If you're coaching younger players in beginners' programs, such as kids in the 10-and-under category, you want the parents to understand that your number one goal isn't winning games. Instead, your primary focus is on introducing the kids to the basic concepts of volleyball — serving, setting, passing, and defense — and making the process so much fun they can't wait to work on their skills at practice or pull on their colorful jerseys on game day.

✔ **Beginners don't care about the scoreboard.** Numerous studies show that young children are far less concerned about winning and losing than their parents. For young volleyball players, what the scoreboard says at the end of the game isn't nearly as important as whether they had fun with their teammates, began some points by hitting a few serves, or heard your words of praise for making a couple of nice plays or hustling to get a ball. Share this information with your parents, and let them know that your main job is to build a strong fundamental foundation and spark their interest in volleyball so that they want to play next season, too.

Many leagues at the beginning levels don't even turn on the scoreboard during games or keep team standings. If you're coaching in this type of league, be sure to mention this fact to the parents. Of course, some of your parents may keep score themselves in the stands and may even relay that information to the kids. (For more information on dealing with problem parents, head to Chapter 18.)

✔ **Winning has its own place in the equation.** If you're coaching an older or more advanced team, such as kids at the ages of 14 and older, let your parents know that along with teaching your players skills and strategies of the game, you'll be encouraging them to compete hard, do their best, and try to win games. However, be sure to stress that winning only matters if you do so within the rules of the game, while also displaying good sportsmanship toward both opponents and officials during the game and afterward, regardless of the outcome.

Regardless of the level of play, winning isn't everything and should never define a child's experience playing volleyball. Ensuring that kids have a positive experience and simply do their best each time they step on the court is what coaching is all about.

Emphasizing good sportsmanship for players

Although your kids' parents correctly assume that you'll be teaching important fundamentals of the game, like making a good pass to the setter or returning an opponent's serve, they probably aren't aware of your commitment to teaching good sportsmanship. Teaching good sportsmanship among the actual skills of the game isn't a sign of weakness on your part. Instead, your commitment to good sportsmanship is the ultimate indicator that you will treat your players to a well-rounded experience that encompasses the entire sport of volleyball — from how they serve at the beginning of the match to how they behave during the game and after the final point has been decided. Parents will appreciate that you plan to teach their kids how to be good sports, because sportsmanship is a valuable lesson kids can apply to many other areas of life.

Being a good sport can be as challenging as learning the jump serve, because some days just aren't going to go according to plan. Despite a really good mid-week practice, you may not recognize the team that shows up on Saturday morning to play. You have to endure days when your players' serves find the net, their passes miss the mark, and their attacks land out of bounds. Even when nothing goes right, though, you must congratulate the opposing team so that your players follow your lead. These are tough lessons for kids to learn, but they are also important ones.

Maintaining model parent behavior in the stands

A fun-filled day of volleyball, featuring exciting points and good sportsman-ship from both teams, can be squashed the moment a parent in the stands utters an inappropriate comment or questions an official's call. Out-of-control parents have no place in the stands of a youth volleyball match, so when you explain the type of behavior you expect from the parents — and the behavior the kids deserve — be straightforward and leave no room for misinterpreta-tion or misunderstanding. Stress the importance of modeling good sports-manship before, during, and after games. Let parents know that children don't perform as well, or have nearly as much fun, when parents scream at them or when they hear their parents' voices booming at the official.

Your season will go more smoothly — and will be more enjoyable for every-one involved — when parents live up to your expectations for model behavior. If you can get parents to understand fully the importance of showing good sportsmanship — such as applauding good plays on both teams — chances are their kids will adopt similar behaviors. Unruly parents in the stands distort the message you want to deliver to your players. Positive actions by you and the parents result in well-behaved players who show respect for the game and everyone involved in it.

To firmly establish your stand on good sportsmanship in the stands, stress the following do's and don'ts to your parents:

✔ **Don't exhibit bad behavior.** Bad behavior can lead officials (or you) to remove parents from the facility. Stress to your parents that although you never want to have parents removed from the stands for negative or inappropriate behavior, you won't hesitate to make that call if they're being a disruptive influence or creating unnecessary tension. (Many leagues have policies for removing spectators, and you need to be aware of the steps you have to follow.) You don't need to use a negative tone when addressing this subject, but hammer home the point that the game is about the kids, not the parents. You want their memories to be of having fun on the court — not watching embarrassing behavior in the stands. (See Chapter 18 for more on dealing with disruptive parents.)

✔ **Do keep all comments positive.** You know the saying, "If you don't have anything nice to say, then don't say anything at all." Well, it's a perfect slogan for volleyball spectators to adhere to all game long. You simply can't allow games to be ruined by parents yelling at officials, coaches, or players on either team. Remind parents that their comments should be only positive and encouraging — and never so overbearing that they infringe on your communication with the players.

✔ **Don't coach from the bleachers.** Parents must know that shouting instructions to their children, or even other teammates, is a big no-no. Let them know that hearing multiple sets of instructions confuses kids and interferes with their concentration. Remind parents that you're the coach and that all the coaching has to come from you.

✔ **Do respect the officials.** Yelling at officials for any reason is unacceptable. Even if parents are sure an official missed a call, they can't disrespect the official who's doing her best to make the right calls and treat everyone fairly. Even in the event that an official makes a mistake, parents — as well as coaches and players — have to put it behind them and move on to concentrating on the next point. When parents don't make a big deal about calls, neither do the kids. By the time the game ends, most players won't pay extra attention to one point out of all the points they played during the match — as long as they didn't hear Mom and Dad screaming about it at the top of their lungs.

Determining playing time and positions

Some parents sign their children up for volleyball with visions of them leading their team as its best attackers. These parents think the offense will revolve around their kids and their kids only. One of the neat aspects of volleyball at the more advanced levels of play that differentiates it from some other popular team sports, is that because the kids constantly rotate around the court, you can easily ensure that everyone gets a chance to hit and return serves, make passes and sets, and perform digs and blocks (see Chapter 3 for a rundown on the rules of the game). At the younger levels, ensuring that all the kids touch the ball frequently is much more difficult because rallies are generally rather short (especially when a team struggles to get serves over the net or return them). Plus, a child's touches may be limited simply because the ball never comes into her area of the court during a match.

At the more advanced levels of play, you can use different serve-receive formations that allow your best players to handle the ball to allow the team to set up and run its offense. (For more details on advanced offensive and defensive techniques, go to Chapters 15 and 16.) But in the beginners' levels, you have to share playing time equally among all your players. Explaining your process for positioning kids well before the first game of the season eliminates unnecessary headaches.

Assigning playing time based on age

Parents show up on game day excited to watch their children involved in the action — not sitting on the bench. Yet, because only six players can play on the court at one time and you may have a dozen players on your roster, your hands are tied. Players have to take turns — and parents have to be patient. So make sure you share with parents how you plan to divide playing time to prevent any misunderstandings or hurt feelings. (If questions about playing minutes surface later during the season, flip to Chapter 18 for tips on dealing with these issues.)

For kids, playing volleyball is all about being on the court and getting plenty of opportunities to set, pass, and dig the ball. Giving kids equal opportunities to play is crucial for their development in the sport. Kids who have to sit on the bench for long stretches, or who don't receive the same amount of playing time as their friends, quickly lose interest in the sport — or may even lose their own self-esteem or confidence.

Be sure to share with parents the importance of participating in practice. As long as kids regularly show up at practices, you divide playing time equally. Make sure that parents understand that children who are infrequent practice participants, or who only find time to show up on game day, will have their playing time cut down. It's not fair to the kids who show up for every practice to have to share playing time with teammates who only show up on game day. Be sure to discuss your practice policy with parents ahead of time to prevent conflicts during the season.

If you're coaching an older or more advanced team, you typically distribute playing time more on skill. The same goes for club teams. (For more details on coaching this more elite level of volleyball, check out Chapter 19.) When letting parents know how you hand out playing time, emphasize that everyone plays a significant role on the team, regardless of whether she starts or not.

Lining up: Who plays where and why

When you're coaching at the youngest age levels, your mission is simply to give kids a taste of the different positions and their roles fulfilling those spots so that they enjoy a well-rounded experience. Most parents appreciate your interest in giving kids a chance to try different aspects of the game.

At the more advanced levels, where playing time hinges more on skill level and performance, parents need to be aware that you make decisions based on the best interests of the team. That means that players will have different roles on the team based not only on what they do well, but also on what their teammates excel at. Go to Chapter 5 to find out how to evaluate players and assign positions. Of course, a parent's evaluation of what's best for the team may not mesh with yours all the time. That's why laying out your approach before the first serve of the season is a good idea.

Shuffling Papers: Managing Parental Forms

Many youth volleyball programs across the country require parents to sign a few forms before their children can play in the leagues. Most often parents fill out these forms during the registration period, but you may find yourself in a league that gives you the responsibility of securing all the paperwork. Although the content and style of the forms vary from league to league, the purpose is generally the same. This section gives you a rundown of the forms you may see.

League documents

Your league may require your parents to read and fill out a variety of forms before the kids can take the court. This section examines the most common ones.

Practice and game schedules

Leagues typically set the game schedule for the season well in advance, so you need to make sure parents get a copy so they can plan accordingly. Also, if the league has assigned your team specific days and times to use the facility's court for practice, make sure to give parents that schedule as well. Parents often have to sign a form saying they received the practice and game schedules. The more information parents have, the better they can plan for what's coming each week.

Consent forms

A *consent form* states that a child may get hurt during practices or games, but that in the event of an injury, the league isn't responsible. Most programs carry insurance against possible litigation, so be sure to ask about the league's coverage and your own status under the policy.

Emergency treatment authorization forms

The child's parent or guardian signs and completes the *emergency treatment authorization form,* which lists the names of three people whom you or someone else should contact if the child is injured and requires emergency medical treatment. The form usually gives the coach or other league personnel the authority to seek medical treatment for the child if no one can be reached.

Medical evaluation forms

Medical evaluation forms, signed by the child's physician, state that the child is physically healthy and able to participate in the sport. If the child has a condition such as asthma or diabetes, the doctor lists that condition on this form.

The National Youth Sports Coaches Association (a program of the National Alliance for Youth Sports) provides insurance coverage to coaches who complete its training program. Visit www.nays.org for more information. The association recommends that all coaches go through training to help ensure that they're knowledgeable in all areas of the sport and can provide a safe and fun experience for every child on their team.

Personal packets

Beyond the league paperwork, you can make your job easier (and keep your sanity in the process) by distributing your own packets of information to parents. Parents will appreciate and use these handy resources throughout the season. We go over a few of these packets in this section.

Basic information about the game

Some of your parents may not know much about the specific rules of volleyball, but you can't go over the entire sport in detail without dragging the meeting into all hours of the night. Passing out a cheat sheet on the rules can give you the opportunity to help parents better understand the game and answer any questions their children may have. Include a page noting any special rules in effect in the league. (Maybe the league has instructed officials not to make certain minor calls to keep the game moving, such as not whistling infractions for touching the net while attacking and blocking.) You can also include a diagram of the court that indicates the positions of each player, as well as a list of common volleyball terms (see Chapter 3 for a court diagram and a list of terms).

Be sure to include a page that shows the officials' hand signals for various calls and what they mean (you can copy them from Chapter 3).

Phone lists and contact information

A list of all the kids' names and their parents' telephone numbers and e-mail addresses can be handy for parents because sometimes they may need to communicate with one another. For example, a parent may be unable to get her child to practice, so she may want to contact another mom or dad to arrange a car pool.

Make sure that you include your own contact information so that parents can get in touch with you, too.

Recruiting Parents to Help on the Sidelines

Parents give a lot of effort and make plenty of sacrifices to help ensure that their children have a great time playing volleyball. Although some parents are content with simply watching their children develop and have fun under your guidance, others enjoy having more active roles throughout the season. Encouraging your players' parents to take an active interest in the season lays out the welcome mat for those who want to help. Parents can assist the team in ways that can make a big difference in the quality of your team's season. The following section explores the different roles parents can assume to help you, and the season, run smoothly and efficiently.

Finding assistant coaches

Running a really good volleyball practice takes an enormous amount of work, both planning drills before you reach the court and making everything come together when you're on the court. The more quality people you surround yourself with — whether they're friends who know the game and are good with kids, or parents you appoint as assistant coaches — the more efficient your practice sessions can be. If you can slide knowledgeable and caring adults you trust into assistant coaching positions, you can accomplish more in each session.

In addition to helping during practices, assistant coaches can be valuable resources on game day, providing additional sets of eyes and ears. (For more details on how to improve the game day experience, check out Chapter 7.) Assistants can help you in many areas on game day, such as the following:

- **Tracking points:** If you distribute your players' playing time according to the number of points each child gets to play, your assistants can monitor that for you to ensure that everyone is involved in an equal number of points. Besides ensuring equality for the team, this information also comes in handy if a parent ever questions the amount of playing time her child receives. (See Chapter 18 for more on dealing with questioning parents.) At the higher levels of play, assistants can also keep other key statistics, such as the serving, passing, blocking, and digging efficiency of each of your players.

- **Helping with pregame tasks:** As a head coach, you have many responsibilities prior to a match. An assistant coach can oversee the team's stretching or get the squad started on its pregame warm-up, if needed.

✔ **Policing the parents:** After the game begins, your focus shifts entirely to the action on the court and your players, so if your team's parents make inappropriate comments to the officials or anyone else, you may not catch them. Assistant coaches can alert you to these issues so that you can address them at the appropriate time to avoid any unwanted incidents.

✔ **Scouting the opponent:** At more advanced levels of play (with older kids), your assistants can check out the opposing players as they warm up. Maybe they'll spot a tendency, such as where on the court particular players always hit their serves or attacks, or which players appear to be less accurate passers. If you're participating in a tournament with several teams, your assistants can check out how other teams attack on offense, or which defensive alignments they use most often. This information can be very helpful for your players to know.

During your preseason meeting, you can gauge the interest level of those parents who may like to help out as assistants, but don't fill those positions based simply on who raises their hands first. You probably won't know most (if any) of the parents at your preseason meeting, particularly if you're in your first season of coaching. Because you're new to coaching this group of kids, use the first few practices of the season to get to know the parents, and pay attention to how they interact with their kids — and others. For example, if you see a dad chastising his daughter for a poor practice effort, you can imagine the problems you may have if you allow him coaching access to your entire team.

You can set aside some time after the first few practices to sit down and talk more in-depth with those parents who are interested in being on the court during your practices. Use these early practices as sort of a mini-interview process, making sure that their approaches and philosophies match yours. By going this route, you're more likely to select parents who will support your coaching philosophy and emphasize the fun and learning you want to stress instead of steering your team in a completely different direction. (See Chapter 2 for more information on developing your coaching philosophy.)

At more advanced levels of play, you always want to find out early who's interested in assisting and then set aside times to interview them. Question what their experience playing and coaching the game is, why they want to be involved, and how they think they can be assets to your team. Through interviews, you want to determine who's going to be helpful and who's going to be a hindrance. Assistants can be of enormous value, but if they overstep their roles, they can create unwanted confusion and actually add to your workload.

Deciding who your assistants will be is one of the most important decisions you'll make all season, so take the time and put in the effort to make sound choices. For example, some parents can surprise you the first time they step on the court with you after you have assigned them the role of assistant

coach. They may try taking over your practices by imposing their own teaching methods, or they may require so much supervision that they actually create more work for you. This distraction takes away from valuable time you should be spending with your players. Someone who doesn't mesh with your philosophy can create turmoil and negatively impact the team's experience. Avoid at all costs choosing a parent who seems laid-back at your preseason meeting but transforms into a yeller when the games begin. If you happen to make a bad judgment call on a parent, you must solve this touchy problem immediately so that it doesn't linger and cause additional headaches for everyone. (You can find suggestions for dealing with this problem in Chapter 18.)

Filling support roles

Some of your players' parents probably played volleyball at some point during their lives, although others may have no clue what the difference is between a set and an attack. Unfamiliarity with the sport limits the ways some parents can help you on the court during practices and games — but they can fill plenty of other jobs outside the playing lines. Most parents want to be involved to some degree; they just need some direction on how they can fit in.

Examine the following list of jobs to figure out where you can most effectively use your parents' help:

- ✔ **Communication coordinator:** Sometimes, for reasons out of your control, games are postponed until a later day, or something comes up that forces you to reschedule one of your practices. Contacting every parent in a timely manner can be challenging, particularly if you happen to oversee a fairly large squad. Giving a parent the job of *communication coordinator* can alleviate a lot of the stress at times like these. This person ensures that messages are communicated to team parents quickly and efficiently.

 If you need to make any last-minute changes to the team schedule, simply let your communication coordinator know the details. The coordinator calls or text messages two parents on the list; those two parents each call or text message two other parents, and so on. In a matter of minutes, everyone is aware of the schedule change.

- ✔ **Team parent:** Handing out healthy refreshments or snacks is a nice way to conclude a volleyball match, particularly at the younger levels. (See Chapter 17 for more information on keeping your kids healthy with post-game snacks.) Choose a *team parent* who can put together a schedule, assigning parents the games or practices they have to bring snacks to. This role can also include organizing an end-of-season party at a local establishment the kids enjoy eating at.

✔ **Concession-stand worker:** Some leagues require each team to provide a couple of parents to work the league's concession stand during the season. Check with the league director to find out what dates need filling and see which of your parents are willing to be *concession-stand workers.*

✔ **Photo coordinator:** Team photos are great keepsakes for the children, who, years from now, will enjoy seeing pictures of themselves and their teammates all decked out in their uniforms. Some leagues work directly with a local photography company, but in other leagues, organizing a photo shoot is left to the coach's discretion. Either way, having a parent fulfill the *photo coordinator* position can be extremely helpful.

Besides working with you to select a convenient time for the team photo, the photo coordinator can arrange for a photographer to come out for a game or two to take action shots of the kids passing or attacking in the heat of the action. Just be sure to verify that all the parents are on board with forking over extra cash for these photos.

✔ **Trophy coordinator:** Depending on the type of league you're coaching in, you may want to consider assigning a *trophy coordinator,* who can arrange to get small participation trophies or plaques to present to all the children at the end of the season. Again, check with the parents in advance to make sure they're all on board with this because, if the league doesn't supply the cash, someone else has to (namely you or the parents).

✔ **Game day helper:** In beginners' volleyball programs, parents sometimes need to help out on game day with tasks such as retrieving loose balls that bounce out of play. In most leagues, each team also has to provide one *line judge,* someone who determines during matches whether balls near the sideline and baseline land in or out of the court of play. Assigning a few parents this job ahead of time helps game days run more smoothly. If your league needs this sort of help, be sure to mention it during your parents meeting. (See Chapter 2 on the importance of knowing your league's rules.) Find out which parents are willing to fill these positions and keep a list of them handy. You don't want to waste valuable pregame time soliciting help when that time can be put to much better use getting your team ready.

✔ **Travel coordinator:** This position is appropriate only for a more experienced team that competes against teams in other cities. (For more on travel teams, check out Chapter 19.) The *travel coordinator* hunts for the most cost-effective and convenient hotels for the team to stay in and arranges transportation, or determines carpool assignments, for traveling to game and tournament sites.

✔ **Fund-raising coordinator:** Sometimes volleyball teams rely on fund-raising to offset the cost of uniforms or travel expenses for participating in tournaments. These events can include everything from selling candy bars to washing cars. The *fund-raising coordinator* develops fund-raising ideas and then coordinates with local businesses in the community to help pull them off.

During your preseason meeting, circulate a list of responsibilities that you need the parents to fill, and have parents jot down their names next to the duties they're comfortable helping out with. If a large number of parents expresses interest in a specific role, your best bet may be to have them work together as a committee so that no parent feels alienated. If no one signs up for a specific duty that you need to fill, check with some of the parents who signed up for another position. If you have a group of parents that signed up for the same task, one of them may be open to switching to fill your need.

Meeting Players' Special Needs

Taking the role of volleyball coach means accepting responsibility for working with kids with vastly different abilities. Some players on your roster will be great jumpers, some will be athletically gifted, and others will lack coordination at this point in their physical development. You may also have a child on your team who has special needs, such as hearing or vision problems or a learning disability. As a coach, you must provide opportunities to all your players and do what you can to make the season fun for everyone. (Check out Chapter 5 for a look at all the different types of kids you may coach this season.)

During your parents meeting, be sure to find out whether any of the children on your team have medical conditions that you need to be aware of, such as diabetes or asthma, and whether you need to make any special accommodations for those conditions. Some leagues provide coaches with a copy of each child's medical evaluation form (see "League documents" earlier in this chapter for more on this form), while others keep those forms private. Whatever the policy is in your league, make sure you're aware of any existing conditions your players have before you take the court. You may also want to be aware of any children who wear contact lenses.

Understandably, parents may not feel comfortable divulging their children's medical information in front of all the other parents, many of whom they probably haven't met before. For this reason, set aside time at the end of the meeting for any necessary one-on-one discussions between you and a parent. Also, let parents know that they can contact you later via phone or e-mail to discuss any issues they didn't get to talk about at the meeting.

Concluding Your Meeting with Q & A

Even though we're confident you'll do an outstanding job covering all the important information during your meeting, some parents may not be completely clear on certain areas. So before wrapping up the meeting, give parents a chance to ask questions.

To help ensure open conversation, let parents know that you're willing to discuss any aspect of the season with them. The question-and-answer session allows parents who didn't want to interrupt your talk to pose their questions and get answers.

Let parents know that if they feel more comfortable speaking with you in private, you're happy to hang around after the meeting to chat with them.

If you can't answer some of the questions posed during your meeting, make a note of them, and let the parents know that you'll get back to them with answers as soon as possible. And then make sure that you do!

Remind parents that if they have any questions or concerns during the season, you're happy to speak with them in person, over the phone, or through e-mail. Make sure, however, that they're aware of the times that aren't conducive to productive discussions — such as before and after games when your focus is on the kids and your other coaching responsibilities. Plus, you don't want to have private discussions in front of other parents or players.

Part II
Building Your Team

The 5th Wave By Rich Tennant

"We covered the basics today —
serving, passing, and why I have
hair growing out of my nose."

In this part . . .

Having a strong understanding of the strengths and weaknesses of your team is imperative for designing and running fun-filled practices that both excite your players and enhance their development. This part provides plenty of great tips for pulling off productive practice sessions. You also find everything you need to know to manage your game day responsibilities, from giving motivational talks to making midgame adjustments.

Chapter 5

Overseeing Your Team

*O*ne of the more interesting aspects of coaching a youth volleyball team is that the kids on your team are different from one another in many ways. Without knowing what you're doing, you fill your roster with players of vastly different abilities and characteristics, not to mention wants and needs. How successful you are in helping them enjoy the season depends, in large part, on your ability to evaluate which areas of the game they excel in and which aspects of the game they need help with. In this chapter, we delve into how to evaluate your players, how to choose a lineup, and much more so that you can help your players progress and reap all the benefits that accompany working together as a team.

Sizing Up the Players

Anytime you're in a position of authority that involves managing people — whether you're a CEO on Wall Street or the volleyball coach of a 12-and-under girls' team — you need to understand the strengths and weaknesses of those under your control to have the most success. If you don't have a handle on the attributes of your players, you're setting yourself up for failure and your kids for a less-than-pleasant experience. To maximize your effectiveness and help your players reach their potential, you have to be proficient in the art of evaluating skills. After you have a sense of each youngster's abilities, you can mold your practice plan accordingly and choose the appropriate drills to begin building the skills your team needs to have fun and be successful.

When you step forward to coach a youth volleyball team, you probably don't know what your players' skill levels are or what strengths or weaknesses they have — particularly if this is your first season of coaching. So be prepared to begin evaluating your players the first time you meet them (at your first practice or at tryouts). This section can help you get started. (For information on evaluating players during competitive travel-team tryouts, check out Chapter 19.)

Evaluating skills

The ability to assess a player's strengths and weaknesses properly is an essential coaching skill that helps you determine which areas of his game need additional work and what you can do to help. If you don't know what you're looking for when you're evaluating, you and your team will be at a disadvantage when the season gets rolling. After all, volleyball is a challenging sport to play and requires a wide range of skills — both offensive and defensive.

Evaluating your players is an ongoing process throughout the season; however, it does take on added importance during the first few practices of the season because you have to try to assess the talent levels of the kids you're working with. So put some real effort into the evaluation process, whether you're in the first week or the middle of the season, and then direct your focus to helping your players strengthen the areas of their game that need developing.

If you don't evaluate your players properly, you risk frustrating them. For example, if you misjudge a player's passing ability and grade him lower than what he really is, guess what happens. During your practices, you saddle him with basic passing drills that bore him and deprive him of the chance to improve.

Small-sided scrimmages, which involve reducing the number of kids on the floor, work well for evaluating players' skills. (If your league plays regulation 6-on-6 games, chop your scrimmages down to 3-on-3, for example.) Because the players get to touch the ball a lot in both offensive and defensive roles, you can see how they handle serve receive, setting, passing, attacking, and defending in a short period of time. In full-squad scrimmages, on the other hand, players can play a dozen points or more without having to hit or pass a ball. For the younger players, be sure to set up a smaller playing area when you use small-sided scrimmages so that covering the court isn't too overwhelming for the youngsters.

Don't allow all your attention to focus on those kids who emerge as the team's most talented hitters. Just because a player is proficient in attacking the ball doesn't necessarily mean he's an all-around, well-versed player. You may be able to attribute his hitting ability to a couple of underlying factors: His team-mates are great passers who can always feed him the ball, or he has more strength than some of the other kids, which makes his attacks more difficult to defend. Remember that even if his offensive skills are fairly well developed, he may have defensive deficiencies that need tending to.

Identifying players' strengths and weaknesses

Having an accurate perception of how well your players pass the ball and serve — as well as perform all the other offensive and defensive actions that comprise the game — helps you plan effective practices that benefit all the kids. When you recognize areas of the game that your team doesn't perform quite as well as others, you can attack those areas enthusiastically with specific drills during your practices. For example, if you notice during your evaluations that a majority of the kids have trouble getting their serves over the net and inbounds, you can target that area during your practice sessions.

Even though you want to focus on teaching techniques that the kids are strug-gling to grasp, be careful not to neglect other parts of the game that the team is more capable in. You still need to run drills in your team's strong areas to keep the players sharp and to allow them to become even stronger performing them. (See Chapter 11 for more details on making midseason adjustments to account for your team's improving skills.) Furthermore, don't get so caught up in the offensive fireworks that they occupy all your attention. Make sure you devote equal amounts of time to passing, defense, court coverage, and so on to help your players become well rounded.

Look for the following characteristics in your players when evaluating them.

Constant movement

Volleyball is a game that requires constant motion, regardless of whether your players are trying to score a point on offense or prevent one from being scored on defense. The more active your players' feet are, the more produc-tive and effective your team is likely to be. Flat-footed players who tend to watch the point being played instead of getting involved in the action aren't very effective. Plus, they can be defensive liabilities because they aren't able to react as quickly to shots hit by the opposition.

When evaluating a player's movement, take the following factors into account:

- ✔ Is he involved in all facets of the game? For example, after an attack, does he quickly get back into position to defend, or does he stand still admiring his hit?

- ✔ When he passes the ball to a teammate, does he become a statue immediately afterward, watching to see whether the ball reaches the intended target instead of getting back into position to react to the ball when it comes back across the net?

- ✔ When he isn't directly involved in a point, does he continue to move his feet and follow the play to get himself in position in case he has to act on the next point?

Favorable reaction to the opposition's pressure

How a player responds to what the opposition does makes a big difference in whether he's an effective member of the team or a liability on game day. Watch for these traits:

- ✔ Does he react to where the opposition hits the ball and move into position to play the ball?

- ✔ Does he play under control when the ball comes his way and focus on making an accurate pass to a teammate, or does he panic and lose concentration on where he needs to direct the ball?

Offensive production

At the advanced levels of youth volleyball, players can jump higher and hit the ball harder, among other more advanced skills. Look for these offensive traits in an advanced level player:

- ✔ Does he have the skills to hit a variety of shots when an opponent or two are trying to block him?

- ✔ Can he pass, set, and attack the ball from both the front and backcourt?

- ✔ Is he equally effective making plays on the ball when it's hit right to him as when he's forced to move several steps for it?

- ✔ Are his sets difficult for the opposition to read where they're going? Does he know how to mix his shots up so that they're tough to defend?

- ✔ Can he hit a variety of different serves and put them all over the net so the opposition never knows where they're headed?

Defensive determination

Sure, most young volleyball players take much greater enjoyment from playing offense than defense, but one of the best indicators of a well-rounded volleyball player is his ability to excel on both sides of the net. A one-dimensional player who's good at attacking — but not very effective at defending a player who's hitting — is a liability that weakens the team's defensive strength. At the advanced levels of play, teams spot these little chinks in the armor and pounce on them. Continually work to make your players tenacious defenders who make generating points a difficult task for the opposition to accomplish. (Turn to Chapter 9 for the rundown on defensive fundamentals.) Keep an eye out for these traits:

✔ Does he approach his defensive responsibilities with the same zeal that he does his offensive ones?

✔ Does he enjoy blocking an opponent's attack as much as or more than delivering one himself?

✔ Is he willing to dive on the floor to keep a ball alive for his teammates?

Mental strength

A player's mindset when he steps on the court is important. At the older and more advanced levels of play, kids can have a positive or negative influence on the game depending on their mental strength. Look for these traits:

✔ Does he give you his best effort every time he's on the floor, regardless of the score? Kids who give 100 percent when their team is winning by a large margin, or losing by a lot, are strong competitors that can swing the balance of a match in your team's favor simply because they refuse to give up — ever.

✔ When he serves into the net or fails to block the opposition's attack, does he drop his head in frustration, pout, or allow that point to dictate his mood for the remainder of the match?

✔ Is he receptive to your feedback when he performs a skill incorrectly? If a player isn't open to your suggestions on how to do something differently, his development stagnates.

Positive team-oriented attitude

What type of teammate a child is speaks volumes about what type of player he is. Players who are positive can push their teammates to greater levels of play, while those who are negative can destroy team chemistry and create all sorts of problems. Look for these traits:

- ✔ Is he a constant source of positive energy, regardless of the score?

- ✔ When the team isn't playing as well as it had hoped, or is facing a superior opponent, do your player's shoulders slouch, or does he pump his teammates up with words of encouragement?

- ✔ When he isn't in the game, is he a source of positive encouragement for his teammates from the bench?

Choosing a Starting Lineup

As a youth volleyball coach, one of your most prominent responsibilities is determining who fills which positions on game day. At the beginning levels of the sport, positioning players isn't terribly important because your main goal is introducing the kids to volleyball and its most basic components. At more advanced levels of play, choosing positions takes on more urgency because fitting kids into the right positions affects how the team performs. This section assists you in putting together your lineup for your match.

Never typecast players based on their physical appearance. Often coaches are guilty of putting the taller players into specialized roles where they only play the front row and relegating the shortest players to positions where they predominantly set and pass. A child who gets pushed into one position early may never fully enjoy the experience of playing volleyball. You may have a wonderfully skilled player just waiting to emerge, but if you don't give him the chance to play different positions and use a variety of skills, he'll never know how successful he could've been, and he may miss out on a rewarding, enriching experience.

Assigning positions

At the beginning levels of youth volleyball, your focus must be on teaching all the kids the basic skills of the game and allowing them to experience playing all the positions. Doing so can help develop well-rounded players who have a better understanding of the game and who are more effective on the court playing it, too.

At the more advanced levels of competition, you need to determine the positions that not only fit your players' particular skills but also benefit the team.

When positioning your players, take these factors into account:

✔ The positions you need to fill

✔ The skills needed to play those positions successfully

✔ The responsibilities that come with each position

✔ The types of kids best suited for handling the various positions

When assigning positions, remind each player that you chose him for that position because of his special skills and the ability he demonstrates in practice. As the season progresses, however, you may recognize that a player is better suited for another position. Flip to Chapter 11 for more information on making midseason adjustments to benefit the team.

Any child is capable of playing, enjoying, and excelling at any position on the court. However, when you're dealing with older, more experienced teams, keep the following general characteristics in mind when determining who plays where:

✔ **Setter:** This player runs your team's offense when the ball is on your side of the net. Similar to a point guard in basketball or a quarterback in football, he orchestrates where the ball goes for the attack. Because a lot of the team's success relies on his ability to place the ball accurately to your hitters, he must have good setting skills, be an excellent communicator, and have a good understanding of the game and how opponents are trying to defend what your team is doing. Confidence is a must, too, because without it, setters aren't likely to enjoy much success.

✔ **Front row:** Players at the outside, middle, and right-side hitting positions benefit from excellent jumping skills (see Chapter 3 for more on these positions). The higher they can get off the floor, the easier hitting the ball over or around a block is , and the more likely they are to pound an attack into the court on the opponent's side of the net. Defensively, these players must read where the ball is being set and attempt to block it from being attacked over the net. The *middle hitter,* known as the *middle blocker* on defense, often is in charge of coordinating the team's blocking strategy. So, he must be adept at reading how the point is developing and then at getting his teammates positioned accordingly to defend the attack. More advanced teams rely on him to help block as many balls as possible.

✔ **Back row:** Being able to pass the ball accurately is a prerequisite for excelling in the back row, especially because most serves from the opposing team end up in this area of the court. Digging the ball (a defensive technique players use to keep the ball alive after an attacker hits it) is also key, because opponents often hit their attacks to the area of the court that back row players must defend (see Chapter 9 for more on digging). These players have to possess excellent hand-eye coordination and quick reflexes so they can react to hard hit balls that they must control and direct to their setter to smoothly transition from defense to offense.

✔ **Libero:** Pronounced *lee*-ba-ro or li-*bare*-o, this player wears a different colored jersey and is the one who can enter the game and replace any teammate on the back row as many times as needed and who doesn't count against the team's substitution limits. He is often referred to as the *defensive specialist*. Possessing sound defensive skills is a must for fulfilling this role effectively. Because this player is in and out of the game at the advanced levels, he has to have strong concentration skills and the ability to stay focused on the game so that he's ready to deliver quality play when called upon.

Finding roles for all your players

Regardless of how much time you devote to configuring your lineup and, at the advanced levels, determining who your setters and attackers will be, you're going to have kids who aren't content with where you position them. Use this situation as an opportunity to begin teaching them the essence of teamwork. Point out that for the team to work as a cohesive unit and enjoy success, everyone has to make sacrifices throughout the season. Not everyone can be the setter; some players have to fill other equally important roles.

If you're working with beginning level players, your focus is on simply introducing all the kids to different aspects of the game. So, they should all get the chance to set, attack, block, and pass the ball, among all the other skills.

If you're coaching an older or more advanced level team, one approach you can take to help kids get over the disappointment of not playing the position they wanted is to take a team field trip to a high school or college game in your community. These contests can be outstanding learning experiences for the entire team. Instruct your team to monitor the athletes who play their positions. Having a youngster watch how a player at a more elite level of competition plays the same position gives him a better sense of the position's importance to the overall structure of the team. He may even pick up a few pointers that can enhance your team's productivity the next time he steps on the court.

Coaching All Kinds of Kids

Whether you're coaching a beginning team of 7-year-olds, who know an attack as a hairstyle and not as an offensive technique, or an experienced team of 14-year-olds, who know the pros and cons of playing the 6-2 alignment, you're embarking on a one-of-a-kind adventure when you become a

youth volleyball coach. It's a journey filled with challenges — both to your creativity and patience — and one that puts your ability to communicate with all types of personalities and skill levels to the ultimate test.

The players on your team show up with vastly different athletic talents and emotional characteristics, and their physical development is probably all over the map. How you handle all these different types of kids plays a large role in determining how much fun they have playing for you and whether they want to return next season. In the following sections, we give you a glimpse of some of the many different types of kids you may be coaching, as well as some valuable insight on what you need to do to have positive interactions with them.

The average child

Most of the kids you come in contact with are average, everyday kids. Average children are players who enjoy playing volleyball and being with their friends. They don't usually attract the attention of a college volleyball coach, but they're content to play for you, learn from you, and improve under your guidance and instruction. Through their involvement with you this season, some of these kids develop a real love and passion for the game and continue playing it for years to come. Others discover that volleyball isn't for them and move on to new sports, but if they ever choose to return to volleyball in the future, they are sure to have a handle on the basics — thanks to you. To improve your chances of connecting with these kids, you must make their overall experience fun. You must also do your best to show that you care about them as individuals, regardless of how skilled they are at the sport.

The inattentive child

The younger the child, the shorter his attention span is likely to be, which means you have to compete with all sorts of daily distractions. Thus, you have a greater responsibility to run practices that grab your players' attention and don't let go.

Using fun drills, and being creative in how you use them, keeps the inattentive child's interest and excitement levels high and puts your team on the inside track to a fun and rewarding season. If you spend most of practice talking rather than letting the kids hit balls around the court, you drain their interest, and boredom quickly settles in. (See Chapter 6 for tips on making your practices fun.)

The shy child

Shyness is as common in volleyball as skinned elbows, but it can be one of the easiest issues to handle, as long as you're patient and gradually work to lure the child out of his protective shell. Be aware that pushing too hard and too early in the season to get him to communicate with you or his teammates may scare him enough that he actually pulls back and further isolates himself from the team.

Shy children often work really hard to blend into the background and dodge attention. During practices, they avoid eye contact; they don't ask for help when working on skills; and they quietly move through the various drills, doing everything in their power not to draw attention to themselves.

One way to help shy players is to rotate the kids who lead the stretches at the beginning of practice sessions. Select a shy child along with a couple of other players to lead the warm-up. Doing so helps the shy youngster become more comfortable in front of the team. Because other players are leading with him, he won't feel isolated or gripped with fear that all eyes are on him.

The child who's afraid of getting hurt

Some kids may be afraid of getting hurt during play. Who can blame them? Getting hit in the face with a hard hit ball is about as much fun as getting a shot at the doctor's office.

Kids need to know that assorted bumps and bruises are going to occur from time to time, but they can't let minor injuries chase them away from a sport they otherwise enjoy. Talk to them about skinning a knee on the playground: Although it hurts at the time, it doesn't stop them from playing with their friends. Encourage your players to use the same approach with volleyball. Help them accept the fact that sometimes things happen on the court that result in a little pain or discomfort, but remind them that the pain is usually momentary and that they shouldn't let it detract from their fun. (See Chapter 17 for ways to keep your players healthy and minimize the number of injuries.)

The bully

You may have had the unpleasant experience of dealing with a bully at some point during childhood — unless you were one yourself! Bullies don't just wreak havoc on neighborhood streets or in hallways at school; they can also make life miserable for teammates — especially when the coach is unaware of what's happening. The volleyball court is no place for a bully, and you have to be the one to make sure a bully doesn't rule your team.

Most kids being tormented by a bully don't complain out of fear of making the situation worse. You have to keep a close eye on interactions among your players — not just during practice, but also before and after practice — because bullies wreak the most havoc when adults aren't able to supervise everything that's going on.

If you're having problems with a child who's bullying others, speak with him away from the team, and let him know that he must change his behavior. Let him know that you admire his tenacity on the court, but that he must use it only during the course of play. If the child is making fun of his teammates, remind him that he has to encourage and support them instead to help make the team stronger and to help them perform better.

The ball hog

During your volleyball coaching career, you may come across youngsters whom you call *ball hogs* — you know, the players who go after virtually every ball in sight and who seem to forget that they have five other teammates on the floor who are also part of the game. These players can create real problems for you because their behavior directly affects everyone's enjoyment of the game and infringes on the team's ability to set up its offense and maintain balanced positioning on defense. This type of player can emerge on your team for many reasons, including the following, and you can help this player discard the ball hog mentality by taking the right approach:

✔ **The youngster is unaware.** Quite often, the child isn't aware that he's moving into areas of the court that aren't his to cover to make a play on the ball. The youngster may just be so excited to see the ball coming over the net that he doesn't realize he's jeopardizing the team's setup by leaving his position on the court to go after a ball that is much closer to another teammate. Anytime you notice a player handling a ball that belongs to another teammate during a practice drill, make sure you bring it to the player's attention.

✔ **Mom and Dad encourage the youngster's overaggressiveness.** A challenging scenario occurs when the child receives instructions from his parents at home that conflict with yours. The parents may tell the child that he needs to exert more control during points because he has superior skills that can be used to dominate the game. (For more on dealing with problem parents, head to Chapter 18.) If you suspect that the parents are causing a player's actions, have a quick meeting with them in private and remind them that for their child to get the most out of his experience and to be a contributing member of the team, you need them to support your instructions at home instead of steering him in the opposite direction.

 🖝 **The child has never played volleyball before.** At the younger levels of play, chances are that the child is new to participating in organized team sports or simply unfamiliar with volleyball. Work with him so he recognizes how and why players are responsible for covering specific areas of the court.

To help eliminate the ball-hogging quality in your players — regardless of why the quality emerged in the first place — you can stress communication and teamwork. Work with your players to yell out when they're hitting a ball coming in their direction. A youngster 15 feet away from the ball, who's thinking about leaving his area to go after a ball, will probably think twice about doing so if he hears that his teammate has it under control.

When you're working with a child to help him break his ball-hogging tendencies, be careful not to embarrass him. If you do, you risk handcuffing the youngster because he may react by not going after any ball that isn't hit directly at him. You don't need to discipline a ball hog; you simply need to further explain to him how his play fits into the overall team structure.

The athletically gifted child

The athletically gifted player stands out. His teammates know he's the best player, and all the parents recognize his talents, too. When coaching a youngster who's far superior in skill development, be aware that you have to challenge him in your drills to allow him to enhance his skills, without compromising the rest of the team in the process. This balancing act can be tricky at times because you don't want to isolate the player from his teammates, but you also don't want to bore him with a drill that he's already good at (but that the rest of the team is just learning). Rely on your creativity to concoct clever ways to help both the kids who are just learning a skill and the talented players excel and learn at the same time.

If you're working with the team on attacking against a blocker, and you're serving as the defender in the drill, you can make minor adjustments to ensure that every player benefits, regardless of skill level. For youngsters who are just learning to deal with opposing players in front of them, put your arms up slightly to the side. Doing so gives the players an opening to deliver the attack through and also helps them become comfortable striking the ball even with distracting arms in the way. For more experienced kids, you can easily increase the difficulty of the drill by actually trying to block their hit. Using just a little sprinkle of ingenuity can make a big difference in meeting all the kids' needs with even the most basic of drills.

Falling into the habit of piling the praise on the players who continually put a smile on your face with their skills is easy to do. Keep yourself in check and refrain from going overboard with the superlatives because overdoing it can have adverse effects:

- ✔ Some kids may begin feeling unnecessary pressure, which can inhibit their performance and smother their fun. They may feel that with all the attention you're throwing in their direction, they have to shoulder more of the responsibility for the team's success and failure. If they don't produce a certain number of points, they may feel personally responsible on those days the team comes up short in the scoreboard department.

- ✔ Continually praising the gifted players can also alienate other members of the team, who may begin to feel that the talented players are your favorites. If you allow this alienation to happen, the team may harbor resentment toward you and the talented players, which causes problems with the team spirit and chemistry you're trying to build.

Enjoying coaching talented players is certainly not wrong (but hopefully you derive equal pleasure from working with all the kids, because each one deserves to see that sparkle in your eye or hear the enthusiasm in your voice when you're talking to them or about them). In fact, if these players possess good attitudes and aren't critical or condescending to their teammates, they have the potential to emerge as great team leaders and positive role models. Just remember to maintain a proper perspective and keep in mind that they are just one piece of the team puzzle. The entire roster is counting on you for your help, support, and guidance.

The child who doesn't want to be there

Sometimes children simply don't want to be involved in volleyball. For example, youngsters with low self-esteem tend to avoid participation, even though a positive experience can be the perfect antidote for building them up and helping them feel better about themselves. A child who doesn't want to be there may have written off having fun playing volleyball for any number of reasons.

Talk to the child to find out the reason for his lack of interest. Some reasons may be out of your control, but you can address others and make a difference in that child's experience by providing comfort and restoring some interest in the sport.

The inexperienced child

Some players get a late start in volleyball. All your players except for one may have been playing the sport for several years. With the relatively short amount of contact you have with this inexperienced player this season, helping him get caught up to the skill level of his teammates simply isn't possible unless he's an exceptional athlete. But you can still help him develop basic skills that allow him to have an enjoyable season, as well as become a contributing member of the team.

Try to gauge whether the youngster is uncomfortable knowing that he's lagging in many skills because of his inexperience. If you sense that he is bothered, you may want to work with him one-on-one for a few minutes before or after practices if he's interested. If he can get to practice even 10 minutes early (and if you have time then, too), you can get some quality one-on-one time together to focus on teaching and developing a specific skill to help get him up to speed.

The uncoordinated child

Kids develop their coordination at vastly different rates, so many children are challenged in this area, particularly at the beginning levels of play. Reflect back on your adolescent years for a moment, and you may cringe as you remember how frustrating it was trying to get your arms and legs to work in unison.

Your players are adjusting to their growing bodies, and, as a result, some of the movements required for playing volleyball may seem unnatural to them. Uncoordinated children struggle with some of the most basic volleyball skills; simply hitting an accurate serve or passing the ball to a target area can present challenges for them. Regardless, these kids are trying their best. Be aware that they can become extremely frustrated. Feelings of inadequacy can settle in and further compromise their experience if you don't step up and stop these types of thoughts from creeping into their heads.

Helping a child improve his coordination takes practice and certainly can't happen overnight, but if you stick with it, you can make a positive difference. Here are some points to keep in mind when coaching uncoordinated players:

 ✔ **If you're frustrated, don't show it.** The uncoordinated kids are at a disadvantage because they can't pick up what you're teaching as quickly as their more coordinated teammates can. Make sure that you don't reveal

frustration in your words or body language. Never give uncoordinated players any reason to think that you're disappointed in them. If you do, your players' confidence may plummet.

✔ **Provide continual support.** Players who are struggling with coordination issues may be a bit apprehensive to step on the court on game day, where their ineffectiveness is on full display for everyone at the facility to see. Their fears may revolve around being afraid of struggling with a basic skill, disappointing their teammates during a key point in the match, or embarrassing their parents or themselves with their level of play. When they see their friends performing at a level they believe they can never reach, they can become disenchanted with volleyball and reluctant to continue participating. Be constantly supportive of their efforts because doing so can help combat these feelings of disenchantment.

✔ **Recruit parental help.** Get the parents involved to help get the kids over some of the hurdles of uncoordination. Parents can help an uncoordinated child simply by passing the ball back and forth to him at home for a few minutes a couple of times a week. That way, the child doesn't have to worry about teammates watching him, and those extra few repetitions sprinkled throughout the week — in a stress-free atmosphere — can help push along his development. Just be sure to have the parents emphasize having a good time and don't dwell on how well the child is performing the skill. Also, make sure that parents don't overdo the sessions at home or push the child into performing them if he doesn't want to.

The child with special needs

All kids have a legal right to participate in volleyball, including those who have special needs — which may range from hearing loss and vision impairment to medical conditions, such as diabetes and epilepsy. Youngsters who have physical conditions that restrict the use of their arms or legs also deserve a chance to play.

As a volunteer volleyball coach, you're likely to question your qualifications to work with these kids. But remember — you're a coach, and these kids are looking for your help and guidance just like your other players, so know that you're more than capable of fulfilling this responsibility.

If you have a child with special needs, set aside some time before the first practice of the season to talk to the child's parents about their hopes and expectations for their child's participation. Keep in mind that this season may be the parents' first foray into organized sports, and they may be nervous and apprehensive about having their child participate. Figure out ways that you can include the youngster and make him feel like a valued and contributing member of the team.

If a child has a visual impairment and has difficulty seeing the ball, perhaps playing with a different colored ball, or one that features black and white panels, can make a difference without compromising anyone's enjoyment of the game.

If you're coaching a team of older kids, ask them for their thoughts and ideas. They can be great resources for you, and they may surprise you with their creative suggestions on how to make their teammate part of the action.

Regardless of the age or skill level of your team, having a child with special needs on the squad can be enormously beneficial to your other players. Youngsters get a firsthand lesson in developing compassion, understanding, and patience for their teammates, as well as in accepting everyone's differences.

Visual versus auditory

One thing volleyball coaches discover fairly quickly when they're out on the floor is that what works for teaching one child a skill may backfire miserably with the next. As a coach who has the responsibility of meeting the needs of every child on the court, you must adapt and adjust — quickly. Be aware that some players on your team are more visual-oriented, while others are more auditory-oriented. Basically, some kids grasp what you're teaching better by *seeing* how you perform the drill or technique, while others learn better by *hearing* you explain how to perform it. During your instructions, pay close attention to what works for the kids and what doesn't. If your demonstrations of a particular skill don't seem to be doing the job, focus more of your instruction on the words you're using to explain it. Putting more emphasis on either the visual or the auditory often is enough to help the child understand.

Chapter 6

Running Fun-Filled Practices

*T*o help your young volleyball squad develop skills and learn key techniques of the game, you need to craft practices that the kids want to be a part of. Your practices — if they're fun and productive — are the launching pad for a truly rewarding season.

In this chapter, we spotlight all the ingredients you need to run sessions that challenge, entertain, and motivate players to reach their full potential. Here, you can find out how to pull off a stress-free first practice of the season, maximize your time on the court, help the players who are struggling to pick up skills, and wrap up your practices on a high note.

The Opening Practice: Starting the Season on a Good Note

Whether you're a youth volleyball coach newbie or you've coached a few teams before, the thought of overseeing a group of kids (and being responsible for whether they like and learn the sport) probably has your palms slightly sweaty. Don't fret — all coaches, regardless of their experience, feel a little anxious about the season's first practice. Being a little nervous is only natural because you have a lot at stake when you step on the court to practice for the first time. The first impression you make sets the tone for the entire season and gives your kids a glimpse of what's in store for them. But not to worry — we're here to guide you and help ensure that you're not tossing and turning the night before your first practice of the season.

The following sections explain how to greet your team, introduce players and coaches, and run a quality practice that sends your players the message that they're in for a fun season of volleyball.

Making a great first impression

First impressions — whether they occur during a job interview, first date, or first youth volleyball practice of the season — are really important. In terms of the latter, you want to set a positive tone from the first moment the kids lay eyes on you because doing so lets them know that you want them to have a fun, successful season as much as they do.

Use the following tips to help ensure that your players' first impressions of you are favorable:

- **Beat them to the court.** You need to be the first person at the court to welcome each youngster as she arrives. You can't find a better way to show both the players and their parents that you can't wait to get the season started. If you arrive after many team members have already shown up, you may appear unorganized and too busy to lead your troops to a rewarding season.

- **Help them relax.** Your players bring more than their knee pads to your first practice. Most of them also show up with a few butterflies in their stomachs because playing on an organized volleyball team for the first time, or simply beginning a new season with a new coach and new teammates, can be as stressful for them as it is for you. You can help them feel more comfortable by sharing a friendly smile and warm greeting. Helping the kids relax before they take the court (by telling them that you're looking forward to watching them perform and asking them about their days) and establishing a stress-free atmosphere from the outset can help them erase their nerves and get ready to practice hard and have fun.

- **Get to know your players.** Showing genuine interest in your players is the springboard to establishing the coach-player bonds that can make participating in volleyball special for both your players and you. If time allows, talk briefly to the players as they arrive to find out more about them. Keep the conversations general in nature. Simply asking them how long they've played volleyball, who their coach was last season, or what they like most about playing can shift their attention away from their prepractice nerves. Plus, they recognize and appreciate your sincere efforts to get to know them, and as a result, you all feel more comfortable with one another.

The following sections delve a bit deeper into areas you can focus on to make a good first impression.

Introducing coaches and players

Chances are fairly good that you're not in the witness protection program, so you don't have to keep your identity a secret from your team. Before the action gets underway, take a moment to formally introduce yourself, along with any assistant coaches you have, to the team. (For more on choosing assistants, visit Chapter 4.) During your introductions, share some quick tidbits about yourself, such as the following:

- ✔ **What you want your players to call you:** Let them know whether you want them to call you Coach, Coach Brad, or some off-the-wall nickname you think they may enjoy using.

- ✔ **What coaching experience you have:** If you're coaching an older or more advanced team, your players are interested in your experience as a coach. Kids who have been playing the sport for several years want to know your experience level because your job is to help them reach new levels of play.

- ✔ **Which player is your child:** Let the other players know who your son or daughter is if he or she is on the team.

After introducing yourself and any assistants, ask each child to say her name. You want to go through these introductions fairly quickly so that you don't traumatize the shy ones (for more on working with shy as well as other types of kids, see Chapter 5) or delay the reason why they (and you) showed up — to hit the court.

If your team is fairly large, or if you're someone who struggles to remember people's names, give each youngster a name tag to wear during the first practice or two to help you. Slap a name tag on yourself and your assistant coaches so that the kids know you're all one team. Name tags help the kids learn each other's names more quickly, too.

Focusing on certain skills first

If you're coaching a beginning level volleyball team, many of your kids probably have limited experience with the sport, at best. Some kids may even be venturing into organized sports activity for the first time. Keep the experience levels of your players in mind as you plan your approach for working with them.

Use the first couple of practices to cover the most fundamental skills — serving, receiving the serve, and passing — to establish a solid foundation that you can build on throughout the season *without* overwhelming your players right from the start. Because of the wide range of skills kids need to play the game — we're talking about everything from aligning the body properly for serving to positioning the arm just right for attacking — your best bet is to pick out a couple of basic skills to focus on initially and then build up from there.

Because every point begins with a serve from one team to the other, serving is one of the best skills to start with. Beginning with serving also helps build the kids' confidence because they can work on their serving skills without facing the pressure of reacting to a ball coming at them. When serving, they're in full control, and they can see immediate results when the ball clears the net and lands inside the lines on the other side. Be aware, though, serving can also be one of the more frustrating skills to learn for those kids who lack the strength to hit the ball over the net. So, be prepared to be there when they need assistance or encouragement.

If you're coaching players who have a little more experience, you can use the first few practices of the season to refresh some of the basics. Doing so gives you the opportunity to check out the kids' skills in specific areas, such as setting and passing, and evaluate which areas the team appears strong in and which areas you need to devote more attention to during practice. (For more details on evaluating skills, head to Chapter 5.) In future practices, you can focus on advanced skills, techniques, and strategies to help your players upgrade their levels of play.

Keeping a practice notebook in which you log the skills you devote practice time to and the drills you use is a good habit to get into. Mark notes next to drills your players enjoy and the ones that help the kids improve their techniques so that you can use them again in the future. Also, be sure to note any drills that take too long to set up, aren't fun, or don't help the kids pick up a particular skill so that you remember not to use them in future sessions. For the scoop on some basic drills for beginners, flip to Chapter 10. If you're looking to upgrade your drills for more advanced players, turn to Chapter 12.

Coming to practice prepared

The more prepared you are for your practices, the smoother they run, and the more likely the kids are to pick up what you're teaching them. You should have your practice plan, which includes a list of the drills you want to run and how much time you plan to allot to each activity, ready to go the day before your session. (Check out Chapter 11 for more about putting together a practice plan to account for your team's ever-changing needs.)

In the following sections, we discuss what you need to bring to practice, including balls and a first-aid kit.

Having enough volleyballs

If you show up to practice without enough volleyballs to go around to all the kids, you become as effective as an accountant without a calculator. One of the basic elements of overseeing an effective practice is having enough

balls for all your drills. Some leagues provide coaches with balls to use at their practices, while other programs rely on you to make sure you have enough available. Having an ample supply of balls is especially important when you're doing a passing drill, for example, where you break the kids up into pairs to pass the ball back and forth with their partners. You never want to have kids standing around waiting for a ball because doing so not only wastes valuable time but also limits the amount of learning taking place. Having multiple balls available allows you to keep a drill moving instead of constantly interrupting it to retrieve a ball at the other end of the gym.

To ensure that the team always has an adequate supply of balls, you can make a team rule that says each child must bring a ball to practice. Just remember to have each player put her initials on her ball so that she can take it home after practice. At the younger levels of play, many programs use lighter-weight volleyballs that make various skills easier for the kids to perform and less painful, too. Whatever type of ball you'll use during the matches is the type of ball you want to practice with, so be sure to relay this information to your parents so all the balls used during your practices are the same weight.

Nothing sabotages a practice more quickly than having players who arrive without bringing their proper equipment. During your preseason parents meeting, emphasize what equipment (mouth guards, knee pads, and water bottles, for instance) kids are responsible for bringing to the court. (See Chapter 4 for more on the preseason parents meeting and Chapter 2 for more on the specific equipment your kids need to play volleyball.)

Bringing your first-aid kit

Even though you may never need your first-aid kit, you need to be prepared. After all, kids can twist ankles, skin arms, or suffer any number of other minor injuries while they're playing volleyball with you, and you have to be able to deal with those injuries when they happen. Some leagues issue a first-aid kit to each coach; others make the coach responsible for bringing supplies to the court.

If the league doesn't provide first-aid kits, talk to the program director about the importance of having them; perhaps she can correct the oversight. In the meantime, never conduct a practice or go to a game without your kit. Check out Chapter 17 for a rundown on the items that you need to include in your kit.

Starting and finishing with fun drills

Although every aspect of your practice is important, you can start and end your first few practices with some fun drills that keep the kids interested. If you're coaching a beginning level team, for example, a fun way to start your

practices is to position the kids on one side of the court while you, and a couple of assistants if you have them, take different spots on the other side of the court. Have the kids try to hit the coaches with their serves. ***Hint:*** This drill works much better when you have a lot of volleyballs so the kids don't spend all their time chasing down balls. Of course, you want to start with this drill only if all your players can at least get the ball over the net.

If you're coaching an advanced team, you can pair the players up and give each twosome a ball. Position the players in each pair about 20 feet apart from each other, and have them shuffle down the court while passing the ball back and forth between them. Besides working on their passing skills, this drill helps loosen up your players and gets their hearts pumping so they're ready to participate in practice. You can add a competitive twist by timing the kids to see which pair can go to the end of the court and back in the least amount of time without dropping the ball.

A short yet effective period of stretching and warming up the body is the perfect segue to a fast-moving practice packed with challenging drills and lots of fun. Stretching is extremely important, especially at the more advanced levels of play, in which players are at a greater risk of straining muscles if they don't take the time to prepare their bodies for the rigors of practice. Although stretching is less important at the beginning levels, you should still spend a few minutes before practice loosening the kids up because doing so instills in them a good habit that they're more likely to maintain as they continue with the sport in the coming years. Refer to Chapter 17 for tips on stretching before and after practice.

Devising Fun Practices for the Whole Season

Each time you meet with your team, you have an opportunity to teach your players skills that spur their development. As a youth volleyball coach, you have to prepare practice plans before your sessions and then follow them to have long-term success with the kids on the court. You increase your chances of success when you take the time to map out the skills you want to teach throughout the season, which depends in large part on the ages and abilities of your players, as well as on how many practices you can have during the season. Considering these factors helps you determine which skills you can cover at each practice and roughly how much time you can devote to each one.

As your season gets under way, you have an enormous amount of information to cover with your players — everything from serving and passing to blocking and defending — and you're no doubt tempted to try to cram everything into one short season. Your best bet, however, is to choose some of the most important aspects of volleyball, address those aspects in your practices, and then do your best to bring in some of the other stuff as the season rolls along. Be careful not to unload so much information on the kids that you actually detract from their experience.

The following sections help you map out an effective practice plan for your season to get you started off strong and help you stay on course.

Setting the tone

One important factor that affects whether your practices are fun and success-ful is the tone you set at the beginning. Your tone needs to be one of constant praise, positive reinforcement, encouragement, and an upbeat approach to working on serving, setting, defending, and all the other skills that comprise the game.

Your mood and demeanor largely dictate the tone you set for your players. Think back to your days of playing volleyball, or any other sport you once participated in. Remember those awful days when you showed up for prac-tice, the coach was in a bad mood, and everyone on the team just wanted to be someplace else. That situation certainly didn't set the stage for enthusi-astic learning or fun, so your goal as a coach is to make sure you set a more upbeat, agreeable tone for your season.

To have the most effective practices, you have to show up at the court in a great mood every time — think big smile on your face and light spring in your step — regardless of your life's circumstances away from the court. Your play-ers know when you're in a good mood, and they use your positive vibes as motivation to play and learn from you — and they have a lot of fun doing so.

You're the person the kids look up to, so the more enthusiasm you display, the more they feel, and thus, the better they perform. When you don't bring a lot of energy to the court — either in your words or body language — the kids' enthusiasm deflates as quickly as a balloon does when you stick it with a pin. Always keep in mind that your behavior and words determine whether kids can't wait to take the court for practice or they dread the hour when practice starts. Good attitudes are contagious, so put a lot of effort into spreading yours around for the kids to soak up. If you do, everyone benefits.

Determining practice length and frequency

Most youth volleyball leagues have well-defined policies in place regarding how often and for how long teams can practice. You need to be aware of this league rule before you create practice plans for your team (we discuss knowing your league in Chapter 2). A league policy that dictates how many practices you can hold each week makes your job a little easier because you don't have to decide how many practices to have. If the league doesn't have any policies in place, use your best judgment to devise your team schedule. Many coaches, in their zeal for teaching the kids every offensive and defensive skill imaginable, cram the schedule with numerous practices sandwiched between games.

In your eagerness to teach your players, you have to remember that you probably want to spend more time practicing than the kids do. So ease back because you don't want to overwhelm your players or drain their interest by having too many practices.

We recommend one hour-long practice a week for younger children who usually have only one game a week. As kids get older, you can bump up the schedule to include a couple of practices a week with a single game. Your practices shouldn't go longer than an hour unless you're coaching at the more advanced levels.

Persuading parents to take the court

Your players' parents can be much more than just chauffeurs and cheering spectators. At all levels of play, your players get a kick out of watching their parents try to return their serves or dig their attacks on the court. Getting involved in practice can also be fun for the parents — and allow them to fit in a little exercise on the side, too.

Be sure to let your parents know in advance when you plan to run a practice that includes their participation — if they're interested. Giving them enough notice ensures that they not only show up but arrive in the proper attire because a dad in a suit or a mom in a dress can't participate.

You can get parents involved in practice by including them in the following:

✔ **Scrimmages:** One of the best ways to involve the parents in practice is to hold a scrimmage between the kids and their moms and dads. The kids love seeing their moms jump up to attack the ball or their dads sprawling on the court, trying to return serves. Devoting a midseason session to this scrimmage is a nice way to give the kids a break from the routine practice schedule. You can bet everyone has so much fun that they beg you to hold another one.

You can help build up the excitement for this scrimmage by talking about it during the preceding practice. Be enthusiastic about the match-up so that the players are equally pumped up to have Mom or Dad running around, sweating, and trying to make plays. Check out the "Choosing the right times for scrimmages" sidebar for more info on running scrimmages.

✔ **Special drills:** Another option for involving your players' parents is to have them participate in some special drills. You can do something basic with the younger players, such as pair them up with their parents to see how many passes they can make back and forth. At the more advanced levels of play, you can have players attempt to deliver attacks while Mom or Dad tries to block them. Of course, switch up the drill so that the parents get a chance to attack while the kids assume the defensive role. Both the parents and the players find amusement in seeing who gets to ride home with bragging rights!

Not every parent wants — or is able — to participate in your practices for reasons ranging from job schedules to physical impairments. Remember, though, that involving even a few parents gives your practice the different look you wanted, and the kids get another type of drill to participate in. You can also include parents in aspects of your practice that don't make them break a sweat. For example, if you're running minicontests or scrimmages, you can ask a parent to keep track of the scores. Doing so allows you to focus on the coaching.

Keeping practices consistent

Kids relate well, and perform better, when you structure your practices so that your players know what to expect when they get to the court. Although you don't want to run the same batch of drills every practice, you do want to stick to the same warm-up and stretching routine. Doing so helps the kids know what to do when they first get to practice. After the warm-ups, you can dive into the drills. If you're switching up your stretching routine every practice, you waste valuable minutes explaining the new routines instead of spending the time on passing, setting, and attacking skills.

Performing the same warm-ups and stretches at each practice gives kids a nice routine that they can settle into every time they step on the court. (See Chapter 17 for more information on stretching and warming up.) Because you change your drills from week to week, and because you work on different aspects of the game each practice, you can help kids focus better so that they can give you their best effort by maintaining a nice order at the outset. Although many of your drills do change, you want to keep a few drills that focus on the fundamentals and use them every week to help the kids get a handle on the basic elements of the game.

Choosing the right times for scrimmages

Scrimmages give kids the chance to experience gamelike situations during practice. Occasionally spending a few minutes at the end of practice on a scrimmage allows the youngsters a chance to perform the skills they've been working on throughout the session in a gamelike setting. Here are some other tips to consider when running scrimmages:

✔ **Run miniscrimmages.** Instead of conducting one full-scale scrimmage with six players on each side of the court, play two 3-on-3 games on separate courts if your facility has the space. If you have younger players, simply split the court in half so they have less territory to cover. Doing so enables all the kids to experience more action — they get to serve more, pass in serve receive more, and make more defensive and free ball passes, for example. The extra practice each player gets pays off when game day rolls around.

✔ **Change the rules around.** By making some minor tweaks to the basic rules of volleyball, or even some major adjustments, you can — dare we say — bump up the energy and excitement of the scrimmage. Plus, by tweaking the game, you can focus on specific skills you want to target. For example, if the team struggles to pass the ball, implement a rule in which all players on one team must touch the ball once before they send it across the net. By changing the basic rule that a team can touch the ball only three times, you add a creative twist that gives the kids valuable practice passing the ball to teammates. With just a little imagination, you can come up with countless ways to help your team learn and improve — and have a little fun.

At the more advanced levels of play, solicit input from your players on other scrimmage ideas. Their experience playing the game through the years, combined with their own creativity, can result in some new and effective scrimmage ideas.

Scrimmages can be a useful practice tool, as long as you use them in moderation. Be careful not to use them too often during your practices because scrimmages take away from the individual teaching and instruction you can provide by working one-on-one with the kids during drills.

Using practice time efficiently

Every time you take the court for practice, you have to focus on making sure that all the players — and we stress *all* — benefit from their time with you. Although this task can be challenging, we know you're up to it! You probably have a mix of kids, each one having different skills and different levels of development. Be confident in your abilities and know that you're qualified to give your whole team a good experience in practice. Remember that you get a real sense of satisfaction from making your practices fun and effective for all your players.

The following pointers can help you use your practice time efficiently:

- ✔ **Don't allow loitering.** Do whatever you can to make standing-around time at your practices nonexistent because the moment kids stop being actively involved in practice, their learning stops, too. When their learning stops, they can't improve their skills or prepare for game day. Your players show up to pass, set, and attack the ball — not stand in line waiting for a few seconds of action followed by ten minutes of standing, watching, and waiting. After all, your players come to *practice,* right?

- ✔ **Split up the drills.** If you have assistant coaches or parent volunteers, you can run a couple of different drills in different areas of the court at the same time. (For tips on choosing assistants, check out Chapter 4.) Running multiple drills lets children get in more repetitions, which is especially helpful when you have a large group of kids to work with. If you're running the team solo, try to focus on specific drills that the kids can work on in small groups. This small group setup gives them more offensive ball touches or more opportunities to defend, depending on which skill the drill targets. You can also use players to toss balls, if the drill requires it, to keep everyone involved and the drill moving along.

- ✔ **Maintain a good pace.** Avoid lengthy pauses between drills because they sabotage the high energy level and enthusiasm you want to maintain through constant motion during the whole practice. (Just be sure to mix in the appropriate number of water breaks, which we cover in Chapter 17.) Maintaining constant motion has some great team benefits, including holding the kids' attention and enhancing their conditioning. At the more advanced levels of play, conditioning is an important facet of the game. Players who are capable of performing as effectively at the start of the match as they are an hour later are difficult to go up against.

Making Practice As Productive As Possible for All Players

Sure, planning practices in advance and coming armed with a variety of drills are important. Keep in mind, though, that how you run the session and interact with the kids defines how productive their time spent with you really is. A practice that builds skills, features positive words of encouragement, and helps the kids who are struggling can be the launching pad for a rewarding and productive season. This section takes a look at these key areas of a successful practice.

Building basic skills

Coaching youth volleyball requires you to work your way along a logical path that focuses on basic skills. As your team progresses in one skill, you build from there and incorporate other aspects of the game into your practices. Gradually, your players come to learn many different skills. They're able to reap the benefits of their new knowledge because they can fully enjoy every aspect of the game — without being overwhelmed with learning all the skills at once.

Showing a youngster how to hit a jump serve makes little sense when you haven't yet covered the underhand serve — the most basic of skills. Likewise, devoting 50 minutes of an hour-long practice to setting the ball and only 5 minutes to passing the ball makes little sense. The best practices allow kids to gain valuable experience by performing a variety of skills.

View every practice you conduct as a building block in your team's development. Every time your team takes the floor, do a quick refresher drill to reinforce what you've taught so far; then, if the players are ready to move forward, add new skills to the ones they've already mastered. This plan takes concentrated effort on your part — you have to refrain from jumping too far ahead of your players' skill levels.

For example, if your players have been working on passing the ball while standing in one place in your previous practices and you think they have a fairly good grasp of the skill, you can spend a couple of minutes at your next practice refreshing that skill. Then, to continue their learning, you can advance to the next level — by introducing how to pass when you're moving or finding out how many balls the team can pass to the target area in a certain amount of time. The *target area* on a volleyball court most often refers to that area just right of center that is 2 to 3 feet back from the net where the setter is positioned.

Evaluating your team and adjusting to your players' needs allows you to teach the fundamentals in the right order and build on each skill as you progress through your practices. (Chapter 11 covers the art of evaluating your team and making midseason adjustments based on how your players are progressing.)

Providing help for those in need

No matter how good you are at teaching new skills and encouraging your players, you're bound to encounter some players who struggle to pick up various parts of the game. Don't worry — all volleyball coaches at all levels have to deal with this issue at some point. Because volleyball is such a unique

sport that requires a diverse set of skills, many players experience difficulties from time to time. You have to be able to identify the players who need help and the skills that need improvement, and then you have to address them. Doing so can be challenging but also very rewarding. As you help your players work through their struggles and see all their hard work pay off when they finally catch on, you discover what coaching is all about.

Whenever a child struggles to learn a particular skill — for example, if her serves keep hitting the net or all her passes go to the left — you first have to acknowledge that the player is making efforts to improve her technique. Let her know that her commitment to getting better will pay off. Mastering the skill may take some time, but by encouraging and motivating her every step of the way, you can help her see gradual improvement.

When you're working with kids who struggle to catch on to a particular skill, keep these other tips in mind:

- ✔ **Reevaluate your approach to teaching the skill.** Sometimes the youngster isn't the reason she's struggling to get her sets right — occasionally, the reason is you! Be aware that at times you may need to modify how you teach the skill. Even when you're not doing anything wrong, seeing the skill from a different approach may be all your player needs to catch on. So, see whether diagramming the play on your clipboard before demonstrating it helps your players better understand the play.

- ✔ **Emphasize a different aspect of your instructions.** Sometimes a minor alteration of your instructions helps the child because she sees the material in a slightly different way. For example, if a youngster's sets are straying off their mark and you've been focusing on her hand position and follow-through with little luck, shift the attention to her footwork. Talk to her about body positioning. Show her how to set up her feet to deliver the ball, and watch what happens. Often, she shifts her attention to her feet, and gradually everything falls into place because she stopped worrying about her hand position.

- ✔ **Focus on smaller parts of the skill.** Instead of overwhelming the child with a litany of instructions on one skill, break the skill down into smaller pieces. For example, you can teach a child how to attack the ball by focusing separately on each of the different parts of that skill, including footwork, body position, and arm swing.

 Begin by focusing on how the player should approach the ball and where her feet need to be when she jumps into the air. Have her go through several repetitions of approaching the net and jumping up without even making contact with a ball. This method puts all her attention on getting that footwork down. After she's comfortable with her approach, progress to the next component of the skill. Gradually, the child pieces everything together and becomes effective in performing that skill.

Anytime you devote a little extra time to a particular player, don't let practice stop for the rest of the team. If you have assistant coaches helping you, make sure they keep drills going so that the other players aren't just standing around. If you don't have any help, start a drill that the kids know well, one that doesn't require any instructions; then spend a few moments with the child who's struggling.

✔ **Turn to a new drill.** The adjustment may be as simple as ditching the drill you're using and going with a different one.

You find more success with your players when they enjoy playing for you, and you can add to their enjoyment by remaining positive and upbeat throughout the learning process. Your instructions are more effective when you say something like, "Kayla, you did a great job of approaching the ball and keeping your eyes focused on it as you jumped up into the air. Just remember to follow through after contacting the ball to make it go where you want it to," rather than a comment drenched in negativity, such as "Evan, you didn't follow through again, and that's why the ball landed out of bounds." Kids need to know when they're making progress, even when that progress is small, so make sure you compliment your players on the slightest improvements. If you fail to acknowledge their progress, they're likely to become frustrated with themselves, you, and maybe even volleyball.

Although telling a player who's struggling with her overhand serve to watch how another player on the team performs it may seem like a good idea, it's not. The struggling youngster's confidence is already wavering, and she may think your comment means that she isn't as good as her teammate.

Piling on the praise for effort

Everyone enjoys a pat on the back for a job well done, and your young volleyball players are certainly no different. Receiving words of praise or a high-five for an effective attack or block, for example, can really motivate your players to continue learning and doing their best.

Following are a few ideas on giving positive feedback to your players:

✔ **Begin building confidence during the warm-up.** Your stretching and warm-up period is a great time to begin pumping your players up. While you oversee the warm-up exercises, mention to a youngster that you're really impressed with how accurately she has been setting the ball lately. Comments like this one build up a child's confidence and set the tone for a productive practice session.

✔ **Be creative with your praise.** Your players like to hear praise that goes beyond the routine "way to go" phrases that many coaches rely on. You can set yourself apart from the ordinary coach — and have a lot of fun in the process — by being creative with your praise. Instead of giving an ordinary high-five to a player for a great pass, for example, try jumping in the air before slapping her hands, or devise some other combination of actions that grabs the kids' interest. The more interesting ways you come up with to acknowledge performance and effort, the more likely the kids are to play even harder to receive it.

✔ **Bench any negative talk.** The volleyball court is a fun place to be, so don't allow any negativity to creep into that environment. Make all of your interactions positive and uplifting in nature. If you use a disappointed tone of voice or reveal frustration through your body language, you risk jeopardizing a child's ability to react naturally to situations. Because of the fast-paced nature of volleyball, a player's performance drops dramatically when she overthinks plays because she's afraid of upsetting you with a mistake. Keep your words and gestures positive, and as a result, players will develop more quickly because they know they're free to play the game, make mistakes, and learn from them — without facing unwanted criticism from you.

✔ **Be specific.** When you're recognizing good plays, general comments like "That's good" or "That's the way to do it" are okay, but you can get more response from your players by zeroing in on exactly what you're applauding. For example, when a player has just hit a really good overhand serve, say something like, "You did a great job extending your arm fully and following through toward your intended target." This specific comment registers better with the child, and as a result, she can reflect on your words during future serving attempts. Doing so helps her raise her effectiveness in serving.

✔ **Use the sandwich method.** This tip has nothing to do with the pregame or postgame meal (for more on eating habits, head to Chapter 17). Instead, the sandwich method is an effective way to correct your players' mistakes without discouraging your team. Simply surround your corrective comment on a skill a child is performing incorrectly with a pair of positive remarks. For example, if a player jumps too soon while attacking the ball and the ball ends up hitting the net, you can say, "Jodie, your feet and body positions were perfect prior to the shot, but you didn't keep your eyes on the setter and, as a result, jumped a little early, which is why your shot hit the net. It would've been a great shot, too, because your arm was in exactly the right position before you made contact with the ball." Delivering your message in this way, especially to a youngster whose confidence has sunk low, works well because she receives important feedback on a skill she isn't performing the right way, as well as a confidence boost from your words that focus on what she did do well.

✔ **Interrupt practice.** As a coach, practice interruptions — such as a player arriving 20 minutes late — can be real distractions to what you're trying to accomplish on the court. But interruptions are okay when you use them to highlight a job well done. In the span of just ten seconds, you can halt practice to applaud a play. Think about the pride you can give your players by singling them out for their hard work and stellar execution of plays.

✔ **Be reasonable.** Of course you want to praise your players for improving their skills or for working hard. Just make sure your praise is within reason. Praising kids without any merit whatsoever takes away some of your credibility with the team. If a player isn't hustling at full speed to go after a ball in the air and you applaud him for his effort anyway, you send a bad message to the rest of your team and that player. Showing your players that giving 100 percent effort isn't important to you can lead your players to develop some bad habits. Plus, kids at the more advanced levels of play recognize what you're doing and, as a result, begin tuning you out.

Make a goal to praise every child on the team during every practice. Doing so is much easier than you may think. You can praise anything from the way she hustles going after a shot — whether she gets to it or not doesn't matter — to the positive attitude she displays during a drill. You can make sure you distribute your praise equally by carrying a roster in your practice planner and making a mark next to a player's name when you make a positive remark about her. Doing so helps you make sure you cover all the kids.

Ending on a Positive Note

Starting your practices on a positive note is critical, and ending them the same way is equally important. How you choose to wrap up your practices has a big impact on what the kids' mindsets will be the next time you gather them for a practice or game. Look for smiles on the kids' faces as they exit the court; if you see quite a few smiles, you know you've ended the session on a high note, which carries over to the next time you see them.

The good news is that we have some tips to share with you for achieving this goal at every practice. If you want to finish your practices on a strong note, consider the following suggestions:

✔ **Use a popular drill.** Go with one of your most popular drills or scrimmage formats at the end of practice. Doing so serves the dual purpose of giving the kids something fun to look forward to at the end of practice and sending them home on a high note.

✔ **Wrap the session up quickly.** Use just a moment to thank the kids for their hard work and effort. Don't make any long-winded speeches because doing so closes your practice with a thud. Keep your closing remarks general and focused on the entire team. Don't recognize individual efforts at this time because if you do, you may alienate the kids you don't recognize.

Never use your chat after practice to go over a drill that didn't go well or to exhibit frustration over how the team performed. Remember that every practice can't go perfectly, but you never want to send your kids home feeling like they disappointed you. Even after practices during which nothing seems to go right — and you can count on having a few days like this — search for something positive (as small as it may be) to highlight. For example, highlight the positive outlook your players maintained even as they struggled with the day's drills.

✔ **Remind them about what comes next.** If you altered any upcoming practice dates, or if the league made any changes to the game day schedule, make sure that all the kids (and their parents) are aware of the changes. If the schedule hasn't changed, a quick reminder of when the next practice or game is never hurts. If you don't have any more practices before the next match, make sure everyone can attend the match so that you can plan your lineup and structure your substitution patterns.

✔ **Send them home.** Thank the team for their hard work, conclude with a team cheer (if you have one), and clear the court.

Chapter 7

Making Game Day Memorable — For the Right Reasons

Game days can be a lot of fun for you and your players. Although one of the most interesting and challenging aspects of volleyball is that your matches are nearly as unpredictable as the stock market, you can make game days more enjoyable for everyone by making the necessary preparations. Coaching a youth volleyball team on game day requires handling all sorts of tasks before the opening serve, during the match, and after the final point.

In this chapter, we go over your game day responsibilities. We discuss meeting with the opposing coach and referee; delivering a motivational pregame speech; helping the kids think positively throughout the match; rotating your players in and out of the game; and sending them home happy, regardless of what the scoreboard reads. Yes, your game days are certainly busy, but this chapter makes sure that none of your responsibilities become too overwhelming.

Tending to Pregame Matters

Your players are anxious to take the court for their match, and you're just as excited to get started, but you have a few important responsibilities to take care of before the match begins. These responsibilities range from inspecting the court to meeting with the opposing coach and the officials. Read on for more details on how to make sure you're prepared to handle these pregame tasks.

Arriving at the court early

Ensuring the safety of your players, as well as those on the opposing team, has to be a top priority for any youth volleyball coach. So before the game, arrive early at the gym and take a moment to inspect the court. Walk around and do the following:

- ✔ **Check the playing area.** Look for wet spots on the floor that need to be cleaned up (someone may have spilled a drink or walked on the court with wet shoes). These wet spots pose injury risks to players who can easily slip on them.

- ✔ **Inspect the net and antennas.** Double-check to make sure all the hard pieces and straps are padded. Some antennas have sharp metal pieces on the bottom, so cover them with tape to avoid potential injuries.

- ✔ **Check the net supports.** Make sure they're secure and padded appropriately so that players are protected if they run into them during the match.

- ✔ **Examine the official's stand.** Verify that it's securely attached and padded so that it doesn't tip over and injure players, or the official, during the match.

Don't rely on the opposing coach or even the referees to handle this court inspection. If you make it a part of your pregame routine every time, you can help the kids on both teams enjoy a fun and safe day of volleyball. Every step you can take — before, during, and after the match — to help ensure the kids' safety is crucial.

Meeting with referees and opposing coaches

Although you're busy getting your players ready for their match, you can't neglect greeting the opposing coach. Always make sure you take a minute to shake hands with him and any of his assistants. Shaking hands with the opposing team sets a good example for the players on both teams, as well as for the parents and other spectators. While you're greeting the coach, find out whether any players on the opposing team have special needs that you and your players need to be aware of or any accommodations that you or your team need to make.

Meeting with the referees who are officiating your match provides another example of good pregame sportsmanship. When introducing yourself to the officials, let them know that you want to be informed if any of your players (or parents) say or do anything inappropriate or unsportsmanlike during the

match. After all, you want to work with the officials — not against them. Even though you have entirely different roles, you're both involved for the same reasons — your love of volleyball and your desire to help children learn and enjoy it. When you make a real effort to work together, the chances of every child enjoying a rewarding experience greatly increase.

During your meeting with the officials, alert them if any child on your team has special needs. Officials can make the proper adjustments when they know this information beforehand. For example, if one of your players has a hearing problem and can't hear the whistle, the official knows to use a hand signal for this child to get his attention to let him know what call has been made.

Submitting your lineup

Before matches begin, coaches submit their lineup to the scorer (see Chapter 3 for more details). The lineup includes the names and uniform numbers of the six starting players in the order in which they serve. Many leagues require that you submit your lineup at least ten minutes before the scheduled starting time of the match, so be sure you're aware of your league's policy.

If you're coaching in a beginning level program, keep track of your lineups throughout the season so that you make sure that all the kids have equal opportunities to start matches on the court. Starting the same group of kids on the bench in every match isn't fair to any of your players.

Holding the Pregame Team Meeting and Warm-up

As a volleyball coach, you want your players focused on doing their best and performing the skills you worked on in practice. A team meeting — even if it consists of just spending a couple of minutes with the kids before they step on the court — helps get everyone in the right frame of mind to focus and work hard. In addition to focusing your players' minds on the game at hand, you also need to get their bodies ready to make all the plays you know they can make. You can prepare their bodies for the game with a pregame warm-up.

In the following sections, we take a look at all the areas you need to cover during your pregame meeting and warm-up to help set the tone for a fun-filled, safe volleyball match for all your players, as well as for yourself.

Pumping kids up

Hopefully, most of your players are excited about taking the court and giving everything they have when the game begins. Sometimes, though, kids require a little push — which you can give through your motivational words of encouragement — to chase down an errant pass or to dive on the floor to go after the opponent's attack. Enter the motivational pregame talk.

Getting the best effort out of all your players every time they take the court can be a real challenge at times, but remember that you're fully capable of handling it. Just keep in mind that your motivational talk needs to pull the players together to work as a team and to want to help one another. Read the following tips to help ensure that your pregame words hit home and produce the effect you're shooting for.

- ✓ **Eliminate distractions.** Your kids' attention spans are short, especially in beginning level programs. Whenever you're speaking to them before a game, you probably have some pretty stiff competition — other kids arriving at the facility, Grandma sitting in the stands with her camera, or the opposition warming up. All these distractions can steal the kids' attention away from you and what you're trying to tell them. So, when conducting your pregame chat, keep in mind that the fewer distractions, the better. Use an empty locker room, side hallway, or side of the bleachers far away from the spectators and the other team to hold your meeting and keep your team's attention on you.

- ✓ **Minimize your words.** Your players don't show up on game day to listen to you talk or to endure lengthy speeches. They come to get in the game and make plays. Keep your pregame talk to a couple of minutes. If you stretch beyond a few minutes, you risk defusing their energy and enthusiasm for the game.

- ✓ **Borrow good material.** Reflect on your own playing days in volleyball (or any other sport you may have participated in growing up) and the pregame talks that probably stick out in your mind from the coaches you played for. Go ahead and borrow the material that hit home with you. Recycle that material for your players, and you'll have the makings of a pregame message that helps get the kids focused and ready for the game. Of course, stay away from those messages that left a bad impression.

- ✓ **Remember your audience.** If your message doesn't fit the age range of your players, you're simply wasting your breath and their time. If you're overseeing a beginning level team, keep your message basic and to the point. If you're dealing with a group of kids who have played the game for several seasons, you can be more in-depth and delve into topics such as the game strategy you want to employ.

✔ **Speak from your heart.** One of the traits of good youth volleyball coaches is being a good communicator. Trust your instincts — you know they're good — and allow your words to flow from the heart. Your passion for the game carries you through and makes a positive impact on your players' pregame state of mind.

✔ **Spotlight your team.** At the beginning levels of play, you don't need to spend time talking about the other team. Keep the focus on your players, especially on their having fun and doing their best. Talk about the skills they've worked on and improved during the past week of practice — such as how the team's serving has made great strides. Pointing out what they've done well provides them the extra boost of confidence they need to perform up to their abilities, and perhaps even beyond them.

At the higher levels of competition, you can certainly spend a little time on the strengths and weaknesses of the opposing team. For example, if you know the team you're facing that day hits really powerful and well-placed serves, you want to remind your players of the importance of communicating with one another as the ball approaches to make sure they've got them covered.

Always be on the lookout for an opportunity to sneak in a positive comment that can stick in your players' minds. The more positive words you put in your players' heads on game day, the fewer negative thoughts or doubts your players have during the match, and thus, the better their performance is.

✔ **Remember that timing is everything.** A comedian's jokes produce silence from the audience if the punch line isn't timed perfectly; your words have a similar impact when they're delivered at the wrong time. You want to chat with your team moments before they take the court for the game, not a half-hour beforehand while they're sliding their knee pads on for the pregame warm-up. You don't want to use your words to pump up the players for a pregame blocking drill; instead, you want your words to help the kids head into the game riding a wave of positive energy.

✔ **Smile — it's contagious.** Address the team with a smile on your face in a calm, relaxed manner. If you display any signs of nervousness, guess what? Your players will take the court uptight and unable to perform up to their normal level of play. Smiling and laughing are great antidotes for calming kids' nerves and allowing them to take the court with a positive frame of mind. The calm nerves and positive frame of mind, in turn, lead to more efficient play on the court.

✔ **Never forget fun.** Be clear that you want the kids to have a good time playing, because if game days aren't fun, what's the point of all the practice? When kids genuinely believe that having fun is important — and,

hopefully, they do because you highlight this point during both your practices and pregame meetings — they play more loosely. They're also probably more effective with their passes, sets, and other skills because they're not afraid of making mistakes or losing games.

✔ **Emphasize sportsmanship.** You want your players to epitomize good sportsmanship at all times, regardless of how the match is turning out. Exemplifying good sportsmanship means respecting the officials, regardless of what calls they make, abiding by the rules of the game, and congratulating the opposing team on a well-played game, regardless of who gets to ride home the winner that day.

✔ **Shout out the team cheer.** Any type of team cheer, even something as basic as "One . . . two . . . three . . . team!" is a great way to conclude your talk and reinforce the fact that everyone needs to work together.

Warming up

Volleyball is a physically demanding sport — after all, players are often sprawled out on the floor, diving for balls to keep their team alive in the point. Plus, with all the short bursts of stopping, starting, and jumping that players perform, mixed with landing on a hard court, injuries are bound to happen. Usually, these injuries are minor in nature and typically involve twisted ankles and scraped-up arms. Although preventing these and other types of injuries is out of your control, you can use a well-structured pregame warm-up to help minimize the chances that they'll occur and decrease the severity of them if they do.

The older the players are on your team, the more susceptible they are to pulling or straining muscles. Pregame warm-ups stretch the kids' muscles, loosen their bodies, and gradually elevate their heart rates — all of which reduce the chance of injury and help the kids perform to the best of their ability during the match. In addition, warm-ups conducted in positive environments can give players confidence, which helps them perform at high levels during the match.

During your practice sessions leading up to game day, spend a few minutes going over your pregame warm-up to help familiarize the kids with the order of stretches and drills. You don't want to waste valuable time before the game organizing players, introducing drills, and giving lengthy instructions on how to perform certain stretches.

Before beginning any stretches, be sure to have the players do some light running in place or a few jumping jacks to get their bodies warmed up. However, you simply want to loosen the kids up for competition, not exert all their energy before the actual game. For a look at some stretches the kids can perform during warm-ups, check out Chapter 17.

Keep the following tips in mind when putting together your pregame warm-up:

- ✔ **Cover the key muscles.** Volleyball players rely on their legs a great deal, so stretches need to cover the hamstrings, calves, and quadriceps. Players also use strong swinging motions with their arms, so make sure you loosen up the shoulders so they can hit those overhand serves and attacks.

- ✔ **Go easy on the drills.** After the kids are stretched out, work them into the drills gradually by having them perform some approach footwork to get their feet moving. Have them move around the court at half speed for several repetitions and work their way up to exerting maximum energy for just a handful of repetitions. If kids go full speed throughout the entire warm-up, they're gasping for breath by the time the match begins, and they don't have enough fuel in their tanks to compete at their highest levels.

- ✔ **Hit all the skills.** Besides getting your players loosened up, you want to get them comfortable performing all the skills that come into play during the match. You don't want your setters taking the court for the game without having executed sets to several different areas of the court during the warm-up. Likewise, you don't want your front row hitters beginning the game without having hit from several different spots on the court.

- ✔ **Keep the kids hydrated.** Make sure the kids have a chance to catch their breath — and consume some water — before the match's action begins. Your players are likely to perform better if they have a couple of minutes to relax and sip some water following the warm-up before taking the court.

You can use your pregame warm-up for more than preparing your players' bodies; you can also use it to help prepare their minds. While your players are stretching, maneuver around the group and provide a little extra encouragement that the kids can take with them onto the court. A pat on the back, a wink, or a general comment about how much you're looking forward to watching them play gives them an extra little shot of confidence that can make a big difference in how they play and how much they enjoy the match. Even general comments directed at the entire team can produce positive results when the game's action heats up.

Coaching a Great Game

Before the referee blows his whistle signaling for the first serve, you have to take care of several tasks, which we discuss in the preceding sections of this chapter. After the match is under way and points are up for grabs,

your responsibilities escalate as all sorts of new challenges come your way. These challenges include motivating players to make sure they give you their best effort (and are excited to do so); rotating players in and out of the game to maintain equal playing time for everyone; communicating plays and, at the more advanced levels of play, signaling for different types of plays; and adjusting the team's strategy during timeouts and in between games to account for how the opponent is positioned. These are just some of the areas you need to focus on during the heat of the action.

The following sections show you what awaits you after the match begins and how you can fulfill all your coaching responsibilities to help your players fully benefit from their participation.

Providing constant motivation

No matter how well your practices go during the week, you never know how your team will perform — or how they will respond to what the opposition does on offense and defense — when they step out on the court for their match. You can't control the match's circumstances, but you can convince your players that continuing to work hard eventually pays off for the team. By being a master motivator, you can make a difference in how your team reacts on game day. Instilling the confidence in them to keep plugging away — regardless of the score or how the match is unfolding — is a great team trait to have and really comes in handy when you're facing highly skilled teams.

A great pregame speech — one that has kids on the edge of their seats and filled with excitement to take the court — is a great way to begin the game. You also need to keep that energetic level of play going all game long, even on those days when your team's blocking is falling apart, its passing is erratic, and its offense isn't producing points. Being a constant source of motivation for the players helps keep them focused and involved in every aspect of the game, which helps keep them performing at higher levels. Keep the following do's and don'ts in mind when trying to motivate your players throughout the game.

Do emphasize that making mistakes is okay

Of course, you'd love for your team to perfectly execute every serve, set, and attack they perform. And, of course, you want to give the scoreboard operator a case of carpal tunnel with all the points he has to punch up on the scoreboard for your team. But volleyball doesn't work like this at the youth level, or even at the Olympic level, for that matter. During the heat of action, players make mistakes, miscues, and poor decisions.

Don't become frustrated or show displeasure to your team, because doing so may take away some of their aggressiveness, as well as the confidence from the players who feel like they let you down. Instead, applaud their efforts and encourage them to execute the offense more effectively the next time the opportunity presents itself.

Do give players decision-making powers

Many coaches have a tendency to tell their players exactly what to do during matches. Even though you may mean well, a coach's constant directions infringe on the players' learning and ability to make quick decisions themselves. Allow kids to make some decisions for themselves so they can get a true understanding for how to play the game. Yes, often they make the wrong decisions that result in points for the other team, but they also learn from their errors. As they gain experience, they grow as a team and make good decisions.

If you spend the entire game telling kids where they need to be on the court and what they have to do when they get their hands on the ball, they become nothing more than robots at your control. Kids need the chance to make their own decisions on how they need to position themselves to deal with how the opposition is setting up its attack.

Don't go instruction crazy

You want to motivate and encourage your players, not annoy them and wear them down with your constant chatter. Giving yourself a case of laryngitis isn't a good sign for the team. Sure, they need to hear your instructions, and you should be in constant communication with them. Just make sure you also allow them to play the game without shouting at them every time they go to deliver a serve or attempt to block an attack.

Sometimes you need to get a player's attention, and raising your voice to make sure you relay your information is okay. Just be sure to convey the instruction in a calm manner, because the louder your voice, the less effective the message may be for a young player.

Don't put on a sideline show

The kids are on the team to have fun playing the game, and the spectators are at the match to enjoy watching their kids or grandkids play volleyball. Make sure that you don't ruin anyone's experience by becoming a sideline distraction. If you're bouncing out of your seat every time your team prepares to set the ball, your players are going to notice. Of course, you don't want to sit in your seat like you would at a movie theater either, because kids do respond favorably to positive energy. Just don't go overboard and allow your actions to become more of a distraction than a help. Make sure you know your league's rules regarding whom — if anyone — is allowed to stand up during points, timeouts, or dead ball situations.

Do keep the feedback positive

The practice environment is much different than the atmosphere that surrounds game day, so expect your players to react differently to your comments at times. Choose your words carefully and keep your comments as positive as possible so that you don't damage your player's psyche. Correcting a youngster who's performing a set the wrong way at practice usually isn't a big deal because he's in a setting that involves his teammates and probably only a few parents hanging around. Yet, telling that child the exact same thing on game day is much different because of all the other sets of eyes and ears in attendance. For some kids, being singled out in front of family members, strangers, and the opposing team can understandably be a traumatic experience.

Offer some instruction, but do it in an upbeat manner. For example, go with something like this: "Susie, remember to extend your arms fully after making contact with the ball just like you did so well in practice this week." By taking this approach, you provide Susie feedback that enhances her play during the game — and also gives her a boost of confidence by pointing out how well she performed the skill earlier in the week.

Do recognize effort

Your players can't control how many of their serves the opposition can't return, or determine how many of the opponent's attacks they can block. The one factor they *can* fully control is how hard they play and hustle when trying to score points — or keep the opponent from scoring them. Applaud your players' work ethic enthusiastically, and reward their hustle with recognition and praise. When you instill this enthusiastic attitude in your entire team, they're more likely to reward you with their best effort.

Players who may not be the strongest servers or the best blockers can still have a significant impact on the game by doing something that doesn't require athletic talent, special skills, or even height — they can hustle. You never want your players to be out-hustled by the opposition, because effort isn't controlled by talent, athleticism, or experience. Sometimes at the higher levels of play, hustling can even be the deciding factor in games in which two teams are evenly matched. Players who give their all on every point are special, and you always need to make room for them on the court and on your roster. Besides being assets during the game, they also benefit their teammates by inspiring them to work harder.

Communicating plays

If you're coaching a beginning level volleyball team, much of your communication during the game probably involves telling players to watch the ball instead of waving at their grandparents in the stands. What you communicate

at the more advanced levels of play is dramatically different and sometimes involves signaling in plays. For example, you may notice that the opponent always positions two blockers to go up against your best hitter. If you have a basic play in your arsenal of plays where your setter uses a back set to get the ball to the front row hitter behind him, you may catch the opponent off balance and create a good scoring opportunity for your team.

Of course, you can't yell out to your setter what you want him to do because then everyone will know what's coming. If you're out of timeouts, you can't call the team over to explain your plays to them, either. So your best option is to have a few basic plays you work on in practice. Label each play with either a number or a word that you can call out to the kids so they know what to do during the game. For example, your back set play can be called *tiger*. Anytime the kids hear you call out *tiger*, they know what play to run.

Whatever method you use to communicate plays, be sure to use it during your practice sessions, too. Just as kids need practice serving and setting, they also need practice learning the code words for plays you want them to run. The purpose of running a play is to create an opportunity to score a point, but if none of your players have a good handle on what play you call, they'll probably just be confused and may even mess up the play.

At the beginning levels of play, children play volleyball to learn the basics of the game and to have fun trying to hit the ball over the net to the other team. You don't need to introduce them to any types of plays because they simply aren't skilled enough to execute them at this level. You want your focus to be on teaching skills and building confidence, which can't happen if you expect them to execute plays that are way above their heads at this stage. At more advanced levels, you can introduce various plays for the kids to learn and use against opponents. Experienced players enjoy the challenge of learning new plays, practicing them during the week, and putting them in action on game day — not to mention seeing their efforts pay off by scoring points.

Making player substitutions

One of the unique aspects of volleyball is that you can constantly rotate your players in and out of games. When making substitutions, try to bring kids out after they do something well rather than when they make a mistake, if possible. Sometimes kids equate failure with the bench, so if you remove a youngster from the game right after he knocks an attack into the net, he may think he lost playing time because of his mistake. This type of thinking is counterproductive and can make your players less effective on the court. Furthermore, some leagues have special rules regarding substitutions, so you have to be familiar with your league's rules. (See Chapter 2 for more information on league rules.)

Being taken out of the game isn't fun for any youngster, because being on the court always beats sitting on the bench. When you rotate your players out of the game, don't ignore them as they take their seats. Pat them on the back or give them high-fives for the effort they're giving to help the team. Kids love those kinds of receptions, which help make exiting the game a little more bearable. Plus, those gestures keep their enthusiasm running high so that they're eager to cheer on their teammates from the bench and excited to continue giving a strong effort when they reenter the match. Most beginning level volleyball programs allow coaches to make unlimited substitutions during games to help ensure that the kids receive equal amounts of playing time. This rule helps your players not feel as though they're stranded on the bench for unbearable amounts of time.

Employing advanced strategy

As you progress in your volleyball coaching, you encounter new challenges as the players become more skilled and experienced. At the older and more advanced levels, your challenges encompass more than just teaching skills; you have to devise strategies for both attacking and defending teams. You can use a variety of different formations to both capitalize on your team's strengths and keep the opponent guessing what your team plans to do next. For information on these more advanced strategies, head to Chapter 15 for offense and Chapter 16 for defense.

During your practices, work with your team on executing a variety of plays that they can eventually become comfortable performing in any type of game situation. Of course, you want to have one or two plays that the kids are really confident in executing, because those plays are the ones you can rely on in the really tight situations when the match is all tied up and you really need a point.

When working on plays with your team during your practices, don't fall into the habit of designing them all for your most talented player to attack the ball. You want to spread the opportunities to score points around. Even if players aren't strong hitters, you can design plays for them by having other players deliver back sets or quick sets to the weaker hitters and then having them attack the ball. Because you use these types of plays to catch the opposition off balance, players who may not be quite as skilled as some of their teammates still have the opportunity to feel the thrill of scoring a point with a kill.

By taking this approach, you begin to build an effective volleyball team. A unit that can score with any player on the court attacking is much more difficult for opposing teams to defend. If teams recognize that your offense comes from certain players, they can adjust accordingly, making your attack less successful.

Working with the Referees

Coaching youth volleyball has several challenging aspects, but one aspect that you may find easier than others to deal with is establishing a positive relationship with the referees. You can create this positive relationship by always showing respect to the men and women who officiate your games (and the teenagers who often referee beginner programs) and by accepting their calls during the game without blinking an eye. This section goes over some tips for making sure you're doing your part to work with — and not against — the referees.

Remembering respect

Anyone who steps forward to referee a youth volleyball match is more than likely doing so because of a love for the sport and a passion for being a part of the players' experience. Just like you, they're not involved for the money. Also like you, they want and deserve total respect from your players and parents for the job they've volunteered to do. You have to set the tone for a good day of volleyball by respecting the referee — and having your players do the same. Show respect toward officials for the job they do, and they often give you the same treatment in return. By working together with the referees, instead of clashing with them over calls, you help create an atmosphere that positively affects the kids and allows them to enjoy their experience on the court.

Don't allow your players to question the referee's calls at anytime during the match, regardless of the circumstances. (For information on how to deal with problems with players who fail to behave the way you expect them to, head to Chapter 18.) Your players have to know that any communication with the referee must come from you or the speaking floor captain. The *floor captain* is the player you choose to represent you and the team. An effective floor captain has a good understanding of the game and all the rules, as well as is a positive leader and constant model of good sportsmanship. (For more information on choosing a floor captain, head to Chapter 3.)

Asking about rules, not judgment

During a volleyball match, the referee makes a wide range of calls on everything from double contacts and lift calls to net fouls and illegal back row attacks. (For a rundown of all the signals referees use to make calls during a match, head to Chapter 3.) Regardless of what call the referee makes, or what

team benefits from the ruling, your job is not to question the referee's judgment. Remind yourself that the referee doesn't ask you why you aren't using a 5-1 alignment or question any other aspect of your coaching, so don't question his judgment, either.

If you have a question about a rule that you may not be clear on, don't hesitate to ask the referee to clarify that rule for you. But if you think the opposing team's player touched the net illegally during the course of play, and the referee made no call, don't waste the kids' time on the court by challenging the referee's ability to oversee the match. Let it go and focus on the next point. Of course, sometimes parents aren't as forgiving, so make sure they're not uttering inappropriate comments from the stands. (For more on dealing with problem parents at games, see Chapter 18.)

If you ask for clarification on a rule during the match and the referee's reply still has you perplexed, don't derail the momentum of the game and force the kids to stand around while you try to get a handle on the situation. Instead, approach the referee after the match in a friendly manner and politely ask whether he has a moment to go into greater detail on that particular rule.

Because of the many rules in place, we recommend that you take some time to review your league's rule book to be prepared. (Check out Chapter 2 for more on the importance of knowing your league's rules.) Even if you're well versed in all the rules of the game, take a glance at your league's rule book anyway — you may discover something you didn't know before. Often, leagues modify certain rules to accommodate the age or skill level of the players who are participating. For example, maybe officials don't whistle for net fouls in a beginning level program to keep the game moving and to ensure that the kids get to play out the entire point instead of stopping just because someone made contact with the net.

Modeling Good Sportsmanship

When two volleyball teams step on the floor to compete in a match, eventually one team wins and one doesn't. Teaching your team how to win and lose with class is the real mark of a quality volleyball coach. Children, regardless of their age or experience level, must understand that they have to leave the court with their heads held high and their manners in check.

Reinforce to your players the importance of always giving their best effort and hustling on every point. If they adopt that mindset and stick to it during every match, then — regardless of the score — they can be proud of their performance and have no reason to be disappointed with the outcome.

Have team chats in which you discuss the importance of playing fairly, abiding by the rules, and behaving gracefully in both victory and defeat. Review the right ways to congratulate a winning team and talk about what's acceptable behavior, and what's not, when you're celebrating a win. The best way to put proper behavior in perspective is to ask your players how they want a team that has just beaten them to behave. Opening the door to these types of discussions helps your players clearly understand what acceptable behavior is and lays the foundation for them to exhibit manners that make you proud.

Winning gracefully

As your season moves along, your volleyball team establishes an identity. Not only will your players be recognized for how they perform on the court, but also for how they behave on it. Displays of poor sportsmanship have no place in any youth volleyball program. Considering all the examples of poor sportsmanship children have access to on television and the Internet, teaching them the art of winning and losing with grace may be one of your most challenging tasks.

Teams work extremely hard for many of the points in a volleyball match. Because of the action-packed nature of the game, emotions run high, and momentum often changes sides several times during the course of a match. You need to show your team how to celebrate good plays without coming across as taunting the opponent. Your players can certainly celebrate winning a point. After all, they've worked hard in practice listening to and following your instructions, and to see all that hard work pay off in a game is rewarding! You don't want to smother their enthusiasm for doing well and taking pride in their performance. What you do want to do, however, is make sure your team shares the excitement and energy among themselves and never directs this energy at the opposition.

For example, when one of your players drives an attack into the court on the opposition's side of the net, he can high-five his teammates, and they can congratulate one another on scoring the point. The celebration crosses into the territory of poor sportsmanship if any of your players purposely look over at the opposition while celebrating to taunt them, or if they make any type of negative comment or gesture to any player on the opposing team.

Sometimes, you find a pretty significant gap between the skills of the players on the opposing team and those of your own team. Being a good sport when these mismatches are in your favor is important. If your team is dominating an opponent that simply doesn't have the talent or skills to compete in passing the ball or in playing good defense to stop your team from racking up points, do everything you can not to embarrass the other team. Embarrassing the other team reflects terribly on you and your team, and that kind of behavior serves no purpose in the development of your players.

Next week your team may go up against a vastly superior opponent, who attacks the ball with speed and accuracy from all over the court, and you don't want that team to demoralize your kids. Recognizing when mismatches are occurring and doing whatever you can to ensure that all the players on both teams have a rewarding experience is one of the most important jobs you have as a volleyball coach.

If you find yourself in a lopsided game, consider some of the following approaches to keeping your team's interest level high and working on a broad range of skills, and avoid humiliating the opponent in the process:

- ✔ **Mix up your playing systems.** If your team normally plays a 5-1 system, a mismatched game in your favor provides an ideal opportunity to work on playing a 4-2, for example. (For the scoop on these systems and what you need to be effective using them, head to Chapter 15.) The kids enjoy experimenting with different approaches, and you may even discover that another system suits your players' skills better than the one you've been relying on most of the season.

- ✔ **Practice different skills.** Encourage your players to focus on areas of their game that they're not quite as comfortable in compared to some others. For example, encourage the kids who usually use quick sets to use more back sets to work on a different aspect of setting. Because the back set is a more difficult one to execute, kids often neglect it on game day. If your players typically use the overhand serve, have them hit topspin and float serves instead. During the games, kids naturally go with what they do well, but remind them that the only way they'll ever get better in these other more challenging areas is by practicing them. Games provide the perfect setting for practice.

- ✔ **Assign your players different responsibilities.** At the advanced levels of play, you typically count on one player to serve as your primary setter. In a mismatched game, you can assign that role to another player on the team. You can then move your setter to a hitting position so he gets the chance to attack. Moving responsibilities around gives kids the chance to experience different roles in the game. Players who can perform a wide variety of skills are real assets to the team and make your unit even stronger. Plus, who knows, you may even notice that your setter is actually stronger at attacking and may be better suited to fill a different role on the team.

- ✔ **Pull your starters off the court.** If you're coaching an advanced level volleyball team, the first move you need to make when the match is out of control is to put your starters on the bench, and give the kids on the bench (the nonstarters) plenty of action. Keeping your best players in the game when the opposition isn't able to contest the majority of the points makes little sense.

Losing with class

Being a good sport following games you win is easy because everyone's in a good mood and spirits are high. Losing with grace is much tougher for kids — and even coaches — but it's an important lesson nonetheless. Of course, you and your players would love to win every time you step on the court. What coach or team wouldn't? In reality, though, you simply can't win every game because even the best coaches and the best teams suffer losses. Handling them in a positive manner is crucial.

As long as your players do their best, and have fun doing it, you can't get upset with losing a match. However, if your players behave as though losing is the worst thing in the world, you have to show your team that they did their best and need to be proud of their performance, not upset about the game's outcome. Crying, throwing things, blaming the officials, swearing, and refusing to shake hands with the opposing team are all examples of behaviors that you simply can't tolerate — ever! (Jump to Chapter 18 to find out more about dealing with some of these behaviors.)

Regardless of what occurs on the court, make a habit of having your players line up and shake hands with the opposing team following the match. This display of good sportsmanship can be difficult for players who just gave their best efforts and came up short. Yet, showing respect for opponents is important for your team's overall development — not only as volleyball players, but as kids, too. Encourage your players to acknowledge a well-played game by the opposition. Remind them to keep everything in perspective; next time, they may be on the winning end.

Many times, you can tell that the opposing coach hasn't spent time talking to his team about being good sports as soon as the ball's in play. So sometimes you may play — and lose to — a team that has no understanding whatsoever of what being a good sport is all about. Regardless of how poorly behaved the opposition is while celebrating its victory, talk to your players about the importance of rising above that type of behavior rather than sinking down to its level. As difficult as losing with class can be —not just for your team but for you, too — always offer a congratulatory handshake or high-five to the other team's kids. Being sincere in the face of adversity or a loss is a great attribute that can serve your players well during their future volleyball experience, as well as in situations they may encounter in everyday life.

Officials play an important role in youth volleyball, too, so have your players seek them out after matches to shake their hands and thank them for overseeing their match. Showing good sportsmanship even to the officials is the classy move to make and a move that teams don't make often enough in youth volleyball programs.

Wrapping Up the Day: Delivering the Postgame Talk

What you say to your team following a game and how you say it has a big impact on the kids because that message resonates in their heads until the next time they step onto the court. Regardless of whether your team won or lost, played great or turned in one of their worst performances, one of your most important responsibilities as their coach is sending the players home feeling good about themselves in some way. Pats on the back, encouraging words, and genuine smiles are well received by kids in any postgame chat, particularly when they've endured a tough day on the court filled with bad passes, mistimed attacks, and ineffective blocks.

When meeting with your team after the game, be sure to keep in mind the following three points.

Zero in on the fun factor

Ensuring that every child has fun every time he steps on the court is one of your top priorities because the child may wonder what the point of showing up is if the experience isn't fun. Be sure to keep a close eye on whether the entire team has an enjoyable experience on game day.

A great way to gauge the fun factor — and this concept is certainly not a new one — is to ask your players. Randomly asking kids whether they've had an enjoyable day on the court provides all the information you need to accurately assess the outing. Hopefully, you get a chorus of enthusiastic responses about how great the whole experience was. If so, probe a little deeper to find out what they enjoyed most about the game. They may have been able to set the ball a lot to their teammates, or perhaps they served their best balls of the season (serves that went unreturned by the opposition). If some kids don't answer quite as enthusiastically as others, try to find out immediately why they didn't have the same amount of fun as their teammates.

Whatever type of information you're able to collect, be sure to put it to good use. Make any necessary adjustments to ensure that those players who had only a so-so time have a more enjoyable experience the next time they put on their knee pads.

Always take the time to solicit feedback, gauge feelings, and uncover answers when you sense that a child didn't derive much satisfaction from the game. Part of being a good volleyball coach is keeping those communication lines

open and reading the kids' body language. Find out whatever information you can to make sure that your players' experience continues to be fun — or returns to being fun — before your next game.

Highlight the positive

Whether the team played its best game of the season or got clobbered, part of your job is pointing out the positives — anything good that stands out — that the team can build on. Pointing out the positives can be as basic as telling your team how well they communicated with one another while receiving the serve, not letting a single serve from the opposition hit the court. By keeping your comments and body language positive and by recognizing some of the aspects of the game that are sometimes lost in the shuffle, you can send kids home feeling good about themselves. One of the many benefits of staying positive is that your players will be eager to return to practice to continue working on their game so they can try to impress you even more.

Never turn to the scoreboard to determine how you feel about your team's performance following a game. How many points your team won or lost by doesn't define how much effort they gave, how much they improved, or how much fun they had playing. Following losses, fight the urge to dwell on the negatives — the ways the kids didn't perform as well as you'd hoped, or as well as they did during practice. If those types of thoughts creep into your mind, you must push them to the side. Your players were out there on the court and know exactly what happened. They certainly don't need a recap of the attacks that sailed out of bounds or the serves that didn't clear the net.

Spotlight good sportsmanship

Your team's ability to set, pass, and attack the ball directly reflects your skills as a teacher and communicator. The same goes for how they behave toward their opponents, the opposing coach, and the officials before, during, and after the game. So be sure to touch on sportsmanship in your postgame chat, and point out any positive behaviors you saw.

Showing your appreciation for good behavior reinforces the importance of displaying good sportsmanship at all times and how much it really does mean to you. If you talk to your team about good sportsmanship at the outset of the season but then fail to recognize it or address the subject at any point during the season, your players are less likely to be good sports. In addition to recognizing the really good athletic performances, make sure you recognize the displays of good sportsmanship that occurred during the match.

Always be on the lookout for examples of good sportsmanship, and make mental notes when they occur during games. One of your players may have said, "Nice serve," to an opposing player who delivered a float serve that was too tough to return. Another player may have said, "Great block," after the opposition blocked an attack. You can even mention displays of good sportsmanship that you witness by the opposing team, which further reinforces how important good sportsmanship is to you. Continually making your players aware of good sportsmanship — and demonstrating that you're constantly watching for it — sends the all-important message that good conduct is as important to you — and should be to them — as making accurate sets, delivering well-placed attacks, and playing strong defense.

Part III
Basic Training: Teaching Volleyball Fundamentals

The 5th Wave By Rich Tennant

©RICHTENNANT

"This next drill is designed to get a little more energy into your attacks. Morgan, what's the name of that boy who broke up with you recently?"

In this part . . .

Here we cover the most enjoyable part of coaching youth volleyball — taking the floor with the kids! In this part, we go through the basic fundamentals — serving, passing, setting, attacking, blocking, and serve receive, just to name a few — that you have to teach your players. We also provide an array of drills that you can turn to during your practices to help accelerate the kids' learning — and their fun.

Chapter 8

Racking Up Points with Offensive Fundamentals

In This Chapter
▶ Coaching first-time players
▶ Introducing basic offensive skills

*A*s a volleyball coach, you must be proficient in many areas — practice planning, game management, and player motivation, just to name a few. Most importantly, you need to have a thorough understanding of the skills of the game and a firm grasp on how to teach them to your team; otherwise, your season will be a major flop.

Don't worry, though — this chapter covers all the key fundamentals of playing offense and the most effective ways to teach these important skills to your team. We cover a variety of serving and attacking techniques, which are the most popular skills according to the kids because they get to take big swings at the ball, as well as several different methods of setting. We also provide a rundown of a couple of the struggles youngsters typically encounter when they're learning these skills. Then we show you how to diagnose the problem and correct the player's improper technique to keep the season headed in the right direction.

Focusing Your Approach for Newbies

When you're trying to teach children volleyball skills, the key is to start with the basics, build the kids' confidence, and gradually advance from there. After players begin picking up on the fundamentals of the game, you can move on to more advanced skills. If you're successful in introducing your kids to the basics first, you plant the important seeds that can lead your players to develop a passion for a sport they can play and enjoy throughout adulthood. However, if you don't take the time to build a solid foundation

for your players, they lose the chance to elevate their games, which often leads to feelings of frustration and maybe even an early exit from the sport — before they have a chance to see what the sport is all about.

Most youth volleyball leagues, particularly at the younger age levels, allot coaches only one or two hours of practice time with their players each week. Because a couple of hours a week isn't much time, be realistic with your expectations. Understand that you can't cram as much into those practices as you may want to, so use your time wisely and plan your practices accordingly. (For more on conducting practices, check out Chapter 6.) If you can give your players a solid introduction to the basic skills — serving, passing, setting, and attacking on offense, and serve receive and playing defense — and put smiles on their faces in the process, you're on your way to a fun-filled season.

When you're coaching first-time volleyball players, you also need to remember to be extremely patient. Beginners are going to struggle to learn the basics. They may not even know how to pass a ball over the net, much less to another member of their team. So, be prepared to work on the same basic skills again and again until your first-timers grasp all the fundamentals they need to advance their games.

Most sports have a unique, and at times, strange-sounding language of their own, and volleyball is no exception. From digging and attacking to passing and setting, you have to explain all the terms and phrases of the game to the kids before you use them in practice; otherwise, your practices and instructions will produce confused looks and a whole lot of frustration. Stick to terms that you already clearly explained to the kids and that you can confidently say everyone on the team understands. (For more on volleyball terminology, check out Chapter 3.)

Mastering the Basics

One of the most exciting aspects of playing volleyball is winning a point with an accurate pass, an on-target set, and a perfectly placed attack. When your players have a good understanding of these basic offensive skills, along with serving, they greatly increase their chances of scoring and, you guessed it, generally have a lot of fun throughout the whole season. As the coach, you can also enjoy watching the team progress in these skills. This section covers all the offensive basics that your players need to master to savor success when the ball is on their side of the net.

At the beginning levels of volleyball, you need to spend time introducing the kids to all the different skills of the game. Don't stick a child with the label of setter or attacker during her first season on the court. Instead, treat all your players to a complete experience; in other words, teach them the basics of all

the skills. Doing so allows your players to have a more enjoyable experience, the kids to develop into more well-rounded players, and your team to become a stronger unit.

Make sure you emphasize to your players the importance of all the skills of the game — not just the ones that receive the most attention at matches. After all, setting and passing are just as critical as attacking because the number of opportunities your team has to hit the crowd-pleasing attacks and to score points decreases dramatically when your team can't perform basic sets and passes.

Serving

Every point begins with a serve, so serving is one of the best skills to start with when coaching your team. The better your players are at delivering serves, the more chances they have to help the team win valuable points.

When preparing to instruct your players on how to serve, you can choose from a variety of types. The best one to start with is the underhand serve. After your players are good at executing the underhand serve, you can move on to some others that may be more difficult for opposing teams to return. The more types of serves your players have in their arsenal, the more problems they pose for defenders because the opposition never knows what type of serve your team will use. This section goes over some different serving techniques. (For details about more advanced serving techniques, such as the jump serve, see Chapter 13.)

Underhand serve

At the beginning levels of volleyball, you need to introduce kids to the *underhand serve* first. The underhand serve involves a few basic movements that many kids can quickly pick up. After your players have a good handle on executing this serve, you can progress to other more complex serving methods, such as the topspin and jump serves, which provide more power and, thus, are more difficult for opposing players to return. In the meantime, work on developing the fundamentals of the underhand serve with your players. The following steps illustrate these fundamentals:

1. **A right-handed server begins with her left foot staggered in front, pointing straight ahead at her target.**

 She angles her back foot slightly, and her toes point to the right (see Figure 8-1).

2. **She holds the ball in the palm of her left hand at waist level.**

3. **She flexes her knees slightly, and she leans forward a little.**

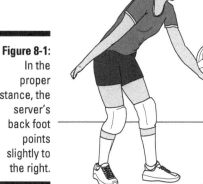

Figure 8-1:
In the proper stance, the server's back foot points slightly to the right.

4. **She holds the ball while moving her serving arm back a little above waist level (see Figure 8-2).**

5. **She steps forward with her front foot while swinging her serving arm through toward the target.**

 She makes contact underneath the ball using the front part of her closed fist. She hits the ball off of her hand much like a golfer hits the ball off of a tee (see Figure 8-3). Using the side of a closed fist results in inconsistent serving.

6. **After contacting the ball, she moves into the court and gets into defensive position.**

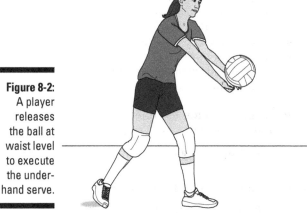

Figure 8-2:
A player releases the ball at waist level to execute the underhand serve.

Figure 8-3: The player makes contact underneath the ball with the front part of her fist.

Overhand serve

After your players can consistently put their underhand serves into play, as well as in the areas of the court they're aiming for, you can start teaching them some overhand serving techniques. *Overhand serves,* which require a lot more practice than underhand serves because they involve more complex techniques, provide many more options for your players — and benefits for your team. Unlike underhand serves, which limit what a player can do tactically, overhand serves allow your players to hit the ball with more force and more spin. Plus, when players can hit overhand serves where they're aiming, they pose more challenges for the opposition. This section explains two different overhand serving techniques, the float serve and the topspin serve.

Float serve

Similar to how butterflies are hard to chase because of their ability to float in different directions and make sudden movements, the *float serve* is difficult to chase because its movements are hard to predict. When a player strikes the float serve correctly, he imparts a knuckle ball action on the ball that makes it float side to side. The float serve is the first type of overhand serve you should introduce to your players to get them comfortable using an overhand motion. To properly execute a float serve, follow these steps:

1. **A right-handed server stands with his left foot slightly in front of his right foot.**

 His weight is on his right foot.

2. **He holds the ball in the palm of his left hand with his elbow slightly bent (see Figure 8-4).**

3. **He extends his right arm and places his palm on top of the ball.**

 When he's ready to serve, he takes his right hand off the ball.

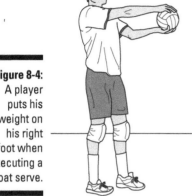

Figure 8-4:
A player puts his weight on his right foot when executing a float serve.

4. **He tosses the ball above his head.**

 The ball should be high enough that he can fully extend his right arm above his head to make contact with it.

5. **He steps forward with his left foot and transfers his weight forward.**

6. **He pulls his serving arm — his right arm in this example — back behind his head with his elbow above the height of his ear and his palm facing forward (see Figure 8-5).**

7. **He locks his right wrist to stay in alignment with his hand.**

8. **He contacts the middle of the ball with the palm of his hand.**

 His fingers are slightly spread apart. As soon as his hand contacts the ball above his head, he stops his arm (see Figure 8-6).

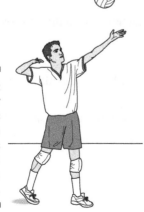

Figure 8-5:
A player moves his serving arm behind his head when hitting the float serve.

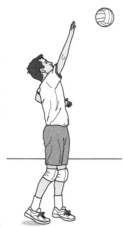

Figure 8-6:
A player
doesn't
follow
through
with the
service
motion
during a
float serve.

Although float serves can help you catch your opponent off guard, you don't want to use them during a match until you know that your players can consistently hit them inbounds. After all, the more consistently your team serves and the more effectively your team places the ball, the more problems you cause for opponents who are trying to return them and set up their offense. But, when your team hits only half of its float serves inbounds, you repeatedly give the opponents opportunities to score points without having to exert any effort.

Topspin serve

The *topspin serve* is a nice one to add to your players' repertoire after they have a good handle on the basic overhand serve because, compared to the float serve, the topspin serve is more powerful and comes at players much quicker, which forces them to make split-second decisions. Plus, the harder the player hits the ball, the more spin he creates, and spin helps drive the ball down toward the floor after it clears the net. The more pressure you can apply on the opposition while you're serving — and the topspin serve applies a lot — the more likely you are to win your share of quick points. Follow these steps to perform the topspin serve:

1. **The player begins with his feet shoulder-width apart.**

 His nonserving-side foot is slightly forward. For a right-handed server, his left foot is a few inches in front of his right foot.

2. **He distributes his weight evenly on both feet and bends his knees slightly.**

3. **He holds the ball in the palm of his left hand at about waist level, and he holds his right hand near his ear with his palm facing toward him (see Figure 8-7).**

Figure 8-7:
The palm of
the player's
serving
hand faces
toward him.

4. **He tosses the ball into the air about 3 feet above his head.**

 The ball should be slightly in front of the player.

5. **He steps forward with his left foot while arching his back (see Figure 8-8).**

6. **He extends his arm fully while rising up on his toes.**

7. **He uses the heel of his hand to make contact just below the center of the ball (see Figure 8-9).**

8. **He uses a downward motion to snap his wrist (see Figure 8-10).**

 His fingertips point toward the floor.

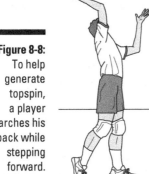

Figure 8-8:
To help
generate
topspin,
a player
arches his
back while
stepping
forward.

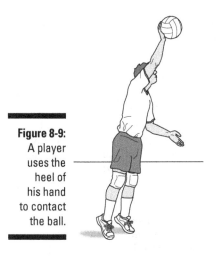

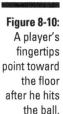

Figure 8-9:
A player uses the heel of his hand to contact the ball.

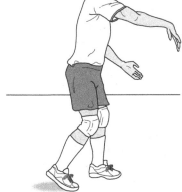

Figure 8-10:
A player's fingertips point toward the floor after he hits the ball.

Correcting serving problems

Picking up all the service techniques that are available can be quite challenging for many kids, so be prepared to help your kids through their serving struggles. The smallest breakdown in fundamentals can result in errant serves — followed by a lot of frustration on the kids' part.

The following are some of the common problems that players encounter when they're learning different serving techniques, as well as what you can do to help your players fix them:

✔ **Can't get the ball over the net with an underhand serve:** This problem has two primary causes, and fortunately for the player — and you — both are fairly easy to correct. First, make sure the player is contacting the ball right out of her hand. If she tries to toss the ball and then hit it, her serve will most likely end up going toward the ceiling instead of over the net. If the player contacts the ball below waist level, the ball will likely go straight into the net line-drive style. Secondly, watch the player's follow-through. If she stops her arm as soon as she contacts the ball, the ball probably won't go over the net. To fix your players' follow-through, have them visualize their arms as pendulums — make sure you explain what a pendulum is first! Doing so helps them better understand the concept of follow-through and, as a result, they will see their serves not only clear the net but also land inside the opponent's side of the court.

✔ **Can't control where the ball goes during underhand serves:** Where the player's hand contacts the ball dictates how much control she has on where it goes. Work with your players to help them consistently hit serves, making sure they're following through to where they want the ball to go, and your team will likely be a more effective unit that doesn't surrender points by netting serves.

✔ **Can't get float serves to float:** Most often you can attribute this problem to what the server fails to do after making contact with the ball. If a child has played other sports — tennis, for example — she naturally wants to follow through with her serving motion, which is a big no-no when you're hitting a float serve. After contacting the ball, the player's hand must come to a stop right away as though she were slapping a wall. Otherwise, she can't generate the unique back-and-forth floating motion that gives the opposition fits.

✔ **Can't clear the net with a float serve:** If your player can't hit a float serve over the net, take a look at the player's feet first. Usually the player forgets to transfer her weight from her back foot to her front foot when she begins the service motion. Also, check out the player's starting position. Sometimes kids start with all their weight on their front feet, which drains a lot of the power they need to get the ball over the net. Other times you can trace the problem to the player's toss. If it's too low or too far out in front of the player, the serve usually winds up in the net.

✔ **Can't contact the center of the ball during float serves:** This problem is usually related to the player's toss. If a player tosses the ball too high or too low, she probably can't make proper contact between the ball and the heel of her hand. Also, a player's toss can't have any spin on it when she releases it from her hand; if it does, the ball may shift when it gets in the air, which often throws off the accuracy of the serve.

✔ **Can't generate topspin:** One of the first problems kids generally face when they learn the topspin serve is not tossing the ball high enough. A good indication that a player's tosses are too low is when her serves

barely cross over the net, which usually happens when the player correctly hits under the ball but doesn't fully extend the arm to get the wrist snap she needs to generate the topspin. No matter how good a player's technique is in all the other areas of this serve, the serve won't be very strong if she doesn't begin with a good, high toss. Remind players that they need to toss the ball at least 3 feet above their heads during the topspin serve.

✔ **Can't hit a topspin serve over the net:** Hitting serves that fail to clear the net and, thus, don't force the opposition to do anything to win a point can smother team momentum — plus it can be a very demoralizing experience for the young server. If a player's serves find the net more often than the opponent's side of the court, pay attention to where her hand contacts the ball. She probably hits the middle of the ball, which is the ideal place for contact in any serve except the topspin one. Move your player's contact spot to lower on the ball, and good results — and plenty more spin — should follow.

Setting

Powerful attacks, in which players slam the ball into the opponent's half of the court, are among the most exciting plays to watch in volleyball. However, before your team can get a big kill, you need someone to set to the hitter. Without the ability to consistently put the ball in proper position to attack, your team will struggle because hitters can't settle into any type of groove when they're always guessing where the ball will end up. This guessing game also greatly detracts from their effectiveness as attackers.

Although many teams rely on only one or two players to handle the bulk of the setting duties, the skill is important enough that all your players need to understand how to set the ball. Teaching this skill to all the kids pays big dividends during the season when a child's ability to set the ball allows your team to create a scoring opportunity out of a broken play.

Basic set

Being a good setter means getting to the ball quickly enough to be able to make an effective play. As soon as the player arrives at the spot where the ball is heading, she follows these steps to execute a basic set:

1. **She raises her hands up quickly.**

2. **She staggers her feet, positioning her right foot slightly in front of her left, and bends her knees (see Figure 8-11).**

3. **She moves her hands above her forehead, which is where she contacts the ball (see Figure 8-12).**

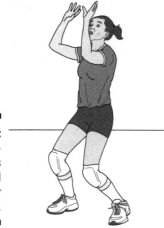

Figure 8-11:
A good setter staggers her feet and bends her knees.

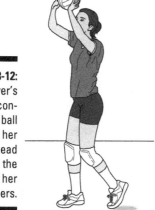

Figure 8-12:
A player's hands contact the ball above her forehead with the pads of her fingers.

4. **She spreads her fingers and rounds her hands to mimic the shape of a volleyball.**

5. **She contacts the ball with the pads of her fingers.**

6. **She pushes up with both hands and fully extends her arms in the direction she's attempting to set the ball (see Figure 8-13).**

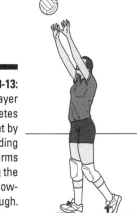

Figure 8-13:
A player completes the set by extending her arms during the follow-through.

Back set

Good setters can set the ball both in front of and behind themselves. The basic set that we describe in the preceding section puts the ball in front of the setter. The *back set,* on the other hand, occurs when a player sets the ball over her head in the direction opposite the one she faces — a technique that often surprises the opposition. The really good setters — the ones who catch the opposition off guard again and again — can disguise their intentions every time they touch the ball.

One of the biggest disadvantages of the back set is how difficult it is for a young player to learn simply because she can't see her target. Another challenge of the back set is that the setter and the attacker have to develop timing with each other without being able to see exactly what's happening. Thus, your young setters will need numerous repetitions before they get a handle on this skill, but after they do, you'll notice a big difference in your team's overall game. To execute the back set, follow these steps:

1. **The player assumes the ready position for a set.**

 She staggers her feet, with her right foot slightly in front of her left foot, and she keeps her feet shoulder-width apart. She flexes her knees.

2. **She raises her arms above her head and makes contact with the ball above her forehead (see Figure 8-14).**

3. **She pushes her hips slightly forward while rising up on the balls of her feet (see Figure 8-15).**

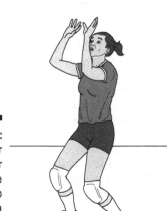

Figure 8-14:
During a back set, a player makes contact with the ball above her forehead.

Figure 8-15:
A player extends her arms above her head to execute a back set.

4. She drives her arms high above and slightly behind her head to deliver the ball in that direction while slightly arching her back (see Figure 8-16).

5. She follows through with her arms above her head while looking straight ahead (see Figure 8-17).

6. Her biceps finish near her ears on the follow-through.

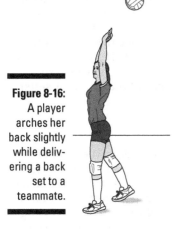

Figure 8-16:
A player arches her back slightly while delivering a back set to a teammate.

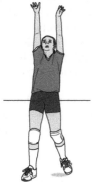

Figure 8-17:
A player doesn't turn her head during a back set to keep the defense off balance.

Setting strategies

Teams can use several different setting strategies to keep the opponent off balance. When opposing teams have a good idea of where the setter is going to put the ball on each play, their job of defending becomes much easier. So the more a setter can mix up the ball placement, the more opportunities to score points the team can enjoy.

At the more advanced levels of play, teams use numbers to identify their different sets. For example, they refer to a set that is 1 foot above the net as a *1,* a set that is 2 feet above the net as a *2,* and so on. Varying the height of sets, along with the location, gives your team a balanced attack that constantly keeps the opposition guessing where the ball will go next. The more guesses you force the opposition to make, the greater your chances of having successful attacks. The following sections describe some of the sets your setter can send to different areas of the court.

Front outside set

The *front outside set* is a basic set that your player puts along the front of the net, near the antenna in front of the setter. (For a diagram of the court, check out Chapter 3.) Your setter places the ball about 3 feet away from the net and varies the height so that the hitter can get into the proper position to attack the ball and not make contact with the net on her follow-through. By setting the ball in this location, setters give attackers a lot of available court space to hit the ball at because they can hit the ball crosscourt or down the line.

High middle set

Many beginning level teams rely on two basic types of sets: the front outside set, which we describe in the preceding section, and the *high middle set.* Both of these sets are good to start young players off with because neither one involves much risk. Many coaches choose to begin with the high middle set because it puts the ball in the middle of the court and doesn't force the setter to judge distance as much as setting the ball to an outside attacker does.

Because you want your players to taste success early in their development to help build their confidence, you want to save the more risky sets, such as the back row set, for the players who are more advanced in their development.

Back row set

Coaches usually reserve the *back row set* for more advanced teams because it requires players to generate an attack from the back row. To execute a back row set, your setter puts the ball anywhere from 6 to 10 feet away from the net. Then your attacker has to time her jump from the back row to attack the ball.

Back outside set

Similar to the outside front set, on the *back outside set* the ball is set behind the setter 3 feet off the net and can be set at varying heights. By delivering a set to the back outside row — again putting the ball about 6 to 10 feet away from the net — you can generate an attack and put pressure on the defense even when the point appears to be lost.

Correcting setting problems

Because setting involves hand-eye coordination and timing and coordinating with a teammate, you can expect some difficulties when your kids are learning this skill. The following are some of the most common problems that appear when players are working on setting and what you can do to help fix them:

- ✓ **Can't get rid of the ball fast enough:** When a ball comes toward a child, her natural reaction is to — you guessed it — catch it! Of course, doing so spells trouble in volleyball because holding the ball is an infraction that quickly brings the point to a halt. (For more on the rules of the game, check out Chapter 3.) Young players often catch the ball with their hands and then toss it back up into the air. To help players work past this habit, remind them that you want their hands to move toward the ball instead of waiting for the ball to drop into them. When their hands are active and moving, they're less likely to let the ball settle in their hands for too long.

- ✓ **Can't contact the ball high enough:** Players have the most control of their sets when they make contact with the ball above their foreheads. As soon as the ball drops below that level, the accuracy of their sets plummets. Players usually fail to contact the ball at that level because they don't get their hands up quickly enough when they move into proper setting position. Reinforce the importance of getting the hands up well before they make a play on the ball. After your players raise their hands, the chances of the ball dropping below forehead level are minimal.

- ✓ **Can't make accurate sets:** When a player's sets don't go where she wants them to go, your team's effectiveness at scoring points can take a nose dive. Most inaccurate sets have one of two causes. First, the player may hit the ball with her palms rather than the pads of her fingertips. When you hear a slapping sound upon contact, you can be fairly sure that the player is letting the ball contact her palms, which eliminates much of her control. Secondly, a player may not remember to follow through, which means that the ball probably doesn't wind up where the player wants it to. Remind players that as soon as the ball touches their fingertips, they must push their hands up in the air and fully extend their arms above their heads.

- ✓ **Can't make good contact with the ball on the back set:** Because players can't see their back sets, many kids often struggle with this technique. So take a deep breath before you introduce this skill, and exercise patience as you work through the technique with your players. One of the main problems players have with back sets is figuring out how to contact the ball in front of them. When players make contact with the ball behind their heads, they lose the element of surprise that makes the back set useful in the first place because by changing their positions, they show the opponent what they're going to do next. To break your players of this

habit, run a basic setting drill in which you toss one ball to them that they have to set in front of them and then a second ball that they must back set. Go back and forth between the two so the players get accustomed to executing both types of sets using the same motion at the beginning of the set. For other setting drills, check out Chapters 10 and 12.

The second main problem players often have with executing back sets is giving into the temptation of peeking to see how their back sets turned out. The moment their eyes leave the ball, they dramatically decrease their chances of making solid contact with it. To correct this problem, stand square to the setter and stress the importance of her looking directly at you while she performs back sets. Get her in the habit of not peeking as soon as she contacts the ball by letting her know how her sets turn out.

Attacking

Not only is attacking the ball one of the most exciting skills in the sport of volleyball, but it's also the skill that draws the most oohs and aahs from spectators. Because of all the mechanics involved, attacking is one of the most complex skills to learn. Players have to learn footwork, body positioning, and rapid arm motion — all of which the player must coordinate for the shot to be successful. Like sets, attacks come in several different forms. We go over these different attacking styles and how to correct problems with them in the following sections.

Basic attack

Along with good footwork, an attack requires a strong jump and the proper technique of swinging the attack arm at the ball. A breakdown in any of these areas likely results in an ineffective attack and a missed scoring opportunity. The following explain how to execute a basic attack:

1. **The player approaches the net at a 45-degree angle.**

 A right-handed player takes a short step with his left foot while swinging his arms slightly forward from his side (see Figure 8-18).

2. **He takes a second step with his right foot that is longer than his initial step.**

3. **He takes his final step with his left foot, which ends up even with his right foot.**

 He transfers his momentum from his heels to the balls of his feet as he prepares to leap into the air. His arms swing backward as he plants his left foot.

4. **He quickly drives his arms up above his head as he jumps.**

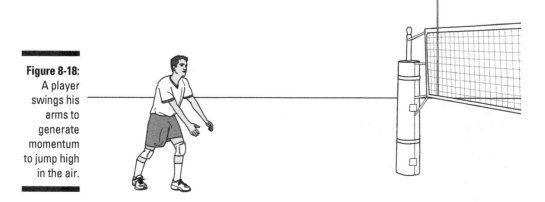

Figure 8-18:
A player swings his arms to generate momentum to jump high in the air.

5. **He bends his hitting arm elbow after both arms are above his head.**

 His elbow is slightly above his ear. The palm of his hitting hand faces up toward the ceiling (see Figure 8-19).

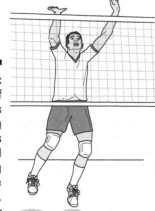

Figure 8-19:
The palm of the player's hitting hand faces toward the ceiling before the attack.

6. **He brings his hitting arm through the ball, contacting it at its highest point.**

 The elbow remains above the shoulder throughout the swing (see Figure 8-20).

7. **He contacts the back of the ball with the palm of his hand while his arm is fully extended.**

8. **He pulls his nonhitting arm down toward the court, which helps create additional power behind the shot.**

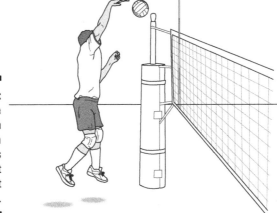

Figure 8-20:
To generate maximum force, a player hits the ball at its highest point.

9. **He snaps his wrist to create topspin on the ball, which helps drive it down into the floor.**

10. **He lands on both feet, which should be shoulder-width apart.**

Tooling the block

Sometimes your attackers don't have any other option than to hit the ball right at the defenders. Don't worry, having to resort to this kind of attack doesn't mean that your chances of winning the point have plummeted like a bad investment on Wall Street. Instead, your players can rely on *tooling the block,* which means hitting the ball off of some part of the opponent's block, to keep the point alive. After your players become proficient in this technique, they can use the opposition's block to their own advantage because a block gives them a target to hit at and to deflect the ball off. Teams that become proficient at hitting balls off the outside of players' arms can really frustrate opponents because a team's chances of winning points go downhill when they can't block attacks.

When a right-handed hitter goes up to tool the block, she relies on the basic attacking techniques we describe in the preceding section while jumping up to meet the ball. When she hits the ball, however, she makes one adjustment: She aims to hit the ball off the outside blocker's outside arm instead of hitting it straight at her intended target (see Figure 8-21). When tooling the block is successful, the ball deflects off the player's arm, which usually makes it difficult for either her or her teammates to get to.

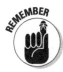

One of the best weapons your team has against the opposition is mixing up their attacks to keep the opposition off balance. You want players to use the tooling the block technique, but you don't want them to overuse it. By mixing this technique in with the other attacks that we cover in this section, you can provide your team with a powerful repertoire of skills to turn to during games. For more advanced modes of attack, head to Chapters 13 and 15.

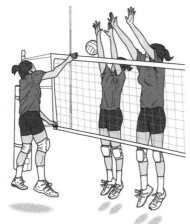

Figure 8-21:
Tooling the block involves aiming for the defender's outside arm.

Tipping over the block

Surprises are fun when they involve birthday parties and marriage proposals, but volleyball teams hate them when they're on defense. Thus, when your team's on offense, implement as many surprises as you can to keep the defense off balance. One technique that tends to surprise defenses is the *tip shot,* which is a soft, one-handed tap that players use to place the ball just over the outstretched arms of the blockers. The secret to an effective tip is not letting the defense know it's coming. To keep your tip a secret, your players have to go up for the ball just like they do during an attack. The only difference is that when the player reaches the ball before a tip, she fully extends her arm and locks her elbow. Instead of swinging at the ball, she uses the tips of her fingers to gently tap the ball over the defenders' hands into what is hopefully an open spot on the court (see Figure 8-22).

Figure 8-22:
Players use the tip shot to catch defenders by surprise.

Correcting attacking problems

Kids love scoring points for their team, so frustration can set in quickly anytime they have problems with their attacks. The following are the most common difficulties players encounter while developing their attacking techniques and what you can do to help fix them:

- ✔ **Can't jump high enough:** The higher a player gets off the ground during an attack, the more effective her attack is. The key to gaining more aerial space is building momentum by taking three steps in succession and driving up with the arms. So, pay close attention to your player's arms if she's having trouble jumping high during her attacks. When her arms aren't an active part of her lift-off — many kids forget to use their arms while jumping — she probably doesn't gain much height on her jumps. Remind your players that the arms and legs must work in unison to produce the results they're looking for.

- ✔ **Can't hit balls over the net:** A player who struggles to get the ball over the net most likely makes contact with the ball after it descends too low, which leads the player to drive the shot into the net instead of forcing the defense to make a difficult dig. Work with your players to strike the ball at the height at which they can fully extend their hitting arms. Hopefully, making that one minor change results in good news for your players — and bad news for the opponent that has to deal with the rocket shots.

- ✔ **Can't control the direction of shots:** If a player is spraying shots all over the court — unintentionally — you can usually trace the problem to the hand and wrist areas. First, make sure the player contacts the ball with the heel of her hand on top of the ball and not on the side of it. If she does hit the top of the ball, move your attention down to the wrist, which is usually to blame. Young players have a tendency to slap at the ball rather than to snap their wrists upon contact. After they master that snapping action, they can deliver their shots with more power and more accuracy — a combination that provides big benefits for your team and a whole lot of trouble for the opposition.

Chapter 9

Developing Defensive Fundamentals

*A*lthough your players may really enjoy serving and attacking, you need to make sure their enthusiasm carries over to the defensive side of the court, too. When game day rolls around, you want a well-rounded team that understands — and takes great pleasure in — playing both offense *and* defense. After all, the more knowledgeable kids are about the game, and the more diverse their skills are, the more they enjoy their participation.

This chapter — to use a defensive term — dives into the defensive fundamentals that your players need to know to handle the opposition's attack. We begin with serve receive, one of the most basic defensive elements, and then move on to the different types of digs, passes, and blocks that players use. We also explain a few of the most common problems players encounter while learning these skills, and we give you some pointers on how to help your players clear these hurdles and become sound defensive players.

Stressing the Importance of Defense

Because of the game's fast-paced nature, players are constantly switching from offensive to defensive mode — often in the blink of an eye. The better your players are at playing defense, the more opportunities they can enjoy both frustrating opponents and scoring points. Conversely, the more struggles your team encounters with the basics of good defensive play, the more your opponents can exploit those weaknesses and score valuable points of their own.

When you approach teaching defensive skills with the same zeal that you do offensive skills, your enthusiasm will spread to your players, and, as a result, they will enjoy a more well-rounded experience. Plus, they'll be more difficult for teams to score against. A few more pointers on how to bump up your team's defensive prowess include the following:

- ✓ **Explain that good defense equals more offensive opportunities.** Every time your players dig or block an attack to keep it in play, they give themselves a chance to set up their own attack. You don't have to have a mathematics degree to understand that the more scoring attempts your team denies — which turn into scoring opportunities for your team — the greater your odds are of winning more points than your opponent. Discuss this concept with your players to emphasize the importance of good defense and its direct effect on developing a more potent offense.

- ✓ **Use the right drills.** Make sure you pack your practices with as many defensive drills as offensive ones. Check out Chapters 10 and 12 for some great drills that can help your players develop the important defensive skills they need to fully enjoy playing the sport.

- ✓ **Recognize good defensive plays.** Applaud your players' defensive efforts and improvements as enthusiastically as you do their attacks and sets. The more passion you show for good defense, the more likely your players are to learn these skills, and the more interested they are in further developing this area of their game — which, of course, leads to a much stronger team overall.

Mastering the Basics of Defense

One of the cool aspects of volleyball is that your team can score points not only through mean attacking skills but also through sound defensive play. With *rally scoring*, the team that wins the volley wins the point, no matter which team served to begin the point. For example, a well-timed block can frustrate the opponent, change the momentum of the game, and — of course — register a point for your squad. Because players often must switch quickly back and forth between offense and defense during a point, you can't afford to focus most of your practice time on teaching the basics of offense. Playing good defense requires a strong commitment from you to devote equal practice time to offensive and defensive skills, as well as a strong commitment from your players to try their best to pick up and build on both kinds of skills.

The younger your players are, or the less experience they have, the less technical your teaching must be. For younger players, you need to focus on the basics of defense. When you have older, more experienced players, however, you can turn to some of the more advanced defensive techniques to help them improve their game. (Turn to Chapters 14 and 16 for information about advanced defensive techniques.) In this section, we explain the basic

techniques your players need to learn to build a solid defensive foundation. Teaching your players these basic skills can help turn your team into a stronger unit overall and help you fulfill one of your essential coaching responsibilities — making sure every player has a sound understanding of all the elements of the game.

Maintaining sound defensive position

Whenever your team is on defense, its primary goal is fairly basic: Keep the ball off the floor. To achieve this goal, your team has to begin with — and maintain — sound defensive positioning. Regardless of how well your players perform the key defensive techniques — such as digging and blocking — they can't be very successful when they're in the wrong positions during points.

You can start your team with a basic defensive position that features three blockers in the front row, who are about an arm's length away from the net, and three defenders in the back row, who form a triangle (see Figure 9-1). The defender who is deepest in the back row is responsible for covering deep balls, and all three players in the back protect the middle of the court area.

Net

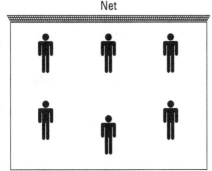

Figure 9-1:
The basic positioning of your players for sound team defense.

Serve receive

Receiving an opponent's serve, called *serve receive,* is one of those skills that has a domino effect on the team. How your players fare dictates, to a large degree, how the point plays out. For example, when your players are proficient at serve receive and can pass the ball to the setter, your offense has a good chance of flourishing. On the other hand, when players struggle with serve receive, they have greater difficulty running their offense and generating scoring opportunities, which means the majority of the scoring opportunities shift to the other side of the net. Players can get into position to serve receive by following these steps:

1. **The player stands with her feet slightly wider than shoulder-width apart so that she has a solid starting base (see Figure 9-2).**

2. **She bends her knees slightly.**

 Doing so provides a good athletic stance that allows players to move quickly in any direction to play the ball.

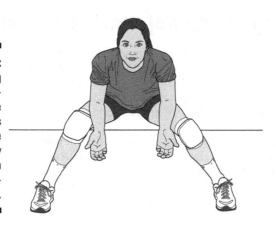

Figure 9-2:
Maintaining a good athletic stance requires having the feet slightly wider than shoulder-width apart.

3. **She looks directly at the server.**

4. **She leans slightly forward with her weight on the balls of her feet.**

 Her back and shoulders form a 45-degree angle to the floor.

5. **She keeps her arms in a relaxed position with her palms facing the server so she can react quickly to any ball.**

Youngsters have a few options for how to return serves. Of course, sometimes the type of serve hit dictates how a player goes about returning it. In this section, we review some of the serve-return options at your players' disposal.

Executing the forearm pass

The *forearm pass* is an important skill to teach your players for a number of reasons. With this pass, the player uses her forearms, with her palms facing up, to direct the ball to a target (another teammate). A breakdown with this pass significantly hampers your team's chances of making a smooth transition from defense to offense. The forearm pass can be a difficult skill for children to master. After all, with balls coming at them at all different speeds and trajectories, they need a lot of repetition to become comfortable both controlling the ball and hitting it in the direction they intend. To execute the forearm pass, follow these steps:

1. **The player moves in the direction of the ball.**

2. **She makes a V with her arms by bringing her hands together (see Figure 9-3).**

The thumbs and heels of her hands touch, and she wraps one hand around the other. Her thumbs point toward the floor. Players should never interlock their fingers because doing so can lead to jammed or broken fingers while executing passes.

Figure 9-3: To make a forearm pass, a player makes a V with her arms.

3. **She locks her elbows and flexes her knees.**

4. **She keeps her arms firm so the ball can bounce off of them (see Figure 9-4).**

Figure 9-4: A player keeps her arms firm while delivering a forearm pass.

5. **She contacts the ball on her forearms, between her elbows and wrists.**

6. **She transfers her weight forward and makes contact with the ball, moving her arms toward the target.**

She keeps her hips below the ball.

Players must learn how to pass the ball from all the different areas of the court because the ball moves in so many directions during a match. To help your kids prepare to pass from these different angles on game day, make sure you give all the kids a chance to deliver passes from all over the court during your practices. You can even run drills that force the kids to hit passes from outside the sidelines and beyond the baseline, too, because kids often have to chase after balls that go well beyond the actual dimensions of the court during games. (For a rundown on some basic passing drills, head to Chapter 10, and for some ideas on more advanced drills, check out Chapter 12.)

Handling a serve with the hands

When your team is in serve receive, you never know what kinds of serves to expect from the opposition. You may encounter an opponent who is adept at serving the ball between players, forcing them to resort to means other than a basic forearm pass to reach the ball. One other option players have is playing the ball with their hands rather than their forearms. Sometimes more advanced players resort to passing with their hands, particularly when the serve isn't hit with a lot of pace, when they want more ball control. To perform this skill, follow these steps:

1. **The player raises her arms above her head and angles them slightly forward.**

 She spreads her fingers wide (see Figure 9-5).

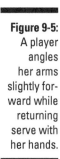

Figure 9-5:
A player angles her arms slightly forward while returning serve with her hands.

2. **She shifts her weight to the balls of her feet.**

3. **She uses the pads of her fingers to contact the ball.**

4. **She pushes the ball toward her target area and finishes with her hands and arms high.**

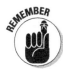

When your players are handling returning serves, it's quite common — and perfectly legal — to make double contact on that first hit. Just keep in mind that your players will hear the official's whistle when they make prolonged contact with the ball. For more on the rules of the game, head to Chapter 3.

Using the run through

Sometimes a player has to run toward a ball at full speed to keep a ball alive during games. Often in these kinds of situations, the player has only enough time to get one arm on the ball. The *run through* is the technique a player uses to stretch out one arm to contact the ball while her momentum from running carries her another step or two past the point of contact. To execute the run through, a player follows these steps:

1. **The player stretches out her arm and keeps it firm while running toward the ball (see Figure 9-6).**

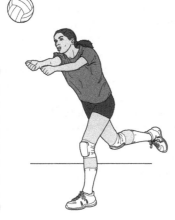

Figure 9-6: A player stretches her arm out and keeps it firm while contacting the ball.

2. **She keeps her head steady and her eyes on the ball.**

3. **She makes contact with the ball with her forearm and pushes the ball toward the target area using her shoulders while allowing her momentum to carry her another step or two past where she made contact with the ball.**

Correcting serve-receive problems

Getting a handle on the fundamentals of serve receive often presents a fair share of problems for youngsters, in large part, because a lot of what the serve receive asks players to do is react quickly and confidently to what the opposition does. This section takes a look at some of those serve-return troubles that often plague players and some solutions you can use to eliminate them:

- **Can't make on-target passes:** This problem can really frustrate players because a pass that strays off target directly impacts the team's ability to generate scoring opportunities. When a player has to scramble to chase an errant pass from a teammate, the advantage for winning the point shifts to the other side of the court. When a player is struggling to make accurate passes, focus on the player's arm position. If he isn't locking his elbows, he isn't giving the ball a level platform to hit, which usually results in an errant pass. Locked elbows, with thumbs parallel to each other and pushing the ball toward the target with the forearms, lead to on-the-mark passes.

- **Can't control hard hit serves:** Younger players typically need a little extra time to adjust to serves that their opponents hit hard right at them. One reason they need more time to adjust is because they're still getting a handle on their coordination. To help these young players get used to hard hit serves, use a beach ball during your practices. Stand a few feet away from your players and throw the ball at them, forcing them to react quickly and return the ball to you. By using a ball that doesn't hurt them, you can help them improve their reaction time. Some players, however, simply can't figure out how to control hard hit serves. Usually these players push their arms forward into the ball during their return, which detracts from the control they have on the ball. Instead, you want them to relax their shoulders to lessen some of the impact on the ball, which gives them more control.

- **Can't stop committing illegal lifts:** Many players are whistled for illegally lifting the ball with their fingertips. When you have a player who repeatedly commits illegal lifts during his serve receives, focus your attention on his footwork because, if he's in proper position, he's more likely to handle the ball legally. When kids are out of position, they tend to grab at the ball, which leads to those illegal lifts.

Passing out of the net

Often during matches your players hit balls that go into the net, but doing so doesn't mean the point's over. Players who have the ability to pass the ball out of the net can extend points. In doing so, they can also frustrate their opponents who thought they'd already recorded a point, as well as inject momentum into their team for keeping the rally going. What makes passing out of the net particularly challenging is that players typically don't have

time to get properly set up and face their target before executing this pass. Follow these steps to pass out of the net:

1. **The player approaches the ball with his knees bent and his arms extended.**

2. **He forms a straight platform with his arms (see Figure 9-7).**

3. **He lowers the shoulder that is furthest away from the net to slightly angle his platform.**

4. **He makes contact with the ball with his forearms and directs the ball back away from the net so his teammates can make a play on it.**

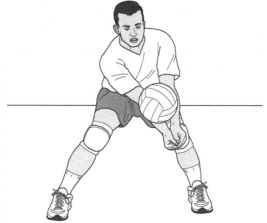

Figure 9-7:
The player angles his arms so the platform can direct the ball away from the net.

Work with your players to help them recognize how the ball typically reacts to the net. For example, balls that hit higher up on the net often drop straight down, while balls that hit lower on the net tend to bounce out.

Blocking

Blocking is an important defensive concept to learn, particularly at the older and more advanced levels of play. The number one goal of any block is to prevent the opponent's attack from clearing the net. A secondary goal — if the attacker manages to get the ball over the net — is to get a hand or hands on it to take some of the speed off the shot so that a teammate can make a play on the ball.

Teams can use single, double, or triple blocks against opponents. One blocker defends an attacker in a single block, while two and three players defend the attacker in the double and triple blocks, respectively. The more players you commit to the block, the less room the attacker has to get the ball through. Of

course, the more players you involve in the block, the fewer players you have to cover the rest of the court if the shot gets through. For details on more complex defensive positioning, check out Chapters 14 and 16.

Because a successful block relies heavily on timing, the skill requires quite a bit of practice on the players' part — and a big dose of patience on your part — to master. The two basic types of blocks are the penetration block and the soft block. In this section, we outline how to execute each one.

Penetration block

Players who are tall enough or who possess the jumping ability to get in the air and reach their hands over the net to disrupt the opponent's attack can use the *penetration block*. Of course, the blocker must avoid touching the net while carrying out the penetration block because contacting the net during play is illegal. Follow these steps to execute a penetration block:

1. **The player assumes the ready position by standing roughly 12 to 18 inches away from the net (see Figure 9-8).**

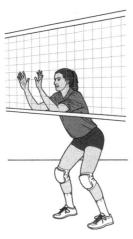

Figure 9-8: The penetration block requires standing no more than 18 inches from the net.

2. **She keeps her feet shoulder-width apart and puts her weight on the balls of her feet.**

3. **She holds her hands slightly above eye level with her palms facing the net.**

 Her elbows are about as high as her shoulders.

4. **She bends her knees to generate force to jump into the air to attempt to block the shot, and she jumps after the attacker commits to going airborne.**

5. **As the player jumps into the air, she fully extends her arms up and over the net without touching it (see Figure 9-9).**

 She keeps her hands about 6 inches apart, with her fingers spread wide and her thumbs pointing toward each other.

6. **She puts both hands across the plane of the net.**

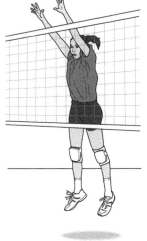

Figure 9-9:
The player reaches over the plane of the net during the penetration block.

7. **She bends her knees slightly to cushion the blow of landing on the floor (see Figure 9-10).**

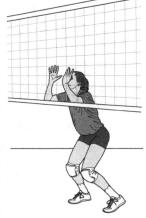

Figure 9-10:
She bends her knees slightly to cushion the impact of landing on the floor.

Soft block

Players who, at this point in their development, probably can't reach their hands over the net to block the ball can use the *soft block*. The soft block technique helps slow down the opponent's shot and creates opportunities for teammates to get their hands on the ball. Follow these steps to execute a soft block:

1. **The player assumes the ready position with her feet shoulder-width apart (see Figure 9-11).**

 Her weight is on the balls of her feet.

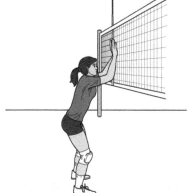

Figure 9-11: The player keeps her knees flexed and her weight on the balls of her feet.

2. **She stands about 12 to 18 inches from the net.**

3. **She keeps her knees slightly flexed and her shoulders forward.**

4. **She keeps her elbows at shoulder height and holds her hands slightly above eye level.**

 Her palms face the net.

5. **When the attacker gets ready to hit the ball, the player jumps into the air, fully extending her arms above her head.**

6. **She tilts her wrists back so that her palms face the ceiling.**

 She spreads her fingers wide and points her thumbs toward each other (see Figure 9-12).

7. **She uses her palms to contact the ball and deflect it up in the air so her teammates can make a play on it.**

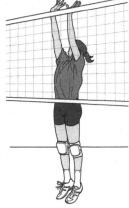

Figure 9-12:
A player tilts her wrists back so her palms face up during a soft block.

Playing the ball after a block

Whenever your blockers get their hands on the ball and slow down the opponent's attack, you don't want to waste that golden opportunity by mishandling the ball near the net. Playing the ball after a block can often be a tricky skill for youngsters to master, but when they execute it correctly, they not only deny a scoring opportunity for the opposition, but also generate one for their team. Stress to your players the importance of watching the ball after a block to see where it drops so that they can position themselves under it — or dive for it if doing so is the only option. Ideally, you want your players to get underneath the ball, crouch down, and pass the ball to a teammate to set up their own attack.

Correcting blocking problems

Players need time to grasp the points of blocking so they can frustrate opponents by denying attacks. Following are a few of the more tricky aspects of blocking that can aggravate players who are trying to improve this area of their game and tips on how you can help them become more comfortable and effective with this skill:

- ✔ **Can't get a hand on blocks:** A good block begins on the ground. When a player isn't in the proper ready position before he makes a block, he probably won't be able to get airborne and make a play on the opponent's shot in time. Although your team probably doesn't think keeping their arms up while following a play is important, you need to teach them to do so anyway. When they keep their arms up and ready, they don't waste valuable time raising them up when an opponent delivers an attack. Active hands are more likely to execute the play, not miss out on it.

- ✔ **Can't stop the ball from going over the net:** Nothing is more frustrating for a blocker than following the play correctly, timing his jump perfectly with the attacker's, getting his hands on the ball, and still having

it slip over the net for a point for the opposition. If a similar situation is frustrating your player, take a look at his hand placement. When a player has his hands above his head, he must spread his fingers out and keep his hands 6 inches apart to execute a successful block. If the gap is bigger than 6 inches, the opponent's shots can go right through his hands, but if the gap is smaller than 6 inches, the shot can easily go around them.

✔ **Can't contact the ball on soft block attempts:** With this problem, the quickest fix is moving the player back a step or two. Playing too close to the net compromises a player's ability to execute the soft block. If moving back slightly doesn't remedy the situation, the problem is probably the player's timing. Kids naturally want to mirror the attacker's jump, but one of the keys to performing a successful soft block is not jumping until the attacker is already airborne and is preparing to hit the ball.

✔ **Can't stop making contact with the net:** One of a blocker's most difficult challenges is getting his hands over the net rather than into or on the net. Make sure your players keep their hands in front of their faces and heads and that they can see them at all times during the block. When players can't see the backs of their hands, the result typically isn't a good one.

Digging

Digging is a skill that any player can become proficient at with a lot of practice because it doesn't require leg or arm strength or special jumping ability. What it does require — besides a firm understanding of the fundamentals — is the heart and willingness to want to deny the opposition an attack. Teams that feature players who dig well not only stop the opposing teams from scoring points with their attacks, but sometimes even shift the game's momentum in their favor. When your players can dig a hard hit ball that appears to be heading to the floor, their confidence increases, their play improves, and, on occasion, the other team's ego deflates as a result of losing what they thought was a sure point. To perform a basic dig, follow these steps:

1. **The player gets in the ready position with his feet a little wider than shoulder-width apart (see Figure 9-13).**

2. **He crouches low to the ground.**

3. **He keeps his hands in front and away from his body.**

 Doing so allows him to move them quickly to either his left or right depending on where the ball ends up.

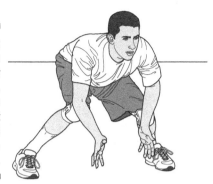

Figure 9-13:
To be in the ready position, a player's feet must be beyond shoulder-width apart.

4. **He puts the heels of his hands together to form a platform, as he does in the forearm pass technique, which we cover in the "Serve Receive" section of this chapter (see Figure 9-14).**

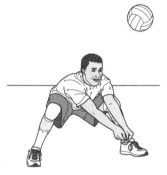

Figure 9-14:
To control a dig, a player moves his wrists together, forming a platform to hit from.

5. **He keeps his arms in close to his body.**

6. **As the ball impacts his forearms, he pulls them back in toward his body to help absorb some of the shot's power (see Figure 9-15).**

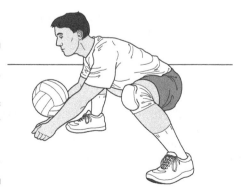

Figure 9-15:
A player absorbs the impact of the shot by pulling his arms toward his body.

When a player performs the dig correctly, he puts some backspin on the ball. This backspin causes the ball to spin toward the player who performed the dig, keeping it on his team's side of the court.

Overhead dig

During games, players may encounter situations in which the ball is coming too high for them to dig it with their forearms. In such situations, players can use the *overhead dig,* which is basically contacting the ball using the pads of the fingers while they're raised above eye level. To perform this dig, follow these steps:

1. **The player raises her arms above and slightly in front of her head.**

2. **She spreads her fingers wide and keeps her wrists firm (see Figure 9-16).**

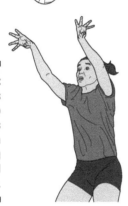

Figure 9-16: Players must keep their wrists firm when performing an overhead dig.

3. **She keeps her shoulders behind the ball and her feet planted on the floor with her weight distributed equally on both feet.**

4. **She pushes the ball toward her target, which is usually a teammate, so the team can transition into its attack.**

Beach dig

A player can jam, sprain, or even break her fingers if she hits a hard hit ball the wrong way. When the ball has a lot of speed and power behind it, players should resort to what is known as the *beach dig.* A beach dig is basically a technique players use — to both protect themselves and keep the ball in play — when the ball is hit directly at their heads or chest levels and they have little time to react to it. To use the beach dig technique, a player does the following:

1. **She cups her hands slightly above her head (see Figure 9-17).**

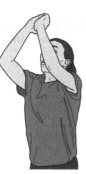

Figure 9-17:
A player cups her hands together when using the beach dig technique.

2. **She overlaps her thumbs.**

3. **She keeps her hands steady so that she doesn't add any additional force to the shot when it makes contact with her hands.**

Juggling

Sometimes all a youngster has time to do is stick out his arm to keep the ball alive for his teammates. This technique is called *juggling*. A player performs juggling by clenching his fist and punching the ball into the air. A player can perform juggling either underhand or overhead (see Figure 9-18).

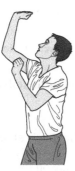

Figure 9-18:
A player clenches his fist and uses a punching motion to perform the juggling technique.

Digging to the side

Attackers try hard not to hit balls directly at defenders. After all, the greater the distance a defender has to move, the better the chance that her technique breaks down and she can't make a successful play on the ball. Thus, your players have to be ready to dig balls hit to their left and right. A player digs balls hit to either side of her by following these steps:

1. **To dig a ball hit to a player's right, she lowers her left shoulder while bringing her arms together to make a level platform behind the ball (see Figure 9-19).**

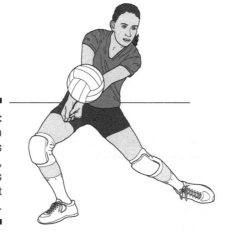

Figure 9-19: On a dig to a player's right side, she lowers her left shoulder.

2. **She shifts her weight to her right side.**

 She wants to get as much of her body in front of the ball as possible because doing so allows her to better control the ball and direct it to a teammate to help the team transition into its attack.

3. **She points her right foot in the direction of the ball.**

 Both feet stay in contact with the floor to maintain a solid foundation as the player contacts the ball.

4. **She keeps her eyes on the ball at all times and makes contact with the ball using her forearms.**

5. **She follows through toward the direction she intends to deliver the ball.**

Dive

Diving for a ball that's about to hit the floor is often the quickest and most effective way to reach it — when you perform the dive correctly, of course. The *dive,* another type of dig, is used as a last-resort play on the ball. Be sure

to stress the proper techniques for executing the dive so that players don't suffer preventable injuries that put them on the sidelines. To perform a dive, follow these steps:

1. **The player moves to the ball as quickly as she can and then takes one big step toward the ball while raising her opposite foot off the ground (see Figure 9-20).**

 A left-handed player steps with her left foot and raises her right foot.

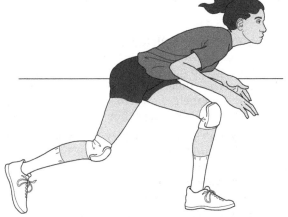

Figure 9-20: A player begins the dive by taking a big step toward the ball.

2. **She lowers herself toward the ball and extends both arms out on the floor (see Figure 9-21).**

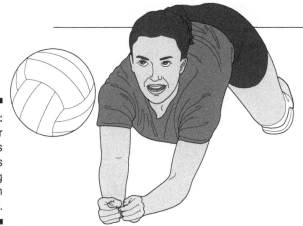

Figure 9-21: A player extends both arms when diving to reach a ball.

3. **The player's lower chest contacts the floor.**

 She slides on her abdomen while keeping her feet raised.

4. **She keeps her head up so her chin doesn't hit the floor.**

5. **She makes contact with the ball before hitting the floor.**

Correcting digging problems

Digging is a difficult skill. Balls whizzing directly at a player or rocketing right into his coverage area present all sorts of problems. We describe a couple of the most common problems associated with digging and offer a few tips on how to fix them:

- ✔ **Can't shake their fear of the ball:** Kids who are afraid of the ball actually handcuff themselves because their fear often makes them less effective players. They also put themselves at *more* risk of getting hurt because fear usually leads them to close their eyes or look the other way. A great way to calm their fears is to start them out digging beach balls like we suggest in the serving section earlier in this chapter.

- ✔ **Can't stop swinging their arms at the ball:** When going to dig a ball, players have a tendency to build their platforms between their legs and swing their arms to play the ball instead of building their platforms behind the balls. Swinging the arms at the ball causes the ball to go back over the player's head or to the side.

- ✔ **Can't control balls hit directly at them:** Some players have a tendency to lower their arms, but not their legs, which often sends the ball uncontrollably in all different directions. The key to digging is being in the right position, which means you have to make sure your players bend low. To help them get comfortable, have them take a squatting stance like a catcher in baseball. Playing in this exaggerated stance for a few rotations may reinforce to them the importance of getting low to dig and control attacks.

Chapter 10

Fundamental Drills for Beginners

. .

In This Chapter

▶ Getting loosened up

▶ Having fun with offensive skills

▶ Drilling defensive skills

▶ Devising practice plans

. .

As a volleyball coach, you probably have little difficulty pumping your kids up for all the serving, passing, setting, attacking, and digging they do on game day. However, generating that same level of excitement during your midweek practices may be a bit more challenging. The secret — which we describe in detail in this chapter — is running drills that grab the kids' attention, are fun to perform, and promote their development.

In this chapter, we go over an assortment of great drills that you can use during your practices to cover the basics of both trying to score points when the ball is on your side of the net and trying to put up a good defensive effort when the ball is on the other side. Because players progress at vastly different rates, you can easily modify any of the drills we cover in this chapter to account for your team's ever-changing needs. You can also find ways to warm your players' bodies up to help prepare them for physical exertion and to reduce the number of injuries that take place. (For more on preventing injuries and stretching, see Chapter 17.)

Warming Up Right

For many players, particularly those new to volleyball, warming up holds about as much appeal as having to clean their bedrooms over the weekend. After all, most kids arrive at the court eager to start playing — not to spend time stretching hamstrings and loosening up shoulder muscles. However, loosening up the kids' muscles is the springboard to developing healthy players. Players who take the time to warm up properly are less likely to sustain injuries during practices and games, which means they can spend every game day playing rather than watching their teammates from the sideline.

Completing warm-ups, which include a complete array of stretching exercises, before engaging in intense physical activity boosts muscle temperatures and increases flexibility — catalysts that help build skills and help players advance in the sport. (See Chapter 17 for the rundown on stretches that hit all the key muscle groups for your players.) Players, especially older ones at the more advanced levels, are susceptible to injury when their muscles aren't loosened up properly before they step onto the court. Exercises that develop muscle flexibility also prevent muscles from tiring easily, which is especially important for those players whom you may count on to attack a lot of balls on game day.

You can structure dynamic warm-ups in many ways, incorporating a variety of different stretches and movements to help prepare young bodies for the rigors of play. You should always begin your warm-up sessions with light exercise, such as a moderate-paced jog around the court. You want to start with some light cardiovascular movement like this to get your players' hearts pumping. After your players' hearts start pumping, move on to stretching exercises (see Chapter 17 for the many different stretches you can use to get your players' bodies ready for action).

If you're coaching older kids, you can make the cardiovascular exercise more volleyball specific by adding a skill component or two. For example, while the kids jog around the court, you can pair them up and have them pass or set a ball to their partners. With a warm-up exercise like this, they can work on some important skills and also prepare their bodies for practice. Here are a few other ways you can add a volleyball element to the warm-up:

- **Pass and run:** Instead of having the kids run around the court for a few minutes, pair them up and have them pass a ball back and forth to each other as they're jogging. Doing so gives them valuable practice directing the ball to a target while on the move, a skill they can certainly use on game day.

- **Jog and attack:** As your players come by the net during their warm-up jog, toss them a ball and have them attack it. After they hit the ball, they can continue their jog until they reach the net again to hit another ball.

- **Follow the leader:** Have all the players pick a spot on the floor while you stand in front of the group holding a ball. When you move the ball to the right, your players shuffle in that direction; when you hold it above your head, they jump in the air and go through the motion of attacking the ball; when you hold it low to the ground, they dive on the floor using proper digging form; and when you shout "Block!" they jump up in the air using good blocking form to simulate defending an attack. This drill gets the kids warmed up, but it also focuses on using proper form to execute many of the basic offensive and defensive fundamentals of the game.

After warming up and stretching, your players are ready to move on to the reason they came to practice in the first place — to learn how to play volleyball!

Going On the Offensive

Your team's ability to score points — and generate quality opportunities for scoring them — depends on how well your players know and understand all the basics of passing, setting, serving, and attacking. The more comfortable and confident your team is at executing these skills, the more productive they can be at racking up points, and the more difficult they are to defend. The drills in this section can help your players establish a sound offensive foundation that can help them fully enjoy this part of the game. Plus, after that foundation is in place, they can continue their development with more advanced drills.

Choosing the right drills for your team can be a challenge, so you can use the age and talent level of your players to help dictate your approach. If your players are new to the sport, or are fairly inexperienced, you can pick and choose from the drills we present in this chapter to help them learn the basics. If you have a talented group of kids who have been playing volleyball for at least a couple of seasons, you may want to jump to Chapter 12, where we provide a plethora of advanced drills more suitable for more experienced players. Also keep in mind that you can tweak any drill we mention in this chapter to meet your team's particular needs by using just a touch of creativity.

When you're choosing new drills for your players, simple and fun drills work best — especially at the younger age levels, where kids' attention spans are really short. For many beginning players, attempting to learn all the basic techniques of the game and trying to put them to use at the same time can be quite overwhelming. No matter how creative you make your practices, don't lose sight of your main goal — to help your players develop the basic offensive and defensive fundamentals of the game, which we cover in Chapters 8 and 9. This development can take place only when you provide your players with quality instruction every time they step on the volleyball court. When you find that a drill is too simplistic or too complex to meet your players' needs, either make some modifications to the drill or discard it and move on to a different one.

Before you jump right into these offensive drills, make sure you allow time for your team to get a good arm warm-up in. Tossing and hitting against a wall or to a partner allows them to take some hard swings and ensures that their muscles are warm before they jump right into serving or attacking drills.

Serving smorgasbord

All eyes zero in on the server every time she prepares to serve because the point doesn't begin until she puts the ball into play. A strong server can be a real asset to the team for a couple of reasons. First, she can win points single-handedly with serves that the opposition can't return. Second, by being able to place the ball anywhere on the court, a server can attack the opponent's weakest returners, which can translate into more point-scoring opportunities for your team. The following serving drills help your players work on consistency and accuracy, two keys to successful serving.

Streaky serves

One of the best attributes a young player can have when serving is the ability to serve the ball all over the court to keep the opposition off balance and unsure of the ball's direction. Use this drill to help your players become comfortable serving to all areas of the court.

What you need: Eight players and a cart of volleyballs.

How it works: Position six players on one side of the court with a player in each zone. (See Chapter 3 for more details on the zones of the court.) Have two players take their serving positions on the other side of the court. Call out the zone you want the serving players to serve the ball to. The first player delivers the serve, and then the second player quickly follows with one, too. If they deliver the ball to the zone you called out, they receive a point. They continue serving to the zones you call out until they miss one. At that point, whichever server missed the zone replaces the player in the zone she didn't get the ball to, and that player becomes a server.

Coaching pointers: Make sure each of your kids receives the chance to be a server. Also, make mental notes of the players who can't string together many good serves in a row — you may need to give them some extra serving practice at your next team practice. Instead of having the players catch the serves, you can incorporate another skill element into this drill by having them work on their serve-receive skills. You can also allow the kids to miss a couple of serves before you make them head over to the other side of the court so that they don't feel any added pressure to hit accurate serves.

Target serving

The more proficient players are at serving the ball to the zone they're aiming for, the more confidence they have as servers — and the more effective they are for their team. Putting the ball where they aim is especially important during matches when the opponent has a weak service returner that you want your players to direct their serves at. This drill helps kids aim for particular areas of the court when they're serving.

What you need: A ball for each pair of players.

How it works: Break the team up into pairs. Line up one kid from each pair along one of the baselines, and give each pair a ball. Have their partners face them about 5 feet inside the court. On your command, the players with the ball serve to their partners. The idea is for the servers to get the ball to their partners without forcing their partners to move to catch it. Have the players receiving the serves alter where they stand — moving up and back so that their partners get plenty of practice trying to hit targets at varying distances. Have the partners alternate hitting serves to each other, and have each player deliver ten serves.

Coaching pointers: This drill is useful with kids of all ages and abilities, plus you can easily tweak it when you want to add a competitive element to the mix. For example, you can award a point to each server who delivers the ball to her partner without making her take a step to catch it. Or, make the drill a fun game between all the twosomes and see which pair can reach ten points first. Because you know exactly where each server is aiming, you can identify the youngsters who are having difficulty controlling the direction of the ball. Then you can make the necessary corrections before any bad habits sink in.

Setting the table with good sets

One of the most fundamental elements of being successful when the ball is on your team's side of the net is the ability to set the ball accurately so that teammates can deliver tough-to-return attacks. The better your team is at setting, the more scoring opportunities you can enjoy. Check out the following drills to help you build your players' skills in this area of the game.

Partner sets

One of the trademarks of good setting is consistently putting the ball in good position — from anywhere on the court — for teammates to attack. This drill enables players to work on their setting skills.

What you need: Two players, one coach, and one ball.

How it works: Position the two players about 15 feet apart from each other. You stand about 20 feet in front of the kids. You begin by tossing the ball toward one of the two players, who sends a pass to her partner, who then sets the ball back to her.

Coaching pointers: Don't show your players who you're going to toss the ball to. You want to keep the drill gamelike so the kids learn to adapt and react quickly. You can also have the players set the ball to you to increase the difficulty of the drill and to give them practice setting in a couple of different

directions. You can use this drill while the rest of your team is practicing another drill (especially when you have assistants) because your players can practice this drill off to the side of the court.

Team challenge

Being able to set the ball to different players, while also receiving passes from a variety of locations on the court, is key to being a good setter. This drill targets that aspect of setting and starts to get kids comfortable making sets.

What you need: Four players and one ball.

How it works: Position four players in a square with about 15 to 20 feet between each of them (see Figure 10-1). Player A is the designated setter for this drill.

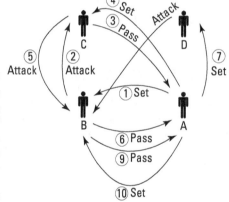

Figure 10-1: Setters get a lot of practice during the team challenge drill.

1. **Player A tosses the ball up in the air to herself and sets the ball for Player B.**

2. **Player B hits the ball at half speed to Player C.**

3. **Player C passes the ball back to Player A.**

4. **Player A sets the ball for Player C.**

5. **Player C hits the ball at half speed to Player B.**

6. **Player B passes the ball to Player A.**

7. **Player A sets the ball for Player D.**

8. **Player D hits the ball at half speed to Player B.**

9. **Player B passes the ball to Player A.**

10. **Player A sets the ball for Player B again to begin another rotation.**

Coaching pointers: You don't want kids to hit attack shots that are really difficult to handle, so run this drill at half speed so the setter has a chance to handle a lot of balls. Because the passes are coming from different directions, make sure the setter is using good footwork and getting into proper position. Be sure to rotate the kids around so that each of them has a chance to play the four positions in the drill.

Passing

When youngsters watch volleyball — or play it for the first time — they're attracted to the excitement of hitting the ball and diving to keep balls alive. (See the "Making kill shots" and "Digging" sections of this chapter for examples of drills that work on these two exciting aspects.) The basic act of passing the ball may draw yawns of disinterest at first; however, you must impress upon your team the importance of learning and developing this area of the game. The stronger their passing skills, the more formidable and effective their attacks can be. The following drills can help improve your team's passing skills.

On the move

This drill enables players to work on their passing skills while moving around the court because players seldom have the luxury of having the ball hit directly to them.

What you need: One ball for each pair.

How it works: Break the team up into pairs and give each pair a ball. Scatter the pairs along the sideline with plenty of room between each twosome. On your command, the players with the ball toss it up in the air to their partners, who get into position and send a forearm pass in return. After the ball is airborne, each pair moves across the court toward the opposite sideline while passing the ball back and forth. After the pairs reach the sideline, have them return to where they started while passing the ball. Doing so gives everyone a chance to both deliver and receive passes while moving forward and backward.

Coaching pointers: You can easily use this drill to create a fun competition among the group. See which pair can move from sideline to sideline in the shortest amount of time. To help ensure that your players focus on accuracy, have them return back to their starting positions to begin the drill again anytime their balls hit the floor.

Around the world

This drill helps youngsters improve their passing skills in a fun group setting and also builds team chemistry.

What you need: Six players and two balls.

How it works: Break the team into groups of six players. Have each group form a circle with at least 10 feet between each player. Have one player on each side of the circle begin with a ball. The object of the drill is to have the players pass both balls around the circle without letting them touch the floor. Begin the drill by having them pass the ball to the left and then randomly shout "Right!" or "Across!" to change the direction of their passes. You can even take turns with the kids and give each of them a chance to shout out the direction in which their teammates have to make the passes.

Coaching pointers: You want players to build their confidence by being able to pass the ball accurately among their teammates, so the younger the kids, the smaller the circles. As they become more proficient, you can expand the size of the circles to increase the challenge. When a player makes a poor pass that forces the group to start over, make sure her teammates make positive and supportive comments. Even during a drill, you want players pumping each other up anytime something doesn't go their way.

Making kill shots

Executing kill shots is one of the most exciting — and challenging — skills for kids to learn. The drills in this section help players become comfortable with the mechanics of an attack so that when game time rolls around, they're hitting the ball with confidence and accuracy.

Shadow shots

You may be tempted to rush kids into hitting drills that involve setters and defenders, but you need to start by focusing on the fundamentals of the attack. This drill works on those important fundamentals.

What you need: A ball for each player.

How it works: Line up the players along the baseline with about 5 feet between each of them. Have them face the back wall. On your command, have them raise the ball up with their hitting arms and, replicating the motion of an attack, throw the ball down on the ground at an angle. The ball hits the floor and then the wall so that it goes right back to the players, who can then perform the drill again.

Coaching pointers: This drill is all about repetition, which helps the kids master the motion of the shot. Keep a close eye on their form because if bad habits emerge and you don't correct them right away, you may not be able to fix them later.

Criss cross shots

Action-packed hitting drills that involve all the kids almost always go over well with the team, so you can't go wrong fitting this drill into some of your practices. Besides focusing on hitting skills, it provides good practice for your setters, too.

What you need: Two groups of three players, two setters, two coaches, and a cart of balls.

How it works: Line one group of three players on the left side of the net, and line the other group on the right side of the net (see Figure 10-2). Position a setter facing each group. With several volleyballs in hand, you and an assistant coach stand on each side of the court facing the designated setters. Follow these steps:

1. **Each coach tosses a ball out to a setter.**

2. **Each of the setters delivers a set for the first player in her line.**

3. **The first player, or attacker, delivers a kill shot down the line.**

 After hitting the shot, the attacker quickly moves to the end of the line on the opposite side of the court to hit a kill shot from that position.

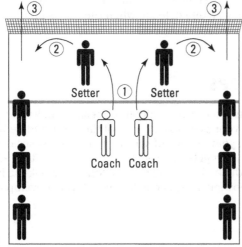

Figure 10-2:
The criss cross drill focuses on hitting kill shots down the line.

Coaching pointers: You want to keep this drill moving at a steady pace so that kids aren't waiting in line for a long time to hit shots. Be sure to move the kids around so that everyone gets a chance to set and hit. Have the players mix their attacks up so that they're hitting balls both down the line and crosscourt.

Dialing Up Defensive Drills

Most of your players may be more interested in executing offensive skills in volleyball than defensive ones because they're more fun. After all, delivering an attack that results in a point for the team rates higher on the excitement scale than digging or blocking an opponent's attack. However, one of your many responsibilities as a volleyball coach is to teach your players all the basics of the game, including the important defensive elements, because your team spends roughly half of its games in a defensive role. (Chapter 9 focuses on defensive skills and shows you how to perform them.)

Although playing defense may not seem quite as appealing to youngsters who are just starting out, the only way to transform them into well-rounded players is to devote your practices and drills to all aspects of the game, including defense. If your defensive drills are creative and interesting, your players may even take an interest in excelling at this part of the game. Plus, teams that play well defensively create more opportunities for themselves to produce points on offense.

Although several of the drills we mention in the "Going On the Offensive" section of this chapter have defensive benefits as well, the following drills directly emphasize playing strong defense when the ball is on the opponent's half of the court.

Receiving serves

How well a team can pass a serve often dictates a team's ability to generate scoring opportunities. If your players can control the serve and deliver accurate passes to the setter, your chance of scoring points increases dramatically; on the other hand, if they struggle to pass efficiently, chaos often reigns as players scramble to get the ball over the net. So don't overlook the importance of serve receive. The following drills can help your players develop this aspect of the game.

Serve frenzy

During games, your players face all types of serves — hard, soft, flat, and spinning, for example — so you want to make sure they get plenty of practice handling these different serves. This drill gives your players the chance to see a lot of serves in a short amount of time.

What you need: Seven players and a cart of balls.

How it works: Designate four players as servers and position them along one of the baselines. The other three players take spots in the opposite backcourt to receive serves. The first player serves the ball, and the players attempt to pass the ball. As soon as the ball hits the floor, the players get back in position, and the next server serves a ball over the net.

Coaching pointers: You want to keep this drill moving along so the kids get plenty of chances to receive serves. Have the players who aren't involved in the drill or your assistants retrieve balls to keep the drill going.

Clean the floor

One of the real challenges in teaching players to make good passes out of serve receive is helping them become comfortable recognizing which serves are in their coverage area and which ones are in a teammate's area. This drill helps iron out this issue.

What you need: Six defensive players, one server, and a cart of balls.

How it works: Six players occupy their positions on one side of the court, while the designated server takes the other side of the court. On your command, the server serves a ball, and the defensive players react by passing, setting, and attacking the ball. The players quickly regroup and get back into position before the server serves another ball.

Coaching pointers: Be sure to emphasize maintaining the proper serve-receive stance (which we discuss in Chapter 9) at all times. Have the server serve five balls over and then rotate to the other side of the court.

Digging

One of the most important aspects of defensive play is keeping the ball in play. Anytime the ball is still alive, your team has a chance to win the point. Thus, *digging* the ball (a defensive technique a player uses to keep the ball alive after an attacker hits it) is an enormously valuable skill to possess. (Check out Chapter 9 for more on how to dig a volleyball.) The following drills cover the basics of digging.

Dueling partners

Digging a ball requires a mixture of proper form, good timing, and coordination. This drill encompasses this trio of attributes.

What you need: One player and one ball.

How it works: Position a player to face you about 20 feet away. Throw a ball in the player's direction and have her try to dig the ball to send it back to you. Begin by throwing balls directly at the player's feet until she becomes comfortable handling those balls. Then you can send balls to her left and right to force her to move in different directions.

Coaching pointers: Be sure to use an overhand throwing motion so that you simulate an attack coming down toward the player. You can add another player to the drill to serve as either a passer or a setter. Simply position that player near the defender. After the defender digs the ball, this new player either passes or sets the ball back to you.

Over and out

This drill focuses on digging but also includes a passing element for your players' added benefit.

What you need: Three players and a cart of balls.

How it works: Position three players in the backcourt. You stand near the net on the same side of the court as the players. You begin the drill by throwing balls that the players must react to and dig. After one player digs the ball, one of the other two players must pass the ball back to you. The players hustle back into position, and you deliver another ball for them to dig and pass.

Coaching pointers: You can turn this drill into a fun and competitive game by awarding the threesome a point for every ball they successfully get back to you and taking a point for yourself every time they fail to get the ball to you. Be sure to distribute the ball in a variety of locations to force the players to react quickly and cover different areas of the court, just like they have to do in an actual game.

Blocking

One of the more advanced components of good defensive play is *blocking*, which simply refers to a defensive player, or group of players (only the three front row players), preventing an opponent from sending the ball over the net. Just the potential threat of a block can be distracting enough to an

opposing player that she alters her shot or even takes her eyes off the ball for a split second, both of which can be highly advantageous to your efforts to score a point. The following drills cover this defensive element.

Jump and touch

This drill focuses on using proper form to block a ball and then being quick enough to react to the ball when it comes back across the net, a common occurrence in volleyball games.

What you need: Four players and several balls.

How it works: Position three players along the sideline about 10 feet from the net with a setter near the middle of the net facing the group. You stand on the opposite side of the net with the balls (see Figure 10-3). The drill begins when the first player in line runs toward the net and then, using proper form, jumps up as though she's blocking a shot. As soon as the player lands, you toss a ball over the net that she has to react to quickly and dig to the setter. Then the next youngster in line heads toward the net.

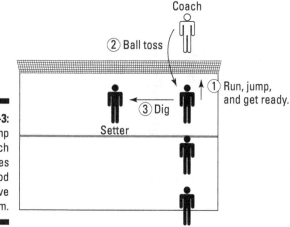

Figure 10-3:
The jump and touch drill stresses using good defensive form.

Coaching pointers: Even though players aren't actually blocking a ball during this drill, you want to stress the importance of using proper form so that when you do incorporate a live ball into future blocking drills, they're better prepared to handle them. After a few rotations, you can toss a ball into the players' hands as they're jumping up for the block so they can begin to get a feel for what making contact with the ball is like.

Blocking bonanza

This is an ideal drill to use because it involves nonstop action, which makes it fun for the players. Plus, it gives them numerous chances to work on their blocking skills in a short period of time.

What you need: Six players and three coaches.

How it works: Three players line up facing the net, while three coaches position themselves on the opposite side of the net, facing the players. The remaining three players begin on the right front sideline (see Figure 10-4). On your command, the coaches across from the three players throw a ball to them, and the players jump up and attempt to block the ball. As soon as the players complete the blocks, the players shuffle to their left until they reach the next coach and again jump up and attempt to block the ball. When players reach the last spot in front of the net, they return to the sideline after blocking the ball.

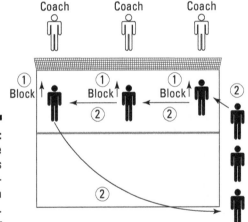

Figure 10-4:
Players face many shots in the blocking bonanza drill.

Coaching pointers: Strong blocking begins with good footwork, so keep a close eye on how the players move into position. You want players to shuffle when they must move only a step or two along the net, but to use the cross-over step when they need to move greater distances. Next, you want proper form as they jump up in the air. Keep this drill moving at a fast pace. Besides simulating the fast action of a game, maintaining a fast pace helps provide conditioning benefits for your team, too. (For more on conditioning, head to Chapter 17.)

Putting It All Together: A Sample Practice Session

Although your players look forward to game day the most, your practices really set the tone for the season. If you make these sessions fun filled and productive in terms of skill building, your players are more likely to be enthusiastic participants, who truly enjoy the time they spend with you.

You can use the following sample one-hour practice to formulate your own practice plan. We describe the drills included in this sample practice throughout the rest of this chapter.

- **10 minutes:** Warm up. Get the kids in the habit of warming up every time they participate in volleyball with some basic stretching and light exercises. (See Chapter 17 for specific stretches your players can do to warm up their muscles.)

- **10 minutes:** Run the target serving drill. This drill gives everyone a chance to work with the ball directly, which grabs the kids' attention and thus starts practice on the right foot.

- **15 minutes:** On half of the court, run the partner sets drill, and on the other side of the court, conduct the team challenge drill. Halfway through this 15-minute block of time, rotate the kids so they have a chance to participate in both drills.

- **10 minutes:** Run the around the world drill to work on passing skills. You can add a fun component to the drill by seeing which group of kids can keep the ball from touching the ground for the longest period of time. By adding competitive elements to drills, you can help keep the kids' attention.

- **10 minutes:** To continue to focus on passing, use the on the move drill to complement the around the world drill.

- **5 minutes:** Conduct a brief cool-down period. Have the kids perform several stretches that are similar to the ones they do during warm-ups. (See Chapter 17 for more information on cooling down after practice.) While they're going through these stretches, be sure to applaud them for their hard work — you always want to send players home feeling good about themselves to help boost their confidence. During this stretching period, you can also recap the upcoming schedule to make sure everyone is aware of the date and time of the next game or practice.

Because this sample practice has a heavy dose of drills that work on offensive skills — serving, setting, and passing — you want to incorporate some more defensive elements in the next practice. Simply substitute some of the defensive drills we describe in the "Dialing Up Defensive Drills" section of this chapter for the offensive drills we include in the sample practice.

At the beginning levels of play, you don't want to give kids an avalanche of information because doing so makes comprehending everything virtually impossible. Instead, pick out a couple of skills to work on at each practice and build from there. Gradually, as your players begin to develop a good understanding of the game, you can run different drills that encompass a wider variety of skills.

Although having a plan in place heading into your practice is important, you also need to be flexible and willing to make adjustments according to how the practice unfolds. For example, when you see several players struggling with a serving drill, you can choose to devote more time than you had originally planned to this skill to help them overcome some of their difficulties. Or, maybe you discover that one of your drills is too complex at this stage in the team's development, so you need to replace it with a different, more basic drill. You should never carve your practice plan in stone. Your plan is simply a guide to help you navigate your team through a productive practice that promotes learning and fun.

Chapter 11

Refining Your Coaching Strategies

. .

. .

*O*ne of the many interesting aspects of coaching a youth volleyball team is that no matter how much progress the kids make — and we're sure they'll make a lot of progress under your guidance — you constantly have to face the challenge of keeping pace with their development. How you adjust to your ever-changing team, from the drills you run during practice to the strategies you employ on game day, determines whether the fun and skill development continue to reach new heights or disappear more quickly than a rabbit into a magician's hat.

In this chapter, you can find everything you need to know about conducting the important midseason evaluations. We cover how to revise your coaching strategies based on the kids' development, tweak your practice plans to target the newfound needs of your players, and review their progress to create realistic — and reachable — goals for the remainder of the season. Plus, we take a look at how to make sure you keep the parents in the loop every step of the way through important one-on-one chats. Read on to find out how to close out the second half of the season as strongly as you began the first half.

Adjusting to Changing Team Dynamics

After spending just a little time with your team, you can gain a fairly good feel for whether the season is motoring along smoothly or whether you're encountering too many bumps along the way. You can also perceive which areas your team excels in, as well as those aspects of the game that present some challenges for your players. Whether you're coaching in an introductory program or an advanced league, you must constantly assess the kids' progress, evaluate your teaching techniques, and then revise your practice plans to target specific areas of their game that need further attention.

Clearly, which areas of the game the kids excel in or struggle with affect your team's makeup. Based on their progress, or lack thereof, you need to tweak some drills, ditch others, and perhaps edit your other practice plans, too. For example, you may want to devote a little extra time talking about the importance of hitting accurate serves to begin points to help the players focus their attention on performing that particular skill well. If you're in charge of an advanced team, your midseason adjustments can also involve sliding kids into different positions and altering your game day strategies to account for the team's new strengths and weaknesses that have come to light as a result of their progress.

Even when your team shows signs of improvement, don't let yourself off the hook because you still have to pay attention to every detail of your changing team. After all, a team that's progressing — while great to see — poses new challenges that you have to be aware of and ready to react to. You have to adjust everything from your plans for practice to your points of emphasis on game day so that you can continue to push the kids' progress in the areas of the game they're excelling at, as well as get them up to speed in the areas they're lagging behind in.

In the following sections, we help you read your team's overall development, offer suggestions for making the key midseason adjustments that can spur the kids' development, and address potential challenges that may come up when you revise your plan.

Never look at the scoreboard when you're evaluating your team's performance or judging their progress because scores can be misleading. Even if your team gets clobbered in the match, your kids may have played one of their best matches of the season. On the other hand, your team may be on the winning side of a lopsided score, but they may simply have pounded a much weaker foe. One of the underlying secrets of good coaching is ignoring the final score — win or lose — and putting the magnifying glass squarely over the kids' performances and attitudes. Ask yourself questions about how well they executed the fundamentals and the areas of the game you worked on in practice earlier in the week.

Revising your coaching plan

Having to create new practice plans or make strategy adjustments on game day based on your team's development may seem like additional work at first glance. Yet, you should find this process enjoyable because having to create new plans means that your players are picking up on your instructions and developing skills — a big part of what coaching volleyball is all about. Anytime the kids are improving individually, and the team is progressing as a unit, you want to embrace this opportunity to help them propel even further

in their development. At this stage, you don't want to suffocate their newly acquired skills by using the same set of drills you used during the first week of practice. Your kids get the most out of their participation and improve faster when you keep challenging them with new drills. (For examples of practice drills you can use to raise their level of play, turn to Chapter 12.)

Making only a slight alteration to a basic drill introduces a new component that challenges the kids and grabs their interest because the drill is different than what they've seen before. Kids' skills stagnate if you run them through the same drills week after week. New drills, or those that are just slightly different, help keep the enthusiasm high all season long.

To help keep your practices fresh and innovative, and your players energized and motivated, look for different ways to tweak the most popular drills you've used throughout the season. For example, if you run a basic attack drill in which the players jump and hit the ball while a defender on the other side of the net attempts to block the shot, bump up the difficulty level for the attacking player. Set up a few cones roughly 10 feet apart in the middle of the court on the defender's side. Now, have the player try to hit the cones with his attack, while also dealing with the blocker. Keep a running tally to see which player can hit ten targets first. After the kids get pretty good at hitting those targets, add another blocker to make the attack more difficult; or, put a player between the targets and have him attempt to dig the balls. By constantly challenging your players in clever ways, you enable them to grow and develop in the sport — as a result, the entire team benefits.

Handling challenges as your team improves

As a youth volleyball coach, you can't beat the thrill of watching your players develop new skills and improve others. Player improvement makes you proud because making everything come together takes a lot of time, effort, commitment, and patience on your part, as well as on the part of your players.

You certainly deserve a pat on the back for a job well done up to this point in the season, as do your players for working hard and following your instructions. Of course, the situation does present some new — and hopefully exciting — challenges. These challenges occur more frequently at the advanced levels of play because older and more experienced players are more likely to make bigger strides during the season that you must adjust to. Beginning level players often require a lot of repetition in the fundamentals of the game for longer periods of time before they're ready to progress to new skills, so the adjustments you need to make at that level are minimal. The following list gives you a peek at some of the most common challenges you encounter as your players become stronger in different facets of the game:

✔ **Changing your game day approach:** As the season moves along, your team may become significantly different from the one that greeted you at the first practice of the season. You have to adjust accordingly to maintain the kids' interest and attention. Perhaps early in the season, the kids struggled with their timing on executing quick sets, thus making that technique an unproductive option to turn to on game day (head to Chapter 13 for details on teaching this skill to your players). Now, however, you're halfway through the season, and you find that your players have a better handle on performing the quick set technique. In this case, you want to capitalize on the improved skill — and allow the kids to put it to use in front of Mom or Dad on game day. You need to tweak your game day strategies accordingly to take advantage of this new skill.

✔ **Shifting players around on the court:** After several practices and matches at the advanced level of play, you may discover that you need to move players to different positions based on how they're excelling at certain skills. During practices, pay close attention to the smallest details that can alert you to a youngster's abilities in different areas. For example, perhaps a youngster you've been relying on to handle the bulk of the setting duties is actually a talented defensive player who can help the team more by passing in serve receive and digging the opponent's attacks. Or maybe when a player goes to deliver a jump set, you notice how high in the air he gets. A high jumping ability is an attribute that may allow him to be a powerful attacker in the front row.

Watching players hit the ball around before practice can be advantageous to both you and your team. Before practice is when your players' athletic abilities often shine through because they don't feel the added stress of having to meet the coach's expectations. At the very least, you can identify valuable backups who can step in and fill roles if any starting players have to leave a match, suffer an injury, or have to miss a match because of other obligations.

Anytime you shift a player to a new position, be sure to alert the parents. You can share this news with them when they pick their kids up from practice, or if doing so isn't convenient, a quick phone call can do the job. Communicating regularly with parents is important because any news concerning their children is big news in their eyes (see Chapter 4 for more on communicating with parents). Open and frequent communication reduces the chances of misunderstandings occurring on game day, when you already have plenty to keep you busy — without adding an irate parent to the mix. Tell the parents why you think their children are better suited for these new positions and how the skills you've watched them develop in recent weeks make them real assets to the team in these roles. Sometimes, parents receive this news well; other times, they receive it with a little more attitude. (For more on dealing with parent issues, flip to Chapter 18.)

✒ **Diffusing disappointment:** A youngster who loses his spot to a teammate naturally feels disappointed, just as you'd feel if you lost out on a promotion to a co-worker you thought was less skilled than you. Going from the court to the bench is often a blow to a child's confidence and self-esteem, so make sure you take the time to explain to the player that he's still a valued and important member of the team.

During your practices, pay extra attention to the child who lost his position to ensure that he remains passionate about the game and supportive of his teammates. Encourage him to keep working hard in practice and supporting his teammates during matches. After all, he never knows when you may call upon him. Let him know that just because you choose to start someone else doesn't mean that he isn't playing well or performing up to your expectations. Explain that this other player's skills have emerged to the point where he deserves to be on the court at the start of the match. Also, stress that by working hard in practice and challenging his teammates during drills, he can help them improve and have a role in making the team a more efficient unit.

As you face some of these potential challenges, keep close tabs on each player's progress. Doing so allows you to be there to deliver a high-five or a congratulatory word whenever the child picks up a skill or shows progress performing a new technique. Maybe the child's development is subtle, such as the position of his arm when he's leaping in the air to attempt an attack; or, perhaps it's much more evident, such as how proficient he has become at hitting floater serves that drive opponents crazy. However big or small the progress, be enthusiastic as you recognize it. Doing so helps fuel more learning and encourages kids to stick around the sport longer.

Conducting the Midseason Review

Whenever your team reaches the midpoint of its season, regardless of whether you're coaching in a six-week or six-month league, sit down with each player and thoroughly evaluate his progress. Conducting a midseason review benefits both you and your players because it helps you keep a season that's already running smoothly on track, as well as rescue one that's drifting a bit off course. Pointing out your players' progress and improvement helps them see that you recognize the positive effects of their hard work and development.

The following sections explain how you can set and reset goals for your players and the team; how you can turn those goals into active plans; and how you can evaluate progress from this point until the season's final match.

Resetting your coaching goals

You set goals with your players near the beginning of the season (check out Chapter 2 for more on how to set goals). At the season's halfway point, put the knowledge you've gained from watching your players for a few weeks to good use by revising and setting new goals they can strive to achieve during the remainder of the season. Besides devising goals that challenge your players individually, you want to develop goals that also fit within your team concept. After all, if the kids lose sight of the importance of working together as a unit, their productivity crumbles. Setting goals for the kids and your team can be one of the most powerful coaching techniques you use — when done the right way. Setting goals that are within the kids' reach helps push them to achieve their full potential. Challenges that are fun to strive for — and even more fun to achieve — help keep the kids' learning and development churning.

To make midseason goal setting successful, keep the following points in mind:

- **Make goals team oriented.** Set only goals that fit within the framework of the team. For example, giving a child the goal of hitting ten attacks or producing five points for his team is unrealistic. After all, the child has no control over individual performance numbers because the skill level of the opponent is out of his control. He can hit a variety of balls effectively, but if the players he goes up against are superb blockers, the number of points he helps the team score isn't indicative of how well he plays.

- **Find a balance.** Choose goals that are in between being too easy and too difficult so that you maintain the child's interest, minimize his frustration, and maximize his chances of success.

- **Use short-term goals.** The younger the child, the shorter his attention span, so you're better off setting a series of short-term goals. Doing so allows the child to see his progress right away. Long-term goals often evaporate in a child's mind from one practice to the next, reducing their usefulness.

- **Use a variety of goal levels.** Set goals at varying levels so that if a player doesn't reach the top goal but makes strides toward it, he can still gain a sense of accomplishment. Having just one goal to shoot for turns goal setting into an all-or-nothing proposition in which failure severely compromises the child's confidence.

 The more skills a player has in his arsenal, the more problems he poses for the opponent. For example, suppose that your player has reached his first goal of becoming fairly proficient at setting the ball for his teammates. After he reaches this level, one of his next goals should be becoming more skilled at executing back and jump sets. The more types of sets he's able to use during matches, the more difficulty the opposition has determining where the ball is going to land, and thus, the more effective your player is on the court.

✔ **Solicit thoughts from your players.** The more you make kids a part of the goal setting process, the more beneficial the goals are for them. At the advanced levels of play, you can make goal setting more effective — and more enjoyable for the kids — by having a short discussion with the whole team on which areas of the game they want to improve. Giving players a voice in the goal setting process helps drive their development because they have invested their own time and energy in the process.

✔ **Promote practice time.** If you're coaching an advanced level team, encourage players to practice skills with their parents or friends at home. Just a few minutes in the backyard or park a couple of times a week can pay big dividends. However, *never* force extra practice — you don't want to make practice feel like dreaded homework. Simply try to nudge kids in the right direction with gentle reminders about polishing certain skills at home to reach new goals. You can also encourage at-home practice time at the younger levels — but again, only if the child is completely interested in doing so. At these beginning age ranges, your top priority is to introduce the kids to the sport, not make them feel like they have to practice several times a week.

✔ **Account for the role of injuries.** Anytime a youngster is injured during the season and misses some playing time, be sure to take that missed time into account when you're setting goals for him. Young players often take a little while to get back up to full speed after spending some time on the sidelines. After you sense that a player has returned to his normal playing level, you can revisit the goals you set during his recovery and adjust them accordingly to coincide with his improved health.

Stay away from setting team goals that revolve around winning a specific number of matches. Although doing so may seem like a good idea at the outset, those types of goals can lead to all sorts of problems. For example, if one of your team goals is to win the last three matches of the season and you lose the first match, your goal is suddenly unreachable. In terms of the goal, whether your team played really well and simply lost to a better team or they played terribly and deserved to lose doesn't matter. The goal is gone, and your players feel like failures. These feelings of failure can linger for quite some time. Steer team goals away from the win–loss record, and focus instead on improving weekly and playing hard on every point. Aim for team goals, such as committing fewer errors as a team or getting a higher percentage of serves in than they did in the last match. Positive team goals such as these allow all the kids to be involved and make a real difference in helping them raise their levels of play.

If you're coaching a beginning level volleyball team, keep the midseason emphasis where it was the first day you stepped on the court — on having fun. Doing so enables you and your players to enjoy your share of wins. More importantly, though, you create an environment that allows the kids to reap the rewards of playing, learning, and achieving together.

Helping your team reach its goals

Your team can reach only goals that are realistic. Anytime you're setting goals for your team, make sure that your players can reach them if they work hard and follow your instructions. You want to set your players up for plenty of success — not failure — and create an atmosphere that allows them to flourish and thoroughly enjoy the season. After you establish realistic goals, act on them by creating plans to help your players achieve them. Goal setting isn't about what *you* want to see happen; it's about what *your players* are realistically able to achieve during the relatively short amount of time they have to spend with you.

Building both your players' skills and their confidence to perform them is much like building a skyscraper — you need a focused effort and a logical progression for everything to come together. Your players must work up to the goals you have in place, one step at a time. To help your youngsters gauge their progress, and to ensure that the goals you set for them fall into the realistic category, make sure that you compare their current performances with those from earlier in the season. As players gain confidence in their abilities, fulfilling realistic goals comes more naturally, and their skill development increases dramatically.

Often, kids attach their progress to how the team fares on game day, which is a terrible habit to get into because wins and losses don't indicate how a player has grown and developed in different areas of the game. For example, just because the team has reeled off a half-dozen victories in a row doesn't necessarily mean that the youngsters have progressed into well-rounded players. Conversely, simply because the team has lost several matches recently doesn't mean that the youngsters haven't become better servers or defenders.

When helping your team reach its goals during the season, always exercise patience. Particularly when teaching new skills, take your time and stay realistic about how quickly your players can grasp them. Volleyball requires a broad range of skills, and no child is going to grasp them all during the first week of the season. Difficulties with certain aspects of the game are sure to pop up during the season. Take the approach of building the kids' confidence in performing a fundamental skill; then slowly add more complex components one at a time. In most cases, you don't see huge improvements during the span of a one-hour practice. Over several sessions, though, you can see positive strides, and thus, you can send more complete players onto the court on game day.

Exploring different approaches for reaching goals

You're coaching different types of kids, so you need to tailor your coaching approaches uniquely for them to help them reach their goals (see Chapter 5 for more information on the types of kids you may encounter). You have to find which approach works best for each player and then apply it accordingly. Some players may require extra doses of motivation from you; some may benefit from a steady flow of feedback; and others may embrace challenges you issue them. Sift through all your options, experiment with your players, and uncover what hits home with each player on your roster.

Watch the facial expressions and body language of the kids during your practices. Do they have smiles on their faces and look excited to be on the court? Or, are they lacking energy as they move from drill to drill? If you're not seeing the reactions you hoped for, or sense that your players aren't fully enjoying the session, take a closer look at your drills. Perhaps they're too difficult, lack imagination, or aren't tailored to the skill level of your players. Whatever the case may be, determine ways to inject more fun into the drills — and do so quickly before you waste any more valuable practice time. (Refer to Chapters 10 and 12 for some fun drill ideas.)

As you attempt to help the team reach its goals, make sure you step back and take a look at the tempo of your practices. Players tend to enjoy the fast-moving sessions that feature little standing-around time. Because all the players are involved, these types of practices are more beneficial to their development than slow practices that focus on only a few players at a time. Don't give kids a chance to be bored or time to think about what they're doing next weekend.

Moving kids to new positions

Tinkering with your lineup and having kids play different positions are things you need to do as you monitor your team midseason. If you're coaching a beginning level team, you should already be moving the kids around so that they get a chance to experience as many positions as possible. At the advanced levels of volleyball, sometimes kids become frustrated with the positions they're playing, so you may need to adjust the lineup at this level, too. Doing so helps keep the players fresh and challenged, but it also gives you the chance to evaluate whether different combinations on the court produce a more potent offense or a more difficult defense to go up against.

For example, one player has his sights set on being the team's primary setter. However, during the first half of the season, you find that he serves the team's needs better in a different role. Remember that kids take playing sports like volleyball very seriously, so when things don't work out according to how they envisioned them in their minds, disappointment can easily and quickly settle in. This disappointment can be especially potent when you shift a player to a new position. Feelings of insecurity often accompany change, so you need to address these feelings before they have a negative impact on the child's season. Talk to the youngster about how his skills are better suited for the new position and how his teammates are counting on him to play well there. Explain how important this position is to the team's performance to help pump up his interest for assuming this role.

Helping players conquer injury fears

No matter how you look at volleyball, it's always going to be a contact sport. Between players diving on the court to dig balls or defending hard hit attacks whizzing at them, young bodies can collect aches, pains, and bruises during the season. A youngster who begins the season fairly fearless can easily change his mind several games into the season, especially if he suffers some nasty floor burns diving for a ball or has the unfortunate experience of being hit in the face with an attacked ball. Regardless of the source of pain — even if you consider it a minor injury — your player definitely has lasting memories of it, and those memories may be enough to make him somewhat reluctant to take the court again or to play as aggressively as he did before the injury. If you don't help your players forget about their injuries, their memories of pain can take precedence in their minds and ruin their playing experience.

If a child is afraid of being hit by the ball, make sure you address this problem as soon as you notice it. Run the player through some drills using a beach ball so that he can practice without the fear of being injured. For example, if the youngster was hit in the face trying to dig an attack in your last match, use the beach ball in a defensive drill to allow him to regain his confidence so that he understands that he can minimize the chances of being hit again by using proper form. After the child regains some confidence performing this drill, you can reincorporate a real ball into the drill. Addressing your players' fears right away increases their chances of growing more comfortable on the court — and thus more successful, too.

Whenever you use a beach ball, or other type of soft ball, make sure that all the kids run through the drill using it. Otherwise, if you use the softer ball only with the player who's afraid of the hard volleyball, you put the spotlight on his fear and make the situation even worse for him.

Meeting One-on-One with Parents

Keeping parents in the loop — from your preseason meeting (see Chapter 4 for more on this meeting) all the way through the final match of the season — is crucial for minimizing the number of problems or misunderstandings you have during the season. Setting aside time to talk to parents individually to find out how their children are enjoying the season not only shows how much you care but also gives you the chance to get the scoop on what type of impact you're having on your players off the court. These one-on-one chats can be especially comforting to parents who are new to the sport of volleyball, or organized sports in general, and who don't know exactly how to gauge how their children are performing or what type of experience they should be having.

When midseason arrives, let the parents know that you want to briefly speak to them one-on-one about their kids to get their input on how the season has gone so far. Making this announcement after a game works well because most parents attend the games. Make sure you conduct these discussions out of the earshot of the youngsters to provide the best environment for receiving honest feedback about how the kids feel. You can hold these private conversations over the phone or in person during scheduled times before or after a practice.

Some of the questions you want to be sure to ask parents include the following:

- ✔ **Is your child having fun?** This question has to be number one on your list because if your players aren't enjoying the experience, you're not doing your job. You see your players for abbreviated periods — sometimes just for an hour once a week for practice and then for a game on Saturday morning — so you may have a hard time getting an accurate reading of how your players feel about the sport, their teammates, and you. Having an open, honest discussion with the parents about whether their children are having fun usually results in candid and helpful responses.

- ✔ **What can I do to make everything better?** Anytime a child's season isn't going well, work with his parents to figure out a solution that meets the youngster's needs, as well as fits into your team concept. Maybe the youngster isn't serving as well as his teammates and wants some extra help on his technique after practice. If he's willing to come a few minutes early to practice, or stay later, you can give him some extra attention to help him raise his level of play to match that of his teammates. Having open discussions and sharing different ideas with the player's parents can lead to positive results. Always make sure the child is on board with the plan, though.

 When a child isn't enjoying the season, your job as his coach is to explore every possible way to reignite his interest and restore the fun.

✓ **Does your child look forward to coming to practice?** These sessions with the kids are when the bulk of the learning and skill development takes place. If they're excited about coming to practice, they also tend to be in a positive frame of mind and more receptive to your instruction, which in turn helps them develop skills more quickly. If they dread showing up, they don't have the proper mindset, and their opportunity for learning skills dwindles.

✓ **Does your child look forward to game day?** Parents know whether their son can't sleep the night before a game because he's too excited and anxious to get on the court or whether their daughter is too nervous to eat before the game because she's feeling pressure to play well from you or another source. Whatever insight you can gain about your players may help you understand them better, as well as help you evaluate your own coaching methods. If several parents tell you that their children are nervous or uptight, you want to reexamine how you're interacting with your players because you may be applying pressure on them to play well without even knowing it.

Be prepared for honest answers. The purpose of asking direct questions is to obtain honest feedback, and sometimes the honesty you receive can sting your ego a bit. Keep in mind, though, that you want to receive honest feedback instead of hearing that everything's going great when it isn't.

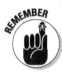

Parents are your primary source for the most reliable information, so tap into that source to get a true sense of how the season is going. Whenever you find out about any problems that a child is wrestling with, act quickly to correct them. Allowing problems — no matter how big or small — to linger for another couple of practices or games after you become aware of them isn't fair to your players. Remember that it's never too late to rescue a child's season.

Chapter 12

Taking Your Drills to the Next Level

*A*nytime you can bring together a group of kids who have a good understanding of offensive and defensive skills, coupled with the confidence and ability to perform them during matches, you have a fairly lethal combination that can lead to a lot of points — and fun. To bring such a group together, you need a wide range of effective, yet attention-grabbing drills at your disposal that you can use during your practices.

Because the drills you use during the first few weeks of the season probably won't grab the kids' interest — or match their ever-evolving skills — as the season progresses, you want to continue introducing them to exciting new ones. In this chapter, you can pick out all sorts of new drills that can help push their development along as you head down the homestretch of your season. You can also use these drills to ignite your own drill ideas.

Upgrading the Offense

The more fun your players have participating in your practices, the more skills they can develop, and the quicker they can progress. For kids around the age of 12, these drills are challenging enough to spur their development in a number of offensive elements. Check out the offensive drills in this section, which can meet all your practice planning needs because they're fun, productive, and easy to work into any session.

Packing more service punch

The more potent your team's serves are, the more problems you cause for your opponents, who are trying to transition into their attack. Because a strong serve is a valuable weapon for all your players to have, be sure to devote enough practice time to helping each player become comfortable hitting several different types of serves. The following drills are more challenging than those presented in Chapter 10 and are designed to help more advanced players become even more effective on the court.

Coach's challenge

Identifying openings on the court — and then being able to put serves there — is a great offensive weapon that can pay some big dividends for your team. As players progress in the sport, you want them to take into account how the opposition sets up to defend the service return and to be able to exploit any openings that exist. This drill helps players become more confident and accurate with their serves.

What you need: Three players and a cart of volleyballs.

How it works: One player handles the serving in this drill, while the other two players are the passers. The server begins the drill behind the baseline on one end of the court, with the coach standing off to the side, while the passers take their positions on the other side of the net, each splitting the court in two. The player serves the ball and tries to put it in different areas of the court so that the returners can't return it. The real challenge for the player is trying to hit the type of serve you announce to her just before she serves. You can challenge your players to hit a wide variety of serves during this drill, including the float, topspin, and jump serves.

Coaching pointers: Make sure the server isn't giving away where she intends to hit the ball before she actually delivers the serve. You don't want your players to angle their bodies in the direction they intend to serve before they even toss the ball in the air, and you certainly don't want them to stare at the area of the court they intend to aim for because effective defensive teams will pick up on these weaknesses and use them to their advantage during matches. You can turn this drill into a fun challenge among all the kids by awarding a point to the server each time she hits one that the pair can't return. Give each youngster ten serves, for example, and see who scores the most points.

Serve and defend

This drill forces servers to hit the ball to specific areas of the court, which helps them hone their overall serving accuracy. It also gives your other players a chance to work on different skills, including serve receive, setting, and attacking.

What you need: Seven players and a cart of volleyballs.

How it works: Designate two players to be servers and have them stand behind the baseline with some space between them (see Figure 12-1). Position two players in serve receive position on the opposite side of the court to return the serve. Put three other players inside the attack line, and designate the middle player the setter for this drill.

The following steps illustrate how the serve and defend drill works:

1. **Server A serves a ball at the passer directly across the net from her.**
2. **The youngster handling the serve passes the ball to the setter in the middle of the front row.**
3. **The setter sets the ball to one of the two front row hitters.**
4. **The hitter attacks the ball.**
5. **As soon as the hitter hits the ball, Server B serves a ball from the nearby cart to the player across from her at the other end of the court.**
6. **This player passes the ball to the setter.**
7. **The setter sets the ball to the other front row hitter to attack.**
8. **The hitter attacks the ball.**

 After the second hitter hits that ball, Server A grabs another ball from the cart and starts the rotation again.

Figure 12-1: The serve and defend drill works on both serving and returning serves.

Coaching pointers: You want to run this drill at a pretty fast pace to limit any standing-around time among the players. You can have the players mix up their serves by having them either hit their serves to the returner across the net or hit their serves crosscourt to the other back row player. Of course, make sure the servers use good form and don't step over the baseline before contacting the ball because doing so during a match gives the ball to the opposition.

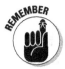

If you don't correct bad habits as soon as you see them during your practices, they will show up during your matches. You don't want your players to throw away scoring opportunities by committing violations that you can easily correct with simple practice drills.

Spicing up the setting

The more challenging situations you put your setters in during your practices, the better their chances are of performing well during matches. The following drills help prepare your setters for whatever the opponent throws at them and also help them develop the quick reaction skills they need when determining which teammate to set the ball to in the heat of the action.

Back row barrage

If you need a fast-paced setting drill that challenges setters to make a lot of quality sets in a short amount of time, this drill is for you.

What you need: One coach, five players, and a cart of volleyballs.

How it works: Position two players in the left and right corners of the back row, a setter in the right or left corner of the front row, and two hitters next to her in the front row (see Figure 12-2). You stand in the middle of the court near the attack line. You begin the drill by throwing a ball overhand — to simulate an attack shot — to one of the back row players. That back row player passes the ball to the setter, who delivers a set to one of the two hitters, who then attacks the ball. As soon as the setter makes contact with the ball, you throw another ball to one of the back row players to begin another point.

Coaching pointers: You can increase the difficulty of this drill by calling out which player you want the setter to deliver the ball to. Of course, the longer you wait to tell her whom to set the ball to, the more challenging the drill is for the setter because she has to react more and more quickly. This drill also enhances conditioning for all your players because you can go through a lot of points in a short amount of time. You can also add blockers to the mix to make the attack shots harder for the players to execute.

Figure 12-2:
The back
row barrage
forces kids
to make a
lot of sets
in a short
period of
time.

Side setter

An important skill for all setters to develop is the ability to recognize how the opponent is setting up its defense across the net and then to be able to adjust their sets accordingly. This drill helps setters become more comfortable making those last-second adjustments on where they set the ball.

What you need: One coach, four players, and a cart of volleyballs.

How it works: You take a position in the backcourt, while the designated setter for the drill positions herself near the net with a hitter on each side of her. Across the net, one player assumes the blocking role by standing in middle front (see Figure 12-3). You begin the drill by tossing a high ball to the setter. The moment before the setter makes contact with the ball, the defender slides to either her left or right to block one of the attackers. The setter's job is to recognize which direction the blocker moves and then to deliver the set in the opposite direction to the uncovered hitter. If she's successful, the attacker hits the ball into the open court. If she sends the ball to the player being blocked, the hitter attempts to attack the ball either through or around the blocker.

Coaching pointers: Make sure the setter watches the ball the whole time. Setters often sneak peeks across the net at the opposing team's blockers, but the moment they take their eyes off the ball, their chances of delivering an accurate set dwindle. Instead, encourage them to rely on recognizing motion out of the corners of their eyes, or to communicate with their teammates, to deliver their sets to the most advantageous positions on the floor.

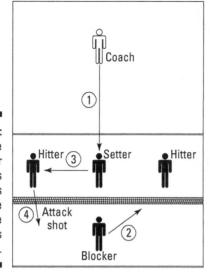

Figure 12-3:
The side setter drill helps players recognize what the opposition is doing.

Passing

Players enjoy the game a lot more when they're able to pass the ball exactly where they want to. The following drills help players become more accurate passers.

Trio touches

Because most of your opponents don't hit balls directly at your players during matches, your players need to be proficient at making accurate passes while on the move. When they can do so, they increase their chances of repeatedly creating good scoring opportunities, regardless of where the opponent hits the ball. This drill keeps your passers moving.

What you need: One coach, three players, and three balls.

How it works: Designate one player the passer for the drill and position her in the middle of the back row. A setter and hitter take their positions in the front row. You stand in the middle of the front row on the opposite side of the net with three balls. The drill begins when you toss a ball several steps to the passer's right (see Figure 12-4). She uses the shuffle step to move in that direction, always striving to take the ball in the middle of her body, and delivers a pass to the setter, who sets the ball for the attacker to hit. After the back row passer has made the pass, you toss a ball deep in the backcourt. She has to chase down the ball and send a much longer pass to the setter, who sets up the attacker for another hit. After your passer hits that ball, you toss a ball near the attack line. The player must move forward, sometimes using the run through or dive to keep the ball alive. Again, the setter handles the second contact, and the attacker takes the third hit.

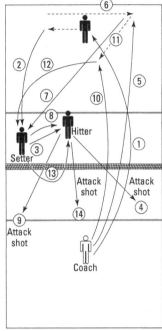

Figure 12-4:
The trio touches drill focuses on a variety of passing skills.

Coaching pointers: You can easily modify this drill based on the skills of your designated passer. For one of the more talented players on the team, you can really challenge her athleticism by tossing balls far away from the passer so that she has to hustle to make successful passes. Conversely, for the kids who are struggling with this element of the game, you can help build their confidence by giving them balls that are easier to get to. After they demonstrate that they can handle these easier balls, you can gradually challenge them with some more difficult ones.

Team relay

This drill enables a large group of players to work on their passing skills in a fun team environment.

What you need: Eight players and two balls.

How it works: Position four players on each side of the court, with a player in each of the left and right corners of the back row and two players in the front row on the left and right sides of the attack line (see Figure 12-5). Give one ball to one of the back row players on one side of the court and one ball to the player in the opposite corner on the other side of the court. On your whistle, the two players with the balls toss them in the air and use the forearm pass to pass the balls to the players nearest them in a clockwise rotation. The group continues passing the balls around the court.

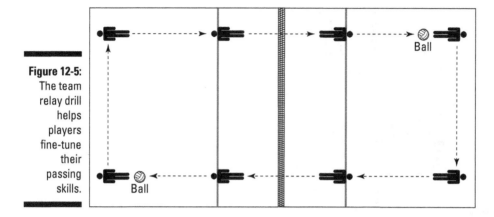

Figure 12-5:
The team relay drill helps players fine-tune their passing skills.

Coaching pointers: This can be a great team bonding drill because it requires all the kids to work together as a unit to keep the balls from hitting the floor. Challenge the kids to see how long they can keep both balls in the air. As the season progresses and you periodically return to this drill during your practices, you should see a significant improvement as the kids' passing skills develop from match to match. Also, to add a unique twist to this drill, you can have the kids reverse the direction of the balls on your whistle. Doing so helps keep their attention and adds a challenging element to the mix.

Attacking

You can have a roster overflowing with kids who are highly skilled at setting and passing, but if you don't have any players who are proficient at attacking the ball, your scoring output will fizzle. The following drills can help increase your team's offensive productivity.

Shooting gallery

Being able to hit an assortment of attack shots — not just the hard hit ones that kids find the most fun to deliver — gives your players a major advantage over the opponent's defense. When your attackers can hit several different shots, the opposing team has to keep guessing what type of shot is up next. This drill helps your players work on a variety of different attacks.

What you need: One coach, four players, and a cart of volleyballs.

How it works: A setter and attacker take their positions in the front row, and you take a position in the midcourt area. One blocker takes her position at the net opposite the attacker. You begin the drill by tossing a ball to the setter, who delivers a set to the hitter. As the hitter jumps in the air — and the blocker goes up to defend the shot — you shout out which type of shot

you want the player to hit, such as a roll shot, an off-speed attack, a tip, or just a basic attack shot, in which the player attempts to pound the ball into the floor.

Coaching pointers: Be sure to mix up the types of shots you call out so that the player gets some gamelike experience with each type. By adding another blocker to the drill, you can increase the drill's difficulty level for the players who aren't having much trouble getting the ball past one defender. Throughout the drill, you should also toss the ball to the setter at different heights and angles so that she can get comfortable dealing with all types of passes.

Backcourt attacks

Ideally, your team would be able to generate all of its attack from the front row, but sometimes your players simply can't get the ball up to that area of the court. In these situations, you have to rely on a longer range mode of attack. This drill addresses this kind of attack.

What you need: One coach, five players, and a cart of volleyballs.

How it works: Position two players behind the attack line on the left side of the court and two players in the same area on the right side (see Figure 12-6). A passer takes her position between the two pairs of hitters. You stand near the net. The drill begins when you throw a ball to the passer, who uses a forearm pass to put the ball in the air for the hitter on her left to hit a long shot across the net. As soon as the hitter makes contact with the ball, you send another ball to the passer, who sends the ball toward the hitter on her right side to deliver a long shot across the net. The drill continues like so, with the hitters on each side taking turns attacking passes.

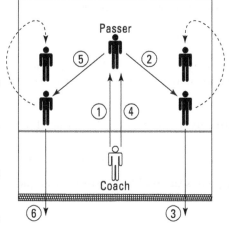

Figure 12-6: Well-rounded players can attack from both short and long ranges.

Coaching pointers: Work with the hitters on delivering the ball deep in the opponent's court, which makes setting up an attack difficult for opponents to do during matches. Also, keep a close eye on where your passers position the ball so that the hitters can make contact with it without having to worry about stepping on the attack line, which is a violation.

Strengthening the Defense

As your season moves along, you'll encounter teams that employ a variety of offensive attacks, and if your players aren't up to the defensive challenge, your kids may be overwhelmed during matches. In this section, we take a look at some drills that can help your players pick up and improve some key defensive skills that can neutralize the opponent's attack.

Serve receive

Teams that feature a number of kids with strong serving abilities make passing those serves — and setting up your offensive attack — quite challenging. The ability to disarm an opponent's serve with strong passing skills can provide a real boost to your players' confidence, plus it can help your players make a smoother transition to their attack. The following drills work on serve-receive passing, a key skill that is the springboard for setting up and executing your team's attack.

Spot the setter

To smoothly transition into your attack, the players handling the opponent's serve must be able to pass the ball to the setter on a consistent basis — with great accuracy. This drill works on developing that skill.

What you need: Six players and one ball.

How it works: Position three players on each side of the court — two players in the back row and one player near the net as the designated setter (see Figure 12-7).

1. **Player A begins the drill by serving a ball that either Player D or Player E returns.**

 Whoever receives the serve must pass the ball to Player F.

2. **Player F immediately passes the ball to Player E, who goes to the end line and serves a ball across the net.**

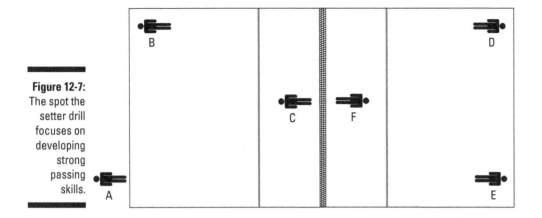

Figure 12-7:
The spot the
setter drill
focuses on
developing
strong
passing
skills.

3. **Either Player A or B handles the serve and attempts to pass it to Player C.**

4. **As soon as Player C has the ball, she passes it to Player B to serve the next point.**

Coaching pointers: To add a sense of competition, you can break the squad up into three-person teams and run minitournaments. For scoring purposes, when the setter doesn't have to move to get her hands on the passer's ball, the team receives two points, and when the setter has to take a step to get to the passer's ball, the team gets one point. If the team fails to return the serve, or the serving team doesn't get the serve over the net or keep it in bounds, they lose a point. Be sure to move the kids around so they all get a chance to work on serve receive. To mix up the drill, you can require players to hit different types of serves because doing so gives your passers practice passing.

Drop and roll

Being able to move from side to side quickly — and hit the floor when necessary — is a prerequisite not only for successfully passing out of serve receive but also for playing sound overall defense. Although you always want to stress to your players to stay on their feet if possible, this drill targets this element of the game for times when staying upright simply isn't an option.

What you need: A ball for each pair of players.

How it works: Pair up the kids and have them stand about 15 feet away from their partners with a lot of space between each pair. One player in each twosome starts with a ball. The player with the ball tosses it far enough to her partner's right that she must dive to get her arms on the ball as she attempts to pass the ball back to her partner. After making contact with the

ball, the player who received the ball quickly returns to the ready position and prepares to handle another ball that forces her to stretch to her left. After handling a series of balls going back and forth between her left and right, she switches roles with her partner and begins tossing the ball.

Coaching pointers: Anytime players are diving on the floor you have an increased risk of injury. Before starting the drill, take a few minutes to go over the correct form of extending for a shot that requires hitting the floor. (See Chapter 14 for more details on executing the pancake dig and the shoulder roll dig.) Even if you're coaching a highly skilled team, your brief refresher may help prevent an unwanted injury.

Digging

At the advanced levels of volleyball, teams run all sorts of attacking systems that help players get open to deliver hard-hitting attacks. So, regardless of how good your defensive alignment is, sometimes during matches your players will have to make digs to keep points alive. Take a look at the following digging drills that can help your players upgrade this element of the game.

Speed digs

The more your drills resemble real gamelike action, the better prepared your players are to perform their skills during matches. The speed digs drill gives players the chance to react to a lot of shots in a short period of time.

What you need: One coach, five players, and a cart of volleyballs.

How it works: Position two players slightly behind the attack line on one side of the court to be the diggers (see Figure 12-8). On the opposite side of the court, position a setter at the net with a hitter on each side of her. You stand near the attack line behind them. The drill begins when you feed a ball to the setter, who sets the ball for the hitter on her left, who attacks the ball at the two players on the other side of the net. They must communicate with each other and dig the ball. As soon as the setter has made contact with the ball, you toss her another ball, which she sets to the hitter on her right, who then delivers an attack. You continue at this fast pace so that the players have to face a barrage of shots to dig.

Coaching pointers: Make sure the players return to a good defensive position after each dig. During a drill like this, in which a lot of shots are coming at them quickly, kids have a tendency to forget about adhering to some of the basic fundamentals. You can mix up the drill by having the hitters use tips on occasion to give the defenders practice recognizing and reacting to different types of shots. This is a good drill to run on half the court, while you conduct another drill on the other half — conducting two drills at one time maximizes your practice time with the kids.

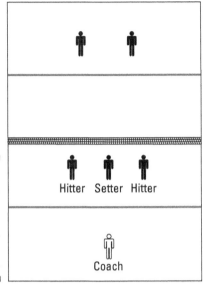

Figure 12-8:
Speed digs
is an action-
packed drill
that focuses
on digging
skills.

Hitter Setter Hitter

Coach

Dig-set-attack

During points in matches, players are often in position to touch the ball on two of the three contacts, so you want them to be able to maximize these touches for the team's benefit. This drill helps your players become more comfortable performing different skills on the move in quick succession.

What you need: One coach, four players, and a cart of volleyballs.

How it works: Position a setter (Player A) near the net. Players B, C, and D begin just behind the attack line (see Figure 12-9). You take your position near the net on the opposite side of the court.

1. **The drill begins when you send a ball to Player B.**

2. **Player B passes the ball to Player A.**

3. **Player A sets the ball for Player B to attack.**

4. **Player B hits the attack shot.**

5. **Player A moves back to the attack line behind the other two players.**

6. **Player B moves into the setting position (where Player A began) while you send a ball over the net for Player C to pass to Player B.**

7. **Each player moves through the rotation and assumes the position of Player B and repeats Steps 1 through 6.**

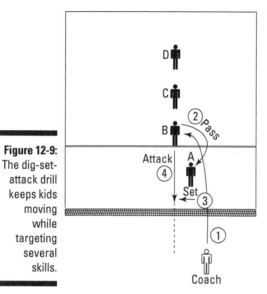

Figure 12-9:
The dig-set-attack drill keeps kids moving while targeting several skills.

Coaching pointers: This drill requires good footwork and solid fundamentals, so pay attention to the kids' defensive positioning as they deliver passes and their transitions as they move from defense to attack. If their passes to the setter are off the mark, take a look at the positioning of their arms on contact. You can run this drill on just half the court when you want to set up a second drill in a different area of the court for another group of kids.

Blocking

Blocking is one of the most rewarding aspects of performing on the defensive side of the net because it stops the opposition from scoring a point it thought was already won. Plus, the stronger your team is at blocking, the less work your back row players have to do trying to dig balls that the opposition pounds at them. The following drills can help your players execute blocks that frustrate the opposition and that may even lead to some points on the scoreboard for your own team.

One-on-one

During matches, defenders often find themselves one-on-one against their opponent's attacker. The more battles the defender can win — even if she only partially deflects the shot so her teammates have a better chance of keeping the ball alive — the more opportunities your team has to go on the attack. This drill can help your players win their share of one-on-one battles above the net.

What you need: One coach, three players, and a cart of volleyballs.

How it works: The setter takes her position near the net with a hitter to her outside near the sideline. The blocker takes a front row position across from the hitter on the opposite side of the net. You stand behind the attack line on the setter and hitter's side of the net. You begin the drill by tossing a ball to the setter, who sets it to the hitter. As the setter sets the ball, you announce whether you want the attacker to hit the ball down the line or crosscourt. The attacker tries to execute the shot, while the blocker attempts to block it.

Coaching pointers: Because the blocker knows where the hitter will hit the ball (thanks to your announcement to the hitter), this drill allows her to work on her positioning to get her hands on shots. Another benefit of this drill is that your attackers get to practice driving a ball through players who are in good position for the block. To make the drill more challenging for the blocker, let the hitter choose whether she wants to attack down the line or crosscourt.

Double duty

When you commit two players to blocking an attack shot at the net, you want to make sure they work well together. If they don't and balls get past them as a result, their teammates suffer because they have more territory to cover — and fewer bodies to do so. This drill helps your double blockers work on their timing and coordination.

What you need: One coach, four players, and a cart of volleyballs.

How it works: Have two players take their blocking positions in the front row, one in the middle and one on the right. Across the net, have a setter near the net next to an outside hitter. You stand near the attack line on the setter's side of the court to deliver balls to the setter. You begin the drill by tossing a ball to the setter, who sets to the outside hitter. As you send the ball in the setter's direction, the middle blocker slides over to form a double blocking combination. The attacker tries to hit the ball between the two blockers.

Coaching pointers: You can turn this drill into a competitive game among all the kids by awarding a point to any attacker who manages to hit the ball between the blockers, as well as a point to each blocker who prevents the ball from getting past her. You can also employ several variations of this drill, such as adding another hitter and blocker so that the middle defender has to react to where the ball is heading and then quickly slide over to form the double block with the appropriate blocker. Or, you can allow the attacker to try to hit balls to the blockers' left and right sides instead of between them each time. Doing so challenges your blockers to defend more space.

Putting It All Together: A Sample Practice Session

You're armed with a whole new set of drills for both the offensive and defensive sides of the net. Now you need to piece them together to formulate some creative practice plans that maximize your time with the kids. Turning to the drills we cover in this chapter can help maintain your players' enthusiasm for the sport, as well as upgrade the different areas of their game. The following is a sample one-hour practice that you can run using the drills from this chapter.

- ✔ **10 minutes:** Warm up. A quality warm-up helps prepare the kids' bodies for practice and reduces their chances of sustaining injuries. See Chapter 17 for a rundown on stretches.

- ✔ **5 minutes:** Run the team relay drill. This drill provides a fun way to kick off your practice, and it forces the kids to work together as a team, which is vital in volleyball. By emphasizing teamwork at the start of your practice, you increase the chances that the kids will work together as a unit during both the rest of that practice and the season as a whole.

- ✔ **20 minutes:** Run the speed digs and dig-set-attack drills. Split the team in half. Run half the kids through the speed digs drill on one side of the court, and run the other half through the dig-set-attack drill on the other side. After ten minutes, rotate the kids so they have a chance to participate in both drills.

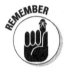

As a volleyball coach, you need to maximize every minute of your practice and take advantage of every inch of court space you have available. Keep in mind that you can run the drills covered in this chapter on half a court, most without having to make any modifications. You always want to strive to have all your players actively engaged in the practice, so the more players you have on your roster, the more important running drills simultaneously on each half of the court is.

- ✔ **10 minutes:** Run the serve and defend drill. Because this drill involves only seven players, you'll most likely have some players not involved in this drill. If so, pair up the extra players and have them work on another skill, such as passing the ball back and forth to each other. Then you can rotate the extra kids through the drill and have the kids who performed the drill first work on passing skills to eliminate any standing-around time.

- ✔ **10 minutes:** Run the one-on-one blocking drill. You can modify this drill by using it on just half the court. By doing so, you make room for some of the other players to work on their serves, while others can head to the other side of the court to work on their serve return. Be sure to rotate the kids around so they get a chance to participate in both drills.

✔ **5 minutes:** Cool down. Have your players go through some light stretching to cool down. While they're doing so, thank them for their hard work at practice and acknowledge areas of the game that they're improving in. Check out Chapter 17 for ideas on cooling down after practice.

You always want to dismiss players from your practice on a positive note so that when they return for the next session, or match, they're confident about their abilities to perform.

Part IV
Net Gains: Zeroing In on Advanced Volleyball Skills

The 5th Wave
By Rich Tennant

"Dan makes up his own stretching exercises for the kids. This is the one he uses at buffet lines."

In this part . . .

As your players become more proficient at executing sets and hitting attacks, among other skills, you need to keep pace with their learning by introducing more advanced techniques to elevate their levels of play. This part digs into the more advanced offensive and defensive techniques and features a variety of drills to help your players hone all these cool new skills.

Chapter 13

Revving Up the Offense

- -

In This Chapter

▶ Upgrading offensive skills

▶ Using advanced techniques

▶ Making the switch from defense to offense

- -

*B*eing able to deliver on-the-mark passes, well-placed sets, and perfectly timed attacks makes playing offense a whole lot of fun for players — when they can do so consistently. After they've mastered some of the basic offensive skills like the ones we discuss in Chapter 8, and after you've molded your team into a cohesive unit, both you and your players may be ready to move on to some more advanced techniques. These advanced techniques, such as jump serves and jump float serves, off-speed attacks, and so on, are critical for maintaining your team's interest, as well as for keeping opponents off balance on game day.

In this chapter, we take a look at some of the key offensive skills you can work on with your players to elevate their levels of play. Teaching kids new offensive skills they can showcase on game day not only makes coaching fun for you but also makes playing the game exciting and challenging for your players. After your players have had a chance to soak up these skills and incorporate them into their arsenal, they can progress to the even more advanced techniques we share in Chapter 15. But don't rush. Take your time and enjoy teaching your players these skills, and take pleasure in watching them perform them during matches.

Eyeing Advanced Offensive Techniques

As players begin to progress in different areas of the game — and you can help them do so by sticking to the material we present throughout this book! — they hunger for more instruction and welcome the chance to

develop more advanced techniques to help them become more effective players. As their coach, you need to be prepared to match their progress and meet their ever-changing needs by teaching them more advanced offensive techniques after they can successfully complete the basic skills. Otherwise, their development comes to a grinding halt, and their experience with you and the team suffers. In the following sections, we take a look at some advanced offensive techniques that you can work on with your players to help increase the potency of their attack.

 When you coach at a more advanced level of play, your offensive decisions depend not only on the skills and abilities of your players, but also on the strengths and weaknesses of your opponents. The younger your players are, the simpler your offensive game plan needs to be.

Pumping up the serving

When your team is serving, you want to capitalize on the opportunity to set the tone for the match and score points quickly. A strong serving team, one that keeps defenses constantly guessing which balls are headed where, can win its share of points without constantly making accurate passes and sets.

To take full advantage of your team's serves, keep the following tips in mind:

- **Watch the opposing team's warm-up.** You may be able to spot some weaknesses among its players that you can exploit during the match. For example, if you notice that certain players have trouble passing the ball, or controlling it, you can tell your kids to hit their serves to those players during the match.

- **Understand game situations.** A big lead by your team gives your players a chance to attempt hitting riskier serves because misfiring when you're comfortably in the lead isn't as costly as when you're in a close contest. Plus, by allowing your players to test out new skills on game day, you help them gain confidence so that when games are close, they can hit the more difficult serves when they need to.

- **Add variety.** Although your players may be able to smack hard and fast serves, having them mix up their speed keeps your opponent off balance and, thus, is a more effective strategy than having them hit extremely hard serves every time. Just as a pitcher in baseball alters the speed of his pitches from time to time to keep hitters off kilter, good volleyball servers can alter the speed of their serves to keep the defense guessing what's up next.

In the following sections, we take a look at some more advanced serving techniques your players can use to step up their game. By using these serving techniques, along with the basic ones we cover in Chapter 8, you can pose all sorts of problems for opposing teams.

Jump serve

As its name suggests, the *jump serve* is a serve that occurs when a player jumps in the air and makes contact with the ball while being airborne. Remember that the more height a player can generate on an attack, the stronger the shot is; the same idea applies to executing a really good jump serve. The higher the player jumps, the more force he can typically generate, which means the more difficulty the opposition has returning the serve. The following steps show how a player performs a jump serve:

1. **The player starts several feet behind the end line.**

 A right-handed server's right foot is slightly forward with her body weight leaning forward.

2. **A right-handed server holds the ball in the palm of her right hand at waist level.**

 Her palm faces up (see Figure 13-1).

3. **She takes a small step with her right foot and another step with her left foot and tosses the ball about 7 to 10 feet in the air (as shown in Figure 13-2).**

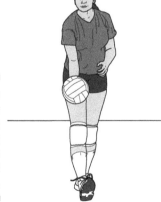

Figure 13-1:
Players hold the ball in the hand they're using to hit the serve.

4. **She steps with her right foot and then with her left foot, and then she jumps in the air.**

5. **She leaves her feet and arches her back.**

6. **She takes a full arm swing and makes contact with the ball out in front of her.**

 She contacts the ball at the peak of her jump. The palm of her hand contacts the ball just below the center of it (see Figure 13-3).

7. **She snaps her wrist through the ball so that her fingertips point toward the floor after contact (see Figure 13-4).**

 Doing so creates the topspin on the ball that helps it clear the net and dive toward the floor.

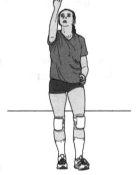

Figure 13-2: Players toss the ball 7 to 10 feet in the air for a jump serve.

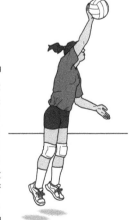

Figure 13-3: Players use a full arm swing and make contact with the ball out in front of them.

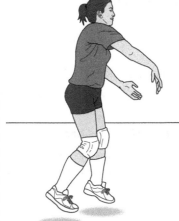

Figure 13-4:
Servers
generate
topspin on
the ball by
snapping
their wrists.

Most kids feel awkward tossing the ball with their serving hands, so start them out using both hands to make the toss. After they're comfortable with how high and where they need to toss the ball to make solid contact with it, remove their nondominant hands from the toss. Using a single-hand toss helps players keep the ball out in front of their serving shoulders, where they can maximize their power.

Make sure the kids start their serves while standing in the same spot each time. Otherwise, they risk stepping over the end line before making contact with the ball or hitting the ball too far behind the line, which gives the opposition even more time to react to the serve and to get in position to return it.

Jump float serve

The *jump float serve* is — as you can probably guess — a combination of the jump and float serves. The jump float serve doesn't generate the speed of the jump serve, but it does allow the server to hit the ball harder than she can with the float serve. (Check out Chapter 8 for how to execute a basic float serve.) The jump float serve is a popular serve to teach kids because it uses a controlled arm swing, which helps the kids nail this serve almost every time. The following steps show how a player hits a jump float serve:

1. **The player begins with her body facing the net.**

 She holds the ball out in front of her at waist level with two hands (see Figure 13-5).

2. **A right-handed server steps with her right foot, then her left foot (almost at the same time), and then she jumps into the air.**

3. **She uses both hands to toss the ball in the air out in front of her on the serving-hand side.**

 The toss isn't high and takes place at the same time that the player jumps into the air (see Figure 13-6).

4. **She raises her serving arm up quickly.**

 She keeps her wrist firm and makes contact in the middle of the ball with the palm of her hand (see Figure 13-7).

5. **After making contact with the ball, she stops her arm.**

 She fully extends her arm on contact but doesn't follow through. Instead, her elbow finishes above her ear with her hand higher than her head.

Figure 13-5:
The server holds the ball at waist level.

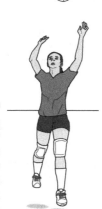

Figure 13-6:
The server tosses the ball slightly out in front of her.

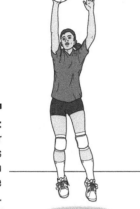

Figure 13-7:
The server
makes
contact in
the middle
of the ball.

Upgrading the attack

As your players gain experience throughout the season, the teams you go up against also make strides in their development and show signs of improvement in both returning serves and defending attacks. Being able to call upon different modes of attack can help you and your team attack your opponents' improvements and enjoy offensive success as the season moves along. In this section, we discuss some advanced offensive techniques your team can use to create chances to put the ball away on the opponent's side of the net.

When you're introducing new offensive techniques, the simpler your instructions, the better. You're much more effective when you focus on one or two different strategies and help the kids become proficient in those aspects of the game instead of overwhelming them with too much information. When you pile on too much instruction too soon, your players may feel overwhelmed, and as a result, they may be unable to perform any of the skills well.

Jump set

Whenever a setter can confuse his opponents and keep them guessing where the ball is going to land, he sets his team up to win points. One of the best advanced techniques your team can use to achieve this confusion is the *jump set*. The only difference between a jump set and a regular set is — as you probably guessed — the player jumps in the air to deliver the jump set. The following steps show how to perform a jump set:

1. **The player positions himself underneath the ball.**

 He uses the same hand and body positioning that he does when performing a set from the ground. (See Chapter 8 for details on executing basic sets.)

2. **A right-handed player takes a small step forward with his left foot and launches himself into the air while raising his arms above his head.**

3. **When he reaches the peak of his jump, he contacts the ball and pushes it in the direction he intends to set the ball (see Figure 13-8).**

Keep the following tips in mind when you teach jump setting to your team:

- Make sure setters are aware of who they're setting the ball to, as well as the strengths and weaknesses of those teammates. Some players react better to jump sets, while others don't adapt easily to the fast pace and, instead, prefer traditional sets that allow them extra time to prepare to hit the ball.

- Ensure that the setters make contact with the ball at the peak of the jump. Otherwise, most of the surprise element — the main advantage of the jump serve — is lost. Also, make sure that the player is making legal contact with the ball while performing the jump set.

- Use the jump set to catch the opponent off guard. Make sure that your setter doesn't overuse the technique on game day. Good defenses pick up on tendencies, so be sure your setter can consistently set the same set whether jump setting or setting from the ground. By mixing in the jump set with other types of sets, you take away the predictability that defenses can easily take advantage of.

- Spread the location of the jump sets around. When your players are executing jump sets, make sure they're distributing the sets to both the outside and middle hitters so that the opponent can't get a read on where the ball is going.

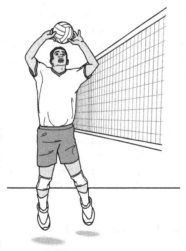

Figure 13-8:
The player is in the air when delivering a jump set.

Quick set

A *quick set* is a set that the setter makes while the attacking player is still jumping up or has already reached the highest point of her leap (see Figure 13-9). This type of set requires precise timing between the setter and the hitter. Use the following steps to execute a quick set:

1. **The player positions herself underneath the ball just as she does while executing a basic set (see Chapter 8).**

2. **The setter contacts the ball with the pads of her fingers above her head.**

3. **She sets the ball about a foot above the net as the attacker jumps into the air.**

Keep the following points in mind when you show your team how to execute the quick set:

- ✔ Use quick sets when you have accurate setters and athletic players who can jump high on your team.

- ✔ Go with the quick set when the opponent has successfully blocked your team's recent attacks. Defenses usually don't expect the quick set, which means you may be able to create scoring opportunities by using it.

- ✔ Use a quick set to force the opposing team's middle blocker to stay with the middle hitter, thus making her late on any other block to the outside.

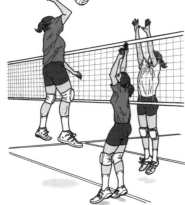

Figure 13-9: Quick sets require excellent timing between the setter and the attacker.

Slide attack

When players are positioned close to the net, they can use a *slide attack,* also called a *one-foot takeoff,* to catch their opponents off guard, as well as to give them a different type of attack to have to defend. A slide attack is simply an attack during which the hitter moves behind the setter and takes a running approach along the net to attack the ball instead of going right at the net. To perform a slide attack, your players need to do the following:

1. **The attacker either moves parallel to the net or approaches it at a 45-degree angle.**

2. **A right-handed hitter uses a three-step approach, beginning with a short step with her left foot.**

3. **She takes a longer second step with her right foot as the setter contacts the ball.**

4. **On her third step, she pushes off the floor with her left foot.**

 She lifts her right leg up so that her thigh is parallel to the floor (see Figure 13-10).

5. **She raises her left arm about shoulder level and her right, or hitting arm, up above head level.**

6. **She follows through and drives the ball toward the floor.**

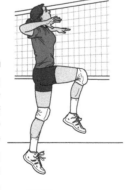

Figure 13-10: The player pushes off the floor and lifts her thigh during the slide attack.

A left-handed hitter modifies Steps 2 through 5, beginning by taking a short step with her right foot to begin the slide attack.

Off-speed attack

To mix up your team's attack — and, thus, to catch the opponent off guard — your hitters can occasionally use the *off-speed attack,* also called the *roll shot.* The off-speed attack simply refers to the shot made by an attacking player who hits the ball softly so that it lands in the middle of the court — out of the reach of both the blockers in the front row and the defenders in the back row. A variation of the off-speed attack is the *tip,* in which a player uses his fingertips to gently tap the ball into an open area of the court, rather than using a hitting motion. Use the following steps to show your players how to execute the off-speed attack:

1. **The player approaches the net the same way he does when he executes a basic attack.**

 For a rundown on how to execute a basic attack, check out Chapter 8.

2. **He raises both arms in the air to generate maximum force to get high in the air.**

3. **A right-handed player opens his right hip slightly (see Figure 13-11).**

4. **His right elbow is above his ear, and as he begins his swing, his left arm falls to waist level.**

5. **He uses a slower arm swing and contacts the bottom of the ball in front of his hitting shoulder with the palm of his hand.**

6. **While he contacts the ball, his fingers roll over the top of the ball, and he snaps his wrist.**

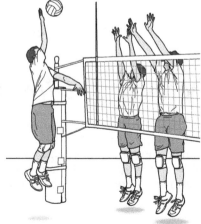

Figure 13-11:
A player uses both arms to jump in the air to deliver the off-speed attack.

If the opponents sense that an off-speed attack is coming — and they will if the attacker doesn't aggressively go up in the air exactly like he does when he delivers an attack — the surprise element is lost, not to mention the likelihood of the shot's success. Many players slow down their approach when they plan to execute this shot, which is a clear giveaway to the opposition that something other than an attack is coming. Scoring points is challenging enough when you don't alert the opposition to what's coming next, so make sure your players use the same approach toward the ball — regardless of whether they plan to use a basic attack or an off-speed attack.

Hitting a down ball

No matter how great you are at teaching your players setting techniques, sometimes during games even your best and most dependable setters can't put the ball exactly where they intend to. Points don't always work out how you or your team planned, but this fact is just a part of volleyball — and all other sports, for that matter. When things don't go as planned, the attacker can hit a down ball.

Hitting a *down ball* refers to when a player contacts the ball while either standing still (being way back in the court) or falling off balance. The key to hitting an effective down ball is putting the ball deep in the opponent's court, if possible, and then getting ready to play good defense. The following steps show how to hit a down ball:

1. **The player moves behind the ball quickly.**

2. **As the ball approaches, a right-handed player steps forward with his left foot.**

3. **He raises his left arm about shoulder high with his fingers pointing toward the net.**

4. **He lifts his right arm above his head and makes contact with the ball with his arm fully outstretched.**

5. **He snaps his wrist as he contacts the ball to create topspin on the shot.**

Transitioning from Defense to Offense

Some of the most interesting elements of volleyball to watch are the organized movements the players make on the court to *transition*, or switch from defense to offense, while the point is being contested. Volleyball can be a fast back-and-forth sport, so being able to make quick and smooth transitions is essential to being successful. A key point to remember about transitioning is

that when your team receives the serve, they can't switch from their positions until the opposing team's server has contacted the ball. (For more on the basic rules of the game, see Chapter 3.) As a result, your players need to be well versed in all areas of the game so that they can react to the ball from whichever position they're in at the time. The more well rounded your players are, the smoother their transitions from defense to offense can be.

In the following sections, we take a look at some of the responsibilities and strategies your players need to be aware of to make their transition from defense to offense effective rather than unproductive.

Examining the setter's responsibilities

In essence, your setter is your team's quarterback, and one of his main responsibilities is to read the play and react accordingly while your team transitions to offense. The following are some other responsibilities of the setter:

- ✔ **Touch the ball.** The number one responsibility of the setter is to get all second balls. He needs to read the play, maintain good position, move his feet, and make a good play on his teammate's pass to set up his team's attack.

- ✔ **Communicate.** When the setter is in position to make a play on the ball, he shouts "Mine!" to alert his teammates that he's going to deliver the set. When he doesn't think he can reach the ball in time, he shouts "Help!" as quickly as possible to alert his teammates that someone else needs to handle the set.

- ✔ **Make decisions quickly.** Volleyball isn't a slow-paced sport, so setters need to think quickly and move fast. The nature of the game leaves no time for sitting back and analyzing the play. Setters must determine, usually in the blink of an eye, whether they can handle the second touch alone or whether another player is in better position to make a play on the ball.

- ✔ **Recognize opposing defenses.** The stronger your setter is at recognizing how the opponent sets up to defend, the more effective he can be at choosing which set to make according to the defense's weaknesses.

As your players are learning different sets, encourage them to go with the easiest option available during games. After they gain some confidence and begin to develop a good feel for the game, encourage them to deliver more complex sets, such as the jump and back sets, that challenge the defense's abilities to read plays and react to them.

Taking a look at the front and back rows

At the beginning levels of volleyball, coaches have youngsters play the positions they rotate into instead of assuming specific roles as either setters or attackers. This strategy is known as *generalization*. As players begin to develop a more in-depth understanding of the game, how you structure your offense and how the team plays points drastically change. At the more advanced levels, players assume more specific responsibilities during a transition based on whether they're in the front or back row. The following points illustrate some of these responsibilities:

✔ **Front row:** In beginning level volleyball programs, your setters typically use regular sets, which go high and wide to the left or right sideline. The outside hitter attacks balls that the setter puts to the left side of the court, while the right side hitter assumes a similar role on the right side of the court. These types of sets give your hitters a good angle from which to approach the balls and hit them into the opponent's court.

In more advanced levels of play, your setter may not always be in a front row position. When the setter is in the back row, he needs to move to the front so that he's available to receive passes. The other front row players need to recognize the setter's actions and react to them by taking a step or two away from the net so that they can assume passing or attacking roles and move the ball over the net.

✔ **Back row:** At the younger levels of play, the primary responsibility of the back row is to deliver accurate passes to the setter, who can then set up the front row hitters.

At the more advanced levels of play, you can use your back row players for attacks, too. When players attack from the back row, their approach to the ball is similar to that of a front row attacker, with the one exception being that they have to begin their jump from behind the attack line. (For more on the markings on the court and game rules, head to Chapter 3.) Teams that can be aggressive from both the front and back rows pose a lot of headaches for opponents because defenders can never be sure from where on the court the attack will come, or from which player.

Covering blocked balls

A good offense isn't just one that generates good attacks — it's one that covers the hitter in case the opponent blocks the attack. *Covering* the attacker basically means surrounding your team's attacker so that if the opposition blocks the ball, teammates are in position to prevent the ball from

hitting the floor. No matter how good your hitters are, the opponent some-times blocks their attacks and sends the balls back to your side of the court. If your team is properly positioned, it can cover the hitter, react accordingly, and keep the ball alive. However, if your team isn't ready, or if they're caught standing flat footed and watching their teammate attack the ball, they'll most likely lose the point because the opponent will block the ball right back into the court.

Ideally, for the most basic coverage, you want to position three players around your hitter — one on each side of her and one behind her — along with the other two teammates deeper in the court (see Figure 13-12). Make sure that no open spaces lie around the hitter. As long as your players fill those gaps, they have a chance to stop a blocked ball from hitting the floor, and thus, to keep the ball alive. Based on how many blockers the opposition is using, you can adjust your coverage accordingly. For example, if the opponent relies on only one blocker, your coverage can feature just two players surrounding the attacker (because the chances of the ball being blocked aren't as good as when the opponent uses two or three blockers). Using only two players in your coverage allows you to cover more of the court with your remaining three players.

When players fill in around your hitter, you want them to assume a low center of gravity, much like they do when they're in position to return the serve. Being low to the ground allows them to get to balls more easily and more quickly. Remember that a hard hit attack that the opponent blocks is going to come back at your players just as hard, if not harder, so they can't waste any time getting into position.

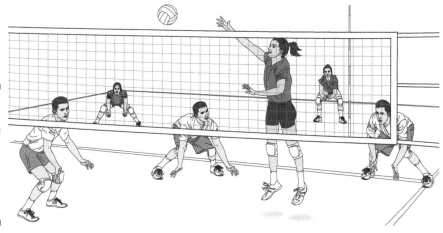

Figure 13-12: In a basic coverage of an attacker, three teammates surround her.

Turning broken plays to your advantage

Often the point doesn't go as expected — players make off-target passes, are slow to react to an opponent's attack, or simply misplay a ball. As a result, the team often has to scramble to keep the ball alive. When these situations occur, your team needs to know how to make adjustments to take advantage of the misplays. How your team reacts when misplays do take place dictates who wins those up-for-grab points that can impact who takes control of the match.

The best way to turn a misplay to your advantage is to have kids on the floor who hustle after the ball on every point. Anytime the ball is in the air and the point is up for grabs, the team that exhibits the most hustle has the decided advantage. During your practice drills, be sure to applaud those players who hustle after balls — even if their effort doesn't result in winning the point. When hustling becomes a habit among all your players, your team dramatically increases its chances of winning points, many of them key ones that can help decide the outcome of matches.

During your practices, make sure you spend some time working on dealing with broken plays. For example, have the kids take their positions on the court, and then randomly throw balls to different spots to force them to react and work hard to get the ball back across the net. Be sure to toss balls at different angles and speeds, as well as beyond the boundary lines. The more experience you give the kids with these types of random, broken shots, the better prepared they are to handle them on game day.

Chapter 14

Bolstering the Defense

In This Chapter

▶ Upgrading defensive skills

▶ Choosing your defensive alignment

*P*laying good defense match after match requires a total team effort, plus the ability to adapt to the opponent's ever-changing attacks. Players who are well versed in all aspects of defensive play — and who can perform these skills both whey they're fighting a tightly contested duel and when they're dominating a match — will squeeze the most out of their experience. If you're coaching advanced level players, or kids who need to upgrade their defensive skills to keep pace with opposing players' improvement on the offensive side of the net, this is where you want to be.

In this chapter, we take a look at some defensive techniques that you can work on with your more advanced players to help them enhance their performance during matches. We introduce some new defensive elements and explore a variety of defensive formations that your players can use to deny the opposition scoring opportunities while creating some for themselves.

Polishing Advanced Defensive Techniques

As your players become more comfortable — and more proficient — performing some of the basic defensive elements of the game, you may want to dig into some more advanced techniques to help catapult them to higher levels of play (check out Chapter 9 for more on the basics). The more defensive skills your players take on the court with them, the more fun they have playing the game, and the more effective the team becomes overall.

In this section, we take a look at using multiple blocking schemes to disrupt the opposition's attack, as well as executing pancake digs and shoulder rolls to recover from diving for the ball — a pair of techniques that players can call upon when the game day action heats up. By working on these techniques during your practices, you can help your players accelerate their defensive prowess and become an intimidating opponent to go up against.

Multiple blocking

A *multiple blocking scheme* is a technique that involves having more than one front row player trying to block an opponent's attack at the same time. When you use multiple blocking in your defense, the good news is that you increase your players' chances of blocking the shot, or at least deflecting it so that a teammate can make a play on it. After all, two sets of hands and arms in front of an attacker are usually more effective than one. The bad news, however — as you may have guessed — is that committing two players to blocking leaves you with one fewer player to cover the court if the shot does get through. Check out Chapter 9 for more on how to block.

So, how do you know whether to take the risk and try out this advanced technique on your team? Well, to make this decision, you have to look at the overall talent level of your squad and how well they understand and handle their defensive responsibilities. (See Chapter 11 for more details on evaluating your players.) If you have several players who are excellent at digging and pretty efficient at reading how plays unfold, you can employ two blockers against the opposition's attacks. Conversely, if your team struggles with court coverage, or doesn't communicate well with each other in terms of who's getting which ball, you probably want to stick with one blocker going up against the opponent's big hitter so that you have enough players in position to deal with the shots after they come across the net.

Keep a close watch on how your team fares during matches when you use a single block versus a double block. At the advanced levels of play, you may want to ask your assistant coach or a volunteer parent to track the percentage of points the team wins using the single block compared to using the double block. If you discover that the team is decidedly more successful with one approach, you have your answer on which type of blocking scheme to use the majority of the time.

Good defensive play doesn't have to translate into a blocked attack landing on the opponent's side of the court for a point — though that situation is always nice! The following are some additional points to keep in mind when you're trying to improve your team's blocking:

✔ **Stick with it.** Blocking a hard hit attack is one of the toughest volleyball skills to execute, so young players can easily become frustrated when they can't get their hands on many balls. Continue to encourage them, because even if they're not blocking shots, they're forcing the opponent's hitters to be aware of them by constantly being in the proper position. Making the opponent's attackers aware of your team's blockers, coupled with the opposing setter's responsibility to keep an eye on where her hitters are at all times, can eventually lead to some points falling in your team's favor.

✔ **Go strength against strength.** Use your best blocker against the opponent's best hitter. Remember, she doesn't have to physically block the ball to be successful. A blocker can be effective simply by forcing the attacker to hit the ball in a different direction than she'd planned, or by touching the ball to slow it down enough for a back row player to have an easier play on it.

✔ **Preach positioning.** If your blockers are continually in the proper position to force the opposing hitter to deliver the ball to specific areas of the court, your other players can cover those zones more effectively. Being ready to cover a particular zone takes away a lot of your team's guesswork of where the ball is headed, and less guesswork makes your entire team stronger and more effective on the defensive side. For more on zones and zone coverage, head to Chapter 3.

Remind players to keep their arms up in the air even when they land on the floor after attempting a block. If their timing is slightly off and they jumped early, keeping their arms raised provides more time to potentially make contact with the ball and deflect it so that a teammate has an opportunity to make a play on it. Keeping their arms raised also lowers their chances of making a net foul.

Pancake digs

Of course you want your players to stay on their feet all the time to dig the opponent's shots — but sometimes they just can't. Quite often, in fact, the only option a player has to hit a shot is to employ the *pancake dig,* a technique that your players should use only in difficult situations when there's no other way to get a hand on a slower moving ball. The pancake dig is similar to the dive (which we cover in Chapter 9), except that the player uses the back of her hand to contact the ball rather than two hands. The following explains how to execute the pancake dig:

1. **When the ball drops toward the floor on your player's side of the net, she dives forward toward the spot she anticipates the ball hitting.**

2. **She fully stretches out the arm that's closest to the ball (see Figure 14-1).**

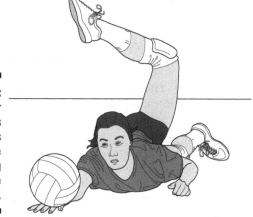

Figure 14-1:
The player
spreads
her fingers
wide while
executing
the pancake
dig.

3. She spreads her fingers wide and keeps them firmly on the court.

4. She uses the opposite hand to cushion her body as she goes down to the floor.

5. She keeps her head up and her eyes on the ball.

6. The ball bounces off the top of the player's hand that is in contact with the floor.

Shoulder roll

When opponents hit balls close to the floor to your player's left, right, or in front of her, she can dig the ball by using the *shoulder roll.* This is a more complex defensive recovery technique. You should only teach the shoulder roll to advanced level players, because your players risk injury when they perform it incorrectly. After all, the shoulder roll requires the player to roll her body over her shoulder on a hard court. The proper execution of the shoulder roll allows the player to quickly recover and return to her feet so that she's ready when the opponent hits another ball to her area of the court.

To execute a shoulder roll, a player performs the following steps:

1. **The player takes a step in the direction of the ball with her lead foot (see Figure 14-2).**

 For example, if the ball is hit to the right, the player steps with her right foot first.

2. **If she can't reach the ball with both hands, which is often the case, she reaches out with the arm nearest the ball.**

The player can use the shoulder roll whether she digs the ball with one or both arms.

3. **As she makes contact with the ball, she pushes through the ball with her legs, lowering herself to the floor (see Figure 14-3).**

4. **She bends her right knee and turns it midline toward her body.**

 Doing so helps prevent her kneecap from hitting the floor.

5. **She flicks her wrist after contacting the ball to help lift the ball up so that a teammate can make a play on it.**

6. **After making contact with the ball, she slides onto her back and then takes her right knee over her left shoulder — if she's going to her right (see Figure 14-4).**

 Her back faces the net momentarily.

7. **She completes her roll and lifts herself up so that she's back in the ready position (see Figure 14-5).**

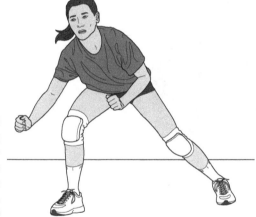

Figure 14-2:
The player steps toward the ball.

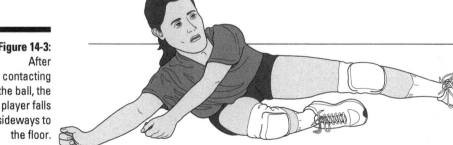

Figure 14-3:
After contacting the ball, the player falls sideways to the floor.

When you're working on this skill during your practices, make sure that you send balls to the players' left, right, and in front so that they receive plenty of opportunities to work on making digs with both hands.

When you introduce your players to the shoulder roll, try to work with them on a surface softer than the hard court until they become comfortable with the technique. If possible, take the kids outside to a grassy area to work on this skill. If working with them inside is your only option, use an old mattress or some type of soft mat. Anything that can cushion the kids' bodies as they hit the floor helps them more safely develop this defensive skill. You should emphasize that the shoulder roll is a recovery skill used after playing the ball, not a means of transportation. The players must run to the ball and make the dig, and then their momentum carries them through to the roll.

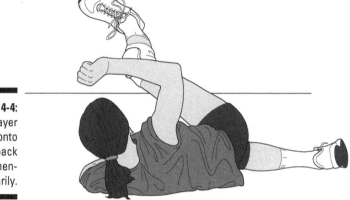

Figure 14-4:
The player slides onto her back momentarily.

Figure 14-5:
After completing the roll, the player returns to the ready position.

Determining Your Defense

Because your team spends roughly half their matches on defense, how you choose to align your players impacts how effective they are in dealing with the opposition's shots. When choosing which types of defense to use during your matches, you have a wide variety to pick from. While you're mulling over your options, take into account several factors, including the age and skill level of your players and the type of team you're going up against. Your opponent's style of play dictates, to some degree, which type of alignment you choose to use.

In this section, we take a look at two advanced defensive formations — the player back setup and the player up alignment — and how you can use them to defend against opponents who attack from the left or right side, or from directly up the middle. (For more basic defensive formations, check out Chapter 9, and for some more advanced ones head to Chapter 16.)

 With so many different defensive systems of play available, the only way you can discover which one fits best with your team is to try them out during your practices or during a scrimmage. Unless you give a few different ones a try, you can't get a true indication of which styles your players are most comfortable — and effective — playing.

 At the advanced levels of play, be sure to mix up the defensive alignments you use during matches. If your opponents don't know which type of system to expect on every point, you have a better chance of keeping them off balance, which means you have a better chance of capturing the point, too. A good time to change defenses is when the opposition is scoring a lot of points in succession because, obviously, what you're going with isn't working! If your team is younger and less experienced and you typically employ only one type of defense, you can try changing the players around a bit to different positions.

Player back setup

The *player back setup,* also known as the *perimeter defense,* is popular with many teams. As its name suggests, this defense focuses on covering the perimeter of the court. It's most effective when teams have good blockers because they can force the opposition to hit the ball along the sidelines, where the defenders are positioned, and not to the middle of the court, which isn't directly being covered by any one defender.

The following are some points to keep in mind when working with your team on this defensive formation:

- ✔ **Dealing with tips:** Because the middle of the court is most vulnerable in this setup, opponents often resort to using tips to get the ball over the blockers and into the middle of the court (for more details on tipping, head to Chapter 8). To counter this strategy, you want your blockers to force the attacker to have to tip the ball high up and over their hands. The longer the ball is in the air, the more time your players in the back row have to react to the shot and make a play on it before it touches the floor.

- ✔ **Handling balls in the corner:** The middle back defender is the player most responsible for handling balls hit into the back left and right corners. She has to stay deep in the court to deal with balls hit over the front row blockers to the back corners. In this perimeter defense, she also has to be ready to step forward and react to balls hit through the front row block that are headed toward the vulnerable middle of the court.

- ✔ **Digging crosscourt shots:** When challenged to dig balls hit crosscourt, the right back and left back players need to position themselves so that they're at a 45-degree angle to the sidelines. This setup gives them a clearer look at the hitter and a better idea of where the ball is headed.

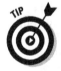 Work with all your players to pay close attention to the height of the opponent's sets so they can time their jumps accordingly. Also, the higher the ball is set, the more opportunities the attacker has to hit the ball deeper into the court. Whenever the set is high, back row defenders should adjust their positions accordingly and move farther from the net. Conversely, the attacker's options are limited with lower sets, so the back row defenders can step forward because the ball will likely be played closer to the net.

Going against a left side attack

When facing an opponent's left side attack, the middle front and right front players have the important responsibility of blocking the opponent's attack (see Figure 14-6). The right back player handles the down-the-line hits. The middle back and left back players handle deep balls that get through the blockers, as well as balls that the opponent tips over their teammates' blocks.

The left front player reacts to back sets (for more on back sets, head to Chapter 8) and makes plays on balls that the middle and right front players partially block.

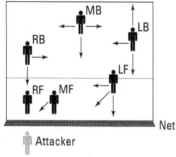

Figure 14-6: The middle and right front players have big blocking responsibilities.

Going against a right side attack

When opponents choose to attack from the right side, the defense's left front and middle front players are responsible for the main blocking duties (see Figure 14-7). Just like in the defensive positioning for the left side attack, the better those two front row players are at denying the attack, the more effective this setup is. In this alignment, the right back defender handles crosscourt attacks that get past the front row blockers, while the left back player takes balls that the opponent hits down the line.

The middle back player's role is the same as it is in the alignment for going against a left side attack — protecting the back row and reacting to tips and deflections in the midcourt area. The right front player handles the crosscourt attacks, as well as balls that the left front and middle front players deflect to her area of the court.

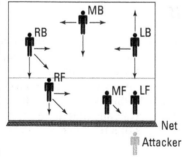

Figure 14-7: When facing a right side attack, defenders on the left play a key blocking role.

Going against a middle attack

When facing teams that employ the middle attack, again the blocking skills of the front row play a big role in how effective the perimeter defense is in denying the opposition not only points but also scoring opportunities, in general. Based on where the ball is set, either the left front or right front player (whoever is closer to the ball) joins the middle front player in attempting to block — or at least disrupt — the shot (see Figure 14-8). To be most effective with this formation, the front row blockers don't have to stop the shot completely — but they do have to get enough of their hands or arms on the ball to slow it down. Doing so enables their teammates to dig the ball and helps their team transition to the attack. Digging a ball hit by a middle hitter — one untouched by blockers — is really challenging for a defense to do and usually results in a point for the opposition.

Figure 14-8:
Facing a middle attack requires good blocking skills from the front row players.

Player up alignment

The *player up alignment* is a formation coaches use to take the middle of the court away from the opposition's attackers. One of the key components of this defense is that it uses a defender who stands behind the attack line (head to Chapter 3 for a rundown of all the markings on the court). Her primary responsibility is to mirror the ball wherever it goes. She positions herself behind her team's blockers and plays balls that are hit in the midcourt area. She also covers the opponent's tips that go over her teammates' blocks.

At the advanced levels of play, you may want to assign your setter the position behind the attack line. Doing so helps ensure that she's near the net and in good position to receive passes and make sets. However, if your opponents rely on tips over your team's blockers, you don't want your setter in this position because if she plays the first ball, she can't set the second ball for the attack.

Another option at the advanced levels of play is to position your weakest defensive player here, because tips are much easier to handle than powerful attacks. In this setup, a weaker defender won't have to try to dig those hard hit drives. Instead, she'll just have to pass tipped balls to the setter — a much easier assignment.

Facing a left side attack

Going against a left side attack requires the middle and right front players to assume the blocking responsibilities (see Figure 14-9), while the right back player positions herself behind the attack line behind those two players. The left front player rotates back to the attack line to take hard hit crosscourt balls; the left back player rotates into the crosscourt corner and protects the midcourt area, as well. The middle back player protects the backcourt area and rotates toward the right sideline.

Figure 14-9:
The right back player stands behind the attack line to stop a left side attack.

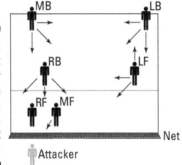

Facing a right side attack

When you're facing a right side attack, the positioning of the players doesn't change significantly (see Figure 14-10). The left front and middle front players handle the blocking of the opponent's attacking player, while the right back player stands behind the attack line behind her left and middle front teammates. The right front player deals with crosscourt attacks hit by the opponent, and the middle back player rotates to the crosscourt corner. The right front player also assists the right back player in handling tips and deflected attacks near the net. The left back player's top priority is dealing with any shots hit down the left sideline, and she also plays deflected balls that are in the vicinity of the attack line.

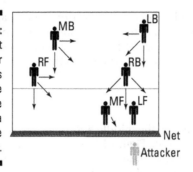

Figure 14-10:
The right
back player
stands
behind the
attack line
to stop a
right side
attack.

Facing a middle attack

When defending a middle attack (see Figure 14-11), the two defenders in the back row (left back and middle back) are responsible for covering a large area of the court. The right back player positions herself up close to the attack line and mirrors the positioning of the ball. This player must be able to move from sideline to sideline for this style of defense to be effective. The middle front and left front players handle the blocking of the opponent's attack, while the right front player steps back several feet from the net so that she's in position to handle deflections. In this formation, your players must be aware that the area of the court between the left front player and the sideline is exposed and that attackers often try to place the ball in that vicinity with a tip shot.

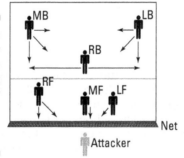

Figure 14-11:
Back row
players
cover a lot
of territory
when facing
a middle
attack.

Chapter 15

Stepping Up the Offense

· ·

· ·

*W*hen you're trying to put together a team that's capable of scoring points in bunches, you have a dizzying array of offensive systems to choose from. After your team has mastered the basics of passing, setting, and attacking, you're ready to take the offense to the next level and increase your team's firepower during actual matches. Doing so may seem a bit overwhelming at first glance.

Don't worry — this chapter runs through some of the different offensive systems you can use to maximize your players' skills and increase the potency of their attacks. We also dive into serve-receive formations, which provide the foundation for tough-to-defend attacks, and we explore how you can use different setting systems to meet your team's offensive needs.

Exploring Different Offensive Systems

As a youth volleyball coach, you can choose from a variety of offensive systems and even more ways to implement them. Choosing the right system for your team creates more opportunities to score points — and challenges the opposition to keep pace with your attacks. In volleyball, coaches and players use numbers to label different offensive systems. The first number refers to how many players are attackers, and the second number indicates how many players are setters. For example, a 5-1 system has five attackers and one setter.

When you're determining which type of system you want your players to run, consider the following tips:

- ✔ **Evaluate your personnel.** Choosing an offensive system without having a good understanding of your players' skills leaves little room for success and may even lead to a season full of disappointment for you and your players. The first step in choosing an offensive system, or systems, is to accurately evaluate the strengths and weaknesses of your players. Doing so enables you to pick a system that matches the skill and experience levels of your youngsters, which in turn, allows them to excel. (For more details on evaluating players, head to Chapter 5.)

- ✔ **Capitalize on your strengths.** If you have more strong hitters than effective setters on your team, choose the systems that allow your team to take advantage of those hitters. Kids enjoy the game more when they have numerous opportunities to use the skills they have.

- ✔ **Hide your weaknesses.** You can quickly eliminate the systems that don't match your team's skill level. For example, if you have only one player who can make accurate sets on a consistent basis, you can rule out the 6-2 and 4-2 offensive systems, because most of their success relies on the abilities of two players to handle the setting duties for the team.

At the beginning levels of play, you want to give the kids experience in all the positions so that they can receive a full introduction to the sport. Thus, you want to run a 6-6 offensive formation. In this system, each child plays the position he rotates into — you count on each one to hit and set — and you don't switch or move players around after the point begins. For example, a player in the middle front position sets and blocks from that area of the court, and when he rotates to his right, he handles hitting and blocking from the right front.

Experiment with the different types of offensive systems during your practices even if you think you know which style of play works best for your team. For example, you may discover that the 6-2 formation is quite effective for your team even though you originally thought its reliance on two setters made it ineffective. Trying different approaches exposes kids to various styles of play, which can be both refreshing and challenging. Plus, trying out several approaches gives you a good look at which ones are likely to work best when matches roll around.

This section takes a closer look at the three most popular offensive systems. The more advanced your team is, the more opportunities you have to implement one of these systems (or even a combination of two or three of them, depending on your lineup).

Implementing the 6-2

Coaches who have a roster full of strong hitters often turn to the *6-2 offensive system,* which features six hitters and two setters (see Figure 15-1). In this system, the first setter — the player you want orchestrating the attack, if possible — always comes from the back row, while the second setter plays opposite him in the front row (this setup allows you to play a right side player who may be a stronger hitter and blocker). When the second setter is in the front row, coaches often substitute a better hitter in his place — if he's not an effective hitter. Then when the substitute hitter rotates to the back row, the coach subs the setter back in (at the same time, the first setter rotates to the front row). The team's strongest hitter begins in the left front position, while the fourth best hitter occupies the right front position. In the back row, the second strongest hitter plays on the right, while the third best hitter takes the left side.

When all your hitters possess similar abilities, how you position them around your setters doesn't really matter. However, when the skill levels of your hitters vary considerably, how you set them up becomes quite important because you don't want to have your two best hitters stuck in the back row for several points after the players begin rotating. The opposition can exploit this setup and increase its chances of stringing together several points. By having the strongest hitter begin in the left front position and the number two hitter starting at the right back slot, you ensure that your attack remains balanced and difficult for the opponent to defend on every point.

Although this system takes advantage of the team's excellent hitters, much of its success depends on the quality of the setting — both the setter's court skills and his understanding of offensive and defensive strategy. When your setter has several strong hitters to choose from, he must be able to recognize how the opponent is defending the court and then pick out which teammates are in the most advantageous positions to receive sets and deliver attacks.

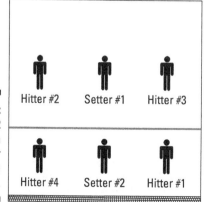

Figure 15-1: The 6-2 formation uses a pair of setters on the attack.

Hitter #2 Setter #1 Hitter #3

Hitter #4 Setter #2 Hitter #1

Attacking with the 5-1

When coaches have one setter who thoroughly understands the game and whom they can count on to deliver accurate sets all match long, they often choose the *5-1 offensive system*. This alignment features five hitters and one setter. The one setter is responsible for making sure this system is effective and point producing. In younger age groups, when the setter is in the front row, he can set balls from the middle front position to either the left front position or the right front position. In older age groups, while in the front row, the setter plays from the right front position, which allows more attacking options with his hitters; from the back row, the setter can choose to set the ball to one of three hitters (the left, middle, or right back positions).

In the 5-1 system (see Figure 15-2), coaches typically place their setter in the right back position — typically the setter's defensive base during play — with the team's strongest hitter in the right front position and the second strongest hitter in the middle back position. (See "Working with the back-court setter" later in this chapter.) By sandwiching your setter between these two hitters in the rotation, all three of them are together in the front row, which puts the team in an advantageous position to capitalize on their strengths and score points. Rounding out the alignment are the third, fourth, and fifth best hitters, who begin in the front left, left back, and middle front positions, respectively.

Figure 15-2: The 5-1 formation relies on one setter to handle all the setting duties.

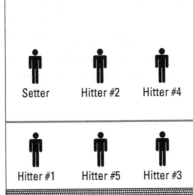

| Setter | Hitter #2 | Hitter #4 |
| Hitter #1 | Hitter #5 | Hitter #3 |

Using the 4-2

The *4-2 offensive system* allows coaches to employ a balanced attack by positioning one setter in both the front and back rows at all times during the rotation. This system works well for teams that attack well from the front row because a front row setter is always accessible to receive the initial pass. In

the 4-2 alignment, used mainly by younger age groups, the team's strongest setter begins in the middle front, while the second best setter starts in the middle back (see Figure 15-3). The front row setter is between the first and fourth strongest hitters, while the back row setter is between the second and third strongest hitters.

Here are a couple of points to keep in mind when you're operating the 4-2 system:

- ✔ **Use dumps to your advantage.** Because this system always features a setter in the front row, only two front row hitters are available. Alert your setter to be on the lookout during points for opportunities to dump, or send, the ball over the net on the second hit to catch the defense off balance — instead of always setting the ball for a third hit.

- ✔ **Pick up the pace.** If you recognize during matches that the opponent struggles against a faster paced tempo, as soon as the point begins, have your setter move into the right front position. Because the hitters are in front of him when he's in this position, he can deliver quick sets that the hitters can pounce on. Doing so leaves little time for the opposition to react.

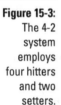

Figure 15-3: The 4-2 system employs four hitters and two setters.

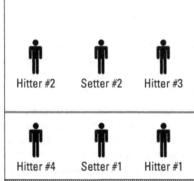

Hitter #2 Setter #2 Hitter #3

Hitter #4 Setter #1 Hitter #1

Analyzing Serve-Receive and Passing Formations

Regardless of how accurately you match up your team's strengths with an effective offensive system, your team's chances of enjoying a successful attack plummet when your serve-receive formation isn't equally effective. A

serve-receive formation is how you choose to set up your players on the court when the opposition is serving. When you're choosing your serve-receive formations, you need to take into account the following three factors:

- ✔ **Which players you want to handle the serve:** So that those players can effectively set up the rest of the attack

- ✔ **Which type of attack you want to run:** So that the players are in the most advantageous positions to make the transition to the attack

- ✔ **Where you want your setter to be:** So that he can get in position quickly to deliver accurate sets

The serve-receive formations we cover in this section give you a lot of flexibility because you can use them with whichever offensive approach your team employs — with just a few minor adjustments. Keep the following points in mind when you devise your strategies for receiving serves:

- ✔ **Stay balanced.** You want the same number of players on each half of the court. You create openings for the opposing server to target when you overload one side.

- ✔ **Focus on the middle.** You always want to try and keep your best passer in the middle of the floor because the majority of the serves hit this part of the court.

- ✔ **Mix up your formations.** One of the best ways to increase your team's chances of winning points is to avoid predictability. If you choose to use the same serve-receive formation on every point, an observant opposing team can easily adapt and use your predictability to its advantage. By mixing up your formations, at least on occasion, you force the opposing servers to guess which formation you will use each play.

- ✔ **Situate the setter.** You want your setter to be able to get to his predetermined area on the court as fast as possible. The more territory he has to cover to get into position, the less likely the attack is to run smoothly. So, for example, if you have a balanced team with two players who are capable of handling the setting duties, you can have these players spaced out on the court when your team is required to rotate following points. Doing so ensures that during your rotation you always have one setter who is in the front row, which eliminates players having to move from the back to the front row to deliver sets.

The best serve-receive formations are those that put your team's top passers in position to handle the majority of the serves. These formations give your offense the chance to set up and run its attack as efficiently as possible on every serve.

The fewer players you rely on to handle the opposition's serves, the less likely your team is to experience communication breakdowns, which usually result in easy points for the opposition. Of course, your first priority on any service return is keeping the ball alive; therefore, go with the alignments that allow your team to do so — regardless of how many players those alignments take. As players become more skilled, you can gradually rely on fewer of them to handle the serve-return responsibilities.

Going with the four-player formation

The *four-player formation* is the most popular serve-receive formation in youth volleyball. Four players are responsible for handling serves hit in their areas of the court (see Figure 15-4). This formation is effective because it allows the hitters to move into position for the attack, and it keeps the setters from regularly handling the serves.

During your practices, pay close attention to which players work well together in reading the incoming serves, communicating with each other, and reacting to the ball. For whatever reason, certain kids just have a knack for knowing what other players are going to do. After you discover which players communicate well with one another, you want to position them next to one another — if possible — because their strong communication skills can help form a much stronger serve-receive alignment.

Whenever your team earns the serve, all your players have to rotate, which makes getting into assigned positions during points slightly more challenging for your players because of all the switching that must be done. Keep in mind that players on the serving team can switch to their preferred positions as soon as the server makes contact with the ball — as long as they're in their proper positions before that contact. For more on the rules of the game, refer to Chapter 3.

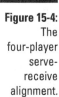

Figure 15-4:
The four-player serve-receive alignment.

Middle back

Left back

Middle front

Left front

Right back

Right front

Dissecting the three-player formation

The *three-player formation* positions three players, who are responsible for handling all serves, across the court behind the attack line (see Figure 15-5). These three players nearly form a straight line, with the left and right back players just a couple of steps in front of the middle back player. Keep in mind that all three of your passers don't have to be in the back row for this setup. For example, if your right back player is one of the team's weaker passers, you can slide him into the corner and move your right front player to pass.

When using this alignment, you want your three strongest passers to handle the serves. Doing so reduces the number of communication problems that pop up because fewer players go after each serve. Of course, one disadvantage of having fewer bodies responsible for passing balls off the serve is that each passer is responsible for covering more of the court.

Figure 15-5:
The three-player system reduces the chances of communication problems among the kids.

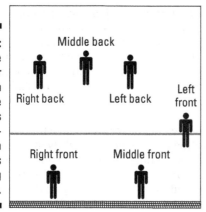

Using the two-player formation

While this system isn't used very often at the younger levels of volleyball, if you have an advanced team comprised of players who are quite proficient at passing, you may want to use the *two-player formation* (see Figure 15-6). With this system, the responsibility of managing the service return falls on the shoulders of two back row players, the middle back player and either the right or left back player. When you can rely on just two players to handle serve receive, you free up the other players on the court to focus solely on their other responsibilities. Plus, hitters who don't have to worry about passing can assume their attacking positions and better prepare themselves to deliver effective hits. Of course, relying on two players to handle the opposition's serves means that each player has to cover a lot of court space, so when you choose this alignment be sure that your passers are up for the task.

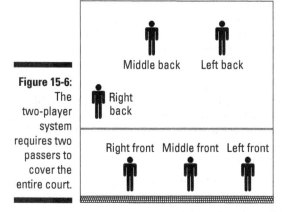

Sizing Up Setting Systems

Every decision you make impacts — to varying degrees — how successful your team is at producing points with its attack. One decision that packs an especially influential punch is deciding which type of setting system to run. Setting systems focus on taking advantage of how skilled your setter or setters are, whereas offensive systems emphasize putting kids in the best position to score points while on the attack. In volleyball, your setter plays a huge role not only in how successful your team is at scoring points, but also how successful it is at creating quality opportunities to do so. Choosing a setting system that matches your setter's skill and comfort levels can be the difference between coaching a team that drives opponents crazy with its high-powered attack and coaching one that struggles to generate any scoring chances.

In this section, we take a look at the frontcourt and backcourt setter alignments. We dissect the pros and cons of each so that you can determine which approach best fits your team.

Playing with the frontcourt setter

As the name clearly states, the *frontcourt setter alignment* places the setter in the frontcourt. As a result, only two hitters are available in the frontcourt in this system. Keep the following points in mind when you use this type of alignment:

✔ **Minimize movement.** In this alignment, the setter typically has to take just a few steps to get in position to receive the ball. Minimizing the movement the setter has to make eliminates a lot of bad hits because the setter is likely to be ready every time a teammate delivers the ball to him.

✔ **Reduce pressure on the setter.** In the frontcourt setter alignment, the setter has two primary attacking options — the two players joining him in the front row — which eliminates a lot of the decision making that often handcuffs youngsters who are learning this position. Of course, if your setter has a strong back row player, he can also deliver sets for that player to hit legally from behind the attack line.

After setters become comfortable operating in the frontcourt system, they can likely make a smoother transition to the backcourt alignment — which involves more offensive options (see the "Working with the backcourt setter" section in this chapter for more information).

✔ **Use surprise attacks.** Although decreasing the number of attacking options can be helpful to the setter, doing so is also one of the biggest drawbacks of the frontcourt setter alignment because it takes away some offensive creativity. A great way to counter this drawback is to use your setter to attack the ball on the second hit every so often. Besides having the element of surprise on your side, you also give the opposition one more player to block. Even if the play isn't successful, it can benefit your team's attack. As soon as the opposing players know that the setter is capable of joining the attack — and willing to do so at anytime — they won't be quite as aggressive when they block your front row hitters because they know they have to account for your setter, too.

The back set (when a setter sends the ball over his head to an attacker he's facing away from) is an effective tool for setters to use in this alignment to help keep the opponent off balance. For the scoop on executing the back set, head to Chapter 8.

✔ **Incorporate strong attacking skills.** Because the opposition typically recognizes which type of alignment you're using, it sometimes responds with a double block on your front row hitters — after all, the opposition has only two hitters to defend. This double-block response makes your hitters' jobs more challenging because they face two pairs of hands attempting to block their shots and disrupt where they want to place the ball. Thus, to be effective, your attackers must be strong and confident.

Your attackers enjoy more success when they have a variety of shots to call on instead of trying to hit a ball between or around two or three defenders. The tip (see Chapter 8) and off-speed attack (see Chapter 13) are two excellent tools to have in your offensive arsenal. Using them can help keep the opposition guessing what your team will do next.

Working with the backcourt setter

In the *backcourt setter alignment,* three frontcourt attackers are available because the setter maneuvers forward from the backcourt. Coaches often use this formation in conjunction with the 5-1 offensive system (check out the "Attacking with the 5-1" section in this chapter for more info). Keep the following points in mind when you use the backcourt setter alignment:

- ✔ **Get creative.** With three hitters in the front row, you have many attacking options to choose from. Be sure your setter takes full advantage of the many possible attacks and distributes the ball around to all the hitters during the match instead of targeting the same player — or location — over and over.

 You can ask an assistant coach to track some basic statistics that you can use to help your team become a more efficient and well-balanced unit. For example, have the assistant track where your setter makes each set. After the match, you can review the numbers in private. You may find that your setter makes the majority of sets to a specific area of the court. To help your setter become more effective, make adjustments during your next practice to focus the setter on being less predictable with his sets so that the opposition can't always figure out where the setter plans to hit the ball.

 Keep in mind the importance of deception when you run your systems. Although fakes are useful tools to use with any offense, they can be especially effective in this alignment. By having each of the hitters step toward the net and launch themselves in the air on every set — regardless of whether the ball is being set their way or not — you force the opposition to defend every player. The defense also has difficulty employing double-blocking schemes, so your players have to deal with only the single block on the majority of their hits.

- ✔ **Recognize the defensive positioning.** Having three hitters to defend makes double blocking difficult for the opposition to implement because they don't have enough time to get into position and react to where the ball is set. However, some defenses are good enough to implement a double block or two anyway. When the setter recognizes which hitters the opponent tends to try to use a double block on, he can adjust accordingly and send sets to other players.

Chapter 16

Tightening the Defense

*O*ne sign of a good offensive team is its ability to attack using a variety of different techniques. On the flip side, one of the best indicators of a strong defensive squad is its ability to adapt to whatever approach the opponent throws at it and — of course — its success in denying points. The more prepared your team is to handle the many different attacking systems they may see during the season, the greater the chances are that they enjoy ample success in shutting them down.

In this chapter, you find everything you need to push your team's defensive play to the next level. We detail the defensive secrets for shutting down back row and off-speed attacks. We also focus on transitioning from defense to offense, handling free balls, and using rotation and perimeter defenses to keep the opponent guessing what you'll do next.

Derailing Different Attacks

Well-coached teams use hitters from all three positions along the front row, so when your players are in defensive mode, they need to be able to adjust quickly to a variety of attack styles from different areas of the court. Teams that can employ various defensive techniques make zeroing in on areas to attack more difficult for the opposition to do. The more challenging you make the attacking team's job, the more success your team can enjoy in preventing scoring opportunities — as well as creating more chances to transition to the attack.

The back row and off-speed attacks are two of the different attacking styles teams use in their pursuit of points. How your team adjusts to these attacks when they appear during matches defines how successful they are in denying scoring opportunities.

Going up against the back row attack

Players can attack from the back row — as long as they're in legal position and jump with both feet behind the attack line to hit a ball that's above the height of the net. (For more on specific rules of the game, head to Chapter 3.) Opponents who use this mode of attack — whether as a part of their offensive strategy or simply on the occasion when a rally puts the ball in that position on the court — present more challenges for your team on defense because a back row attack doesn't allow your defense to focus all of its attention on stopping the front row attackers. The more diverse an opponent's attack, the more challenges your team faces in slowing it down.

The better prepared your players are for dealing with the back row attack, the more successful they can be as a team, and the less potent the opposition's attack is. Keep the following points in mind when you focus on derailing the back row attack:

- **Be patient along the front row.** Players near the net are always anxious to get their hands in the air to prevent the attacked ball from clearing the net; however, timing a blocking attempt on a back row attack can be difficult because the ball that comes from the back row takes slightly longer to reach the defender. Remind your front row players to refrain from going airborne at the same time the attacker does because, if they do jump at the same time, they won't likely block the ball — or even touch it. They need to hold off for a split second before jumping to increase the likelihood of getting their hands on the shot.

- **Go low near the net.** The front row players who aren't involved in the block should position themselves near the attack line and cover their blockers. Doing so gives them the best chance of reaching the balls that their teammates deflect by blocking.

- **Dig deep.** Chances are good that a ball from a back row attack is traveling fast and going deep in the court. Thus, you want your back row players deep in the court so they have an extra split second to handle the fast ball. If they creep in too close to the attack line, they make successfully digging the back row attacks much tougher because they give themselves less time to react to them.

Defeating an off-speed attack

The *off-speed attack,* also called *tipping,* is a popular offensive technique that teams use as a surprise tactic. They hit the ball with less force, usually with their fingertips, and hope to catch the defense off guard and out of position.

Roll shots, those hit softly with topspin, also fit into this category. Opponents usually choose to go with an off-speed attack after they notice a soft spot in the defensive alignment that they can exploit.

To stop an opponent's off-speed attack from gobbling up points, use the following tactics:

✔ **Zone 6 movement:** The middle back player occupying Zone 6 must move up several steps so she's right behind the attack line (for a refresher on the six zones of the court, head to Chapter 3). She positions herself so that she's behind the middle front blocker (see Figure 16-1). From there, she can make plays in the midcourt area, as well as get her hands on balls tipped near the sideline.

✔ **Wing movement:** The wing defenders — the players in the left and right back positions — take a couple of steps back toward the corners of the court. Because the middle back player scoots up to deal with tips, the wing defenders' responsibility shifts to covering more of the backcourt area, devoting less attention to covering balls hit near the attack line.

✔ **Double trouble:** The stronger your right and middle front blockers are, the more effective they can be as a unit. The weak spot of this defense is deep in the middle of the court, but if the front two blockers deny the opposition the off-speed attack by constantly being in good defensive position, the attackers won't enjoy success delivering the ball where they want to, or will at least face a more challenging time doing so.

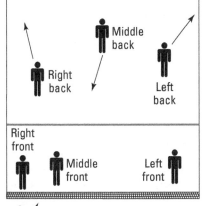

Figure 16-1: Proper defensive positioning can slow down an off-speed attack.

Eyeing Special Defenses

You can take several different approaches to help your players learn and excel on the defensive side of the net. If you stick around the sport long enough, you'll discover that some groups of kids have more success when they allow the opponent to dictate the play while they use their quickness to react to where the ball ends up. Other groups have more success when they adopt a more aggressive defensive style of play that forces the opponent into more difficult shots.

In this section, we take a look at a variety of different defensive styles of play, such as switching in transition, handling a free ball, and using the rotation and perimeter defenses, you can use to keep the opposition guessing what it will face next. Plus, being able to play a variety of defenses increases your team's chances of finding a style of play that causes a lot of problems for your opponents.

During your practices, or in scrimmages with other teams, experiment with several different types of defenses. Besides helping you find out which style of play the kids are most comfortable and effective playing, switching up your defense keeps the season interesting as you expose your players to the many different elements of the game. Plus, you want to make adjustments with your defense based on what the opposition is doing and what you find works best in slowing down its attack.

Switching in transition

At the advanced levels of volleyball, coaches want their players to be in the positions they excel at — which requires a lot of coordinated movement while the point is being played. This strategy of moving players into their strongest positions is known as *rotational transition* or *switching*.

Switching in serve

When your team is serving, your players' transitions to their positions are usually quite trouble free. As soon as your server contacts the ball, your players should move into their positions. In the front row, the outside players run behind the middle blocker, taking the most direct route to their positions as possible. The less time your players waste moving into position, the more time they have to set up a properly aligned defense. When the setter is in the frontcourt, the team can dig and pass the ball a little lower simply because the setter is already in position near the net. When the setter

begins in the backcourt, teammates must be aware of this positioning and adjust accordingly by making their passes and digs higher. Doing so gives the setter time to get into position before making contact with the ball.

During your practices, help the kids move at the sound of the server's hand contacting the ball. After all, during a match, you want your players' eyes zeroed in on their opponent across the net — not peeking over their shoulders to see when their teammate has served the ball.

Because players can serve from anywhere behind the baseline, they can stand near where their back row position is. Doing so enables them to quickly take their position on the floor after they serve, without giving the opposition a chance to capitalize on the time they take to move into position.

Switching in serve receive

By far, the more complicated rotational transition takes place during serve receive. Of course you want to have your best hitters in position to attack, but your attack can operate at its most effective level only if the best passers are in position to handle the serve.

To get your best hitters in position, you first need to make sure your setter has an easy transition to her spot on the court. Moving from the left back position is the most difficult move for a setter because she has to cover so much territory to get into position. When the setter is in the backcourt, work with your players to dig the ball a little higher to give her extra time to get into position. When she's already in the front row, your players can dig lower because she doesn't need the additional time to get ready.

During transitioning, your setter can't forget to play defense. Sometimes during the match, she needs to make the first contact on serve receive, although doing so isn't ideal. For situations like this, you should have a plan in place. For example, you may want to designate a particular player or position to handle the set when the setter makes the first contact. Also, make sure you run through scenarios like this one during your practices so that your players are prepared to deal with them when they pop up in the heat of the match.

Another important aspect of rotational transition is deciding which type of hitter coverage to use when your team's receiving serves. After one of your players passes the ball and your setter sets it, the other players on the court have to move into position to cover the hitter in case the opponent blocks her attack and the ball ends up on your team's side of the net again. Your team has to try to keep the ball alive and generate an attack from the positions they're in when the ball crosses the net again. If the attack isn't blocked, your players can continue with their transition to their positions.

Facing a free ball

A *free ball* refers to a softly hit ball that your opponents hit over the net when they're unable to generate an attack during that point — usually with a forearm pass. Defensive teams typically have to resort to this type of play when a player makes a bad first pass that the setter can't put in good attacking position for her teammates. When your defense receives a free ball, you want to capitalize on the opportunity because, during most matches, your team will rarely gain control of the ball without having to dig an attack shot — especially at the advanced levels of play. So when the opposition gives your team a free ball — a true gift — you want to turn it into a point. *Note:* Your best passer should handle the free ball — if possible — so that she can send it to the setter who can then orchestrate your team's attack.

Keep the following tips in mind when your team handles a free ball so that they can turn the situation into a quality scoring opportunity:

- ✔ **Count on communication.** As soon as your team sees a free ball coming their way, they need to shout out "free" or "free ball." Doing so alerts any team members who haven't yet recognized the situation and ensures that everyone is in sync and knows what to do to respond.

- ✔ **Have blockers back off.** The front row blockers step away from the net so they're ready to pass short balls and get ready to attack.

- ✔ **Move forward fast.** The setter quickly moves to her position near the net so she's ready to run the offense.

Using a rotation defense

The *rotation defense* is a fun defensive style for the kids to learn because its primary focus is on tracking the ball and then moving in whichever direction it goes on the opponent's side of the court. Of course, what makes this defense challenging is that all the kids must move in unison. If all the players aren't in sync, the opposition will pounce on the openings and attack the uncovered spaces.

One of the real strengths of the rotation defense is that the corners are well defended, which means that attacks down the line aren't good options for the opposing hitters. The soft spot of this alignment, however, is the middle of the court. This area is wide open for attack if the attacker can deliver the ball over, around, or through the block.

The following is a look at how players perform the rotation defense when the opposition sets the ball to be attacked from the left front. Check out Figure 16-2 for a clearer idea.

- ✓ **Middle front and right front:** This tandem forms the block to deny the attack.

- ✓ **Right back:** She moves up behind the two blockers. Her job is to deal with tips and deflections.

- ✓ **Middle back:** She moves toward the sideline, reducing the opportunity for the opposition to send shots down the line.

- ✓ **Left back:** She rotates toward the corner and must be ready to dig balls that find their way to the midcourt area.

- ✓ **Left front:** She moves back off the net past the attack line and slides a step toward the attacker. She defends against tip and roll shots, as well as attacked balls that get deflected into her area of the court.

If the attack comes from the opposite side of the court, the left and middle front players attempt to block the attack, while the left back player moves up near the attack line to handle any deflections or the opponent's attempts to hit a tip or roll shot (see Figure 16-3). The middle back player moves toward the sideline to help guard against any down-the-line attack shots, while the right back player rotates toward the corner. The right front player steps away from the net, past the attack line, to be in better position to get her hands on any shots that the opponent attacks at an angle or that her teammates deflect into her area of the court.

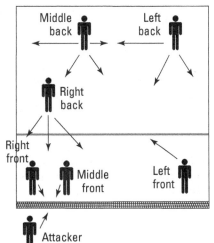

Figure 16-2:
The rotation
defense
requires
teams to
work in
unison to
be most
effective.

Figure 16-3: The rotation defense can use the left and middle front players as blockers.

Right back

Middle back

Left back

Right front

Middle front

Left front

Attacker

Employing a perimeter defense

The middle of the floor is a popular target — and often a very inviting one when a team leaves it vacant — for offensive teams to attack. So, turning to the *perimeter defense,* a type of defense that is played near the boundaries of the court, can help your team counter a midcourt attack and force the opposition to aim elsewhere for scoring opportunities. In this defense, your top defensive player — the youngster who excels at digging balls and keeping rallies alive (the libero at the more advanced levels of play) — handles the middle back position. Keep the following points in mind when your team uses the perimeter defense during a match:

✔ **Cover the corners.** The back corners of the court are the most exposed areas with this defensive alignment, so the players in the left and right back positions have to be ready to cover these spots when necessary. These areas are particularly vulnerable when your team's playing an opponent with attackers who can effectively deliver balls to these sharp angles and depths.

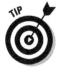

When your team's facing lesser-skilled teams, you can have your back row players pay less attention to these corner spots because the opposition won't likely be able to get the ball back there. In this situation, your back row players are free to move slightly forward in the court, which

provides stronger court coverage of the areas where lesser-skilled teams are more likely to hit the ball, which, in turn, also increases your team's chances of being able to handle them.

✔ **Take advantage of the libero.** Inserting the libero into this defensive alignment is a great idea because she can then perform the majority of the digs, which increases the likelihood that your team will transition into an effective attack.

Regardless of whether your team is using the perimeter defense to face an attack from the left (see Figure 16-4) or right side (see Figure 16-5), the roles of the back row players remain the same: The middle back player handles any shots to her left, to her right, and in front of her that she can reach. Both the left and right back players guard their respective sidelines to limit the attacking team's down-the-line options.

The biggest difference between facing an attack from the right and facing one from the left is that when the attack originates from the left side, the middle and right front defenders slide over to provide the block, while the left front player moves back off the net so that she has a better angle from which to deal with tips, deflections, and the occasional sharp angle shots. With a right side attack, the left and middle front players assume the blocking roles, while the right front defender moves back toward the attack line so that she's in the best position to react to balls coming to her area of the floor.

With the perimeter defense, you also have the option of relying on only one blocker to get the job done. Some of the advantages of going with one blocker instead of two include the following:

✔ **Relieves pressure:** If you have one player who's capable of handling the blocking duties by herself, you can take the pressure of having to step up and assist with blocks away from her teammates. Whenever one blocker is skilled enough to perform a job that often requires two bodies, your defense can be that much stronger and that much more likely to transition into its offense quicker and more efficiently.

✔ **Slows down off-speed attacks:** Using only one blocker effectively enables the rest of your team to focus on digging the balls that do find their way past her, as well as maintaining ideal positioning to react to the shots that are deflected. Teams that like to hit tips and off-speed attacks have more difficulty finding openings against teams who use only one blocker because five other players are in position to cover the rest of the court.

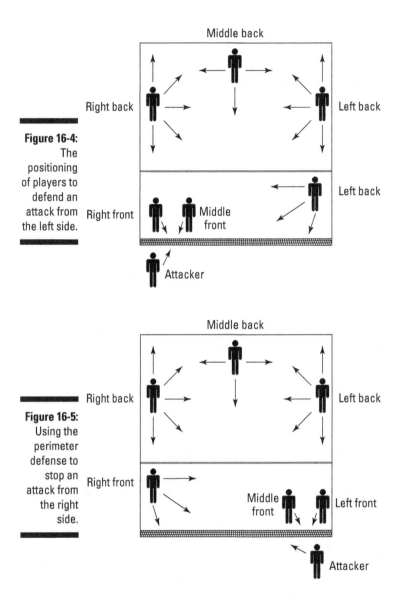

Figure 16-4: The positioning of players to defend an attack from the left side.

Figure 16-5: Using the perimeter defense to stop an attack from the right side.

The primary disadvantages of using only one blocker in the perimeter defense include the following:

- **Leaves open lanes:** Attackers look for *open lanes* — the areas, also known as *gaps* or *seams,* that defenders' hands and arms aren't covering — to hit the ball through. The more open lanes that exist on your side of the net, the more likely the attacker is to hit the ball over

to your side, which puts a lot of pressure on your defenders to dig fast-paced shots. Because one blocker can take away only a certain amount of hitting space, many shots are likely to find their way across the net.

✔ **Tests communication skills:** Because several attacked balls — both fast-moving shots and slower, deflected ones — are likely to make their way across the net when you rely on only one blocker, how well your players communicate with one another impacts everything from who handles each ball to how effectively they transition into their attack.

✔ **Weakens defense against the big hitter:** Opponents who have one really strong hitter often score repeatedly against a one-blocker defense because the attacker has the distinct advantage of being the aggressor and knowing where she wants to hit the ball. As a result, the defensive blocker is forced to guess where the attacker intends to hit the ball and do her best to limit the gaps available for her to hit the ball through. Anytime an opponent features an exceptionally strong attacker, your team is better off sending two players up to block. Ideally, doing so reduces the number of tough digs your other players on the court have to perform to keep the ball alive.

Part V
The Extra Points

"Let's see — I'll need some children's aspirin for my players and some sedatives for their parents."

In this part . . .

What your players do before they step on the court impacts how well they perform on it. In this part, we serve up some pregame and postgame nutritional tips to help prepare your players to perform at their optimal levels. We also share some tips for protecting your team from those unwanted injuries that can jeopardize their enjoyment of the sport. If you must resolve a problem with a parent, coach, or player, you can find some solutions here. You can also find details about coaching a more competitive volleyball team.

Chapter 17

Keeping Your Players Healthy and Injury Free

As a volleyball coach who cares about providing all your players with a top-quality experience, you need to pay careful attention to a few key aspects of the game that often get overlooked amid the excitement of conducting practices and overseeing matches. So what are these key aspects that many people overlook? We're talking about preventing, recognizing, and treating injuries that can pop up during the season, as well as understanding what types of foods and fluids your players should consume before and after matches — not to mention which ones they should definitely avoid.

This chapter covers all those areas and more. We provide important information on nutrition and hydration, two key areas that affect your players' performance in more ways than you may have imagined. We also take a look at specific stretches your players can do before every practice and match to help prevent injuries. Finally, we share with you what you need to have in your first-aid kit and how to deal with injuries — both minor and major — that can occur during the season.

Following a Healthy Diet

In addition to teaching your players skills ranging from setting and attacking to blocking, you also can affect how your players fuel their bodies. If they aren't eating the right foods before stepping on the court, they drastically reduce their chances of performing their best. Although you can't control what your team eats before practices and matches, you can affect their food

choices — to a certain degree — by what you teach them about good nutrition and its impact on performance. Be sure to spend some time during the season discussing the importance of good nutritional habits so that your players can get the most out of their abilities.

What a child eats and drinks before, during, and after matches affects his performance, as well as his recovery before the next match or practice. The following sections cover what your players should put into their mouths before they take the court, so be sure to share this information with your team.

Talking to kids about how today's food choices can affect their health when they're older may not be very effective because young minds and their short attention spans don't always relate to the long term — just think back to when you were a kid. But if you frame your nutrition discussion in terms of how their meal this morning affects their performance in the match this afternoon, you're much more likely to grab their attention. Plus, they're much more interested in what you have to say when it directly relates to their game. Focusing your discussion on the short-term effects nutrition has on their performance is much more likely to have a positive influence on kids' eating habits than talking about the possibilities of having a stroke at the age of 55.

Understanding the fuels needed

Discussing nutrition with your players (and even with their parents) can make a difference in what they consume before practices and matches. You may even be surprised to find that your words affect their eating habits on a regular basis. However, before you can have these discussions, you need to have a firm grasp on what your players need to eat before stepping on the court.

Two primary ingredients fuel a child's muscles during practices and matches and get used up the longer the activity goes on:

- ✔ **Fluids:** Kids lose fluids through perspiration, which is why water is so vital to keeping their body temperatures from rising during exercise. The longer children exercise without replacing lost fluids, and the more extreme the temperatures and conditions happen to be that day, the less effective their performances are, and the worse the kids feel overall.

- ✔ **Glucose:** You may recall learning in science class that *glucose,* a sugar derived from carbohydrates, is an important muscle fuel. It's carried to the working muscles through the bloodstream and stored in the muscles in long chains called *glycogen.* With all the moving, stopping, starting, and jumping that players do during a volleyball match, players steadily deplete their glycogen stores. The more carbohydrate fuel a child loses during competition, the less energy he has to perform at his peak.

Children can take home healthier eating habits when you take some time to explain good nutrition and tell them what a difference it can make in their ability to perform various skills on the court.

Fueling up before the match

If your players show up for practices or matches with nothing in their stomachs, or if they hit the drive-through window of a fast-food restaurant and fill up on burgers, fries, and soda, they can compromise their ability to perform on the court — and concentrate on the game. Not to mention, running on the court and diving for balls on a full stomach can make them sick! A nutritious prematch meal clears the way for children to execute and concentrate at optimum levels. A youngster who eats a healthy meal — or at least a healthy snack — comprised of plenty of carbohydrates has the muscle energy to play hard, play long, and play well.

Players need to consume a prematch meal two to three hours before the match. They shouldn't eat within an hour of the match because if they do, their bodies have to spend the opening game digesting their food, which cuts into their performance. The prematch meal should consist of foods that derive most of their calories from carbohydrates because your players' bodies can convert them into energy quicker and more efficiently than other nutrients. For the most performance-enhancing punch, youngsters can opt for a combination of the following:

- ✔ Pastas
- ✔ Breads
- ✔ Chicken or fish
- ✔ Cereals
- ✔ Whole grains
- ✔ Fruits or vegetables

If the player and his parents don't want to eat a full meal before the match, they can settle on a healthy snack. Some tasty, and effective, prematch snacks include the following:

- ✔ Bagels
- ✔ Yogurt
- ✔ Dried or fresh fruit
- ✔ Energy bars or fruit granola bars
- ✔ Whole grain crackers with peanut butter or cheese

If you're coaching older kids, encourage them to bring a piece of fruit, such as a banana, to munch on between games to help fuel their energy for the remainder of the match.

Whether your players opt for a full meal or a snack, they need to steer clear of candy, cookies, doughnuts, and all sodas — regular and diet.

If you notice that your players start to feel sluggish as matches progress and that their performance isn't as strong at the end of matches as it is earlier in matches, try a little experiment during practice. Ask them to consume some healthy snacks before a practice and see whether you notice a difference in their energy levels. If you do, ask them to use that knowledge and feed their bodies those healthy types of foods prior to matches, too.

If your team has a morning match and your kids can't get up early enough for a full prematch meal, advise them to eat a nutritionally sound meal the night before. That meal should be a serving of pasta with some vegetables, chicken, or fish. And even the night before a game, kids need to steer clear of junk food that can rob them of the energy they need for setting and attacking.

Although prematch nutrition is important, remind kids to follow good eating habits before your practices, too. You don't want them feeling miserable or being unproductive because they ate a lot of unhealthy foods before taking the court for your sessions.

Filling up after the match and practice

What you say to the kids following a match or practice — and how you choose to deliver those words — impacts their confidence and self-esteem. Similarly, what your players eat after a match or practice impacts their bodies and their ability to recover. Giving kids a tasty and healthy snack as a reward for a match well played is a fun way to drive home your message about healthy eating, but giving them junk food contradicts this message and impairs their ability to recover before the next match or practice. The following are some postmatch eating tips for your players and their parents:

- **Carbohydrates to the rescue:** Foods rich in carbohydrates that also have a protein value are beneficial for young athletes. Ideally, your players' postmatch meals or snacks should look a lot like their prematch meals. The only difference is that the portions should be a little smaller. For example, a great postmatch meal is a turkey sandwich, fresh fruit, and crackers with cheese.

- **The sooner the better:** The sooner your players dig into their postmatch meals, the better. Foods packed with carbohydrates that kids consume within 30 minutes after a match or practice provide the most benefits for them.

Many coaches enjoy taking the team out for a postmatch pizza, which is okay, as long as you do so in moderation. Consuming greasy burgers and fries or slices of pizza after *every* match sends a bad message about proper nutrition, but occasionally straying from healthy foods provides a nice treat for the kids. Also, keep in mind that healthy alternatives, such as taking the team out for a fruit-based shake or to an all-you-can-eat salad bar, can serve as great team-building options, too.

Staying hydrated

We really can't stress enough the importance of consuming fluids — the right kinds — for young volleyball players. While kids are moving around the court exerting energy, their body temperatures rise. And the younger the children, the less they sweat because their sweat glands aren't fully developed yet. This fact makes hydration very important before and during the action, especially for younger kids.

Water is the best form of hydration. How much water your players need to consume varies because match and practice conditions — such as playing in a hot, stuffy gym — dictate whether your players need more water to remain sufficiently hydrated. Also, because your kids have different body types, they sweat at different rates and need different levels of fluid intake.

Keeping water in a player's body is an important preventive step to take to help ensure that he remains hydrated. Ideally, you want your kids to drink water with their prematch meals and during prematch warm-ups and also to take sips from water bottles on the bench during matches and practices (check out Chapter 10 for some great warm-up ideas). When kids don't consume fluids before an activity, they can't replenish the fluids after they take the court.

Here are some additional tips you can follow to quench your players' thirst for knowledge about fluids:

- ✓ **Talk in terms the kids understand.** Even though your young kids hear you telling them to drink water, chances are they may not be consuming enough. During a break in practice or a timeout in a match, tell your players to take five sips of water. This specific instruction ensures that your kids hear you and get enough fluids into their bodies. Youngsters are often so excited on game day that drinking water is the last thing on their minds, so make sure you stress drinking water at every opportunity.

Kids should sip water from their water bottles while you talk to them during breaks in the action. Make sure each player's bottle is clearly marked with his name — this helps prevent the spread of germs by ensuring that kids drink out of their own bottles.

- **Don't worry about too much water consumption.** Most kids drink water based on need. It's a voluntary habit, and thirst is the mechanism that tells them to drink. Concentrate on providing plenty of water breaks, and don't worry about the kids sitting on the sidelines chugging too much water because they aren't likely to consume so much that they're bloated and unable to hit or dig the balls the opponent hits at them.

- **Utilize sports drinks.** Some kids prefer the tasty flavors of sports drinks over water. If that's the case, encourage them to consume these beverages — the ones not loaded down with sugar — to get those valuable fluids in their systems.

- **Remind kids to consume water even after the final point has been played.** After exerting themselves, kids need to consume fluids to replenish what they lost throughout the practice or match. Giving the body water after exercise helps the liver and kidneys push out all the waste — a key element in recovery.

- **Involve Mom and Dad in the process.** Ask the parents to remind their youngsters to sip from their water bottles on the rides to and from matches and practices. (Chapter 4 provides more advice on communicating with parents.)

- **Bring extra water.** Always have extra water on hand so your kids can refill their water bottles. You can even designate a couple of parents each week to bring extra water. You can't afford to have a water shortage at any practice or match.

Tell your players to avoid caffeinated beverages before, during, and after matches and practices. Caffeinated beverages act as *diuretics,* which are substances that increase the production of urine and eliminate extra water from the body. These drinks do the exact opposite of what water does to keep kids hydrated. Also, advise your kids to avoid carbonated drinks because carbonation discourages continued drinking.

Stretch It Out: Getting Your Players' Muscles Ready for Action

Maintaining and improving your players' flexibility is essential not only for preventing injuries but also for giving them a solid foundation of strength, balance, and coordination — the trifecta for performing well on the court.

Incorporating a variety of warm-up stretches is a key component for improving flexibility and preparing youngsters for the demands of the match. A sound stretching regimen — performed before and after matches and practices — not only enhances flexibility but also provides added protection against unwanted aches and pains.

Players who work on their flexibility often see dramatic improvements in their effectiveness in performing skills. For example, tight thigh muscles limit jumping ability, a skill that kids rely on heavily when attacking and blocking. By sticking to a stretching regimen before practices and matches, a youngster gradually gains more flexibility in his thighs, which leads to a fuller range of motion, more powerful jumping ability, and more efficiency in spiking and blocking, among other benefits.

Getting players' hearts pumping

Before you dive into stretches or drills at your practices, be sure to devote a few minutes to warming up the kids' bodies — particularly at the advanced levels of play where children are at more risk of suffering injuries such as pulled muscles. The younger your players are, the less elaborate your warm-ups need to be. At the beginning levels, you can simply have the kids perform some basic jumping jacks and light running to get them ready for the action on the court.

If you're overseeing an older and more advanced team, you want your warm-ups to be much more specific to meet the players' needs. For example, performing some approach steps up to the net, jumping, and following through with the proper arm motion for delivering an attack not only warms the kids' bodies up, but also helps them hone their technique for executing this particular skill.

When leading your team in warm-ups, keep the following points in mind:

- **Be consistent.** Always start practice and prepare for matches with a warm-up, such as a moderate-paced jog. You can also give players a few volleyballs to pass back and forth with a partner while jogging to help maximize your time with the team. After you get their hearts pumping, begin your team's stretching regimen. When your youngsters know they have to stretch before and after every practice, they recognize that warm-ups play an important role in their development.

- **Keep it simple.** For young kids, the stretching period can be basic and quick. The goal is to warm them up, introduce them to the concept, and get them in the habit of stretching before any physical activity.

✔ **Cover the major muscles.** Have your stretches cover all the major muscle groups that your kids use on the court. That means hitting the hamstrings, calves, and thighs for the legs; and the arms, shoulders, and back for the upper body. (See the next section for specific stretches you can use to warm-up these muscles.)

✔ **Use controlled movements.** You don't want the kids bouncing or straining to reach a desired position, because doing so can lead to injury. Instead, the kids need to focus on using controlled movements, known as *passive stretching*. During this type of stretching, a player slowly moves to the desired position, which is just slightly beyond discomfort, while breathing in through his nose and exhaling through his mouth. He holds the position for a short period of time and then relaxes. For example, for a standing squat, the youngster slowly lowers his body into a deep knee bend to work the thigh muscle and then slowly pushes up to return to his starting position. Remind your kids that mild tension — not pain — is the goal of stretching.

✔ **Get involved.** Even though stretching isn't a drill, you still need to be involved in the process. While the players are going through the stretches, take advantage of the time for some one-on-one contact with them. Most of them are probably unfamiliar with the concept of stretching, especially if they haven't been playing volleyball for very long. When a child is stretching out his hamstrings, for instance, you can place his hand on the back of his leg so that he can feel the exact area he's stretching. Then you can reinforce to him how this stretching helps him perform skills on the court. Visiting with each child in this manner also helps you ensure that all your players are using proper form.

✔ **Don't allow horseplay.** The stretching period isn't a time for goofing off. The team has to treat it as a valuable part of your practice, so make sure you keep their attention focused on the task at hand. Otherwise, horseplay can lead to the injuries you're trying to prevent.

✔ **Help protect yourself from injury, too.** You can't find a more effective way to tell your players how important stretching is than to perform the team stretches with them. Plus, taking part in the stretching provides a big benefit for you, too. Think about it: During practice, you run around the court teaching skills and demonstrating techniques, so the last thing you want to happen is to injure yourself by pulling a muscle that limits your ability to teach your team. Warming up alongside the kids also provides a good opportunity to bond with your team.

A great way to boost kids' self-esteem is to rotate who leads the team warm-ups on game day. Just make sure that every child gets a chance.

Covering the basics of stretching

After the brief warm-up, you want your players, especially the older and more advanced ones, to stretch thoroughly. Your stretching regimen needs to cover the legs, arms, shoulders, and back because players use these muscle groups the most when playing volleyball. Devote the opening five to ten minutes of your practice to stretching and warming up, and if players arrive late, don't allow them to take the court until they have adequately warmed up and stretched.

Depending on the type of league you're coaching in, you may not have enough time to squeeze in a complete warm-up if you're allotted only a few minutes between matches. If time is limited, modify your warm-up. Perhaps you can gather the team in a hallway for some stretches and light running in place to get loosened up. A few minutes of stretching are always better than none at all!

The following are some basic exercises you can use to get the key muscle groups ready for action.

Standing squats

Standing squats work the quadriceps. The child starts with his feet shoulder-width apart and his hands on his hips (see Figure 17-1). He squats into a deep knee bend and holds for a count of two, keeping his body upright and steady and centering his weight over his heels. In a slow, controlled motion, he pushes up into his starting position. The player repeats this motion ten times.

Figure 17-1:
Players can strengthen their leg muscles by using standing squats.

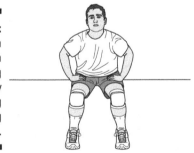

Make sure that the child's weight isn't distributed over his toes; doing so places excessive stress on the knees. Also make sure the child maintains good posture and doesn't relax his upper body; relaxing the upper body places too much stress on the lower back.

Forward lunges

The child begins with her body in an upright position with her arms relaxed at her sides. She steps forward as far as possible with one leg. Bending her knees, she lowers her back leg toward the ground, stopping just before her back knee touches (see Figure 17-2). The knee of her leading leg needs to align directly over the heel. Using the hamstrings (back of the thigh) of the leading leg, she pulls her back leg forward and returns to the starting position. She repeats the procedure with the opposite leg. The player performs five lunges with each leg.

Watch the child's form closely during this exercise. When the youngster doesn't step forward far enough, the knee of the leading leg can pass over her toes, placing stress on the leading knee. Pushing off the back leg to return to the starting position eliminates the benefits of working the hamstrings, so make sure the child uses her leading leg to push back to the starting position. Also make sure she maintains good posture throughout this stretch because bad posture places unwanted stress on the lower back.

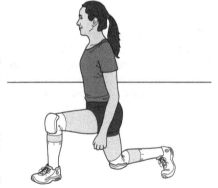

Figure 17-2: Forward lunges help youngsters stretch out their hamstrings.

Calf raises

The child begins with her feet shoulder-width apart and her hands on her waist. She rises onto the toes on both feet (as in Figure 17-3), holds for a second, and slowly lowers herself toward the ground. She stops just before her heels touch the ground and then repeats the upward phase of the stretch. She performs ten repetitions.

Make sure the child distributes her weight evenly across her toes; if she doesn't, she works only part of the calf muscle. Don't let the child lock her knees because doing so reduces the effectiveness of the stretch.

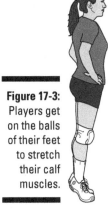

Figure 17-3:
Players get on the balls of their feet to stretch their calf muscles.

Hamstring stretch

While sitting, the child assumes the hurdle position by extending her right leg fully and bending her left leg, placing the bottom of her foot along the inside of her right thigh (see Figure 17-4). While keeping her back straight, she leans forward slowly, bringing her chest toward her right knee and reaching toward her toes with her right hand. Depending on how much flexibility the child has, she either places her hands on the ground alongside her right leg or holds her toes. She holds the stretch for a couple of seconds and then releases. Next, she repeats the stretch with her left leg. Make sure the child isn't lunging for her toes. She shouldn't feel any pain — just a slight stretch in her muscles. She performs five stretches on each leg.

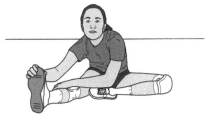

Figure 17-4:
The hurdle position helps players stretch their hamstrings.

Waist and lower back stretch

The child stands with his feet beyond shoulder-width apart, arcs his left arm over his head, pointing to the right, and rests his right arm against his right

knee (see Figure 17-5) while counting to two. Then he reverses to the other side, using his right arm and pointing to the left. He performs five repetitions in each direction.

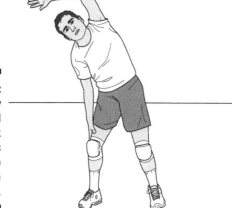

Figure 17-5:
A properly stretched lower back enables players to move more freely.

Upper back stretch

The youngster stands and stretches both arms behind her back from the standing position. If possible, she clasps her hands together while puffing out her chest (see Figure 17-6). She holds the stretch for a few seconds and then releases. She performs five repetitions. This can also be a good stretch to perform in pairs, because the partner can hold the other player's arms and gently lift them to provide a better stretch.

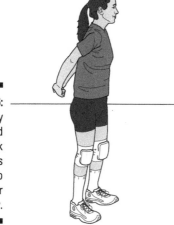

Figure 17-6:
A properly stretched upper back allows players to move their arms easily.

Hip flexor stretch

The child stands with his feet in a lunge position with both feet facing forward and his front knee slightly bent (see Figure 17-7). He briefly pushes up onto the toes of his back foot. He presses his hips forward while tightening his buttocks and then slowly lowers his body until he feels a stretch in the front of his hips; he holds the stretch for a count of two. While he performs this stretch, his upper body remains upright and centered directly over his hips. He performs ten repetitions.

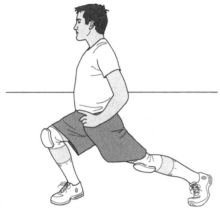

Figure 17-7:
Players
keep their
bodies
upright
while per-
forming the
hip flexor
stretch.

Arm stretch

The youngster stands with her feet shoulder-width apart, interlaces her fingers, stretches her arms straight up over her head, and holds for a count of three. Her palms face up (as shown in Figure 17-8), and she performs five repetitions.

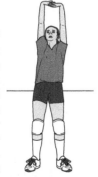

Figure 17-8:
This
exercise
allows
players to
get their
arms ready
to play.

Standing arm circles

The child stands with her feet shoulder-width apart. She stretches her arms out to the sides so that they're parallel to the floor with her palms facing down. She makes small, circular motions at first and then gradually makes larger circles. Then she reverses the motion and performs the circles in the opposite direction. She performs this stretch for one minute.

Diving into more advanced stretching

For the older and more advanced kids, you can use some more aggressive stretches to help get their bodies ready for a more demanding workout. You can use any of the following stretches to help your players warm up.

Arm pulls across chest

The youngster stands with his feet shoulder-width apart. He brings his right arm across his chest and holds his forearm with his left hand (see Figure 17-9). The child should feel the stretch in his right shoulder. He holds the stretch for ten seconds and then repeats it on the opposite arm. He performs three repetitions of each.

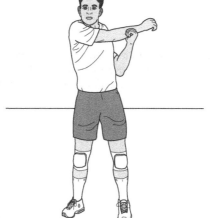

Figure 17-9: Players hold their arms across their chests to stretch the shoulder muscles.

Pretzel stretch

The child lies on her back with her arms stretched out to the sides (see Figure 17-10). She crosses her left leg over her right leg. Her left foot wraps around her right calf. She twists to the right so that her left hip bone points toward the ceiling. She keeps her shoulders on the floor, which ensures a

good stretch in the lower back. The child holds this position for ten seconds and then repeats it by twisting to the left. She performs three repetitions on each side.

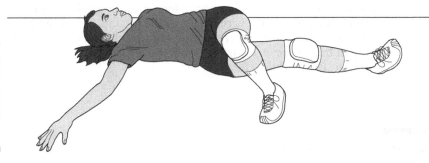

High knees

The child takes an exaggerated high step forward, lifting one knee as high as possible while simultaneously pushing up on the toes of the opposite foot (see Figure 17-11). The arm opposite the leg he's lifting swings up to chin level. This movement works the hips and shoulders and also stretches the quadriceps, buttocks, shoulders, and lower back. Have your players go the length of the court performing this high knee stretch; then have them turn around and repeat the move on the way back.

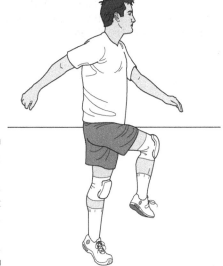

Lunges

The youngster begins the lunge by placing her hands behind her head, with her fingers interlaced. She takes a long stride forward, placing her leading foot flat on the ground while coming up on the toes of her back foot (see Figure 17-12). The knee of her back foot is barely off the ground, while the leading knee is at a 90-degree angle to the ground. She brings her back leg up and stands upright before repeating the stretch with the opposite leg. Lunges stretch the buttocks, hamstrings, hip flexors, and calves. Have your players do 10 to 15 repetitions for each leg.

Figure 17-12:
Lunges stretch the hamstrings, hip flexors, calves, and buttocks.

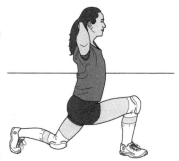

Straight leg kicks

Straight leg kicks stretch the hamstrings, calves, and lower back. The youngster begins by kicking his right leg up as high as he can; then he reaches out his left hand to touch his toes (see Figure 17-13). His extended arm remains parallel to the ground. Then he repeats the stretch with his opposite leg and arm. Have players perform ten repetitions for each leg.

Figure 17-13:
Straight leg kicks stretch the hamstrings, calves, and lower back.

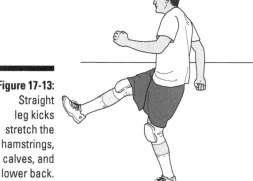

Running butt taps

Running butt taps stretch out the quadriceps and hip flexors. The child begins running, flexing her knees so that each time she lifts her foot off the ground during the run, her heel comes all the way back and contacts her butt (see Figure 17-14). While performing this stretch, she needs to lean slightly forward and swing her arms close to her body. Have your players complete 20 total kicks within about 30 feet, or have them do this stretch while running in place.

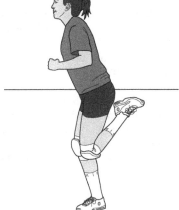

Figure 17-14: Kids stretch their quadriceps and hip flexors with running butt taps.

Running carioca

The running carioca stretches the abductors, buttocks, ankles, and hips. The youngster begins on the balls of his feet and twists his hips while crossing one leg in front of the other. He brings his back leg through and crosses his leading leg behind his back leg (see Figure 17-15). His shoulders remain square through the entire drill. You can have the players use this stretch to go the length of the court and then return to their starting positions.

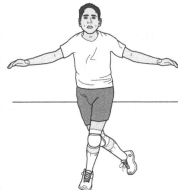

Figure 17-15: The running carioca stretches the abductors and hips, among other areas.

Cooling down in practices and games

Just as warm-ups are important for getting kids' bodies prepped for participation, cool-downs following those practices and matches are equally important for maintaining the long-term health of your team. The cool-down helps reduce muscle soreness, aids circulation, and helps clear waste products from the muscles. After practices or matches, have your players perform some light stretches — perhaps some of the same stretches you use for the prematch warm-ups.

Have your players get into the habit of going through a specific cool-down every time they participate in a practice or match. The cool-down doesn't have to be quite as focused as the warm-up session because the purpose is to wind down from an activity rather than to build up to one. Completing an effective cool-down takes only a couple of minutes and is well worth it.

Following a match, you can turn the cool-down period into a fun activity for the kids by talking to them about some of the interesting or humorous aspects of the match while they go through their stretches. Joke with them about a crazy point that they played. Or, if you're coaching older players, take a more serious approach and discuss a specific strategy that worked well in your team's favor, for example.

Pump It Up: Conditioning Your Team

Conditioning your players is just as important as both stretching your players' muscles and teaching them different aspects of attacking and defending, particularly at the more advanced levels of volleyball. So what does conditioning mean and why is it so important? *Conditioning* refers to preparing the body for the physical exertion that playing volleyball requires through strength and cardiovascular training. After all, if your players begin wearing down later in the match and aren't able to perform as well as when the match began, they compromise their effectiveness on both offense and defense, and the opponent can capitalize on that weakness.

Because volleyball involves a lot of short, high-intensity bursts — such as when players are leaping in the air or diving on the court to keep the ball from touching the floor — the best-conditioned players are those who have a combination of aerobic and anaerobic fitness so that they can perform at their top levels all match long. (Check out the "Aerobic versus anaerobic: What they mean" sidebar for a background on these two types of fitness.)

If you're coaching an advanced level team, you often know which players are on your team before the season begins. If so, you can meet with them prior to the season to discuss conditioning. You can encourage them to begin running to help build up their cardiovascular endurance, which enables them to perform at higher levels for longer periods during matches. If they have access to weights, you can also encourage them to work out to build leg strength for jumping and arm strength for attacking — but only under adult supervision. You can even ask a professional trainer from a local gym or a strength-and-conditioning coach from a nearby collegiate team to share insights on this aspect of the game with your players. (For more details on coaching a club volleyball team, flip to Chapter 19.)

Players who are tired and fatigued are at greater risk of committing sloppy errors with their techniques because they don't have the energy to move their feet and get into the proper positions. Good footwork is vital for performing all skills, and poor footwork is the first indication that a child may be wearing down. During games, keep a close eye on those kids who look tired and need a breather on the bench.

The most productive volleyball practices are those that incorporate a variety of both the skills needed to play the game and the conditioning needed to keep the team strong and able to endure long and intense matches. When you can incorporate conditioning into your practices without the kids even realizing that you're doing so, they reap even more benefits. Although having kids run mind-numbing laps around the court does get them in better shape, it also bores them and may even drive them away from the sport. Also, this uncreative approach wastes valuable practice time. A much better approach is to use drills that feature constant movement and that don't give kids the opportunity to stand around. Doing so helps your players become better conditioned — and more effective, too! (Check out Chapters 10 and 13 for some great practice drills.)

Bruises to Sprains: Recognizing and Treating Injuries

All volleyball players, regardless of their age, skill level, or experience, are at risk of suffering an injury at any given time during both practices and games. No matter what you do as a coach, eliminating the threat of injuries occurring is impossible. You can, however, take steps to reduce the chances of injuries interrupting, or even ending, a child's season. This section gives the lowdown on injury prevention, as well as the steps to take for dealing with injuries when they do occur.

Stocking your first-aid kit

As a volleyball coach, being prepared to deal with a twisted ankle, sprained finger, or any other type of injury that may pop up during the course of play is essential. To do so, you need to have a fully stocked first-aid kit on hand.

Your first-aid kit needs to include the following items:

- **Antiseptic spray or wipes:** Use these items to clean cuts and abrasions.
- **Athletic tape:** Use the tape to hold ice bags in place when you need to reduce swelling around an injury.
- **Bandages in different sizes:** Use waterproof bandages to cover cuts and scrapes.
- **CPR mouth barrier:** Use this item if a child needs mouth-to-mouth resuscitation.
- **Emergency contact list:** Tape your list of emergency contacts inside your first-aid kit. You need to have your parents fill out emergency contact forms and return them to you *prior* to the season's start (see Chapter 4 for more about these and other parent forms).
- **Emergency tooth-preserving system:** Use one of these kits for a tooth that gets knocked out. You can pick up a tooth-preserving system at a local pharmacy, or you can ask your dentist where to purchase one.
- **Freezer-type storage bags:** You can use these plastic storage bags for holding ice packs.

Aerobic versus anaerobic: What they mean

In terms of conditioning young volleyball players, coaches need to take aerobic and anaerobic fitness into account when designing drills and running practices. Ideally, you want your players to possess both aerobic and anaerobic fitness, which opens the door for them to perform more effectively on the court.

You may already be familiar with these terms, but just in case, here's a brief refresher:

- **Aerobic:** *Aerobic* fitness refers to the level at which youngsters can take in and use oxygen. The stronger a youngster's heart and lungs are, the longer he can run around the court without tiring.
- **Anaerobic:** *Anaerobic* fitness pertains to how long a youngster can perform at high intensity, such as darting back and forth on the court during a long point.

✔ **Hot and cold packs:** Use these packs for applying heat or cold to injured areas of the body.

✔ **Latex gloves:** Wear gloves when dealing with bloody cuts and wounds. If any parents tell you at the preseason parents meeting that their children have allergies to latex, be sure to stock your kit with gloves made of a different material. (For more information on what to ask parents before the season, see Chapter 4.)

✔ **Nail clippers:** You can repair torn nails with a pair of clippers.

✔ **Prescriptions:** You need to be aware of any medical conditions that youngsters on your team have. If a child has asthma, for example, make sure that his parents give you a spare bronchodilator to keep in your first-aid kit in case the child forgets his and the situation calls for it.

✔ **Prewrap:** This is a type of athletic wrap that you apply directly to the skin. You can use it to wrap players' ankles to provide extra support for them while they move around the court.

✔ **Scissors:** Use scissors to cut bandages and athletic tape.

✔ **Sterile eyewash and prepackaged sterile eye pads:** Use these items when any type of debris becomes stuck in a child's eye.

✔ **Tweezers:** Use tweezers to remove any debris that becomes lodged in a child's skin.

Some leagues issue first-aid kits to their coaches, and some leave getting one up to you. (For information on getting to know your league, see Chapter 2.) If your league doesn't provide a first-aid kit, be sure to explain the importance of every coach's having one to the league administrator; perhaps he can correct the oversight. In the meantime, never conduct a practice or go to a match without a kit. Many facilities keep a first-aid kit on hand, so you can use it if you don't have one, or if you don't have a particular item in your own kit. Just make sure you know where the kit is kept or where to go to request it.

Tending to common volleyball injuries

When a youngster suffers an injury during a volleyball match or one of your practices, it's usually minor in nature. The most common volleyball injuries include bumps, bruises, twisted ankles, and scrapes. Of course, what may be *minor* to you can be *major* in the eyes of a child who can't put his full weight on his ankle, or who sees a trickle of blood on his elbow. By being prepared, acting quickly, and administering the proper treatment for these injuries — all while comforting the youngster — you can help him bounce back and return to action in no time. The following sections show you how to do so.

Cuts and scrapes

Youngsters can suffer skinned elbows when diving for balls or cuts when bumping into a teammate going for the same ball. Minor cuts and scrapes can produce major tears from young players, but you can treat them quickly and effectively with the materials in your first-aid kit. (Having a first-aid kit nearby is important; check out the "Stocking your first-aid kit" section in this chapter.) Keep the following steps in mind when treating cuts and scrapes:

1. **Put on latex gloves.**

 Immediately put on a pair of latex gloves (or gloves of another material if you have a kid who's allergic to latex) or use some other type of blood barrier to limit your contact with the blood.

2. **Apply direct pressure.**

 Grab some clean dressing materials and try to stop the bleeding by applying direct pressure to the wound. If you have trouble stopping the bleeding, elevate the child's injured area above his heart while maintaining pressure.

3. **Clean the wound.**

 After you stop the bleeding, you need to clean the wound. You can use premoistened towelettes, alcohol swabs, or over-the-counter antibiotic creams to clean minor cuts and scrapes.

4. **Cover the wound.**

 Use a bandage or a piece of sterile gauze to cover the cut. Be sure to secure the covering tightly in place — particularly if the child wants (and is able) to continue playing.

5. **Discard the trash.**

 Place your gloves and any other cleaning materials that you used in a sealed bag, and place the bag in the trash.

Diseases such as HIV and AIDS are scary, but your fears should never influence how you treat a child's injury. You put yourself at risk only if you allow the blood of an HIV-positive person to come into contact with an open wound on your body. If one of your players has AIDS or is HIV-positive, his parents should make you aware of this fact during your preseason parents meeting (see Chapter 4 for more about this meeting). Whether you're aware of the player's HIV status or not, the latex gloves provide the protection you need to treat the injured youngster without worry.

Twists, sprains, and strains

During matches, volleyball players make many sudden stops, starts, and turns going after balls, and these movements can result in twists, strains, and sprains. Most of these types of injuries involve the ankles, knees, hands, and fingers.

When a player strains a muscle or sprains or twists a body part, keep in mind the RICE method for treatment:

1. **Rest:** Immediately move the child to the sidelines so that he can rest the injury. If he has twisted his ankle, for example, have an assistant coach or a parent help you carry him off the court so that he doesn't put any additional pressure on the injured area.

2. **Ice:** Apply an ice pack to the injured area. The coldness helps reduce the swelling and pain. Don't apply the ice directly to the skin. Wrap an ice bag in a towel and then place the bag on the injured area. Apply the ice for approximately 20 minutes, and then remove it for 20 minutes. Continue putting the ice on and off every 20 minutes for the next few hours. In the meantime, move on to Step 3.

3. **Compress:** Compress the injured area by using athletic tape or another type of material to hold the ice pack in place.

4. **Elevate:** Have the child elevate the injured area above his heart level to prevent blood from pooling in the area.

Anytime a child has any swelling or discoloration or experiences pain in a specific area of his body, a physician needs to examine the player before you let him back on the court. Never let a child return to action before his injury has completely healed; if you do, you put him at greater risk of reinjuring the area and missing even more time.

Other common but painful injuries

At the more competitive levels of volleyball, the players are bigger and hit the ball harder. With this added physical prowess comes the increased possibility of more serious injuries. Here's a look at some of these injuries and how you should respond to them:

- ✔ **Concussion:** A *concussion* is a jarring injury to the head, face, or jaw that results in a disturbance of the brain. This injury can be mild or severe. Mild concussions may require up to a week for recovery, and a physician must set the timetable for the player's return. Severe concussions, on the other hand, require at least four weeks of recovery, and a head-injury specialist must give the player permission to return to play. Symptoms include a brief loss of consciousness, headache, grogginess, confusion, glassy-eyed look, amnesia, disturbed balance, or slight dizziness.

 After a blow to the head, immediate care includes having the child rest on the sidelines with an adult to provide careful observation. If you or the adult see any evidence of something more serious — such as prolonged unconsciousness, change in the size of his pupils, or convulsions — call an ambulance to take you and your player to a hospital. If only the minor symptoms remain, allow the child to rest on the sidelines. Don't rush

him back into practice that day. Make sure parents consult with the child's doctor and obtain permission for him to resume practicing or playing.

✔ **Injury to the eyeball:** When a youngster gets poked in the eye, first examine his eye. If the youngster isn't in significant pain and you see minimal redness and no discharge or bleeding, simply clean the area with cool water and allow the athlete to rest for a while. If you see any type of discharge or blood, take the child to a doctor immediately.

A direct injury to the eyeball is a medical emergency. Symptoms include extreme pain, loss of vision, hazy vision, double vision, change in vision colors, bleeding or discharge, and obvious cuts or scrapes to the eye. Put on your latex gloves and apply a sterile eye patch or piece of gauze to the eye along with a bag of soft, crushed ice. Immediately have the youngster taken to an emergency facility. (See the next section for more on handling emergency situations.)

✔ **Orbital fracture:** An *orbital fracture* is a fracture of the bony frame around the eye. These fractures are serious and require expert medical treatment. Symptoms include severe pain and possible double vision or other vision problems. Cuts, scrapes, bleeding, and black-and-blue marks may accompany the fracture.

✔ **Shin splints:** *Shin splints* are painful injuries that occur on the lower shin — they feel like the front of your lower leg is burning — and can require a lengthy healing process. They primarily are caused by the weight pounding down on the player's shins. Other factors that can contribute are muscle weakness, poor flexibility, improper warm-up and cool-down exercises, and improper footwear. The four stages associated with shin splints are

- Pain after activity

- Pain before and after activity that doesn't affect performance

- Pain before, during, and after activity that adversely affects performance

- Constant pain that prohibits activity

The early stages of shin splints are relatively mild, but the later stages can become severe. If you don't properly manage the injury, it can result in a stress fracture. If a player develops shin splints, have him apply ice to his shins to reduce the pain and swelling, and ask him to eliminate any weight-bearing activities to allow the affected area time to heal.

✔ **Loss of breath:** A youngster who gets the wind knocked out of him for the first time likely starts to panic when he has trouble breathing. Comfort him and have him take short, quick breaths. Ask him to pant like a puppy until he can resume breathing normally. The two of you can share a laugh about it later!

✔ **Knocked-out tooth:** If a child has a tooth knocked out, retrieve it by holding it by the crown and not the roots. Don't clean, rub, or scrape the tooth. Place it in an emergency tooth preservation kit or a small container of milk or warm tap water. Immediately have someone take the child to a dentist (with the tooth along for the ride, of course).

✔ **Nosebleed:** When a player gets a bloody nose, slide on your latex gloves, grab some gauze to absorb the blood, and gently squeeze his nostrils together to try to stop the bleeding while the player leans forward. If the bleeding doesn't stop after a couple of minutes, get him to a doctor because the injury may be more serious, such as a nasal fracture.

Handling an emergency situation

Before the season gets into full swing, make sure you spend time going over how you plan to handle emergency situations so that if they do occur, you're ready to respond — quickly. How you respond can make the difference in saving a youngster's life. The following list presents some pointers to keep in mind:

✔ **Assess the situation.** You must be prepared for any type of injury, including unconsciousness. The acronym *COACH* is a handy reminder of how to respond in an emergency situation:

 • **C:** Determine whether the child is *conscious.*

 • **O:** Find out whether the child is breathing and getting *oxygen.*

 Look at his lip color, feel his chest, or put your cheek next to his nose to see whether he's breathing. Feel for a pulse in his neck or wrist. If he has a pulse but isn't breathing, begin mouth-to-mouth resuscitation, but don't use chest compressions. If he isn't breathing and you can't find a pulse, initiate CPR and have someone call for immediate medical assistance. With young children, be especially careful not to press down on the lowest portion of the breastbone; doing so can injure the internal organs.

 A coach should never provide any treatment that he isn't trained to do because doing so can make the child's situation worse. So, if you're not trained to initiate CPR or another necessary procedure, find someone who is or wait for medical personnel.

 If the child is conscious and breathing, move on to the next step.

 • **A:** *Ask* the youngster where he's hurt.

 • **C:** *Control* the painful area.

 • **H:** Determine what type of *help* the child needs.

 Decide whether you need to call for immediate medical assistance and have the child taken to the hospital.

✔ **Know where you're playing.** Be aware of the name of the facility where you're playing or practicing, as well as the address. If you have to call 911, you'll need to provide as much accurate information as possible to ensure a quick response.

✔ **Have medical forms handy.** Medical professionals benefit, as does the child, if you have the medical forms we discuss in Chapter 4 with you during every practice and match. The form explains whether a child is allergic to any type of medication, for example. Always carry the forms in your first-aid kit and have the kit easily accessible.

✔ **Provide first aid.** While awaiting the arrival of medical personnel, provide the first-aid care you're trained to perform.

Proceed cautiously when dealing with any type of injury — particularly if the injury involves the head, neck, or spine. Never attempt to move a player who's lying on the ground with such an injury because doing so can cause further damage.

✔ **Alert the child's parents.** If the child's parents aren't in attendance, have one of your assistants call them and let them know what's going on. Your foremost responsibility is caring for the child, so designate someone else to make that initial call to the parents.

✔ **Comfort the child.** If the child is conscious, comfort him by talking in a calm and relaxed voice. Tell him that he'll be okay and that medical help is on the way.

We encourage you to take a CPR class before the season begins. You can receive CPR and first-aid training from the American Red Cross or another nationally recognized organization.

Anytime a player loses consciousness — for any period of time — you can't allow him back on the court until he has permission from a doctor.

What to do with your players during an injury stoppage in play

Whenever an injury occurs, whether it's a broken finger or something more serious, your players are naturally going to be curious about what's happening to their teammate. Your job is to keep them away from the injured player while you and others provide treatment, particularly if it's a serious injury and medical personnel have been called to the scene to provide treatment. In these types of situations, you don't want teammates or players from the opposing team to crowd around the injured child. Being crowded can make the injured player more frightened than he already is — especially if they stare at him with concerned looks on their faces. Whenever a player on your team or the opponent's team suffers an injury, have your players return to the bench area. Have one of your assistant coaches remain with the kids on the bench to ensure proper behavior while you tend to the injured child. At the start of the season, be sure to go over with the team how you want them to respond in injury-related situations so that if an injury does occur, you aren't forced to waste valuable time telling the kids what you want them to do.

Chapter 18

Dealing with Common Coaching Challenges

*C*oaching a youth volleyball team involves many fun aspects that you know well, such as running quality practices, helping kids learn and develop skills, and being a positive influence on game day for your players. Other areas aren't nearly as enjoyable, and you probably haven't given much thought to the more challenging issues, such as dealing with behavior problems involving your players, their parents, and other coaches — both your assistants and those who oversee opposing teams.

Hopefully, you don't have to tackle any unfortunate situations. However, if at any time during the season, you have to discipline one of your players or address any inappropriate comments or actions from parents, coaches, or other spectators, this chapter can lend a hand. We want to fully prepare you to know how to resolve problems quickly and efficiently so you can return your focus to the reason you started coaching volleyball to begin with — to have a positive impact on your players and to spur their development.

Addressing Problem Parents

Sometimes the childish behavior you see during volleyball games doesn't come from the kids on the court. Instead, it comes from the parents in the stands. Whenever you bring a group of parents together — all of whom have very different motivations for signing their children up to play and vastly different experiences playing the sport themselves — the potential for problems

to occur increases. Most of these issues may be minor and cause you little difficulty, but others may take on a more serious tone and require additional work to correct.

Take the time to conduct a preseason parents meeting, in which you lay some key groundwork to prevent problems from escalating to the point where the kids' memories of the season are unpleasant. (See Chapter 4 for how to organize a parents meeting.) During the meeting, detail your expectations of parent behavior during games; be sure you clearly explain what constitutes appropriate versus inappropriate behavior for both parents and players. Then hold everyone, including yourself, accountable for adhering to this code of behavior. You and your players will be glad you did.

Letting parents know how you expect them to behave during games is important, but doing so doesn't guarantee that everyone will be a model of good behavior all season long. You never know when someone will make an inappropriate comment in the heat of the action, so you have to be prepared to step forward at the first sign of trouble, as small as it may seem. Anytime you allow a problem to linger, you open the possibility that it may snowball into something much worse.

In the following sections, we look at some of the most common types of problems parents can bring to the volleyball court, and we discuss the best ways to clear up these situations before they escalate.

Win-at-all-cost parents

Parents invest time and money in their children's volleyball experience. So, of course, they want to see their youngsters excel on the court and reap the benefits of participating. However, some parents go overboard in their enthusiasm and pile unrealistic expectations on their children and you to win every match.

Some parents, for reasons out of your control, equate a positive volleyball experience with winning the league title. If the team fails to claim the first-place trophy, they view the season as a failure and look at their children with disappointment — and often blame you for everything! This type of outlook is unhealthy for the kids and creates a lot of unnecessary stress around your team. This additional pressure infringes on all the kids' enjoyment of the game and can spoil the season for everyone.

Win-at-all-cost parents go against everything you're trying to teach the kids about doing their best and having fun — and not letting the scoreboard dictate whether they have an enjoyable time playing the game. If you find yourself coaching a team that has one or more win-at-all-cost parents causing problems, don't panic. Just take a deep breath, and use the following tips to help handle the situation:

✔ **Keep in mind that you're in control.** You simply can't allow outside influences to disrupt your messages about striving to do your best, adhering to the rules, being good sports, and accepting wins and losses with dignity. How parents choose to rear their children, and what they say to them at home, is out of your control. But when your practice begins, or a game gets underway, you're in full control, and what you say goes at all times. If parents can't respect your authority and abide by your rules, you simply can't tolerate their attendance.

✔ **Hold a pregame parents meeting.** If you hear some grumblings among parents at a game and sense that the behavior of several parents may soon cross the line, gather your parents for a meeting before your next game. You don't want the competitiveness of some parents to sway the behavior of others and create more problems for you. Just take a moment to remind the entire group — you don't need to single anyone out at this time — that this is a recreational volleyball league and that winning games is not the most important element of the program. (For information about more competitive club volleyball, see Chapter 19.) You want this chat to put parents in the right frame of mind and to serve as a reminder that you're fully aware of what's happening on and off the court and that your number one priority is making sure your players can participate in a stress-free environment.

If you coach in a program that has staff members who monitor the behavior of fans, tell your parents that their actions are being observed. Explain that you don't want to see their children embarrassed when these staff members have to ask parents to leave the facility because they can't control themselves during the game.

✔ **Use one-on-one discussions.** If your chat with the entire group of parents doesn't produce the results you desired, arrange to speak privately with any parent who's still causing disruptions. Share your concerns that her comments are hurting not only her child's development, but also the rest of the team's. Be sure to reiterate that you're trying to help all the kids learn skills and that although winning the game is one of the objectives you're striving to achieve (especially at more advanced levels of play), it's not your sole goal.

✔ **Discuss the parent's options and clearly state the consequences.** Anytime a parent isn't happy with your coaching philosophy, clearly explain that she's welcome to remove her child from the team and enroll the child with a coach or program that's more to her liking. In the meantime, let the parent know that if she wants to keep her child on your team, she has to cooperate. Tell her that you don't want her to miss this exciting time in her child's life, but if the improper behavior continues to detract from the values you're teaching, you'll have to speak to the league director.

Don't be confrontational in these discussions with parents, but do be firm in your stance because you're looking out for the welfare of an entire group of kids. You may also want the recreation supervisor or league director to sit in on this discussion so that she's aware of the problem and exactly what steps you're taking to resolve it.

Parents who use you as a babysitter

Many parents spend a lot of time driving their kids to and from practices and games. Juggling schedules and chauffeuring kids all over town can be exhausting, so don't be surprised if some parents view your practices — and sometimes even games — as a convenient babysitting service.

After your season gets underway and you have a chance to hold several practices and play a few games, you start to get a good sense of which parents are taking advantage of the situation and dropping their children off and then leaving to tend to other matters. Although having parents present at your practices isn't necessary in the older and more advanced levels of volleyball, their presence on game day to cheer on not only their children, but also the team, is extremely important. Children of any age and experience level need positive feedback from their parents. As for the beginning levels of volleyball, having parents stick around during practice is helpful because children at this level are often more comfortable if Mom or Dad is nearby. Plus, when they make a good pass to a teammate, they enjoy being able to look to their parents for a nod of approval or a smile for a job well done.

One of the best ways to convince parents to stick around for practice is to include them in some of the drills. (For ways to include parents in practices, turn to Chapter 6.) When the parents who typically don't hang around see all the fun the other parents are having with their children, they may start sticking around themselves. When they drop their kids off, encourage them to hang around for a moment to see how you involve the other parents in the practice and that, if they're interested, you'd like to have them participate, too.

At the beginning levels of volleyball, you may find that your season is many parents' first experience with any type of organized sport. So parents may need some time to get a handle on what their role is during practices. You can help them by letting them know that their presence during routine practices can do a lot for a child's confidence and also help maintain her interest in the sport. You can even go a step further and explain to a parent a passing drill, for example, that you do in practice that her child especially likes so they can perform that drill together at home. Practicing at home helps the child continue to improve that particular area of her game and gets her parents more involved in her development, which is good for everyone involved.

Parents who question playing time

You probably don't know what your players' parents do for a living or how much experience they have with the sport. What you do know, though, is that they don't sign their children up for volleyball, pay the league registration fee, and equip their youngsters with brand new knee pads just to watch them sit on the bench. Unfortunately, depending on the number of kids on your team, your hands may be tied here. You have to rotate players in and out of the game to help ensure that everyone gets to play an equal number of points, as well as gets the chance to deliver serves to begin points. Based on the size of your team, kids may get a chance to play in only about half the game — and parents may find this news tough to take.

At the more advanced levels of play, in which you use skill level to dictate who plays in more of the action, many parents mistakenly equate how much playing time their children receive to how effective their parenting skills are. They assume that the more skilled their children are at executing attacks or passing balls — and the more playing time they receive because of those skills — the better parenting job they're doing. In their eyes, the children's playing time becomes a status symbol; they think that a lot of playing time reflects favorably on them as they sit in the stands with the other parents.

Complaints about playing time are quite common among parents, but luckily, you can handle this issue fairly easily when you keep the following points in mind:

- ✔ **Turn to the league's policy.** Most youth volleyball leagues have clear policies in place regarding equal playing time. This policy is one of the selling points of getting children involved in these programs because parents know from the start that their youngsters — regardless of their skill levels — will receive as much time on the court as everyone else. At the beginning levels, equal playing time is important for fueling a child's interest in the sport and giving her a chance to develop some basic skills, such as passing, serving, and attacking. Before the season starts, take time to explain to parents how you plan to distribute those coveted game day minutes. (See Chapter 4 for information on how to address playing time at your parents meeting.)

 Even though you have a policy in place regarding playing time, you still may have a parent who thinks her child deserves to be on the court more often because of her wonderful attacking or defensive skills. If you find yourself in a similar conversation, let the parent know that you enjoy coaching her child and would like to give her more playing time, but explain that you have to abide by the rules of the league, as well as be fair to all your players. After all, rules are rules — no matter how hard a player hits a serve or how accurately she passes the ball.

✔ **Remind parents what you said during the preseason meeting.** Chapter 4 discusses the importance of having a preseason parents meeting. If you take the time to conduct one, you'll be glad you did, especially when a parent requests to talk to you about playing time a few weeks into the season. At this point, you can offer a friendly reminder of what you stated during that meeting when you spelled out your stance on playing time — namely, that all kids receive equal amounts of playing time as long as they're regular participants at practice. Remind parents that kids who frequently miss practice can't simply show up on game day and expect the same treatment as those players who attend every practice.

✔ **Track the number of points each player plays.** Keep track of the number of points your players play on the court on game day for a couple of important reasons:

- To ensure that each child is getting her fair share of the game day action

- To prove how much time each child is playing when disgruntled parents question why their children aren't playing as much as some of their teammates

Written documentation of the great lengths you go to make the season fair for everyone is usually enough to make your point and silence any criticism from parents. If you have assistant coaches, you can appoint one of them to track each player's court time to ensure fairness. (Check out Chapter 4 for details on how to choose your assistant coaches.) You also want to let parents know in advance that because volleyball is an unpredictable sport, sometimes kids can be on the court for extended lengths of time and still never touch the ball, except perhaps to serve. On the other hand, sometimes the ball seems to follow one or two players wherever they go, and they get the most touches of anyone.

Disruptive parents

A parent's decision to cross the line and cause a disruption with her negative behavior during a game can wash away all the cool aspects of youth volleyball — experiencing the game's excitement, learning new skills, and understanding the benefits of working together as a team. You often don't know and can't control what leads parents to behave in childlike manners during games, but you can keep negative behavior from ruining your season and disrupting your players.

Even though having to deal with a parent who makes an inappropriate comment during a game may be unpleasant for you, it's even more unpleasant for the players and other spectators who have to listen to it. No matter what you do, don't ignore the comment and hope it doesn't happen again. If you fail to address the issue, you just make matters worse because chances are good

that the behavior will continue to the next game. Plus, ignoring a misbehaving parent sends a bad message to everyone — parents and children alike — that this type of behavior is acceptable. Parents must know that inappropriate words and actions can't be tolerated in any form at any time. Dealing with these types of problems swiftly lets the other team parents know that if they step (or act) out of line, you plan to deal with them in the same way. Parents who are at the games to be supportive and enjoy their children's experience playing volleyball will appreciate your commitment to ensuring that everyone has a rewarding time.

What can you do when a parent yells at her child for serving out of bounds? What move can you make when you hear a parent yell at the official? Do you get involved when tensions seem to be rising among parents in the stands? We hope you never have to deal with these issues, but in the event that they do pop up, make sure you address them quickly. In the following sections, we provide some strategies to help you deal with such situations. Because you're only human, such disruptions are bound to spike your blood pressure at times, so we also advise you what *not* to do.

What to do

You can take the following steps to help keep everyone's temper in check and to allow the game to move along without any unnecessary disruptions for the kids:

- ✔ **Use friendly reminders.** Parents, amid the excitement of watching their kids attack a ball or dig a hard hit ball, often don't even realize when they've crossed the line with a remark or an action. You can remind them to keep their emotions in check and their comments to themselves in a friendly, but firm, manner. Usually, a friendly reminder can remedy the situation.

- ✔ **Know your league's parent policy.** As we discuss in Chapter 2, knowing your league's rules thoroughly is extremely important. When the league has a policy in place regarding handling disruptive parents, you have to follow it. Choosing to deviate from that policy and attempting to handle the situation on your own may result in creating even more problems. Many youth volleyball leagues around the country have parent sportsmanship programs in place — both voluntary and mandatory — to help give parents a clear understanding of their roles and responsibilities in the stands.

If your league doesn't have a sportsmanship program for parents, you may want to recommend implementing one to your league director. Such a program is sure to make life easier for all the coaches in the league by encouraging parents to work with coaches in their children's best interests. Additionally, a sportsmanship program makes the bleachers a more fan-friendly place where fans don't have to listen to the rants of misbehaving parents.

✔ **Remain civil.** You can defuse a tense situation with an upset parent by maintaining a calm, friendly demeanor. Setting a civil tone from the start is a critical building block for a productive discussion. Keep in mind that being civil may be difficult at times, particularly when a parent accuses you of being the worst volleyball coach she's ever met. Politely ask the parent to tone down the volume and explain that you're happy to listen to her point of view, as well as share your own — in an adult manner. If the parent refuses to speak to you in a reasonable manner, end the conversation and report the problem to your league director.

✔ **Listen to the parent's point of view.** Sure, you may not agree with a parent's stance on an issue you're discussing, but you still have to listen to her point of view. Be courteous and listen to what she has to say — if she's speaking to you in a polite manner and not swearing before every word! If you're not willing to listen to what parents have to say, how can you expect them to listen to you? Focus as much on listening as on trying to get your point across.

✔ **Control your body language.** Of course, the words you use have a big impact on both parents and kids — the same goes for your body language. For example, if a parent asks you why her child served only two points during the game and you put your hands on your hips before responding, you're already sending a negative message. This kind of body language reduces the chances of having a productive conversation because the parent perceives you as being upset and defensive right away.

✔ **Give parents the boot as a last resort.** Yes, having a parent removed from the facility is an extreme step to take, and it's equally embarrassing for the adult and her child. But in extreme cases, sometimes ejection is the only way to ensure the safety and well-being of the young participants on the court, as well as of the other spectators. If all other attempts to curtail the behavior have failed, and the person's comments or actions continue to pose a serious problem, as the coach, you have to make the tough decision and proceed with removal. This removal should always be handled by a league director, never by you. When emotions are running high, these situations can escalate out of control pretty quickly, so you want to distance yourself and allow the person in authority to handle them.

Keep in mind that when parents request a meeting with you, in most cases, they're acting out of genuine love and concern for their children's well-being, and you need to respect that concern. Let the parents know that you want the best for their children, just as they do. Listen intently to whatever concerns the parents may have; then talk through the issue with them to come up with a solution. A good idea is to end the chat on a positive note by acknowledging the children's attributes and pointing out what a pleasure they are to coach.

What not to do

Whenever you have to deal with an aggravating situation, you're understandably willing to do just about anything to rid yourself of the headache. Sometimes, however, your actions can add to the problem instead of getting rid of it. As you work to resolve unpleasant situations, we recommend that you avoid using the following tactics:

- ✔ **Raise your voice.** Parents may agree to meet with you about their behavior and then use the meeting as an opportunity to bombard you with accusations and complaints about how you're running the team. Those comments may be upsetting, but don't turn the meeting into a negative exchange of shouting back and forth. Getting lured into this type of heated discussion accomplishes nothing. If parents choose to attack you using foul language and nasty tones, let them know that you don't want to speak to them until they can speak to you in a reasonable manner.

- ✔ **Embarrass the parents.** Being parents of young volleyball players isn't easy, especially for some moms and dads who have little or no experience in organized youth sports programs. Take a moment to step back from the situation and understand that some parents have genuine difficulty getting a grip on their emotions. When they see their children sitting on the bench, or the official calling one of their attacks out when they're sure it landed in, they may not be able to keep their displeasure to themselves. When you hear a negative comment shouted from the stands, look over your shoulder at the offending parent. That brief eye contact lets her know that what she just said is unacceptable and that she needs to tone down her behavior. Using this approach delivers your message without embarrassing the parent.

- ✔ **Take your anger out on the parent's child.** Regardless of what a parent says to you, never drag an innocent child into the situation. Remember that the youngsters on your team have no control over how their parents behave on game day, so don't slice their playing time or take any other drastic measures in an effort to rein in their parents' emotional outbursts. Push your feelings about the parents to the side and continue coaching these children as enthusiastically as you do the other players.

- ✔ **Use the parking lot to discuss the game.** Parents' emotions, as well as your own, typically are at their highest immediately following a game. So not having any type of discussion on a serious issue at the court or in the parking lot is a good idea. Productive discussions have little chance of occurring during this time. Instead, explain to the parents that you're happy to meet with them to discuss any concerns they may have. But be sure to point out that you can meet only at a time that's convenient for everyone involved and in a place that's private — not in front of their children, the rest of the team, or the parents of the other players. Some coaches even have a 24-hour rule in place that says they won't discuss issues until at least 24 hours after the match. This rule gives everyone a chance to cool down and think about what happened.

Perpetually late parents

Late-arriving players can be a real nuisance to you and your team when you're trying to run practice. They can cause you headaches for any number of reasons: They disrupt the flow of practice, grab your attention away from the drill you're running, or interrupt the skill you're teaching. Even worse, late arrivals on game day can smother the flow of the game and create chaos in your rotation.

Besides being an inconvenience, kids who arrive late also miss the valuable prepractice or pregame warm-ups (see Chapter 17 for more information on warm-ups). Remember that sending kids onto the court without properly preparing their bodies for physical activity increases the risk of injury.

You need to address late arrivals as soon as they occur, because if you allow them to continue, the consequences can be problematic for you and your team. For example, if you have a few kids who aren't on time for a game, and you don't have enough players to put on the court, you may have to forfeit.

Talking to tardy players

When talking to players who are continually tardy, use the following tips to help get the kids to your practices and games on time:

- ✔ **Speak to the team.** As soon as late arrivals begin to create problems, talk to the entire team to reinforce your expectations on attendance. Make the chat a quick one, but stress that being part of a team is a commitment — one that they need to keep at midweek practices and championship matches alike. Explain to them that you're at the court on time for all practices and games and that you expect and deserve the same consideration from all your players.

- ✔ **Rev up the fun during roll call.** Even though you can easily see which kids are at the practice, especially if you're working with a small group, employ a fun roll call during warm-ups if you're coaching young children. You can call out funny nicknames for players, for example, or use an amusing voice that gets a chuckle from the kids. Roll calls aren't necessary for knowing who's there and who hasn't arrived yet, but they can be fun moments that the kids enjoy and don't want to miss in the future.

- ✔ **Play fun games before practice.** If you throw in little games before practice begins, you may be pleasantly surprised by the number of kids who suddenly show up at practice well before it starts. Ideally, they're pestering their parents to drop them off at practice early so they don't miss this fun activity with their teammates. This game can be as basic as standing on one side of the net and seeing which players can hit you with a serve.

Talking to tardy parents

Anytime you have to talk to a child about a matter that concerns you, be sure to follow up with her parents to let them know what's going on. Doing so is especially important when you're dealing with lateness. Keeping parents in the loop reinforces how important being on time is to you. Some parents, especially those new to organized sports, don't realize what a big disruption their children's lateness causes for the rest of the team. Ideally, all you need to prevent the problem from recurring throughout the rest of the season is a brief conversation with parents reminding them of the importance of having everyone at the court on time.

You may want to mention the following points to parents to ensure that the discussion goes smoothly and you resolve the issue:

- ✔ **Lateness is a nuisance for the entire team.** Stress that you really need your players to be on time at every practice, for both the team's sake and their own development. The more practice time they miss, the fewer chances they get to improve their passing, execute digs, and work on all the other fundamentals that are part of your practices. Plus, the missed practice time affects the timing among all the teammates. One of the key elements of volleyball is perfecting timing with sets and attacks. The less time players get to work on timing their sets and attacks together during practice, the less effective their offense can be.

- ✔ **Together, you can come up with possible solutions.** Be proactive and work with parents to find solutions that get their kids to practice on time. For example, suggest having a teammate's parent, who lives near the player, pick her up and bring her to practice. (Check with the other parent before mentioning this possible alternative, of course.)

- ✔ **Practice attendance equals playing time.** Remind parents that you distribute playing time in games based on practice attendance. Tell them you don't want to penalize their children, but you have to be fair to all the other kids who are on time. Explain how crucial punctuality is, both for the season to run smoothly and for the children to learn and develop skills (not to mention for your sanity!).

Being a part of the action on game day is important to kids. Ideally, you want to give all the players equal amounts of time on the court, but only if they've been showing up at your practices — and been on time for them. Being on time translates into game day action. For players who are continually late, you need to cut playing time accordingly. Giving equal playing time to a child who's always late isn't fair to her teammates who show up on time week after week and never miss out on any drills or instructions.

What makes this issue tricky is that a child may have to rely on her parents to get her to practice on time. As we discuss in Chapter 4, you need to address the importance of showing up on time at your preseason parents meeting.

✔ **Building skills requires attendance.** Because your practices often build on what you covered in the previous session, kids have to be on time to review the techniques last covered, as well as to learn new skills. Arriving late and missing your instructions or drills that emphasize key parts of the game compromise a child's development and limit her practice in those particular areas of the game.

Handling Problem Coaches

During your volleyball coaching career, you meet many fun and interesting parents, officials, and coaches of other teams. You come in contact with some great people who care deeply about kids and want to ensure that all the players have fun and memorable experiences on the court. Unfortunately, though, you may also encounter some coaches whose top priority isn't ensuring positive memories for their players. Rude and obnoxious coaching isn't limited to the older and more competitive levels of play; it can show up in introductory programs, too.

The following sections look at some of the most common problems you may encounter with coaches — both opposing coaches and those on your own sideline.

Opposing coaches who encourage unsafe play

Chapter 2 discusses the importance of having a coaching philosophy and how difficult sticking to it can be at times, which is certainly the case when your team's in a game where the opposing coach is immune to — or even encourages — the unsafe techniques her players use. You want to protect your squad, as well as the kids on the other team.

Sure, minor injuries do occur (see Chapter 17 for how to deal with them). But if you find your team going against a squad that's using unsafe methods — most notably diving for balls incorrectly — you have a responsibility to remedy the situation for the benefit of the kids at risk. Here are a couple of steps you need to take:

✔ **Speak with the league director.** When you have a concern about inappropriate techniques, share your concern with the league director. Be clear that you're concerned about the welfare of all the kids, regardless of what the score is during the game. Never be reluctant to bring up any

issue that directly affects players' safety. After all, the parents of the opposing players will be grateful that they don't have to pay a dentist a pricey fee to work on their youngsters who smashed their chins on the floor and chipped some teeth because their coach didn't teach them how to dive for balls correctly.

✔ **Never embarrass the opposing coach.** Use discretion if you notice the opposition using something like an incorrect diving technique. Speaking to the opposing coach in the heat of the action with everyone looking on simply creates unnecessary tension. Put yourself in that coach's shoes. A direct confrontation may come across as a ploy, especially if your team happens to be losing at the time.

Opposing coaches who display poor sportsmanship

Youth sports like volleyball bring out some really great qualities in volunteer coaches, as well as some not-so-good ones. Although most of the coaches you encounter hopefully display model behavior, occasionally you may find a coach pacing up and down and giving her lungs a workout by screaming at her players or the official.

What's the best way to handle opposing coaches who are ruining the experience for everyone else? Keep the following tips in mind when the game heats up:

✔ **Maintain a level head.** Opposing coaches who display unsportsman-like behavior challenge your patience, test your poise, and can really get under your skin. You have to discover for yourself what helps you maintain control of your emotions and then stick to it, no matter how discouraging the situation gets. Your solution may be as simple as taking a deep breath — or even a few of them — and counting to ten. You can also direct all your attention to your team and provide them with encouraging words.

✔ **Turn the negative experience into a learning experience.** Your players recognize negative behavior taking place, so take a moment to remind them that they have to rise above that type of conduct. Be sure to applaud their model behavior, especially under such difficult circumstances, following the game.

✔ **Meet with the league director.** You have a responsibility to your team, as well as to the other teams in the league, to report any negative behavior to the league director or any supervisor at the facility where you play your games. Tell her which coach is setting a poor example for the kids, and outline the behavior that's disrupting the experience for everyone else.

✔ **Focus on your players.** Even when chaos surrounds you, you have to continue coaching, encouraging, and motivating your players. Talk to them in a positive manner, and keep their attention focused on the game and their skills. Don't let their attention wander to the opposing coach's obnoxious behavior when they need to focus on executing efficient serves, productive attacks, and solid defensive moves.

Dissenting assistants on your team

Assistant coaches play important roles on your team, and the higher the quality of individuals you surround yourself with, the better the experience is likely to be for the kids. Assistant coaches are extra sets of eyes and ears during games, and they can help provide instruction and keep drills moving during practices. Make sure you take great care before choosing the people to fill these key slots (see Chapter 4 for how to choose assistants). You may be surprised by some of the assistant coach–related problems that can pop up. The more common issues you may encounter include the following:

✔ **She wants her child to receive more playing time.** Parents in the stands aren't the only ones who closely monitor their children's court time — assistant coaches can become fixated on it, too! Your assistant may have volunteered to help you out as a way to make sure her child sees the most game action of anyone. At the first sign of trouble, have a private chat with the assistant and let her know that to continue in her role, she has to abide by your rules and keep her focus on helping all the kids and treating them all equally.

✔ **She causes distractions during games.** Even the most laid-back, mild-mannered parents can evolve into sideline screamers as soon as your team hits the first serve. This type of behavior detracts from the kids' enjoyment and interferes with what you're trying to achieve. You have to take swift action in these situations so that the assistant's behavior doesn't disrupt the entire game. Talk to her right away and tell her she has to rein in her emotional outbursts.

✔ **She's a poor teacher of volleyball skills.** Having unqualified assistants around — parents who don't know much about volleyball — isn't fair to the kids, who are there to learn and develop skills. You may have some great, well-meaning parents who raise their hands and volunteer to help out, but if their volleyball knowledge is limited, or if they're unable to pick up from you how to teach and work with kids in a positive manner, all sorts of problems are likely to result. To avoid these problems, thank the parent for her interest in helping out, and suggest other ways the parent can be involved with the team besides serving as an assistant (see Chapter 4 for ideas).

✔ **Her coaching philosophy conflicts with yours.** During your preseason meeting with the parents, you need to stress that winning takes a back seat to skill development and fun. (See Chapter 4 for what else to cover in your meeting.) Although all the parents may have nodded in agreement with your words back then, you may discover after the games begin that the parents who are now your assistants no longer share those views. They may have adopted a win-at-all-cost mentality. Instead of working with you and supporting your coaching philosophy, they go against everything you want to stress to the kids and undermine the positive impact you're trying to have on each youngster.

Be sure to talk to these assistants right away and remind them that they need to be on board with you and your philosophy, or else they need to return to being spectators. If you don't address a problem like this with your assistants immediately, the season can dissolve into chaos.

Your assistant coaches are basically an extension of you — which makes everything they say and do on your behalf extremely important to the overall success of the season. Especially during your first few practices of the season, monitor them closely to see how they oversee drills, teach skills, and interact with the kids. Just like you step forward and correct mistakes in a child's over-hand serving technique, you have to correct an assistant who's saying or doing something that's counterproductive to your overall approach and philosophy.

When an assistant coach isn't fulfilling the responsibilities you had in mind when you agreed to let her help out, you need to have a one-on-one talk with her right away to remind her what you want to accomplish this season. Usually, this chat is enough to get the assistant back on the right track. If problems continue, let her know that you think she needs to step down from her assistant duties for the team's sake. The position is too important for you not to address any problems associated with it immediately. If kids continually receive mixed messages from you and the assistant, they can't get a clear understanding of the game or the coach, and this detracts from the kids' overall experience. Be sure to thank the assistant for her time and effort, and encourage her to continue being a part of her child's season as a positive sideline supporter.

Dealing with Discipline Problems on Your Own Team

Teaching kids passing, setting, and blocking tests your abilities to teach techniques, spot flaws, and make corrections in a positive fashion. Making sure that your players follow your instructions, respect your authority, and

stick to the team rules you set forth poses a whole new set of challenges that you may not have been completely aware of — or prepared for — when you stepped forward to coach this season.

At some point during the season you may find yourself in the position where you have to discipline one of your players for breaking an important team rule or saying or doing something inappropriate. Sometimes children act out in a disruptive manner because they're frustrated by their lack of progress, they feel like you're not noticing their contributions, or they don't feel like they're really part of the team.

A youngster's inappropriate actions may be a cry for help or attention, and if you don't answer them, her experience may turn out to be a miserable one. And if a player doesn't have fun, she likely won't return to play volleyball next season. Evaluate your interactions with this youngster and make sure that you're devoting as much time to helping her learn and develop skills as you are to the other team members.

The following sections illustrate different techniques you can use to deal with problems you may have with your own players.

Using the three-strike technique

When you have to deal with discipline problems with your team, we recommend using the *three-strike technique.* This method is effective because it gives children a little room for error and gives you the chance to restructure their behavior.

Be sure to inform the parents of the procedure you plan to follow at your preseason meeting (see Chapter 4 for more details on what to cover at this meeting). You want parents to be aware of these policies well in advance of any problems materializing so that everyone fully understands how you plan to hand out punishment.

The following sections highlight how the three-strike technique works.

Strike one

The first time one of your players displays unacceptable behavior, issue a verbal warning to show her that you're not pleased with what she said or did and that you will punish her if she repeats the behavior. Behavior we're talking about here includes swearing, criticizing a teammate's play, and displaying unsportsmanlike conduct. When kids see your unhappiness and know that you will hand out punishment if they repeat their unacceptable behavior, you likely won't have to deal with the issue again.

Kids are going to act out and misbehave from time to time, but you can't act like a drill sergeant, go berserk, and treat the youngsters like criminals. Coaching kids means being able to deal with the minor hiccups in their behavior and recognizing that if you address the situation right away — much like a good parent does at home — you significantly reduce the chances of that behavior occurring again.

You're dealing with many different types of kids, who are being raised in many different family environments. Because so many different factors are at work, most of which are out of your control, sometimes kids will either ignore your warning or simply not take it seriously. Be aware that your first warning may not produce the desired effect. If a player ignores your first warning, be willing to go to the next discipline level — which is where strike two comes in — so that players don't trample your authority and disrespect your position as the leader of the team.

Strike two

If a player continues to disobey your instructions — if she's still making inappropriate comments about a teammate who makes mistakes during games, for example — you have to go beyond strike one's verbal warning to resolve the problem before it becomes a bigger distraction to the team. Stepping up the punishment, such as taking away a portion of her playing time in the next game, sends a clear message that she has no room for negotiation and that if she doesn't stop this behavior immediately, she doesn't get to play on the court. Let the player know in clear and specific terms that if she misbehaves again, she jeopardizes her future with the team.

Anytime you find yourself in strike-two territory, let the parents know what's going on. After all, you can probably assume that the child's not telling her parents that she's been acting up and causing problems! Explain to the parents exactly how you want the child's behavior to change so that you can work with them to ensure the change happens. Be clear that you want their child to be part of this team and that she won't face repercussions the rest of the season if she behaves in an appropriate manner. Relay exactly what you said to the child so that the parents can follow through at home. This reinforcement makes the child aware of the seriousness of her behavior and the need to take immediate action so she can continue playing on the team and become a positive — not a negative — influence.

Let the parents know that their child will sit on the bench for an extended period at the next game as punishment for her behavior. Telling them ahead of time eliminates any surprises for the parents on game day. If you're coaching in a more competitive league, and the offending child is a starter, not allowing her to start is usually all you need to do to turn her behavior around. After all, she doesn't have much fun watching her teammates working together to win points without her help.

Strike three

Most players stay far away from the dreaded strike-three step. In this three-tiered approach to passing out punishment, with coveted playing time at stake, most youngsters get their behavior in order after the first warning, or after they get a taste of sitting on the bench on game day. Yet, every so often, you may have a child on the team who disregards your authority and continues to behave in an unacceptable manner that disrupts the team environment you're trying to maintain. Because you have a responsibility to all the players, you may have no choice but to remove this player from the team.

Ideally, you never want to be in a position to force a child away from volleyball. Before you resort to this measure, you want to meet with the league director and the player's parents to detail how she's behaving, what you have done to remedy the situation, and what other options are available at this point.

If you do kick the child off the team, don't slam the door on her future return. If she and her parents come to you several days later willing to apologize to you, and if she's genuinely intent on being a positive and contributing member of the team, then as someone who cares about children, welcome her back to the team. Kids can turn over a new leaf. Maybe a few days away from her teammates — and missing the excitement of game day — helps her realize how much she misses playing volleyball.

If you have a child return to the team, you have to start with a clean slate, too. Bury any disappointment that may linger as a result of how the child behaved earlier in the season and approach her first practice back like you did the first practice of the season. If the child senses that you're still harboring animosity toward her, the remainder of the season may be a disaster for both of you.

Using other techniques

If you have some behavior issues on your team, the bottom line is you can't ignore them. Consider the following other tips for handling behavior problems among your players:

- ✔ **Don't use conditioning as punishment.** When a child misbehaves, you may be tempted to make her run laps as punishment, but refrain from going that route. Conditioning plays a very important role in volleyball, especially at the more advanced levels of play, because tired legs translate into less lift when your players are jumping for attacks and blocking an opponent's attack. The better conditioned your players are, the more effective they are late in matches. (For more on conditioning, check out Chapter 17.) You want players to have a positive view of conditioning and embrace its role in their ability to play the game at their most effective levels, so don't give conditioning a bad reputation by using it as punishment.

✔ **Mean what you say.** When you go over your team rules and detail the disciplinary action that accompanies misbehavior, make sure you follow through whenever a problem occurs. Backing up your talk with action maintains your authority and respect with the team. The quickest way to lose credibility — as well as respect — with your players is ignoring inappropriate behavior.

✔ **Be an equal enforcer of the rules.** Overlooking a youngster's inappropriate actions because she happens to be the team's best player is sometimes easy to do. Be aware that one of the most disastrous moves you can make as a coach is playing favorites when you're handing out discipline. Everyone on the team can tell when you're playing favorites, and team morale plummets as a result. A youngster's ability to score points for the team with well-placed attacks or laserlike serves doesn't mean that she's immune to discipline or that a whole new set of team rules should exist just for her. Apply your team's rules equally to everyone — regardless of skill level — so that you don't create resentment among your players and destroy team unity.

✔ **Keep problems in perspective.** You stepped forward to be a coach to teach the kids different skills of the sport, not to spend your time handing out punishment. Keep in mind that because you're working with a group of children, not every practice or game day is going to run as smoothly as you may have hoped. But you can't lash out at everything that occurs. Keep a level perspective when enforcing team policies. For example, if a child forgets her water bottle at practice, don't treat that as a serious infraction. During the course of a season, minor lapses are inevitable. Don't go out of your way to turn them all into major problems — after all, you have much more important matters to focus on.

✔ **Have a short memory.** When a child misbehaves and you hand out punishment, you need to forget about it and move forward with the youngster. Hanging on to any animosity doesn't accomplish anything productive. Show the child that you're willing to forget her past behavior by treating her exactly as you did before she misbehaved. Treating the youngster any differently is just another form of punishment, and making her endure mistreatment all season long is unfair. Instead, focus on making sure that she feels like a valued member of the team again.

✔ **Maintain a cool demeanor.** Displaying a temper, or losing your cool, is a sign of weakness and a lack of control. Even if a child's behavior has your blood pressure sky rocketing, you have to always keep your emotions in check and display model behavior for your team.

✔ **Never discipline miscues on the court.** Kids make errant passes and send attacks into the net. Some miscues occur on the opening point of the match, while others happen with the game on the line. Regardless of how or when miscues occur, never discipline a child for them. Not every point goes according to plan, and kids can't execute every play perfectly.

Dealing with the nonlistener

We have full confidence that you're an energetic speaker who — after flipping through this book, of course! — has a lot of really great information about all aspects of volleyball to share with your players. Yet, because of the nature of young kids and their wavering attention spans, some of your players are going to pay little attention to what you're saying. Kids may choose to tune you out for any number of reasons. This inattentiveness can be especially troublesome if you're detailing how to run a specific drill because the drill can't run smoothly if your players aren't paying attention to what their roles are during it.

If you recognize that a child's inattentiveness is disrupting a team drill or causing her to perform a particular technique the wrong way, pull her aside and have her watch practice for a moment. After a few minutes, ask her whether she's ready to return to play and listen to what you have to say. Your nonlistener is likely to be much more receptive to your instructions after spending any length of time by your side watching her teammates having fun on the court.

If you suspect that a child isn't performing a skill correctly because she's not paying attention to your instructions, ask her why she isn't doing the drill like you demonstrated. Maybe she simply didn't understand your instructions and, out of frustration, tried doing the drill her own way.

Playing time means everything to kids (and to their parents, too!). Whenever you encounter a child who refuses to listen to your instructions, taking away her playing time — or just issuing the mere threat of taking it away — is a great equalizer. Simply mentioning that you plan to take away a player's play-ing time has the power to change attitudes and improve attention spans. No one enjoys sitting on the bench for extended periods of time while friends and teammates are out on the court.

Addressing the nonstop talker

When you think about rapid-fire speakers, you probably think about used car salesmen, television newscasters, and auctioneers, but sometimes, 9-year-olds in knee pads who love playing volleyball fit into that category, too. Kids who are constantly talking — especially when you're trying to talk to the team at the same time — can cause all sorts of problems. When players are more interested in talking than listening to what you have to say, they can drown out some of your instructions, causing the rest of the team to hear only bits and pieces. If your team can't concentrate on what you're telling them, you can't be an effective coach, and your team can't reach its full potential.

The moment you see that too much talking — and not enough listening — is taking place, remind the team that when you're speaking, no one else should be speaking so that everyone can hear what you're saying. If this reminder fails and a youngster continues talking, you may have to call the youngster out in front of everyone. For example, say something like "Susie, please don't talk while I'm addressing the team. It's important that everyone hears what I'm going over. If you have a comment or question, please hold it until I'm done or raise your hand."

If a particular player continues to cause disruptions, have a one-on-one chat with the youngster. Pull her aside and be firm in your stance that she must abide by your rules or face the consequences — and then spell out those consequences clearly so she knows the penalties for any continued misbehavior. Let her know that if you have to reprimand her again to be quiet, she'll lose significant amounts of playing time. Usually, threatening her with more time on the bench is enough to grab her attention — and close her mouth.

Anytime you talk with a youngster regarding her behavior, and what the results will be if she continues to misbehave, be sure to alert her parents, as well. Keeping Mom and Dad updated on what's going on helps prevent problems down the road if you have to discipline the child further.

Snuffing Out Problem Spectators

Your responsibilities as a coach on game day extend beyond ensuring an enjoyable day for your players on the court. In fact, they reach all the way to the people in the stands, who deserve to watch the game without having to listen to inappropriate comments from other spectators. On game days, the moms and dads of your players, along with other family members, are in the stands to cheer and support the team. Parents supporting the opposing team and any number of other people are on hand, too.

If you or your assistants hear a spectator making inappropriate comments — someone other than your players' parents, with whom you've established relationships and shared expectations for proper behavior — inform the league director or person in charge of the facility right away. Send an assistant coach (if you have one) or a parent you have a good relationship with to locate the director so that you don't surrender important time with your team during the game.

Never make the situation more volatile by confronting the problem spectator. Doing so increases the chances of the situation escalating further out of control. Let the director resolve the situation or, if necessary, remove the individual from the premises.

During your preseason parents meeting, encourage parents not to confront unruly spectators from other teams during the season. (See Chapter 4 for more on what to cover during the parents meeting.) Ask them to alert the league director or person in charge if they have a problem with a spectator. Doing so reduces the chances of an embarrassing scene unfolding and allows players to focus on setting and attacking instead of their parents arguing in the stands.

Chapter 19

Coaching a Club Team

*M*any youngsters take such a liking to volleyball that they crave opportunities to play against stronger competition than recreational leagues can offer. The same goes for some coaches who, after being around the sport for a few seasons, may have a strong desire to coach in a more competitive setting. Club teams provide the more competitive atmosphere some coaches and players are looking for. If you think you're ready to move to club teams, this chapter is for you. In it, you find everything you need to know to make your transition to the club team sideline a smooth one. You get the scoop on running a tryout that gives players the best chance to showcase their skills and you the best shot to identify the most deserving kids for your roster. We also provide tips for putting together your team, resolving problems that can arise on the road, and helping your team sidestep burnout and squeeze the most enjoyment out of their experience as possible.

Getting Familiar with Club Teams

The atmosphere surrounding club teams is a lot different from the one surrounding local recreational volleyball programs — the practice schedule is more intense, and the games are more competitive, for example — but what remains the same is your role as a coach who keeps the best interests of all the kids in mind. As long as you maintain your focus, the club experience can be a richly rewarding one for both your players and you.

Club teams provide good opportunities to youngsters, generally in the 12- to 18-year-old age range, who are interested in focusing on volleyball and who want to play against top-level competition on a regular basis. These teams give kids the chance to play in highly competitive tournaments against other

talented teams from different clubs and, in some cases, even from different states. Club teams also require a much greater time commitment — and often a bigger financial commitment, too — from both players and parents than recreational volleyball programs do.

A typical week on a club team involves several practices, and one or two weekends a month often consist of traveling and competing in tournaments. Seasons usually run much longer than they do in recreational programs.

Most experts say that kids younger than age 12 should not be involved with club teams. Instead, they should try out a variety of sports and activities that allow them to develop a wide range of skills — including balance, coordination, and agility — before specializing in one sport. This guideline is a general one, of course. Children mature at vastly different rates, both emotionally and physically, and some 11-year-olds may be better equipped to handle participating on a club team than some 13-year-olds, for example.

Assembling Your Club Team

Coaching youth volleyball is full of unique challenges, and stepping up to lead a club team brings a whole new set of hurdles — many of them unexpected — into the picture. Besides planning and running a tryout (some clubs offer extensive assistance in this area, while others place the bulk of the responsibility on the coach) and analyzing players' abilities, you have the rewarding job of sharing the good news with those kids whose skills land them a spot on your roster, as well as the unpleasant task of breaking the bad news to those who don't make the team. In this section, we explore how to handle all these responsibilities.

Holding a tryout

The more organized you are, the smoother your tryout can be, making your job of identifying which players most deserve to make the team easier. Keep the following points in mind when you're planning your tryout to ensure that it gives all the kids an equal opportunity to showcase their skills and that it's headache-free for you.

> ✔ **Be friendly and informative.** Introduce yourself and take a couple of minutes at the start of the tryout to share with the kids how the session will run. Letting players know ahead of time what's in store for them eases some of their nervousness (probably not all of it, though) and eliminates surprises along the way.

A quick overview of club volleyball

Hundreds of thousands of boys and girls dig, defend, and dive for balls in club volleyball programs around the country each year. Club programs are widely popular today. They emerged on the volleyball landscape to offer opportunities for players and coaches interested in participating in more advanced-level competition.

USA Volleyball (USAV), the national governing body for the sport of volleyball in the United States, provides opportunities for children to participate in club programs and volunteers to coach in them around the country. You can visit

the USA Volleyball Web site at `www.usavolleyball.org` for more information and to find contact info for your regional office reps. Contact your regional rep for a list of teams near you. Besides USAV, many other organizations in each state offer a wide array of club programs.

The boys' club regular season generally runs October through January, with tryouts taking place in September, while the girls' club season typically begins in November and lasts as long as July in some programs.

✔ **Loosen up the kids.** Even though you're just holding a tryout and you may never see many of these kids again, you have a responsibility to ensure their safety and well-being while they're on the court with you. And ensuring the kids' safety means approaching the tryout the same way you approach a regular midseason practice with your team. Begin by having the players go through a proper warm-up. (For more on warming up, see Chapter 17.)

Don't choose players to lead the stretches. Even if you've had some of the kids on your team in the past and know that they're good at leading warm-ups, don't begin your tryout by sending the wrong message to everyone else. The other kids, many of whom are probably well aware of who has played for you in the past, may think that you're playing favorites and already have your mind made up on who's going to make the team.

✔ **Limit your coaching.** Because you're a volleyball coach, your natural tendency during the tryout is to — you guessed it — coach the kids! A tryout is one of those unusual situations when you don't want to get too caught up in coaching because coaching takes away from the purpose of the tryout: evaluating the players' skills.

Sprinkling your tryout with comments, such as correcting improper form on a dig, for example, is okay. Because you may be coaching some of these players for several months, you can take this opportunity to gain some insight into how receptive certain kids are to your feedback. If certain players reject your remarks, make a note to yourself that they may not be mature enough to handle the demands of a club team and may need to play one more season of recreational volleyball.

✔ **Make the drills challenging but doable.** The best way to assess talent and determine whether players are ready for elite level competition is to put them in drills that are challenging but that also mirror real game conditions as closely as possible. Then you can see how they respond to pressure and what types of decisions they make in the heat of the action while on offense and defense.

✔ **Minimize the standing-around time.** Observing players in scaled-down drills or games — two-on-two or three-on-three — provides a wealth of information about their abilities. Putting them in situations that give them plenty of ball touches, in both offensive and defensive situations, can help you determine how well they communicate on the court, what their level of competitiveness is, how they attack and defend the opposition, and how they cover the court, along with other strengths and weaknesses. Taking in all this information helps you put together a pretty comprehensive evaluation of each youngster's abilities.

✔ **Don't go station crazy.** You want to get a good handle on the kids' skills in many different areas of the game during your tryout, but you don't need to have separate stations for serving, passing, attacking, blocking, digging, and so on. If you have too many stations going at once, you can't effectively monitor the performance of each youngster. To maximize your time, combine different skills into one. For example, if you choose to have a serving station, you can also assign kids to the other side of the net to pass the serves.

✔ **Conclude on a positive note.** Wrap up your tryout by thanking all the players for coming out and giving their best, and let the group know how impressed you are with their skills. Also, thank the parents for bringing their children to the tryout. Showing your appreciation to everyone is a nice way to end on a high note.

Let parents and players know by what date you will let them know who has made the team. Understandably, everyone will be anxious to get the news, so giving them a timeline can eliminate being bombarded with calls while you're making your decisions.

Limit the tryout to 1 hour for kids ages 12 and younger. For older kids, you can bump it up to $1\frac{1}{2}$ to 2 hours. If you have many kids trying out, you can hold a couple of sessions to evaluate all of them effectively.

Selecting players

After you've mapped out a plan for conducting your tryout, remember that your work is just beginning. When the players take the court — setting, attacking, blocking, and putting everything they have into every drill — you have to keep close tabs on all of them and how they perform. What you observe determines who makes your team.

Playing time primer

Amid all the excitement of making the team, a key issue that both the kids and their parents often overlook is playing time. For youngsters making the jump for the first time to this higher level of competition, one of the biggest differences from recreational volleyball programs, aside from the obvious skill level of the players, is that playing time is based on ability instead of being distributed equally among all the children who regularly attend practice.

Make sure that everyone understands that club teams are vastly different from recreational leagues. Although all players receive plenty of work in practice, you hand out playing time in games to those players who possess the most skills and who can put the team in position to perform at its best. Reminding parents of this fact gives them the chance to further evaluate whether a club team is the right place for their youngsters at this time. Also, you may have a child who made the team, but based on the skill level of the others who made it, you know that he probably won't receive a lot of game day action. As a courtesy, you can let his parents know so they aren't surprised when the season gets rolling.

Having extra sets of eyes overseeing the tryout can be a big help, particularly if you have a large turnout. If you have several adults helping you, make sure that they get a chance to see all the kids perform; otherwise, their evaluations won't be as accurate or comprehensive as they need to be. Meet with your assistants prior to the tryout so that you can explain what you're looking for so everyone is on the same page. (For more details on choosing assistants, check out Chapter 4.)

Of course, evaluating skills is a top priority, but make sure that you (and your assistants, if you have them) don't neglect the following qualities that are just as important as physical skills to note during the selection process:

- ✔ **Team player:** Good volleyball teams rely on teamwork and communication. The stronger the kids are in those aspects of the game, the more success the team enjoys. When players don't buy into the team concept, the team as a whole suffers; you may see confusion on the court, and the team's ability to score points, as well as to stop the opposition from scoring points, weakens. Assessing how players work with their teammates is crucial during your tryout. During your drills, watch how kids interact with one another on the court. A player who's constantly making plays on balls that are out of his range can be a liability because that player may not understand your team concept. No matter how talented players are, they also have to fit into your team concept.

- ✔ **Positive demeanor:** You don't want to have players on your team who display frustration when a teammate misses an attack or makes a poor pass. You want players who are supportive and encouraging toward their teammates rather than negative and demeaning. So watch how players respond when points don't turn out in their favor.

✔ **Mentally tough:** The game's mental side is just as important as the physical side. Keep a close watch on each player to see what type of competitor he is. When he misses an attack, does he become frustrated and pout, or does he bounce back and deliver a quality shot the next time he gets an opportunity? Does he congratulate teammates who make nice plays or high-five the setter who feeds him the ball in a perfect location to unleash his power?

These aspects of the game aren't automatic qualifiers or disqualifiers, but they are pieces of a much bigger picture. You have to evaluate each child individually. Keep in mind that if you decide to choose a player whose behavior borders on inappropriate during your tryout, you have to assume responsibility for working with that youngster and teaching him the importance of behaving in a respectful manner and being a team player.

The majority of club teams comprise a larger organization, so you can tap into the expertise of other coaches to help you with tryouts and players. If this season is your first one coaching a club team, and you have limited access to other coaches, or the organization doesn't feature several teams, contact the previous coach. You may be able to gain some valuable insight on how to run a tryout or tips on how to coach this type of team. If that coach isn't available, or doesn't provide the type of information you can use, contact other club team coaches in your community to see if you can pick their brains on different aspects of coaching these elite level teams. Most coaches are happy to share their insight and talk about the sport because they have such a love for the game and for teaching it to children.

Breaking the good and bad news to players

During your volleyball coaching career, you're bound to enjoy a number of special moments that will stick in your memory bank for years to come. Along with those happy memories, though, you undoubtedly have a few not-so-pleasant ones. You need to know that both good and bad situations come with the territory of coaching a club team. On the positive side, you get to inform kids when they make the team and watch the excitement in their eyes as they realize that they're pretty good at the sport. On the negative side, you have to deliver the bad news to the kids who don't make the team. You and the players alike experience a wide range of emotions during this part of the club team process. You share happiness and heartbreak, smiles and sadness, and delirium and disappointment.

Pay close attention to the following do's and don'ts when you're informing kids whether they get to play for you this season:

✔ **Don't drag your feet.** Yes, you probably have some really difficult decisions to make when you're trying to fill those last few roster spots, but don't procrastinate. Besides keeping you up half the night, dragging your feet drives the players (and their parents) crazy, wondering whether they made the team or not. So make your decisions in a timely manner.

✔ **Do notify every child.** Just talking to the kids who made the team and avoiding contact with those who didn't make the team may be tempting, but doing so isn't fair. The youngsters who sweat and gave everything they had during the tryout deserve the courtesy of hearing directly from you that they didn't make the team.

✔ **Do break bad news gently.** Yes, a child may be very disappointed when he finds out that he didn't make the team. In many cases, be prepared for tears to accompany hearing your news. Keep in mind that what you say — and how you say it — can determine how long that disappointment lingers and whether he uses it as motivation to work on his skills or to give up on the sport. Make sure the youngster and his parents know what areas of his game really impressed you. If he didn't make the team simply because more talented kids tried out, be sure to let him know. If the reason he didn't make the team is more because of a specific area of his game, speak to him in a positive fashion about concentrating on improving that skill. Let him know that you're confident that if he sticks with the sport and commits to improving that particular area of his game, he has a good chance of playing on one of these elite level teams in the future. You never want any youngster to regret that he tried out.

Handling Player Problems on the Road

Taking trips with your team can be great fun because it gives you a chance to get to know the kids better, but be aware that traveling isn't always strictly fun. Being on the road with your team creates the potential for problems to arise — and we're not talking about a flat tire on the highway. These problems can make the trip memorable for all the wrong reasons. However, as long as you're prepared to handle them if they do occur, these problems won't compromise the kids' experiences. In this section, we examine some of the most common road woes.

Addressing safety issues

Being in charge of an entire team, not just at the playing facility but also away from it during out-of-town tournaments, is an enormous responsibility. After all, you have to ensure the safety of every child on the road to and from the event, as well as at the location where the team is staying overnight.

Your players' parents hold you accountable during the whole trip. You're a chaperone, so you need to monitor and know the whereabouts of all your players at all times.

Keep the following tips in mind to help you ensure your players' safety:

✔ **Use a buddy system.** This approach, where each child is assigned a partner that he must keep track of at all times, helps ensure that no player is ever out of someone's sight. Also, you should never let kids roam around the motel without adult supervision, so make sure that adults you trust are supervising them at all times.

✔ **Use carpool assignments.** By making specific assignments of who's driving which kids, you have written documentation of where the kids are at all times. (Check out Chapter 4 for a list of duties, such as travel coordinator, that parents can handle so that you can devote your attention to coaching.)

Tackling behavior issues

How your team prepares for matches and tournaments is a responsibility of coaching that you're fully aware of. A responsibility you may not have given much thought to — but one that falls equally on your shoulders — is how your team behaves after they've played the final point of the day. When you take a team of kids (and their parents and other family members) to a weekend tournament, certain issues, including the following, tend to crop up at some point:

✔ **Late nights in the hotel pool:** Volleyball is a strenuous game and demands a lot from your players' bodies. Many tournaments require teams to play several matches during the course of the day (especially if the team keeps winning!), which means that a well-rested team is likely to perform better than one that splashed around in the motel pool for several hours the night before. Although children naturally enjoy staying in motels and using the pool or game room, you have to control the situation and enforce curfews. You can choose the time of the curfew based on the ages of the players and the starting time of their game the following day.

Let both the kids and their parents know, well in advance of the trip, what time the curfew is and what happens if a player breaks it. This notice helps eliminate the chances of misunderstandings occurring while you're on the trip. *Note:* One of the most effective ways to ensure that the kids stick to the curfew is by letting them know that anyone who breaks the curfew won't play in the next match.

✔ **Out-of-control parent parties:** Volleyball tournaments represent a chance for many families to enjoy an out-of-town trip together, and sometimes parents hang out together in the evenings. What

parents do during their own time isn't your business, as long as their good times don't escalate into problems involving alcohol or excessive noise.

Before departing for any tournament that requires an overnight stay, let the parents know that you want them to have a good time, but remind them that the tournament is a youth volleyball event. Parents need to model good behavior and set good examples at all times during the trip, whether they're at the volleyball court or away from it.

Enjoying the Season

Sometimes youngsters new to the club team environment require a short period of adjustment. The same goes for you. After all, you both have more practices and games to participate in than you're probably accustomed to, more out-of-town tournaments to travel to, and higher levels of competition to face. The following sections delve into how you can help ensure that your players, as well as you, aren't overwhelmed by the whole experience and don't regret stepping up to this higher level of play.

Warding off burnout

The calendar-filled practice and game schedules of some club teams leave some kids seeing volleyballs coming at them in their sleep! When seasons stretch out over several months, some players may show signs of burnout. The term *burnout* refers to a player who's physically or emotionally exhausted, or a combination of the two. Burnout can happen to anyone at anytime, but it's especially prevalent in players who play volleyball year-round. Even though kids love playing volleyball, a club team's season is much different than a recreational program's, so when kids experience a heavier practice schedule than they're used to, as well as an increased number of games, they're susceptible to burnout.

You can use the following tips to keep your team's energy and enthusiasm from fizzling out because of the dreaded burnout:

- **Mix up your practices.** Because club teams typically have a heavier practice load than recreational teams, switch up your sessions and the drills you use during them. The more variety you infuse into your practices with different drills, the more likely your players' energy tanks (and enthusiasm) are to remain full all season long.

- **Focus on fun.** Yes, the club team environment is typically more competitive and win-oriented than the local recreational volleyball program's, but even so, fun should never be nudged out of the equation. Playing the game has to be fun for the kids; otherwise, what's the point? Kids often

feel pressure to win —from you, their parents, or their teammates — and this pressure can wear on them. Even though you want your players to do their best to win games, you don't want them to forget to have fun. If you sense that fun is slipping away, take a look at how you're interacting with the kids and make sure that you're not the reason for the higher levels of stress. Remind yourself that children perform better when they're enjoying the experience of being on the court. Then, recap these thoughts to your team, pointing out that doing their best and having fun are more important than how the match turns out.

✔ **Alter your practice schedule when needed.** During the season, you have to stay flexible in your practice scheduling and recognize those times when your players benefit more from being off the court than on it. For instance, if your team has a heavy tournament schedule on the horizon, or is playing several games in a short time span, ease back on your practices leading up to those games. Scaling back helps keep the kids' energy and enthusiasm at optimum levels, plus it keeps them fresher for the games. Cutting back on practices during these busy times is a preventive approach for keeping burnout from affecting your players.

Keeping everyone interested

Even though the biggest slices of playing time are spread out among your most skilled players, the youngsters who don't hit attacks as hard or as accurately as the team's top players can still fill important roles. One of your tasks is making sure that every player — regardless of whether he's the team's top server or its weakest — is well aware of that fact.

Even when players are on the bench during games, you want them to be actively involved in cheering on and supporting their teammates. Also, encourage them to monitor the game's action closely. Having players keep an eye on the game not only holds their attention, but also enables them to spot weaknesses of the opposing team that they can then take advantage of when you call on them to enter the game.

One way to make every player feel like a part of the team is to organize team activities away from the court. Competing in tournaments in different locations provides opportunities for sightseeing and participating in activities that don't involve volleyball. ***Note:*** Team activities can provide great team-building opportunities for all team members, both starters and nonstarters. Before departing for the event, go over the tournament schedule with the players and their parents, and let them know well in advance whether they'll have any time for extracurricular activities. When choosing team activities away from the court, just be sure that the activity doesn't compromise the kids' ability to perform on the court. Keep in mind the added expense of extra activities; you don't want to put a financial strain on some parents or force them to participate in events that they may not be able to afford.

Part VI
The Part of Tens

"Hey! When I said take out the person who's making us lose, I didn't mean the score keeper!"

Part V

The Part of Tens

Tip and More

by Deb Johnson

In this part . . .

1 f you're looking for some creative ways for making the season a truly memorable one, this is the place for you. You can also find some great tips for helping propel your players to the next level.

Chapter 20

Ten Ways to Make the Season Memorable

*O*ne aspect of being a youth volleyball coach that you may not have considered is the impact you have on your players well after the final serve and attack of the season. Kids will look back on their season with you for years to come, and what they'll most remember is whether they had a fun-filled, encouraging experience or a miserable one that turned them away from the sport altogether. One of the many goals you can set at the start of every season is to do everything you can to ensure that all your players smile big when they reflect on their time with you. Check out these methods you can employ to help make your goal a reality.

Encourage Laughter

Like with other youth sports, everyone from the coaches on the sidelines to the parents in the stands often takes volleyball way too seriously. What results is a stress-filled, fun-deprived season for the players — something they didn't sign up for. To help ensure that the kids play relaxed and have fun, encourage them to laugh off their mistakes and the points in which the ball simply doesn't bounce in their favor. Kids who can smile and laugh during the game — as long as they don't direct the laughter at a teammate or opposing player — typically derive more enjoyment from the sport, because they play more relaxed and, thus, perform at higher levels.

Solicit Player Feedback

Because your primary goal as a youth volleyball coach is to make sure your players develop basic skills — while having fun doing so — you want to

continually make sure you're fulfilling this goal. To do so, go directly to your players and have open conversations about what they like about your practices and what you can do to make them better. Get honest feedback from them on which drills they love doing and which ones they really hate. These types of open conversations have double benefits: You become a better coach by determining what best meets the kids' needs, and your players feel better about themselves and their relationship with you because you value their input.

Make Every Child Feel Special

As a volleyball coach, you're in a great position to make a difference in your players' lives. Children crave attention and require constant feedback on how they're doing. Set a goal to say something positive to each child at every practice and game. Your feedback can be volleyball related, such as acknowledging a player's effort diving for a ball (whether she got to it in time doesn't matter); or it can be completely unrelated to setting and attacking, such as congratulating a player for doing well on a test in school. The more you're able to connect with your kids, the deeper your bond is, and the more value they gain from their experience.

Share Your Own Experiences

If you played volleyball as a youngster (or any other organized team sport), you can shake the dust off some of your memories and share them with your team. By doing so, you can help your players progress in the sport. For example, if you can share a humorous tale from your playing days — perhaps you attempted to hit a ball really hard during a match and completely missed the ball — kids can better understand that they shouldn't dwell on the crazy plays that take place on the court. Plus, the next time they do something during a match that embarrasses them, they can look at their miscue from a different perspective (the one you showed them through your stories), shake it off, and move on to the next point.

Set Up a Coaches-Players Tournament

To end the season, take a creative and fun approach and conduct a mini volleyball tournament where your coaching staff plays against your team. If you have a couple of assistant coaches, conduct a three-on-three tourney, where you and your helpers comprise one team. Break the kids up into evenly matched three-player teams, and play short matches up to five points. Doing so allows the kids to play several matches. Or, have your coaching

staff challenge each three-person team and see which groups can beat you or score the most points against you. The kids love going against you. Ending the season with a fun day of volleyball enables the kids to reflect on the whole season as a great experience during the off-season.

Run Silly Scrimmages

Sometimes kids — especially the younger ones with short attention spans — become bored as the season winds along, particularly if all the practices seem similar. To inject some much-needed energy into the sessions — and rev up the fun — try running a scrimmage with a few crazy rules in place. For example, require that every player touch the ball one time before the team can send it over the net. Sure, it's not an accurate volleyball rule (see Chapter 3 for a rundown of the real rules), but this fun twist can regain the kids' attention. Running scrimmages like this also helps you work on the kids' skills (especially passing skills) at the same time that you're reviving their enthusiasm for the sport.

Present Team Awards

Handing out creative team awards to each player helps you recognize each youngster for her contributions throughout the season, which, in turn, sends her into the off-season smiling. At the end of every season, you want all the kids to feel appreciated and valued for their efforts. Create special awards that recognize kids for their skills or special characteristics that stand out to you during the season. With a little imagination, you can come up with ways to highlight each child's efforts during the season. For example, create fun awards, such as Best Display of Sportsmanship, Most Supportive Teammate, and Most Likely to Dive.

Stay away from giving out Most Valuable Player awards. Doing so gives the impression that certain kids are more important in your eyes than their team-mates, and that message clashes with the teamwork philosophy you've (hope-fully) stressed and adhered to all season long. Plus, most kids are well aware of who the most talented players are and don't need you to point them out.

Involve the Parents in Practice

At the younger age ranges, kids enjoy having Mom or Dad breaking a sweat with them during practice. Besides having a scrimmage pitting the kids against the parents (see Chapter 6 for more details), you can involve the parents in other ways, too. They can corral loose balls during a hitting

drill so that you can give the kids more time attacking the balls rather than retrieving them from around the gym. Also, you can recruit parents to serve as blockers during attacking drills or servers during passing drills. You don't have to involve parents in every practice, but if you don't have any assistant coaches, a few helping hands can help the kids get the most of their weekly sessions with you.

Present Team Photo Albums

Putting together a team photo album for each child provides a great keepsake that helps your players remember their season. Before the season starts, designate an interested parent to take photos during some practices and games. Make copies of the good shots, and make identical albums for each youngster. Or, if you (or a parent) have time, make an album for each player that includes a team photo and a variety of action shots of that child competing in matches or practice.

Keep the Season in Perspective

Regardless of whether you're in your first or tenth season on the sidelines, getting caught up in the excitement of winning matches and securing first-place trophies can be tempting. However, if you're coaching in a league that keeps scores and standings (check out Chapter 2 for more details about the type of program you're coaching in), don't become a scoreboard watcher or track the league standings closer than you do your stock portfolio. Always keep in mind that the season is about the kids and their needs, not the number of wins you have. Plus, just because your team goes winless doesn't mean you're a terrible coach or the team had an awful experience. If the kids learned basic skills, showed improvement, had fun, and ended the season with a smile, you can be sure your season was a success!

Chapter 21

Ten Ways to Help Players Take Their Game to the Next Level

*Y*ou can use several approaches to prepare your volleyball team for a match. Even more options are available for helping players take their games to the next level — and beyond. The more creative and interesting your approaches are, the more likely your players are to improve their skills and savor the experience of playing for you. Use the fun information we present in this chapter to help your players reach higher levels of play — levels that some of them may never have dreamed of reaching.

Visualize Success

You have to see success to achieve it may sound like a corny bumper sticker, but visualizing success really is a useful approach for helping players elevate their performances because it puts kids in the proper mindsets to play well. To help your players visualize success, encourage players to find a quiet spot where they won't be disturbed the night before a match. Tell them to spend five to ten minutes with their eyes closed picturing how they see themselves playing. You want them to focus on seeing themselves serving with accuracy and efficiency, executing quality sets, making on-the-mark passes, and executing amazing defensive plays. Whenever players take the court with positive images in their heads, they have a much greater chance of performing their skills to the best of their abilities.

To help get your players in the habit of using positive visualization techniques, devote a minute or two before practice to having all the kids close their eyes and picture themselves performing a particular skill really well. When they see this positive visualization translate to success on the court, they become more willing — and even excited — to use this technique prior to game day.

Nullify the Nerves

All good volleyball players, at all levels of play, experience butterflies — that tingly and aching feeling in the pit of their stomachs — just before matches begin. To help your players overcome those nerves, encourage them to use deep-breathing techniques before practices and matches and even during matches. These techniques simply involve taking deep breaths in and slowly exhaling. For example, if a child feels nerves gripping his entire body before serving in a tightly contested match, have him take one deep breath and exhale slowly while he's getting in position to serve. He may just be relaxed enough to smack a good one.

Nervousness is a great indicator that the kids care about performing their best for the sake of the team. One of the differences between good players and great players is that great players don't allow their nerves to infringe on their setting and passing skills and likely perform at higher levels and enjoy greater success.

Meet with Players to Discuss Their Goals

Take time both before the season and during the season to chat with each player and discuss his goals for the season. Have each player write down a couple of personal goals. When goals are set on paper, the players (and you) are more easily reminded of them, and thus, your players are more likely to achieve their goals (see Chapter 11 for more details on goal setting).

At the conclusion of the season, have one-on-one chats with all your players to determine whether or not they're interested in working on their games in the off-season so they can come back stronger next year. If they're excited about exploring new ways to work on their skills to become more well rounded next season, share with them some ideas for upgrading their play. Remember, though, that if the interest isn't evident in some players, you need to allow them to step away from the sport and enjoy pursuing other activities. Doing so gives them a chance to take a break; they may even come back more energized and more anxious to play next season after a few months off.

Give 'Em Drills to Perform at Home

For those players who are interested in working on their skills even when they're not at practice or in games, provide them some drills they can perform at home. Even spending just a few minutes a day on certain drills helps kids enhance a variety of skills. At-home drills can be as basic as seeing how many times they can pass the ball to themselves without allowing the ball to hit the ground so they can work on their ball-handling skills; or they can involve recruiting friends or parents to throw balls at them at different speeds and angles so they can work on their defensive skills.

Send 'Em Camping

Regardless of how good a volleyball coach you are — and we know if you've devoured all the chapters in this book, you're well on your way to becoming a great one! — the more types of coaches you expose the kids to, the better your chances of expanding their skills. Suggest that your players attend volleyball camps where they can further develop and improve their skills under a different coach.

Many communities offer volleyball camps that a college or high school volleyball coach runs for local players. Kids who are really serious about the game can find more elite level national camps all around the country. Besides getting quality coaching and soaking up different perspectives and teaching methods at volleyball camps, kids derive immense benefits from practicing with — and playing against — kids of equal and superior skill levels. Competing against highly skilled kids brings out the best in those players aspiring to reach higher levels of performance.

The costs of these camps vary greatly, so before suggesting this option to your players, gather all the information, especially costs, about your local camp and present it to the parents. If the camp doesn't fit into their budgets and isn't an option at this time, you don't want to get the youngsters' hopes up and then see them disappointed.

Push the Right Buttons

Motivating kids is tricky, but after you discover what works for a particular child, you can propel him to higher levels of play. Many youngsters embrace challenges and love trying to prove to you that they can do more than you

expect of them. Identify those players and then test and push them during practice. For example, you can challenge them not to make an off-target pass during practice. Kids with this challenge-motivated mental makeup really benefit from being pushed by you, their coach and motivator.

You can add an extra element of fun by letting the kids know that if they meet your challenge, you'll do ten push-ups or run a couple of laps around the court. Make sure they know that if they fall short, they'll be doing the laps instead of you!

Issue these types of challenges only to those players who have shown that they're highly competitive and enjoy pursuing them — and can also handle those times when they fall short of the challenges you throw out to them. Otherwise, you risk discouraging the kids who aren't quite ready to handle this type of coaching technique.

Cue the Conditioning

When kids are exploring ways to elevate their games, the aspect that many coaches and players alike quickly overlook is conditioning — and with good reason — because the mere mention of the word often conjures up pain, sweat, and unpleasantness for many children. Yet, conditioning directly impacts every player's performance. To help your players take their game to the next level, make sure you include conditioning in your practices and encourage your players to work out a few times a week outside of practice.

Regardless of how skilled your players are, they compromise their ability to impact a match if they're too tired late in a game to pass or attack a ball as efficiently as they did at the start. Talk to your players about the importance of not only maintaining good conditioning but also improving it. During the off-season, they can run, jump rope, and perform jumping jacks, among other activities, to strengthen their legs and improve their cardiovascular endurance. This increased strength and endurance comes in handy during those long, closely contested matches in which players have to work extra hard to win a point.

Weight-training exercises that focus on the thigh and calf muscles are also extremely beneficial for volleyball players because they lead to a more powerful base, which translates into higher leaping ability. This increased leaping ability comes in especially handy when your players are attacking and blocking. (Check out Chapter 10 for more on conditioning and appropriate exercises for volleyball players.)

Avoid Practice Perfection

Coaches often fall into the habit of performing skills too well during practices. Yes, we know you want to play well just like the kids do, but less-than-perfect play from you can actually pay big dividends for your players. For example, if you're running a hitting drill and you're the designated setter, refrain from giving the kids a perfect set to hit each time. By setting balls at different heights, as well as too far in front and behind them (and off to their right and left) you force them to make quick adjustments. Because your players won't always receive perfect sets from their teammates during matches, forcing them to adapt to balls in different locations during practice helps them develop into well-rounded players who are ready for anything come game time. Plus, kids who can make plays on any balls — and who have the experience and confidence to do so — enable your team to play at a higher level.

Bring In Guest Speakers

You can shake up your practices by bringing in a guest speaker or two to address the team and practice with them. A local high school volleyball coach can talk to the kids and motivate them, as well as run them through some of his favorite drills. Have the coach emphasize to the kids what they have to do to improve their game. Guest speakers who focus on the importance of dedication and commitment for achieving goals can have a big impact on the kids.

Master the Art of Conversing — With Yourself

Having conversations with yourself may attract some strange looks, but when you're talking about performing well on the volleyball court, these one-sided chats can be as useful as a really good vertical jump. Continually encourage your players to recite positive messages to themselves. Let them know you have full confidence in their ability to get the job done against the opposition.

Players who are successful not only possess strong physical skills, but also have the confidence to perform them on game day. Encourage players to motivate themselves by reciting comments such as: "I love the challenge of trying to return really hard serves because I'm good at reacting to them" or "I've played really well in practice this week and my skills are improving, so I know I will play very well today."

Index

• U •

• V •

• W •

• Z •

BUSINESS, CAREERS & PERSONAL FINANCE

Accounting For Dummies, 4th Edition*
978-0-470-24600-9

Bookkeeping Workbook For Dummies†
978-0-470-16983-4

Commodities For Dummies
978-0-470-04928-0

Doing Business in China For Dummies
978-0-470-04929-7

E-Mail Marketing For Dummies
978-0-470-19087-6

Job Interviews For Dummies, 3rd Edition*†
978-0-470-17748-8

Personal Finance Workbook For Dummies*†
978-0-470-09933-9

Real Estate License Exams For Dummies
978-0-7645-7623-2

Six Sigma For Dummies
978-0-7645-6798-8

Small Business Kit For Dummies, 2nd Edition*†
978-0-7645-5984-6

Telephone Sales For Dummies
978-0-470-16836-3

BUSINESS PRODUCTIVITY & MICROSOFT OFFICE

Access 2007 For Dummies
978-0-470-03649-5

Excel 2007 For Dummies
978-0-470-03737-9

Office 2007 For Dummies
978-0-470-00923-9

Outlook 2007 For Dummies
978-0-470-03830-7

PowerPoint 2007 For Dummies
978-0-470-04059-1

Project 2007 For Dummies
978-0-470-03651-8

QuickBooks 2008 For Dummies
978-0-470-18470-7

Quicken 2008 For Dummies
978-0-470-17473-9

Salesforce.com For Dummies, 2nd Edition
978-0-470-04893-1

Word 2007 For Dummies
978-0-470-03658-7

EDUCATION, HISTORY, REFERENCE & TEST PREPARATION

African American History For Dummies
978-0-7645-5469-8

Algebra For Dummies
978-0-7645-5325-7

Algebra Workbook For Dummies
978-0-7645-8467-1

Art History For Dummies
978-0-470-09910-0

ASVAB For Dummies, 2nd Edition
978-0-470-10671-6

British Military History For Dummies
978-0-470-03213-8

Calculus For Dummies
978-0-7645-2498-1

Canadian History For Dummies, 2nd Edition
978-0-470-83656-9

Geometry Workbook For Dummies
978-0-471-79940-5

The SAT I For Dummies, 6th Edition
978-0-7645-7193-0

Series 7 Exam For Dummies
978-0-470-09932-2

World History For Dummies
978-0-7645-5242-7

FOOD, GARDEN, HOBBIES & HOME

Bridge For Dummies, 2nd Edition
978-0-471-92426-5

Coin Collecting For Dummies, 2nd Edition
978-0-470-22275-1

Cooking Basics For Dummies, 3rd Edition
978-0-7645-7206-7

Drawing For Dummies
978-0-7645-5476-6

Etiquette For Dummies, 2nd Edition
978-0-470-10672-3

Gardening Basics For Dummies*†
978-0-470-03749-2

Knitting Patterns For Dummies
978-0-470-04556-5

Living Gluten-Free For Dummies†
978-0-471-77383-2

Painting Do-It-Yourself For Dummies
978-0-470-17533-0

HEALTH, SELF HELP, PARENTING & PETS

Anger Management For Dummies
978-0-470-03715-7

Anxiety & Depression Workbook For Dummies
978-0-7645-9793-0

Dieting For Dummies, 2nd Edition
978-0-7645-4149-0

Dog Training For Dummies, 2nd Edition
978-0-7645-8418-3

Horseback Riding For Dummies
978-0-470-09719-9

Infertility For Dummies†
978-0-470-11518-3

Meditation For Dummies with CD-ROM, 2nd Edition
978-0-471-77774-8

Post-Traumatic Stress Disorder For Dummies
978-0-470-04922-8

Puppies For Dummies, 2nd Edition
978-0-470-03717-1

Thyroid For Dummies, 2nd Edition†
978-0-471-78755-6

Type 1 Diabetes For Dummies*†
978-0-470-17811-9

* Separate Canadian edition also available
† Separate U.K. edition also available

Available wherever books are sold. For more information or to order direct: U.S. customers visit www.dummies.com or call 1-877-762-2974.
U.K. customers visit www.wileyeurope.com or call (0)1243 843291. Canadian customers visit www.wiley.ca or call 1-800-567-4797.

INTERNET & DIGITAL MEDIA

AdWords For Dummies
978-0-470-15252-2

Blogging For Dummies, 2nd Edition
978-0-470-23017-6

**Digital Photography All-in-One
Desk Reference For Dummies, 3rd Edition**
978-0-470-03743-0

Digital Photography For Dummies, 5th Edition
978-0-7645-9802-9

**Digital SLR Cameras & Photography
For Dummies, 2nd Edition**
978-0-470-14927-0

**eBay Business All-in-One Desk Reference
For Dummies**
978-0-7645-8438-1

eBay For Dummies, 5th Edition*
978-0-470-04529-9

eBay Listings That Sell For Dummies
978-0-471-78912-3

Facebook For Dummies
978-0-470-26273-3

The Internet For Dummies, 11th Edition
978-0-470-12174-0

Investing Online For Dummies, 5th Edition
978-0-7645-8456-5

iPod & iTunes For Dummies, 5th Editi
978-0-470-17474-6

MySpace For Dummies
978-0-470-09529-4

Podcasting For Dummies
978-0-471-74898-4

**Search Engine Optimization
For Dummies, 2nd Edition**
978-0-471-97998-2

Second Life For Dummies
978-0-470-18025-9

**Starting an eBay Business For Dumm
3rd Edition†**
978-0-470-14924-9

GRAPHICS, DESIGN & WEB DEVELOPMENT

**Adobe Creative Suite 3 Design Premium
All-in-One Desk Reference For Dummies**
978-0-470-11724-8

**Adobe Web Suite CS3 All-in-One Desk
Reference For Dummies**
978-0-470-12099-6

AutoCAD 2008 For Dummies
978-0-470-11650-0

**Building a Web Site For Dummies,
3rd Edition**
978-0-470-14928-7

**Creating Web Pages All-in-One Desk
Reference For Dummies, 3rd Edition**
978-0-470-09629-1

**Creating Web Pages For Dummies,
8th Edition**
978-0-470-08030-6

Dreamweaver CS3 For Dummies
978-0-470-11490-2

Flash CS3 For Dummies
978-0-470-12100-9

Google SketchUp For Dummies
978-0-470-13744-4

InDesign CS3 For Dummies
978-0-470-11865-8

**Photoshop CS3 All-in-One
Desk Reference For Dummies**
978-0-470-11195-6

Photoshop CS3 For Dummies
978-0-470-11193-2

Photoshop Elements 5 For Dummie
978-0-470-09810-3

SolidWorks For Dummies
978-0-7645-9555-4

Visio 2007 For Dummies
978-0-470-08983-5

Web Design For Dummies, 2nd Edit
978-0-471-78117-2

Web Sites Do-It-Yourself For Dumm
978-0-470-16903-2

Web Stores Do-It-Yourself For Dumm
978-0-470-17443-2

LANGUAGES, RELIGION & SPIRITUALITY

Arabic For Dummies
978-0-471-77270-5

Chinese For Dummies, Audio Set
978-0-470-12766-7

French For Dummies
978-0-7645-5193-2

German For Dummies
978-0-7645-5195-6

Hebrew For Dummies
978-0-7645-5489-6

Ingles Para Dummies
978-0-7645-5427-8

Italian For Dummies, Audio Set
978-0-470-09586-7

Italian Verbs For Dummies
978-0-471-77389-4

Japanese For Dummies
978-0-7645-5429-2

Latin For Dummies
978-0-7645-5431-5

Portuguese For Dummies
978-0-471-78738-9

Russian For Dummies
978-0-471-78001-4

Spanish Phrases For Dummies
978-0-7645-7204-3

Spanish For Dummies
978-0-7645-5194-9

Spanish For Dummies, Audio Set
978-0-470-09585-0

The Bible For Dummies
978-0-7645-5296-0

Catholicism For Dummies
978-0-7645-5391-2

The Historical Jesus For Dummies
978-0-470-16785-4

Islam For Dummies
978-0-7645-5503-9

**Spirituality For Dummies,
2nd Edition**
978-0-470-19142-2

NETWORKING AND PROGRAMMING

ASP.NET 3.5 For Dummies
978-0-470-19592-5

C# 2008 For Dummies
978-0-470-19109-5

Hacking For Dummies, 2nd Edition
978-0-470-05235-8

Home Networking For Dummies, 4th Edition
978-0-470-11806-1

Java For Dummies, 4th Edition
978-0-470-08716-9

**Microsoft® SQL Server™ 2008 All-in-One
Desk Reference For Dummies**
978-0-470-17954-3

**Networking All-in-One Desk Reference
For Dummies, 2nd Edition**
978-0-7645-9939-2

**Networking For Dummies,
8th Edition**
978-0-470-05620-2

SharePoint 2007 For Dummies
978-0-470-09941-4

**Wireless Home Networking
For Dummies, 2nd Edition**
978-0-471-74940-0

OPERATING SYSTEMS & COMPUTER BASICS

Mac For Dummies, 5th Edition
978-0-7645-8458-9

Laptops For Dummies, 2nd Edition
978-0-470-05432-1

Linux For Dummies, 8th Edition
978-0-470-11649-4

MacBook For Dummies
978-0-470-04859-7

**Mac OS X Leopard All-in-One
Desk Reference For Dummies**
978-0-470-05434-5

Mac OS X Leopard For Dummies
978-0-470-05433-8

Macs For Dummies, 9th Edition
978-0-470-04849-8

PCs For Dummies, 11th Edition
978-0-470-13728-4

Windows® Home Server For Dummies
978-0-470-18592-6

Windows Server 2008 For Dummies
978-0-470-18043-3

**Windows Vista All-in-One
Desk Reference For Dummies**
978-0-471-74941-7

Windows Vista For Dummies
978-0-471-75421-3

Windows Vista Security For Dummies
978-0-470-11805-4

SPORTS, FITNESS & MUSIC

Coaching Hockey For Dummies
978-0-470-83685-9

Coaching Soccer For Dummies
978-0-471-77381-8

Fitness For Dummies, 3rd Edition
978-0-7645-7851-9

Football For Dummies, 3rd Edition
978-0-470-12536-6

GarageBand For Dummies
978-0-7645-7323-1

Golf For Dummies, 3rd Edition
978-0-471-76871-5

Guitar For Dummies, 2nd Edition
978-0-7645-9904-0

**Home Recording For Musicians
For Dummies, 2nd Edition**
978-0-7645-8884-6

**iPod & iTunes For Dummies,
5th Edition**
978-0-470-17474-6

Music Theory For Dummies
978-0-7645-7838-0

Stretching For Dummies
978-0-470-06741-3

Get smart @ dummies.com®

- **Find a full list of Dummies titles**
- **Look into loads of FREE on-site articles**
- **Sign up for FREE eTips e-mailed to you weekly**
- **See what other products carry the Dummies name**
- **Shop directly from the Dummies bookstore**
- **Enter to win new prizes every month!**

Separate Canadian edition also available
Separate U.K. edition also available

Available wherever books are sold. For more information or to order direct: U.S. customers visit www.dummies.com or call 1-877-762-2974.
U.K. customers visit www.wileyeurope.com or call (0) 1243 843291. Canadian customers visit www.wiley.ca or call 1-800-567-4797.